Vicki Dodds Memorial Art Book Collection

HUNTSVILLE PUBLIC LIBRARY

Donated By

The Dodds Family

In Honour Of

Vicki Dodds

JUL 2 8 2016 **PROPERTY OF HUNTSVILLE PUBLIC LIBRARY**

Independent Spirit

Independent Party

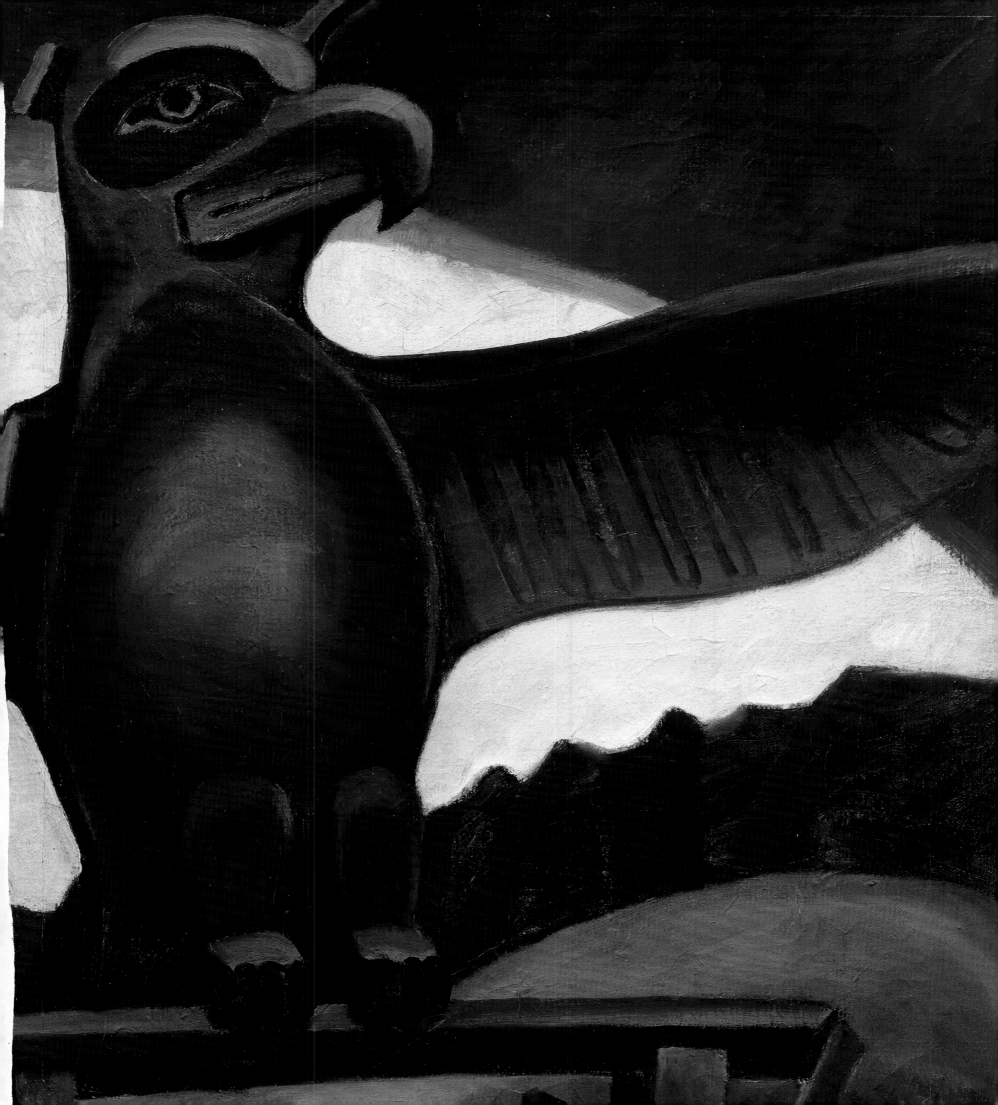

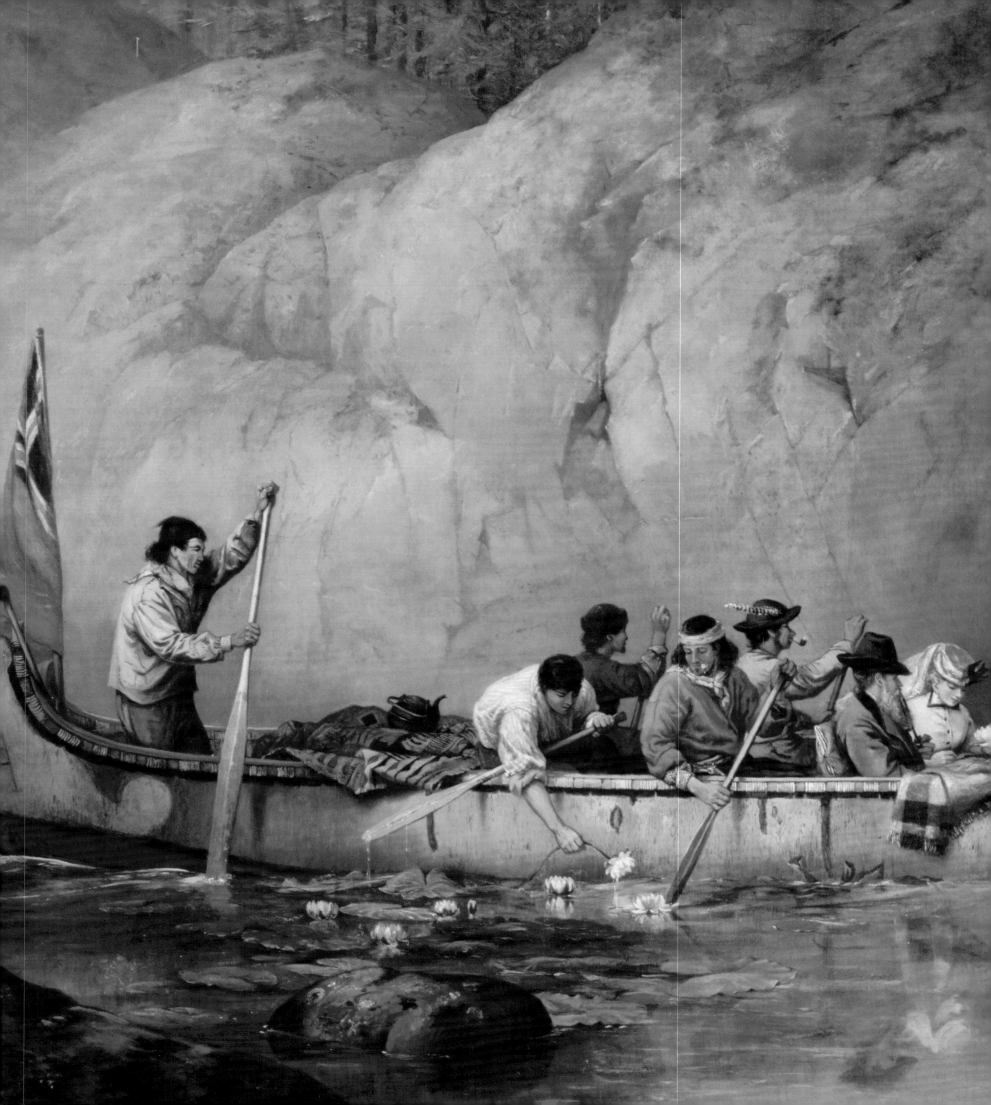

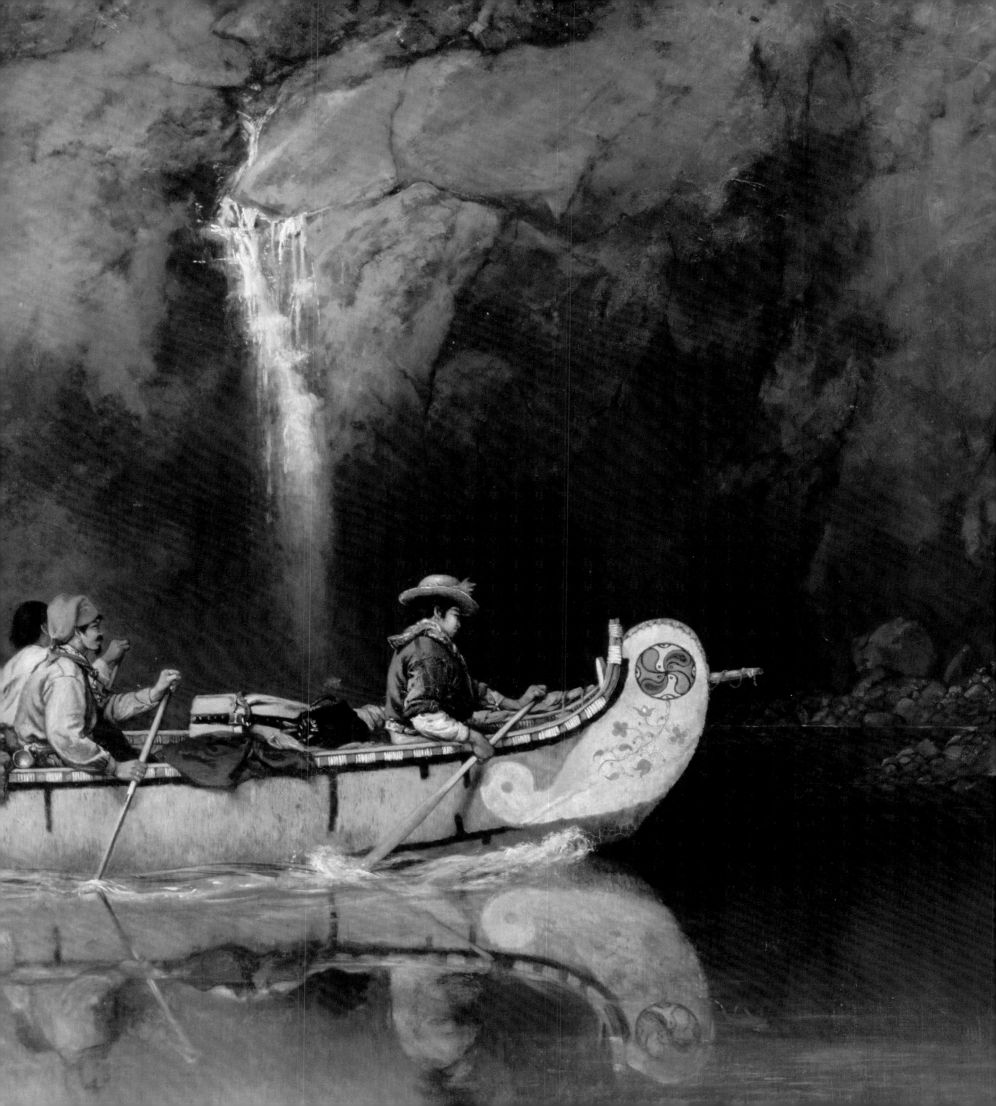

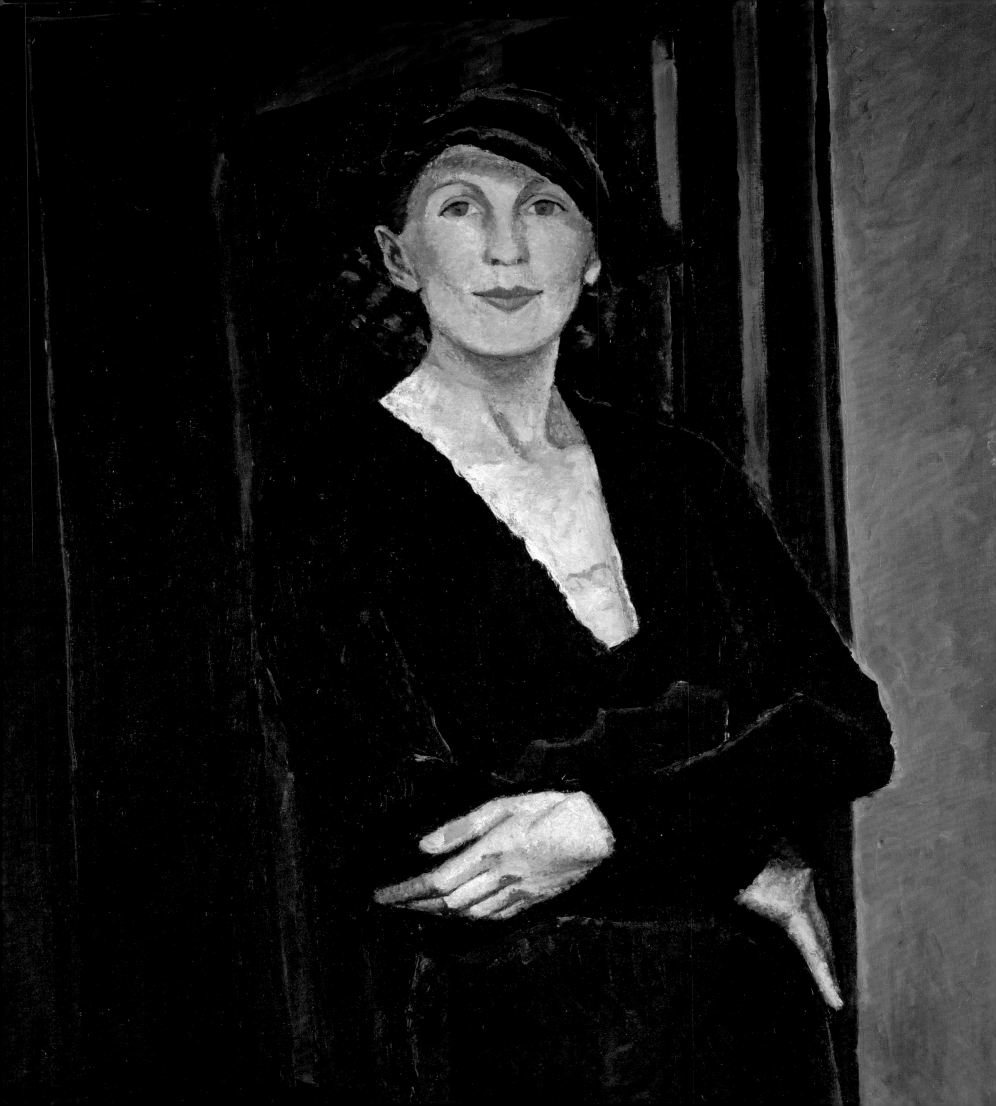

Independent Spirit

Early Canadian Women Artists

A.K. Prakash

Firefly Books

A Firefly Book

Published by Firefly Books Ltd. 2008
Copyright © 2008 A.K. Prakash

All rights reserved. No part of this publication may be reproduced, stored in a retrieval system, or transmitted in any form or by any means, electronic, mechanical, photocopying, recording or otherwise, without the prior written permission of the Publisher.

The List of Illustrations on pages 384–388 constitutes a continuation of this copyright page. Every attempt has been made to trace ownership of copyright material in this book and to secure permissions. The publisher would appreciate receiving information as to any inaccuracies in the credits for subsequent editions.

Publisher Cataloging-in-Publication Data (U.S.)
Prakash, A.K.
Independent spirit: early Canadian women artists.
[410] p. : photos. (chiefly col.); cm. Includes bibliographies and index.
Summary: A survey of early Canadian women artists from the 18th to the mid-20th century.
ISBN-13: 978-1-55407-417-4
ISBN-10: 1-55407-417-7
1. Women artists—Canada. 2. Art, Canadian—18th century.
3. Art, Canadian—19th century. 4. Art, Canadian—20th century.
5. Women artists—Canada—Biography. I. Title.
709.71 dc22 N6540.P735 2008

Library and Archives Canada Cataloguing in Publication
Prakash, A.K.
Independent spirit: early Canadian women artists / A.K. Prakash.
ISBN-13: 978-1-55407-417-4
ISBN-10: 1-55407-417-7
1. Women artists—Canada—History.
2. Women artists—Canada—Biography. 3. Art, Canadian. I. Title.
N6548.P735 2008 700.82'0971 C2008-903014-1

Published in the United States by
Firefly Books (U.S.) Inc.
P.O. Box 1338, Ellicott Station
Buffalo, New York 14205

Published in Canada by
Firefly Books Ltd.
66 Leek Crescent
Richmond Hill, Ontario L4B 1H1

Jacket and text design: Counterpunch Inc./Linda Gustafson
Editor: Meg Taylor

Printed in Canada

The publisher gratefully acknowledges the financial support for our publishing program by the Government of Canada through the Book Publishing Industry Development Program.

Captions for opening pages:
3 Emily Carr, *Thunderbird,* Campbell River, B.C., cropped. See page 65.
4–5 Frances Anne Hopkins, *Canoe Manned by Voyageurs Passing a Waterfall,* cropped. See page 43.
6 Paraskeva Clark, *Myself,* cropped. See page 171.

FOR SIENNA AND SASHA

Step by step, bravely on.

Forge your path.

Light the way.

CONTENTS

MASTERS OF THEIR CRAFT

PART II: LIVES OF THE ARTISTS

PART III: INDEX OF EARLY CANADIAN WOMEN ARTISTS

The contribution of women artists has been a neglected subject in the history of art, yet it deserves the sensitive and thorough appraisal offered by A.K. Prakash. In this volume, the difficulties that women artists have faced beyond the scope of artistic challenges are recognized, and their successes honoured.

Independent Spirit: Early Canadian Women Artists is the first interpretive study of the subject. It is my hope that its publication will engage sympathy in the reader and stimulate further inquiry among scholars. The author is to be admired for his passion, dedication, and readiness to break new ground, in this, as in so many other realms of Canadian art.

David Thomson
Chairman
Thomson Reuters Corporation

My intention in writing this book has been to single out the women painters, sculptors, and printmakers I believe to be particularly significant and thus provide a framework for further investigation of early Canadian women artists. Rather than dissecting the life story of each individual in order to reveal the artist, I have decided to take the reader on a visual journey of discovery – first the artwork, then the creator. The colour reproductions and detailed interpretations of the artwork in Part I "The Visual Journey" will, I hope, stimulate the reader to delve further by referring to the biographical information in Part II "Lives of the Artists."

My investigation of the art of Canadian women artists has presented its particular research problems. Among these were the re-examination of the scholarship devoted to them and the assimilation of recent interest in their work as reflected in a number of exhibitions and monographs, as well as the reassessment of the work of many artists in the light of the general re-evaluation of the modern movement in Canada.

The intent of this book is frankly exploratory rather than definitive. It covers women and the art they made over the last two centuries in a wide assortment of media as an attempt to arrive at a broad, chronological picture of their artistic activity. An exploration of this kind cannot hope to be entirely comprehensive, but within its guidelines, I endeavour to raise awareness about the changing nature of the way we regard women artists.

I have separated the Canadian women artists in Part I into two distinct, albeit subjective, categories: "Trailblazers" and "Masters of Their Craft." The "Trailblazers," for me, are those who changed Canadian art forever. That is, the originality and force of expression embodied in their work have survived the test of time. Those I include in "Masters of Their Craft" are artists who created art with strength and authority, but did not seek to revolutionize Canadian art. Consummate professionals, they created work that is aesthetically and technically impressive.

Part II, "Lives of the Artists," provides concise biographies of the thirty-six women included in Part I. The biographies are illustrated with additional colour images of the artists' work.

Part III, "Index of Early Canadian Women Artists," lists all of the professional women artists who were active in Canada from the mid-eighteenth century through the mid-twentieth century. It includes women artists who pursued training in art and who participated in public exhibitions. It does not include amateur artists or First Nations artists, who are outside the scope of this study. Much information still remains elusive, including authenticated dates for some of the women artists.

My hope is that this book will stimulate further study of early Canadian women artists, and that it will prove to be a useful reference for all those interested in the subject.

ACKNOWLEDGEMENTS

This book would not have been possible without the assistance I received from friends and colleagues over the years. To the scholars and curators who have stimulated and refined my own understanding of the challenges faced by each artist, I owe an enormous debt of gratitude. I would like to thank the following individuals and institutions for their generous help: in Ottawa, Charles C. Hill, Curator of Canadian Art at the National Gallery of Canada, who has always been willing to share his knowledge on the subject, and the Library and Archives of the National Gallery of Canada; in Toronto, Anna Hudson, former Associate Curator of Canadian Art, Art Gallery of Ontario, and currently Assistant Professor at York University, who read the book in manuscript and offered many helpful suggestions, and Donald Rance at the Edward P. Taylor Research Library and Archives of the Art Gallery of Ontario, who contributed research on a number of women in the Index of Early Canadian Women Artists, as did Katerina Atanassova, Curator at the Varley Art Gallery in Markham; in Montreal, Janice Anderson, Visual Resources Curator at Concordia University, and graduate researcher Alena Buis provided access to unpublished research at the Canadian Women Artists History Initiative.

Other distinguished scholars who read parts of the book in manuscript and offered helpful comments include: Shirley Thomson, former Director of the National Gallery of Canada and Chair of the Canadian Cultural Property Export Review Board, Ottawa, and Roald Nasgaard, former Chief Curator, Art Gallery of Ontario, and currently Professor of Art History and former Chair of the Art Department, Florida State University, Tallahassee. Joan Murray, writer, curator, and Director Emerita of the Robert McLaughlin Gallery in Oshawa, served as my first editor, and I thank her for the commitment with which she worked to improve the manuscript.

To my confreres abroad, who have facilitated my understanding of the influences of art produced outside Canada on the artists included in this book, I extend my deep appreciation: in New York, Nanne Dekking; in Los Angeles, George Stern and Danny Abiri; in San Francisco, Peter Fairbanks; in London, U.K., John Williams; and in Paris, Manuel Schmit.

I am grateful for the confidence and companionship I have enjoyed over the last several decades with many of the leading art dealers in Canada: in Calgary, Rod Green and Peter Ohler, Jr.; in Edmonton, Douglas Udell; in Montreal, the late Walter Klinkhoff and Gertrude, Eric, Alan, and Jonathan Klinkhoff, Giancarlo Biferali, Paul Kastel, Jean-Pierre and Heather Valentin; in Ottawa, Francine and Vincent Fortier; in Quebec, Louis Lecerte; in Toronto, Michel Bigué, Gisella Giacalone, Mira Godard, Gerard M. Gorce, Geoffrey Joyner, the late G. Blair Laing, Don Lake, Alan Loch, José Lopes, Joan Martyn, George Nanowski, Linda Rodeck, Lynda and John Shearer, and David Silcox; in Vancouver, Peter Ohler, Sr., the earliest patron of historical Canadian women artists, Torben Kristiansen, Jeanette Langmann, and Barry Scott; and in Winnipeg, David Loch.

I also wish to acknowledge the assistance of many public institutions, private collectors, and individuals who represent the estates of artists across North America or who have allowed me to illustrate the images in this book: in Alberta, Gordon Emmerson and Renae and Michael J. Tims; in British Columbia, Angela Arkell, Carolyn and William Askill, Peter Brown, Paul Courtice, Carolyn Cross, Norm Francis, Gunter Heinrich, Dean May, and Nancy and Richard Self; in New Brunswick, Laura and Byrne Harper; in Newfoundland, Heather Morgan; in Nova Scotia, George Vlamis; in Ontario, the late Lord Kenneth Thomson, David Thomson, Brian Ayer, Qennefer Browne, Clive Clark, Felicia Cukier, Andrée Dell, Scott Durston, Viktor Gordin, James Hallop, Peter Hodgson, Avrom Isaacs, Susan Kilburn, Eleanor Koldofsky, Bill McKague, Michael Pflug, Penny and Peter Regenstreif, Beverly and Fred Schaeffer, Laura Schiffer, Eric Sprott, Jeff Stevens, and Michael Weinberg; in Quebec, Jean-Pierre Beaulac, Paul Bradley, John B. Claxton, Fiona and Jake Eberts, Barbara and Jim Marcolin, Jonathan Robinson, Sandra and Leonard Schlemm, and Gilles Vaillancourt; in California, Jim Cameron and Stephen Diamond; in Colorado, Pierre Lassonde; in New York, Elizabeth and Bert Chilton and Francis Forbes Newton; and others who remain anonymous.

I remain indebted to those without whose support I could not have survived the rigours of writing. Foremost among them: Julie Hinton Walker, who was the first to encourage and assist me in planning this book. Julie conducted the preliminary research for Lives of the Artists and the Index of Early Canadian Women Artists by working diligently with museums and archives across Canada. Her contribution facilitated the successive phases of research required to complete this critical component of the book. I also wish to acknowledge here my indebtedness to an excellent website created by Library and Archives Canada to honour the Achievements of Women Artists, which provided information for several of the biographical entries, and to the Canadian Women Artists History Initiative website created by Concordia University, which contributed to the accuracy of the dates in the Index of Early Canadian Women Artists.

My thanks to Ana Ugarte for her devotion to coordinating changes in the manuscript and images. Many thanks also to Andrea Dixon at the National Gallery of Canada for her timely assistance in identifying some of the estate owners, Anastasia Apostolou at Thomson Works of Art Ltd. for locating a file on Florence McGillivray, Helaine Glick at the Monterey Museum for help in tracking down a Henrietta Shore painting, Allison Archibald for arranging access to a Sophie Pemberton painting, and Melanie Ramsay for the skill with which she secured images for the book from the following institutions: in Calgary, Masters Gallery Limited; in Halifax, Art Gallery of Nova Scotia; in Hamilton, Art Gallery of Hamilton; in Montreal, Walter Klinkhoff Gallery, Galerie Jean-Pierre Valentin; in Oshawa, the Robert McLaughlin Gallery; in Ottawa, Library and Archives Canada, National Gallery of Canada; in Toronto, Thomson Works of Art Ltd., Art Gallery of Ontario, Canadian Fine Arts Ltd., Heffel Gallery Inc., D. and E. Lake Ltd., Loch Gallery; in Vancouver, Peter Ohler Fine Arts, Vancouver Art Gallery; in Victoria, Art Gallery of Greater Victoria; in Winnipeg, Winnipeg Art Gallery; in Woodstock, Ontario, the Woodstock Art Gallery; in Los Angeles, George Stern Fine Arts; and in Monterey, California, the Monterey Museum.

In conclusion, I would like to express my gratitude to a group of extraordinary people who toiled with me, day after day, night after night, in resolving the challenges of taking the book from manuscript through production. I thank my publisher, Lionel Koffler, and Firefly's associate publisher, Michael Worek, for their unconditional support. Thanks to Meg Taylor, my editor, Ruth Gaskill, who assisted with the copy edit and supplemental research, Edna Barker, the proofreader, and Belle Wong, the indexer. Last but not least, the design of the book reflects the prodigious talents of Linda Gustafson, whose dedication to excellence complements the creativity for which she is already acclaimed. Without her relentless hard work, problem-solving abilities, and insightful guidance, *Independent Spirit* would never have seen the light.

Finally, only I am responsible for any oversights in this publication.

A.K. Prakash
Toronto, July 2008

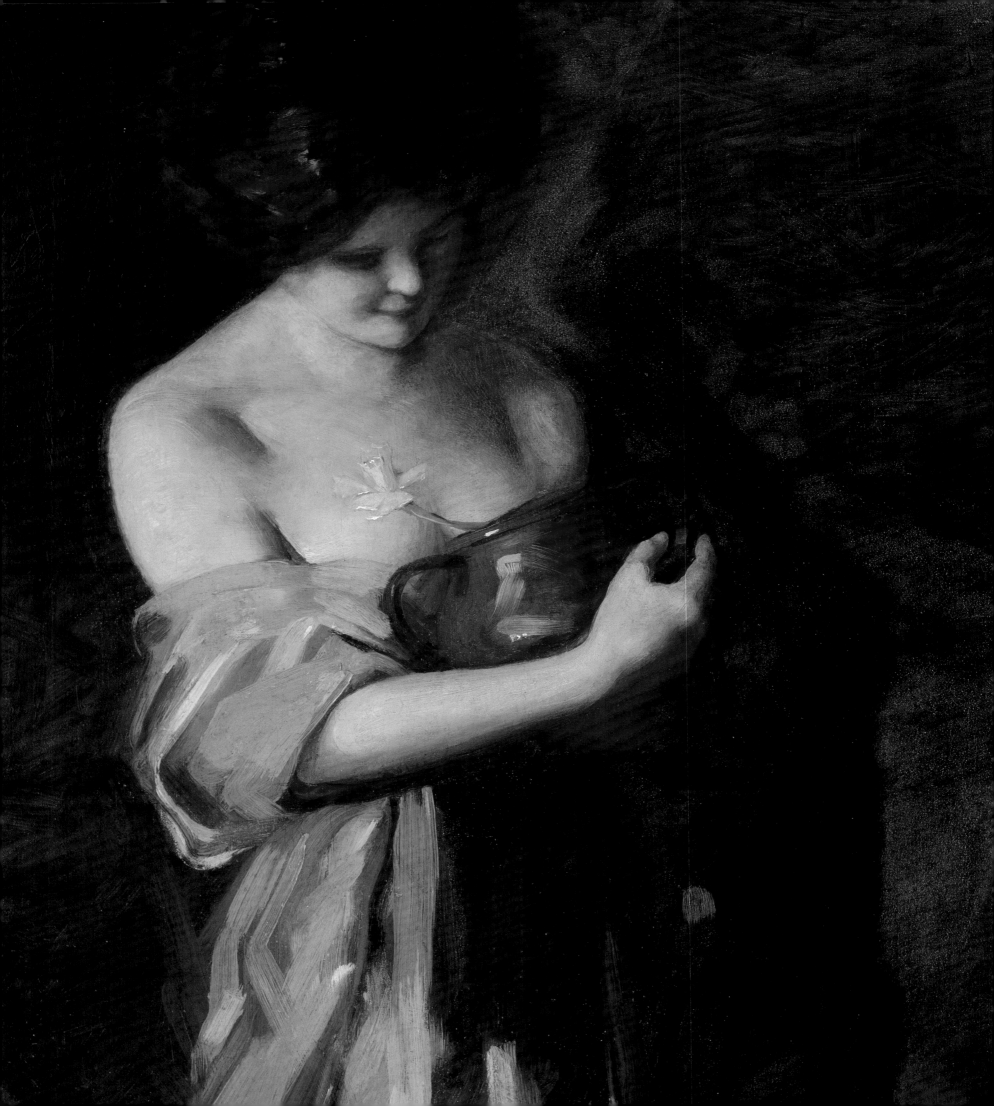

INTRODUCTION

Was art once a man's franchise, plain and simple? If so, what happened to the women who became full-fledged professional artists in earlier centuries? Why is the art of so many of them, though perhaps once famous, now forgotten?

A survey of early Canadian women artists reveals a breadth of work that reflects the culture of this country in a multitude of images of the land and its people. At first the path taken by women artists ran parallel to the mainstream. By the early twentieth century, women artists came to play a significant role in the mainstream yet continued to offer a separate viewpoint.

Does the difference between men and women affect the creative process? Women artists, like men, work within the context of their environment but take art somewhere we think we have seen before, but haven't. Broadly speaking, women artists have been particularly sympathetic to themes that reaffirm and dramatize the importance of life – painting children, young women, and mothers and children. This subject matter would have been in keeping with their audience's expectations. At the same time, upon close examination of their artwork, we see that they often succeeded in breaking loose from what was considered appropriate to a woman's expression.

The visual arts are one of the lasting achievements of humankind. Embodied in form and content and with a special relationship to the viewer, art manifests all the struggles and bounty this world has to offer. But to understand anything in its entirety, a dissection of parts is necessary. Whether we study the chronology of painting, the way in which each "ism" of art is interpreted, or the way in which artists select and portray their subject matter, knowing the basic properties enables us to see beyond the obvious in art.

The beginnings of modern society are generally traced to the late eighteenth century when two kinds of revolution – industrial and political – began to transform the Western world. The Industrial Revolution, in particular, brought about economic change that redirected the priorities of the working class and specifically affected women.

Florence Carlyle
Woman with Daffodil
See page 59.

One of the immediate effects of the American and French Revolutions was the expansion of women's legal rights. Together, these revolutions set in motion a course that contributed to a greater acceptance of education for women, and this in turn led to new-found freedoms in intellectual life.

Throughout the nineteenth century, working-class women found employment mostly as servants or within the garment industry. Industrialization did not dramatically influence the kinds of work that women performed, but by the mid-nineteenth century in Europe, social conditions had improved. The working day was shortened from twelve to ten hours. Although two hours may not significantly change a single day, cumulatively they allowed an increase in family and personal time as well as the pursuit of activities outside the home. These activities included participation in the larger community and the exploration of special interests and hobbies.

By 1900, prosperity had reached more families, and the separation between home and work was virtually complete. Women of privilege were able to partake in activities hitherto reserved for men. Access to education also became a reality for women of both the middle and upper classes; in time, the art academies of Europe felt a growing pressure to change their admission policies to allow female enrolment.

European women who came to Canada, from the first settlers to immigrants in the early twentieth century, dealt first with the immediate challenges of life in a new land. They and their families risked their lives travelling across uncharted territory in the harshest of conditions until they found a place they could eventually call home. Communities had to be established before anyone could entertain the idea of artistic expression. The only creative work of the early settlers, with some notable exceptions, tended to be everyday items used on the homestead that were sewn or spun; these objects, some of which were works of art by today's standards, have by and large not been preserved.

In Canada, primary education for girls became mandatory only after the 1880s. At this time in Europe, working-class families received virtually no education. Girls from merchant and aristocratic families received a rudimentary education either in religious schools or with private tutors. The focus of this education tended to reinforce a woman's role as a housekeeper rather than offering training in professional skills that might lead to financial independence. It is interesting to note that instruction in drawing and painting was part of a young woman's education at this time; it was considered an appropriate and amusing pastime yet was frowned upon as a professional calling.

Advances in technology and transportation near the end of the nineteenth century allowed greater flexibility of movement. By 1880, trans-Atlantic shipping lines such as Allan, Beaver, and Dominion were established to facilitate travel to Europe. At the same time, social conventions that governed the lives of women of a certain class, such as the

idea that an escort was required for any engagement outside the home, had come to seem pointless and unnecessary. As a result, during the 1890s in Canada, numerous daring individuals of the female sex took the newly available opportunities to expand their horizons and enrolled in schools abroad.

The academies of Paris and London offered training far superior to that which could be obtained in Canada. Art students benefited from access to the finest art galleries and museums in the world; they could join the lively communities of artists; and the picturesque countryside was nearby for sketching trips. Among those who ventured to Europe to study art, we must count many of the women mentioned in this text, most notably Florence Carlyle, Emily Carr, Laura Muntz Lyall, and Helen McNicoll.

Predictably, the path to this new training was lined with thorns. Private ateliers were more inclined to take female students but charged a higher rate for them than for male students, thus making attendance a privilege only for the wealthy or those lucky few who were assisted by relatives. Still, more and more women signed up. In 1801, only twenty-eight women artists exhibited in the Paris Salon. By 1878, that number had grown to 762, and by the year 1900, over one thousand of the exhibitors were women.

Charlotte Schreiber in her studio, Toronto, c. 1880.

Laura Muntz Lyall,
c. 1925.

In Canada, Maritime and Prairie women took the lead in organizing schools of art. In 1887, Anna Leonowens founded Halifax's Victoria School of Art and Design, today's Nova Scotia College of Art and Design. Mary Ewart was instrumental in founding the Winnipeg School of Art at the beginning of the twentieth century. Mary Dignam was responsible for organizing the Woman's Art Association of Canada (today, the Women's Art Association) in Toronto in 1890; it was a group that grew quickly and soon had functioning branches from Winnipeg to Saint John.

Although women's participation in art schools increased markedly in the late nineteenth century, they still found they had to struggle alone and pay dearly for their survival. The opportunity to study the nude model was restricted for women, as was instruction in anatomy: women students drew from engravings and casts of torsos. Many of the art associations allowed women members, but prohibited their participation in decision-making. By not being allowed participation in forums on art, women could not exercise self-definition as easily as men. They could not easily partake in art movements or develop their ideas into metaphors for historians to study and write about. Above all, they could not achieve the public presence afforded their male counterparts. As a result, independent clubs surfaced for women only; while they addressed some of the crucial issues facing the female artist, such groups tended to act as buffers, further insulating women from the general course of art.

Despite the growing involvement of women in the suffrage movement of the early nineteenth century, women still found it difficult to participate in society as individuals. Only in 1920 could women vote in the United States. In Canada, women voted as early as 1916 in Manitoba, Saskatchewan, and Alberta and as late as 1925 in Newfoundland and 1940 in Quebec. However, once women won the right to vote and overcame other legal impediments, they felt entitled to voice their opinions and exercise actions that were their right.

Creative women balanced losses and gains, adjusting and readjusting their lives to achieve independence. The majority of them, of course, felt a sense of conflict between the responsibilities they faced and the making of artwork. In the end, it may have been the power of negative reaction that helped drive their art. John Ruskin, the nineteenth-century art and social critic, expressed the idea that it is necessary to spend time in an "anti-world" in order to become free and powerful in the chosen one. We read of the struggles, recognize the untrodden path, and hear the voice of sacrifice that forced the work into being.

In the last decades of the 1800s and the first years of the nineteenth century, gifted art teachers such as William Brymner, director of art classes at the school run by the Art Association of Montreal, and Franklin Brownell at the Ottawa Art School encouraged women in the arts. Both were appointed in 1886, and both treated women students well, nurturing their talent. A sign of the changes that were occurring in the status of women

Prudence Heward
and Yvonne McKague
Housser in Bermuda,
c. 1946.

artists, the first Jessie Dow Prize awarded by the Art Association of Montreal in 1908 was won by a woman, the gifted Helen McNicoll, for an Impressionist painting judged the "most meritorious" by a Canadian artist. She shared the prize with fellow Impressionist painter W.H. Clapp.

In general, however, official recognition of Canadian women artists occurred only after the First World War, partly as a result of the voluntary participation of women in the war effort. Frances Loring and Florence Wyle were commissioned by the government during the war to sculpt statuettes in honour of munitions workers. These were purchased by the National Gallery of Canada in 1918, reflecting the public acclaim and growing recognition of women artists. The 1920s were a decade of increasing educational and economic freedom and the wider acceptance of a woman's right to pursue a professional career.

While the country was being shocked, bewitched, and bewildered by the newly formed Group of Seven, an Ontario-based group of male artists who came together in 1920 and laid claim to the rugged Precambrian Shield as a symbol of our northern landscape, a solitary woman, Emily Carr, had already made sketching trips to the wilderness of Alaska in 1907, and to Alert Bay, British Columbia, in 1908. In the following decades, she was to

give us philosophical and spiritual symbols of Canada's forest that were well ahead of their time. Carr's paintings did not capture the imagination of the public until well after her death in 1945.

Although women began to exhibit with the growing national and provincial artists' societies across Canada such as the Royal Canadian Academy, the Ontario Society of Artists, and the Art Association of Montreal, they did not receive the attention their work warranted. Early artists such as Margaret Campbell Macpherson and Frances Jones (Bannerman) occasionally signed their work with their initials to avoid gender prejudice and thus ensure that their paintings would be shown to advantage at exhibitions. One way to get exposure was to be invited as a guest exhibitor by, say, the Group of Seven. From 1926 to 1931, exhibitions of the Group included the work of talented women peers. The roster included both professional and amateur artists such as Emily Carr, Rody Kenny Courtice, Mary Eliot, Prudence Heward, C. Ruth Hood, Bess Housser, Mabel Lockerby, Mabel May, Yvonne McKague (later Housser), Isabel McLaughlin, Marion Huestis Miller, Doris Huestis Mills, Kathleen Munn, Lilias Torrance Newton, Pegi Nicol (later MacLeod), Sarah Robertson, and Anne Savage. Eric Brown, the founding director of the National Gallery of Canada, was a proud supporter of the women artists of his time. In an unprecedented decision, Brown selected the work of thirty Canadian women (out of a total of 108 exhibitors) to be included in the British Empire Exhibition of 1924 held in Wembley, England. This was the first international exhibition of Canadian art and became in time the largest exhibition anywhere in the world with 27 million visitors.

In 1920, Mabel May and Lilias Torrance Newton joined Randolph Hewton and Edwin Holgate to form the short-lived Beaver Hall Group in Montreal, with A.Y. Jackson as president. Other than May and Newton, five other women appeared in the inaugural exhibition, in January 1921: Jeanne de Crèvecoeur, Mabel Lockerby, Sybil Robertson, Anne Savage, and Regina Seiden. The number of women in the group varied with the later participation of Nora Collyer, Emily Coonan, Prudence Heward, Kathleen Morris, Sarah Robertson, and Ethel Seath. This was the first Canadian artists' association in which women played a major role.

The Beaver Hall Group held only three more exhibitions in the following two years before its dissolution due to lack of funds and leadership. In 1933, the Canadian Group of Painters was established, which was one-third women in its membership. Many of the Montrealers in the Canadian Group of Painters were drawn from the Beaver Hall Group.

Though not represented equally, all through this period women artists were taking their place as exhibiting professional artists and teachers. Florence Carlyle, Emily Carr, Laura Muntz Lyall, Lilias Torrance Newton, and many others used their income as teachers to finance their professional training abroad. By the end of the Second World War, the role

of women in the art of Canada was firmly entrenched, due partially to their assistance in recording the efforts of men and women in the service. Molly Lamb Bobak, Paraskeva Clark, Pegi Nicol MacLeod, and Lilias Torrance Newton helped to create a unique record of this painful period in the history of this country and the world.

Canadian women artists continued to question and test their limits, cultivating a new kind of modernist art. Kathleen Munn was one of the first to embrace abstraction. The painting she did in Toronto in the mid-1920s reflects her knowledge of Paul Cézanne's work. Other leaders in the creation of modern art in Canada included Marcelle Ferron in Montreal, one of the young artists who, like Jean-Paul Riopelle, followed in the wake of Paul-Émile Borduas to found the Automatistes in 1947. In the same year, Alexandra Luke, a painter who was studying with Hans Hofmann in Provincetown, Massachusetts, was selected to be one of seventy-two women artists from across Canada in *Canadian Women Artists*, an exhibition at the Riverside Museum in New York. In 1952, Luke organized the first Canadian all-abstract show, the *Canadian Abstract Exhibition*, which travelled throughout Canada. In 1953 she gathered together some of the artists she had met through that show to organize the Painters Eleven in Toronto. Luke introduced many of the members to the importance of artists in the New York School, whom she knew personally. Luke's work, using glowing colour and gestural effects, animated by suggestions of both the natural and the spiritual, was important to the growth of the abstract tradition, as was the work of Marion Nicoll in Calgary, who in 1946 had begun to make automatic drawings and, later, paintings with hieroglyphic-like forms and strong silhouettes.

In the early 1960s in Toronto, Christiane Pflug painted emblematic scenes of the everyday life of the homemaker. Rich in observed detail, they combine an abstract way of seeing and a naturalistic painting style. Esther Warkov, painting in Winnipeg at much the same time, evoked a similar feeling of nostalgia but drew as well on a rich offering of fantasy. Such talents invigorated the Canadian tradition, offering different configurations of meaning, a multitude of styles and techniques, and a transformation of sources. Today, painters such as Joanne Tod in Toronto are exploring the potential of representation. While involving the past, her images come from photography, combined in intriguing ways to make viewers aware of stereotypes and their own cultural insecurities.

This book celebrates the talent and achievement of early Canadian women artists, from the mid-eighteenth to the mid-twentieth century. The women whose stories are told in this volume and others whose stories, regrettably, could not be included due to restrictions of space, are an inseparable part of the history of Canadian art. Their art exists beside that of their male counterparts, providing us with a rich world of experience and identity.

Marcelle Ferron in her Paris studio, 1961.

Independent Spirit

PART I

THE VISUAL JOURNEY

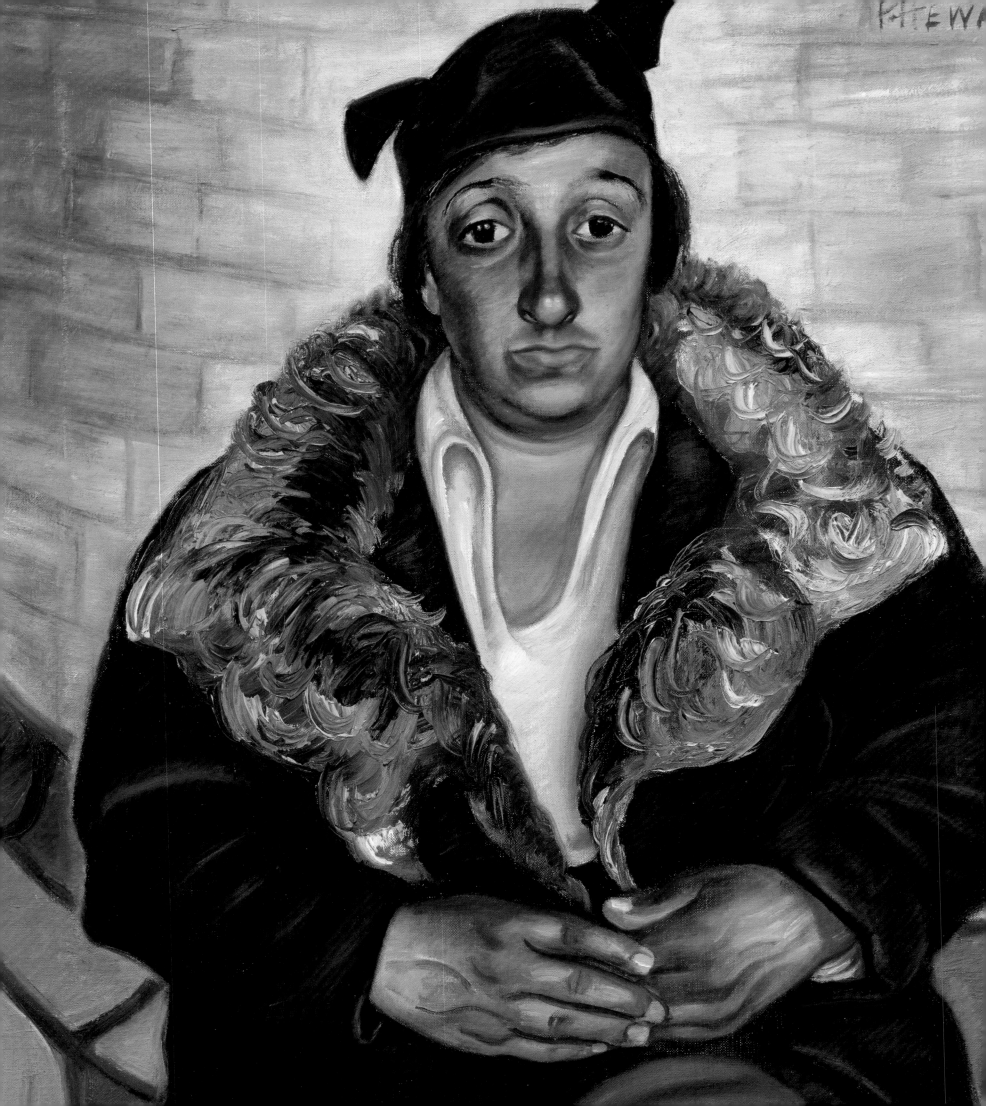

TRAILBLAZERS

"Trailblazers" are artists who changed Canadian art forever. That is, the originality and force of expression embodied in their work have survived the test of time. The first part of the "Visual Journey" features the artwork of twelve early women artists who were trailblazers, arranged in chronological order.

Prudence Heward
Italian Woman
See page 99.

Charlotte Schreiber

1834–1922

Charlotte Schreiber was a successful professional artist in England before her marriage brought her to Canada. Her skills were as sophisticated as those of any Victorian painter. In 1880 she became the first female academician in the Royal Canadian Academy of Arts, which had been the exclusive bastion of male artists until then.

The everyday world was material for Schreiber's brush. For *Springfield on the Credit,* she based her work on close observation of children engaged in winter games on the slopes of the Credit River. She expertly captured their preoccupation with the activities of the moment, painting with a sensual relish for work and play. This fierce insistence on realism reflects her ambition to introduce to Canadian audiences the strength of the academic tradition of painting. With Schreiber, it was not just a question of painting with facility, but of painting intimate subjects modelled in tonal planes.

A painter of independent means, Schreiber devoted herself to expressing through art her vivid impressions of life in her adopted land. Her subject matter, gathered from direct contact with the people in her life, was thus elemental. It speaks of her clear preferences, as a woman who kept her attention focused on those she knew. *Springfield on the Credit* is Schreiber's homage to Canadian life, or that part of it which moved her deeply.

Springfield on the Credit
c. 1880
Oil on canvas
32 x 43 inches (81.3 x 109.2 cm)
Private Collection, Ontario

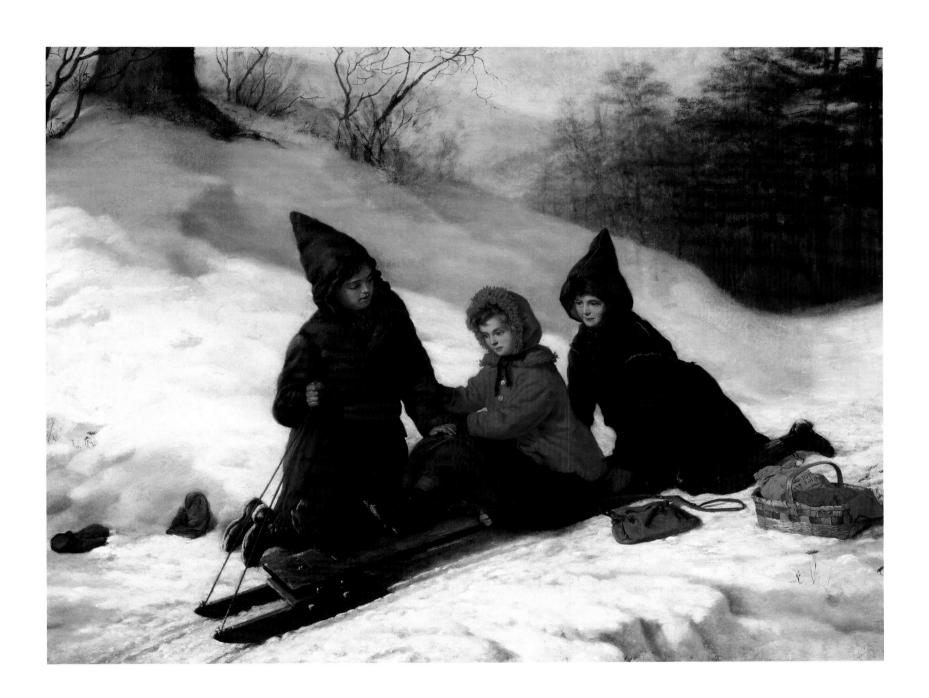

Charlotte Schreiber

1834–1922

Trained in Europe, Charlotte Schreiber introduced to Canada the high realism popular in England at the time. Her fellow artists in Canada were largely unaware of the stylistic changes that had occurred in European art in the middle of the nineteenth century. Thus her work contributed directly to the developing maturity in Canadian art.

During her training in England, Schreiber would have been exposed to the neoclassicism of Sir Joshua Reynolds, a style that was emulated throughout Europe in the first half of the nineteenth century. The success of this style was due in part to the elegant portraits it produced of members of the aristocracy. The neoclassic style was countered by the romantic tendencies in portraiture seen in the work of Sir Thomas Lawrence, which emphasized that which lies beyond the reach of reason.

Influenced by both neoclassicism and romanticism, *Portrait of Edith Quinn* is painted in a manner that may be described as central to the realist movement. What was remarkable about this movement was the skillful blending of detail and sophistication, recording in particular the everyday world of the privileged.

Portraiture, one of the most prevalent forms of Canadian art in the nineteenth century, has been accorded only limited consideration by art historians. Modern art focuses on creative self-expression, leaving the formal art of portraiture in the realm of academic research. Essentially, portrait paintings of any period may be examined either in terms of their subject or in terms of the artist's treatment of the subject. Whilst the former approach generally serves a social or political purpose, the latter is an aesthetic exercise. Technically *Portrait of Edith Quinn* is innovative, showing an interior scene with glistening naturalism, inspired by the lyrical poems and literature of the period. The portrait also reflects the growing fascination with women of the aristocracy, a dominant feature of Victorian culture.

*Portrait of Edith Quinn
(née Schreiber)*
c. 1890
Oil on canvas
39¾ x 32 inches (101 x 81.3 cm)
Private Collection, Ontario

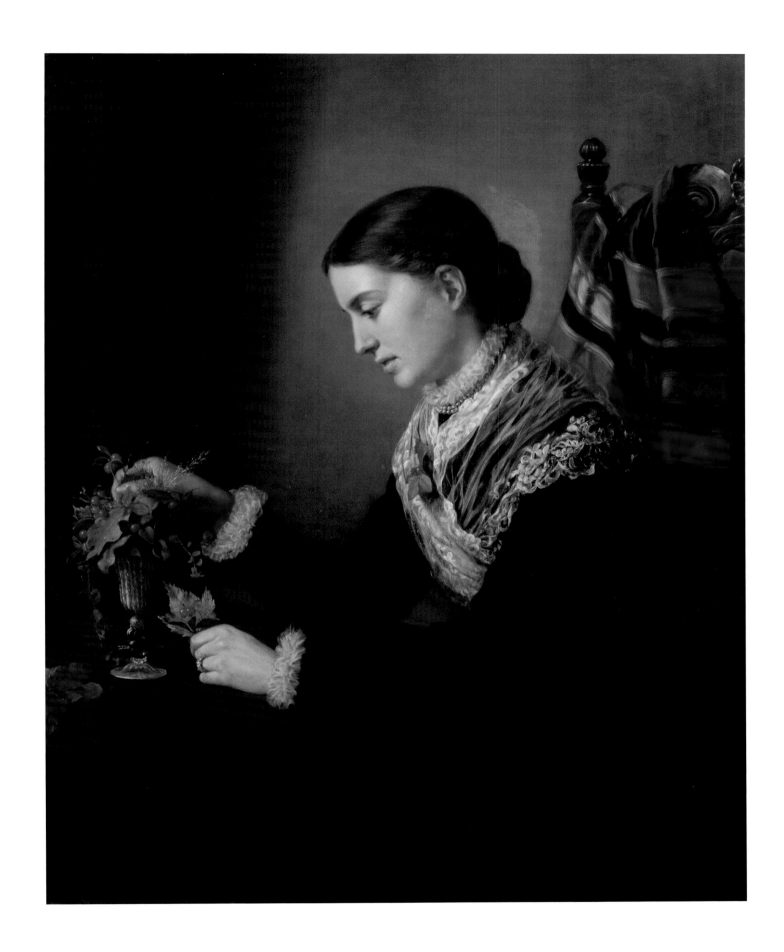

Frances Anne Hopkins

1838–1919

Although the railway had come to Canada by the 1850s, travel by birchbark canoe was still a common mode of transportation to the remote trading posts on the Great Lakes established by the Hudson's Bay and North West companies. By undertaking repeated expeditions, between the years 1858 and 1870, visiting such places as Manitoulin Island in Lake Huron and Kakabeka Falls near Lake Superior, and always in the company of her husband, Frances Anne Hopkins developed a unique sensitivity to the balance between humanity and nature as it existed on this new frontier.

Her ability as a storyteller was heightened by her sensitive and delicate rendering of colour and ability to faithfully present the scene before her. *Canoe Manned by Voyageurs Passing a Waterfall*, painted in 1869, is an example of her singular touch transforming a narrative into an image of unsettling effect, conveying both drama and romance. The horizon is delineated with taut precision, contrasted with the pellucid water of the lake. Distance is rendered uncertain, suspending the action in a space that is highly charged. The air of adventure is evoked by the determination of the paddlers. The scene is, however, infused with a sense of assured calm by the presence of a female traveller in the centre, representing the artist herself.

Paintings such as this reflect the uneasy duality that pervaded the attitude of Canadian artists towards nature throughout the nineteenth century, when the implications of human intervention on the wilderness were not yet fully evident.

*Canoe Manned by Voyageurs
Passing a Waterfall*
1869
Oil on canvas
29 x 60 inches (73.7 x 152.4 cm)
Library and Archives Canada, Ottawa

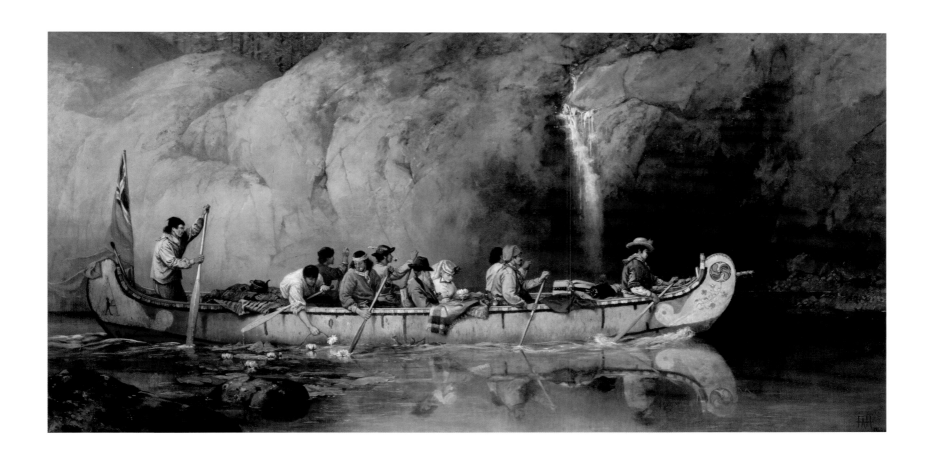

Frances Anne Hopkins

1838–1919

Victorian painters followed a pictorial aesthetic that celebrated, above all, beauty – beauty that may have had little to do with the real world. The artist's main concern was to create a poetic narrative that would evoke an emotional or tender feeling on the part of the viewer.

Frances Anne Hopkins's *No One to Dance With* renders the expression of a sincere and tender emotion dangerously close to Victorian mannerism. All the qualities of a young girl coming of age in Victorian society are here: grace, cultivated restraint, and gentility. The exquisite suggestion of form and adroit handling of colour demonstrate a natural development in Hopkins's style.

Refusing to traffic in the accepted practice of painting pictures by formula, Hopkins, throughout her career, exercised her skill in painting from the experiences of her own life. Thus, upon her return to England, without the Canadian frontier as inspiration, Hopkins's subject matter turned to themes in keeping with her environment. In fact, comparing *No One to Dance With* and *Canoe Manned by Voyageurs Passing a Waterfall*, one can barely recognize that they are the work of the same artist. This contrast reflects her belief that painting, in its purest manifestation, is at its best when it is an expression of the authentic experience of life. In the 1870s, painting with authenticity – that is, painting from direct experience rather than objectively rendering documentary subjects – was a newly forming goal in Western art.

We honour Hopkins's work because it is not derivative. Although somewhat historical in content, her paintings are rendered with a sense of lightness and *joie de vivre*.

No One to Dance With

1877
Oil on board
10 x 6¾ inches (25.4 x 17.1 cm)
Private Collection, Ontario

Decidedly one of the most accomplished Canadian women artists of her era, Laura Muntz chose Paris as the centre for her studies. Following vigorous training and the exhibition of her work at the Paris Salon among other venues, Muntz received immediate attention upon her return to Canada.

The Pink Dress, originally titled *In the Springtime,* is one of her finest paintings. Infusing the composition with latent romanticism, Muntz has skillfully used the flowers in the foreground as the *repoussoir* directing our gaze to the girl's face. Like the mystery of the partially hidden bouquet, the future of the young girl is unknown; the flowers act as a metaphor signifying the journey of life. The depiction of flowers anywhere else in the painting would have diminished their impact.

Muntz's nimble intelligence uses the elements of composition as musical notes to create a song with a surprise ending. By contrasting exquisite hues of gold and pink within the figure against the cool blue-greens of the surroundings, Muntz has heightened the reflected light on her model. Her sense of colour leads the eye on an engaging journey that radiates a mood of serenity, a mood congruent with the disarming innocence of the young girl. The absence of melancholy, a quality that dominated her work after leaving Paris, suggests that Muntz's vibrant state of mind while in Paris mirrored the exuberance conveyed in the painting.

Idealizing her forms, stripping away useless detail yet preserving the Impressionistic use of colour, Muntz has painted an image of startling originality, creating a lasting imprint on the memory. *The Pink Dress* has elicited the admiration of art critics since it was first exhibited in Toronto at the annual exhibition of the Ontario Society of Artists in 1898.

The Pink Dress,
or *In the Springtime*
1897
Oil on canvas
14½ x 18½ inches (36.8 x 47 cm)
Private Collection, Ontario

Laura Muntz Lyall

1860–1930

Themes of domesticity dominate the art of Laura Muntz. Within her chosen realm, she sought to convey the inner emotional life of her subjects, a goal that remained a focus throughout her artistic life. *Interesting Story* expresses Muntz's own feelings about reading, to which she was keenly devoted. Books had only recently become accessible to a large number of people; through this new world of literature, they were able to experience the thrill of escape from their everyday lives.

Interesting Story derives its strength from the portrayal of inner emotions veiled by outer passivity. The two children face inward, engrossed in reading, their thoughts reflected in their innocent faces. The book offers a refuge, held secure in their hands. They are fascinated by the world beyond the warmth of their home. The absence of the parents is deliberate, anticipating their initiation into adult life. The urban landscape glimpsed through the window above their heads provides a sharp contrast to the intimacy inside the home.

Interesting Story
1898
Oil on canvas
32 x 39½ inches (81.3 x 100.3 cm)
Art Gallery of Ontario, Toronto

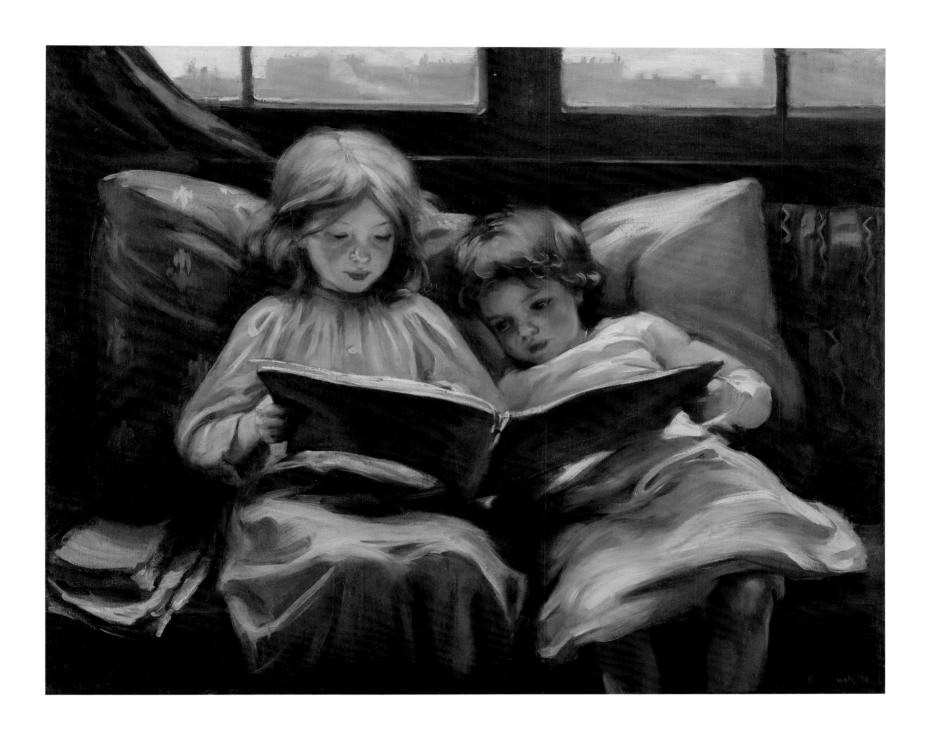

Laura Muntz Lyall

1860–1930

Laura Muntz painted images of women and children engaged in private activities removed from the company of men. *Woman Reading Book* captures Muntz's impression of an adolescent girl, a profile portrait of one of Muntz's favourite sitters, most likely her cousin Bessie Muntz, seated in an arbour, lost in concentration over a book. The elongated composition is deliberate, designed to suggest spatial extension, an effect that is reinforced by the pathway into the distance at the upper left and the trees in the background.

The play of light filtering through the soft feathery leaves creates a hazy atmosphere, which contributes to the sense of privacy and abandon implied in the scene. This is a place where a woman could exist in harmony with the natural world. Muntz could easily identify with this subject, having a solitary temperament herself.

In 1915, at the age of fifty-five, Laura Muntz married her brother-in-law, Charles Lyall, following the death of her sister, presumably to care for her sister's eleven children. The evocation of introspection in her painting prior to her marriage is absent from the work she was to do thereafter. *Woman Reading a Book* was acquired by the present owner from a Montreal collector; it was most likely painted before her marriage.

Woman Reading a Book
c. 1910
Oil on canvas
40 x 22 inches (101.6 x 55.9 cm)
Private Collection, British Columbia

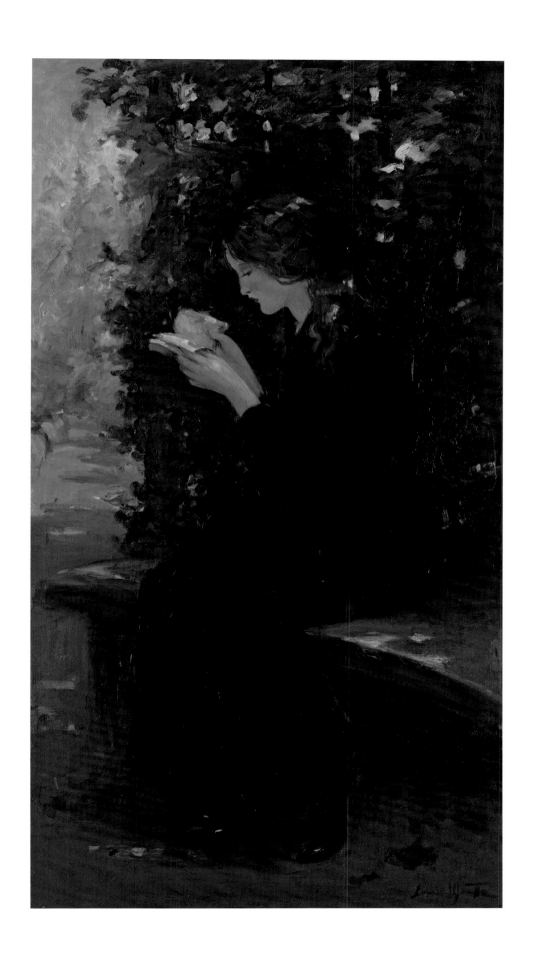

Laura Muntz Lyall
1860–1930

Laura Muntz Lyall's painting was defined by the excellence with which she was able to convey the pure innocence and power of childhood. Works inspired by her love for children seem to have carried her beyond the bounds of her own childless existence. If she despaired of her situation, or was saddened by thoughts of destiny, it was never reflected in her painting.

In the late Victorian period and continuing into the early twentieth century, the close bond between mother and child and between siblings was universally celebrated. Muntz was one of a number of painters, including Mary Cassatt, who made *maternité* her subject.

Muntz succeeded in capturing a moment in time – in *Mother and Children,* she conveys the spontaneous expression of love. The grouping of the three figures recalls Italian Renaissance paintings of the Madonna with the Christ child and the young St. John. In its representation of natural light, it is a model of intensified lights and darks expertly blended to enforce intimacy between the figures. So perfectly fused are her pigments, it appears that Nature herself, in some subtle mood, had crystallized her colours in a glazed pattern.

At this time, Muntz had shifted her work towards a stronger, Post-Impressionist statement, one with greater richness in the colour and a thicker impasto. With this bolder style, Muntz asserted herself as a modern artist in the art world of the 1920s.

Mother and Children
c. 1913
Oil on panel
7¾ x 5¾ inches (19.7 x 14.6 cm)
Private Collection,
British Columbia

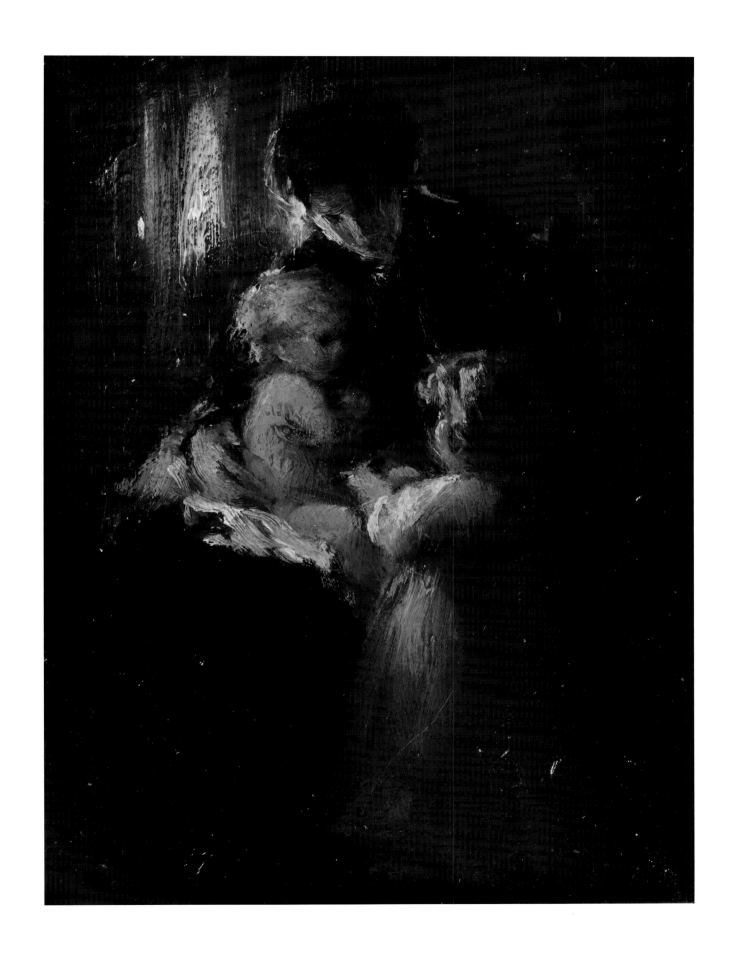

The magic of *Young Woman Before the Hearth* lies in its simultaneous depiction of light and darkness. Here, Carlyle has used the fire in the hearth as an inquisitor. Instead of focusing on the naked flame, the viewer's eye is led to where the flame's glow casts its emphasis. Light floods the face of the young woman, bringing it to life.

Carlyle was influenced by Paul Peel, the well-known painter of *After the Bath*. She would certainly have been familiar with the way he used reflected light to create a sense of intimacy and even mystery. This technique of rendering reflected light also preoccupied Florence Carlyle, who accompanied Peel on his last journey from Canada to France in 1890.

Carlyle, who lived in New York from 1899 to 1908, was also influenced by the Ten American Painters. The work of this group, especially of those members Paris-trained as she was, struck a sympathetic chord. She would have looked with interest, for instance, at the paintings of Edmund C. Tarbell, who painted firelight, though only through its reflection on the scene, as here. Like Tarbell, she attempted to catch the nuances of light and atmosphere in an illuminated interior space.

At a time when everything was lit by lamplight or fireplaces, the special intimacy created by reflected light may have gone unnoticed. The advent of electricity soon heightened awareness of its inherent magic. Carlyle continued to paint subtle lighting effects in her figurative subjects until the end of her career, but without the inspiration of her favourite young model, seen here, some of the intensity went out of her work.

Young Woman Before the Hearth

1902
Oil on canvas
40½ x 30 inches (102.9 x 76.2 cm)
Private Collection, Alberta

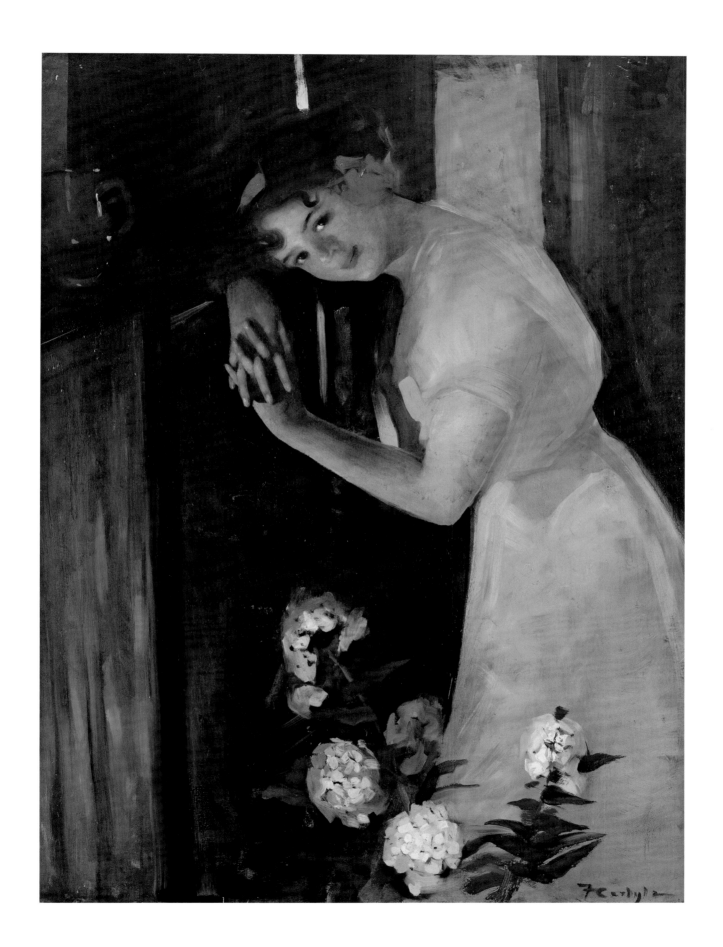

The Tiff captures a private moment. Rendered in the romantic tradition, Florence Carlyle's painting is an honest reflection on the fragile state of human relations. The viewer almost intrudes upon a young couple seemingly at a loss for words following a disagreement. The painting speaks of the psychological challenges in maintaining relationships constantly threatened by misunderstanding.

The woman sits illuminated by a tenuous light, assuming a studied indifference. The rich assortment of hues falling on her slender figure conveys the romantic aspirations lurking in her soul. The flash of bright red lining in an otherwise virginal dress of pastel pink roses on white voile suggests hidden passion. In contrast, the man is predominantly void of hue, thus emphasizing his sadness. Head bowed and turned away from the woman, he is painted in an attitude of resignation that enhances the drama of the moment. Brilliant light from the window serves to contrast the interior with its dark emotional disorder and the natural world beyond.

Their thoughts are mirrored in the large glass bowl on the table. As a member of the Aesthetic Movement, Carlyle, like Maurice Maeterlinck, used a glass object as a metaphor for the soul, both shielded and separate from the outside world. Its colour, a scintillating yellow-green, may refer to jealousy.

The Tiff brought Carlyle widespread success. When it appeared, critics commented on the dress of the woman, which dates from long before her day. Carlyle cast the players from members of her family: her brother Russell and one of her sisters served as models. In 1904, when the work was shown in Montreal at the Royal Canadian Academy of Arts annual exhibition, a reviewer in the *Montreal Daily Star* described the artist as foremost among the figure painters of the younger generation in Canada.

The Tiff

1902

Oil on canvas

72½ x 53 inches (183.8 x 134.6 cm)

Art Gallery of Ontario, Toronto

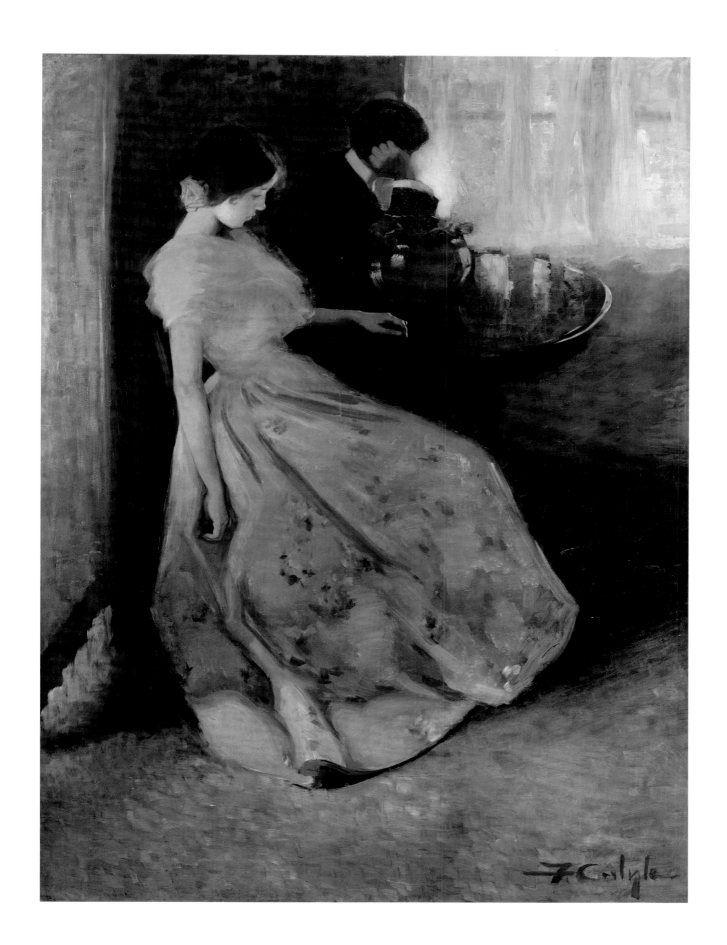

Florence Carlyle specialized in paintings of women charged with literary associations. Usually featuring Victorian women, they sometimes allude to ancient mythology, but more often than not the inherent symbolism is of a personal nature.

Carlyle was one of the earliest women in Canada to paint with breadth and freedom. *Woman with Daffodil* demonstrates Carlyle's mastery in the treatment of light and mass. The woman emerges from shadow, cradling a copper pot holding a single daffodil. The reflected light draws the focus to her face, bare shoulders, and voluptuous arm and hand. The mystery of the moment is enhanced by the suppression of superfluous details – a departure from traditional Victorian painting. Carlyle shows that human attributes can be expressed by a certain look and accentuated by a delicate treatment of light.

Woman with Daffodil shows the artist's confidence in the use of colour to evoke the essence of her subject. The woman's natural ease is expressed in the flow of the bright green fabric and the way in which she holds the vase and gazes at the single daffodil. While this inward gesture is seductive, it also conveys the pleasure she takes in her own company – symbolized by the single flower. Carlyle is inviting the viewer to wonder, Is the woman receiving a flower from an admirer? Or is she enjoying a private, contemplative moment as a prelude to the day?

Woman with Daffodil
c. 1905
Oil on canvas-board
28 x 23¼ inches (71.1 x 59 cm)
Private Collection, Ontario

Florence Carlyle
1864–1923

Much like Paul Gauguin, Florence Carlyle believed that permanence in art resided in timeless themes. Inspired by the works of the Italian Renaissance, Carlyle searched out models to express the ideals of the Gilded Age: beauty, freedom, and manifest destiny.

Carlyle developed the composition of *Pippa Passes* to represent the liberation of women from the confines of past ignorance, symbolized by the darkness, and into the freedom of a bright future. The young woman has bare feet and a crown of wildflowers, indicating her natural state. Clothed only in a white diaphanous dress resembling a classical Greek chiton, she extends her arms in a dramatic gesture expressing her joy in life. Her gesture is echoed in the sweeping curves and wispy folds of her gown. The placement of the rapturous figure in a landscape is idealized; she, like the flowers at her feet, is full of the budding promise of spring.

Carlyle has employed a smouldering palette of deeply saturated hues to magnify the sense of drama. The sinuously delineated figure reveals Carlyle's interest in the decorative designs of Art Nouveau, whilst the eerie light, which acts as a counterpoint to the shadows, suggests her affiliation with the Aesthetic Movement of Oscar Wilde. Most of all, in *Pippa Passes*, Carlyle has succeeded in creating a powerful image of the female journey.

When the painting was shown in an exhibition in Montreal in 1911, one critic gave it the place of honour. It was described as imaginative, with an admirable composition.

Pippa Passes
1908
Oil on canvas
38¼ x 38½ inches (97.2 x 97.5 cm)
Woodstock Art Gallery, London

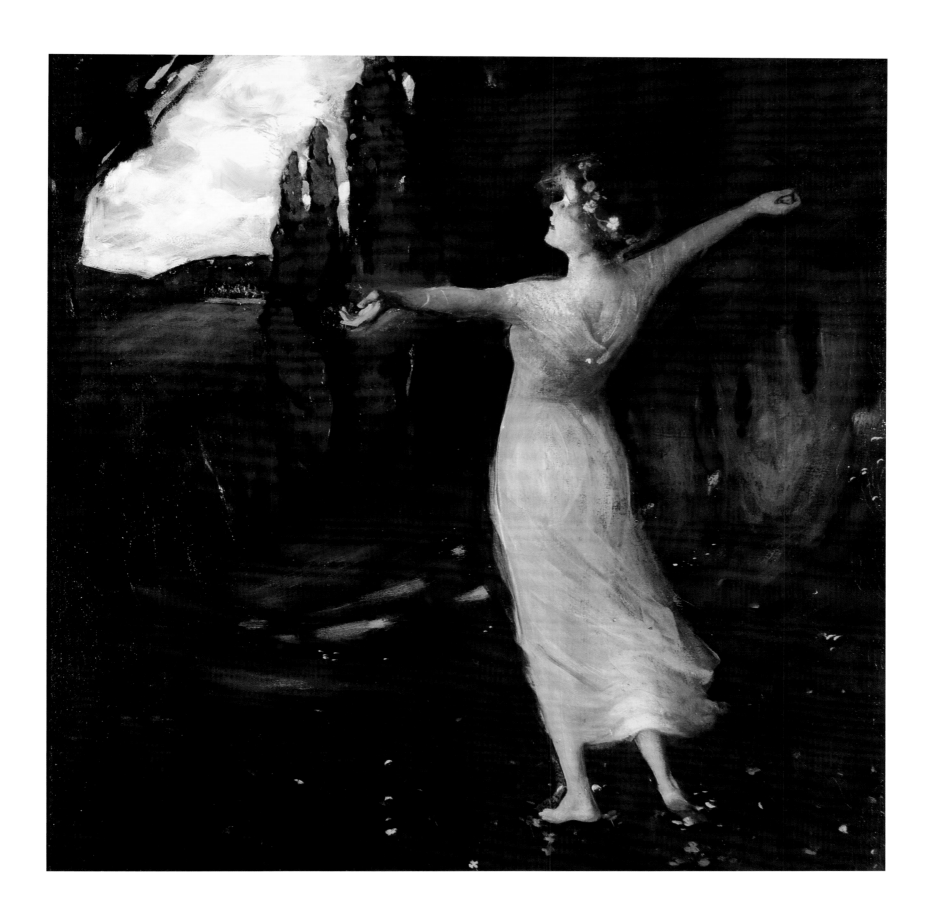

Emily Carr

1871–1945

With a fresh palette and renewed vigour, Emily Carr sought out the Native art of northern Vancouver Island. In Alert Bay, she recorded the Kwakiutl (Kwakwaka'wakw) nation's elaborately carved totem poles. Carr painted the village of Alert Bay repeatedly, expressing a sense of impending doom not approached by any of her contemporaries or followers.

Carr's desire to reduce the forces of life to their most elemental resulted in images infused with spiritual energy. In village scenes rendered in watercolour, we sense an artist pondering reality and defiantly telling the story of a vanishing culture. Her paintings of this "Paradise Lost," to which she was bound by her own spiritual search, carry a classic nobility and, at the same time, convey the oppression and loneliness that unite all human souls.

In the 1920s, her work drew the attention of some of the greatest painters and critics of her own time. Marius Barbeau, an eminent anthropologist, told others about her work. Eric Brown, the founding director of the National Gallery of Canada, travelled to British Columbia to meet Carr and see her work; he then invited her to participate in an exhibition of Canadian West Coast Indian Art at the National Gallery in 1927. After the opening, she went to Toronto to meet Lawren Harris and began a lifelong friendship with the eminent Group of Seven painter. Subsequently, Harris was a strong influence on Carr, encouraging her painting and engaging with her in wide-ranging philosophical discussions.

Indian Village, Alert Bay
1912
Watercolour on paper
15 x 11 inches (38.1 x 27.9 cm)
Private Collection, Ontario

There are only a handful of painters such as Emily Carr who have shaped our way of seeing particular things. Before her sojourn in France, Carr's painterly manner was descriptive. Upon her return in 1912, her style changed dramatically, shifting from the real to the symbolic, from the contemporary to the timeless.

Carr focused on expressing the desolation of a people and place stripped of identity. Her paintings of totem poles and other Native carvings pay tribute to humanity's quest for spirituality. In this subject, she achieved a tragic vision of the human condition marred by cultural conflict.

Thunderbird, Campbell River, B.C. is a striking image that carries a moral message. A prophet of doom, the thunderbird is bathed in an unnatural light. Though embattled, the bird seems to be holding its ground – one wing outstretched, one broken – an iconic sentry between the earth and the heavens. Light paralyzes and energizes it simultaneously; it is a moment of infinity in a fleeting experience. The dramatic Fauvist colouring sets the tone. The heavens are open, and light unites all elements of life within the dynamic centre of the composition.

The image strikes us with the force of a fearsome storm: terrible yet at the same time awe-inspiring. What Carr has achieved here is something extraordinary, transcending the symbolism of one particular image. *Thunderbird, Campbell River, B.C.* is one of Carr's most compelling elegies for the unresolved anxieties of existence. She infused the work with her own struggles, her poverty and, ultimately, her own uncertainty about survival. It is a powerful and foreboding image, produced by one of Canada's greatest spiritual artists.

Thunderbird,
Campbell River, B.C.
c. 1929
Oil on canvas
24 x 18 inches (61 x 45.7 cm)
Private Collection, Ontario

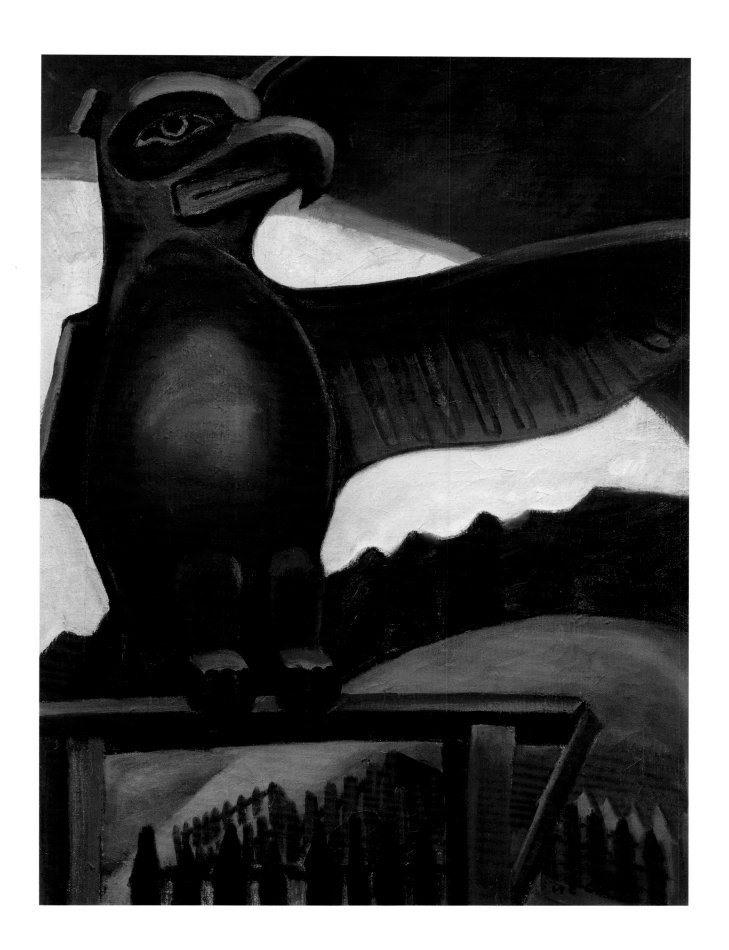

Emily Carr

1871–1945

Emily Carr's devotion to nature was intense and authentic. There had been artists before Carr who had painted the landscapes they loved and understood, but it was Carr who explored the spirit of nature, revealing nature's latent forces, moods, rhythms, secrets, and mysteries. Trees were Carr's first and greatest love, and although she focused much of her artwork on Native traditions such as totem poles, she remained faithful to a broad poetic vision of art as a medium for her own spiritual quest.

Sunlight in the Woods is one of Carr's masterpieces. Its theme is similar to many of her other paintings of the forest interior. We see here a group of trees and undefined spaces, but the loose technique with its swirls of paint and rich colour announce that the work is part of Carr's epic – nature as seen in a tranquil forest, both powerful and lyrical. The dramatic effects suggest empyrean realms.

Carr gave this painting to Eric Brown, the founding director of the National Gallery of Canada, as a token of her gratitude for having been one of her earliest supporters.

Sunlight in the Woods
c. 1934
Oil on paper
36 x 24 inches (91.4 x 61 cm)
Private Collection, Ontario

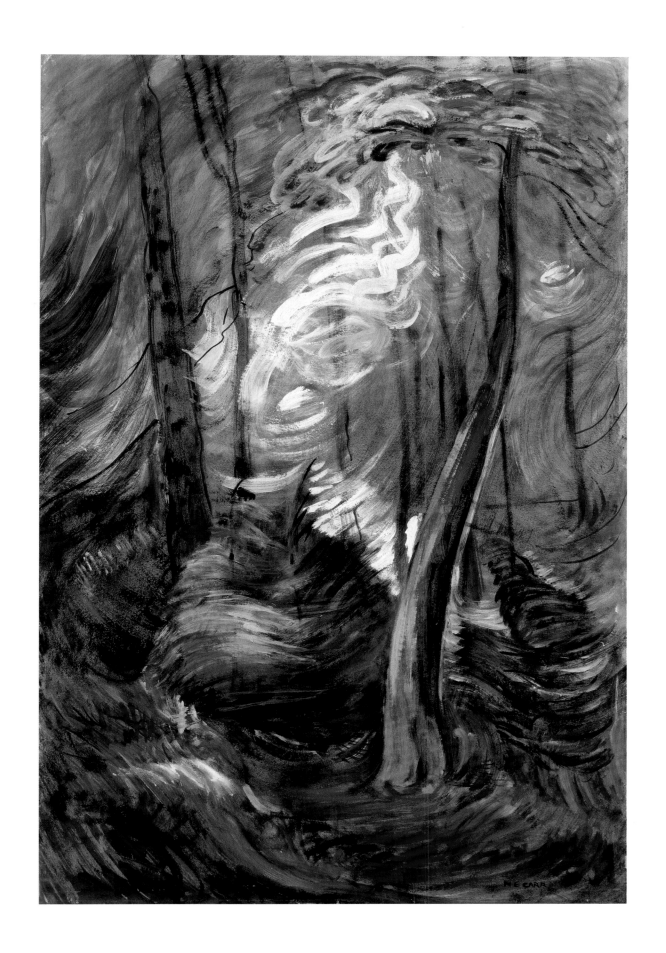

Emily Carr is one of the most original artists Canada has ever produced. Certainly, she was the most poetic artist since J.E.H. MacDonald. Working directly from natural phenomena, she instills in her paintings her love for the forests of British Columbia – their elemental power, the mystical wildness of the land.

Carr explored the landscape with the eye of a naturalist and the soul of an artist. During the summer Carr and her beloved menagerie travelled outside Victoria by caravan, setting up camp in the forest. She would paint during the day and write at night. In 1941, she won the Governor General's award for non-fiction for her book *Klee Wyck*, meaning "laughing one," the name given Carr by the Nootka (Nuu-chah-nulth) people of Vancouver Island.

Pine Near the Hillside is a late work, painted when Carr was almost seventy. The trees in her paintings seem to embody a living spirit springing out of the ground. Carr's free-flowing brushwork captures the energy and power of nature. In *Pine Near the Hillside,* earth, sky, and trees are transformed into a rhetorical rhythm, symbolizing raw power. It is not a pretty picture, but as an embodiment of the forces of nature, it is unsurpassed in Canadian art.

Pine Near the Hillside

c. 1940

Oil on canvas

22¾ x 29¾ inches (57.8 x 75.6 cm)

Private Collection, Ontario

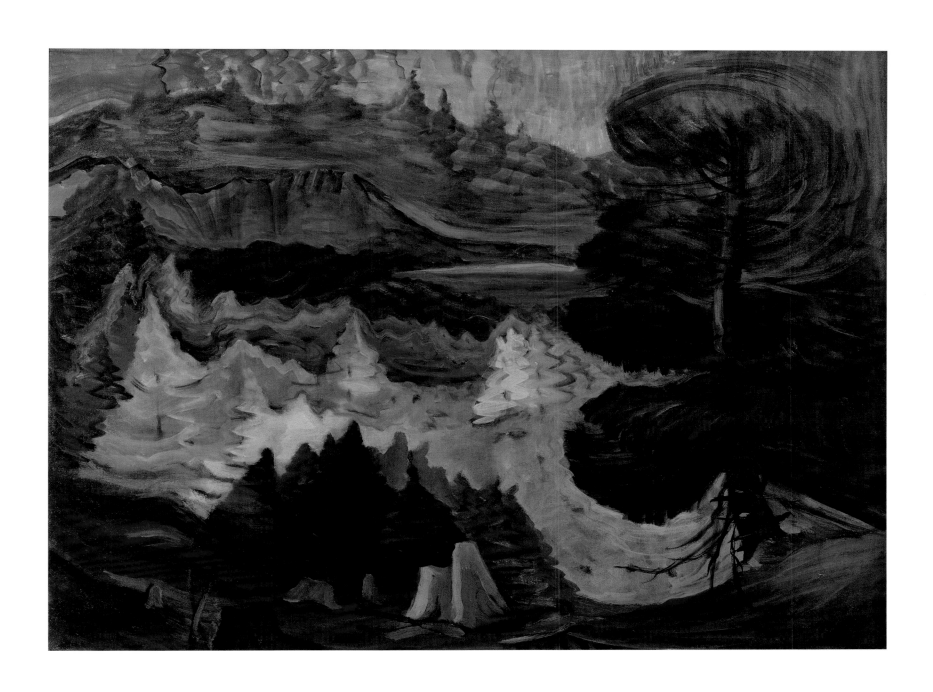

Helen McNicoll

1879–1915

As one of Canada's early female Impressionists, Helen McNicoll painted with a sensual rendering of light and space, distinguished by a restraint unique to her work. She often painted in the company of her lifelong companion, British Impressionist Dorothea Sharpe. Like Sharpe, she enjoyed painting women and children at leisure; her paintings show subjects engrossed in activities such as reading, sewing, and gardening, as though unaware of the painter before them.

The model for *The Chintz Sofa* was most likely Dorothea Sharpe, with whom McNicoll shared a flat in London. They often served as each other's model. In the painting, Sharpe is turned away from the viewer and absorbed in her sewing. McNicoll has balanced the composition by uniting the horizontal plane of the sofa with the wave-like diagonal from the upper left to the lower right of the figure; any sense of enclosure has been moderated by the exuberant pattern of the colourful chintz fabric.

The woman on the sofa is as deeply absorbed in her sewing as the letter readers in seventeenth-century Dutch master paintings. For the moment, peace has triumphed over oppression and servitude. Perhaps McNicoll is suggesting that home is not only an arena of confinement and turmoil, but also of passion and liberation.

The Chintz Sofa
1912
Oil on canvas
32 x 39 inches (81.3 x 99 cm)
Private Collection, Ontario

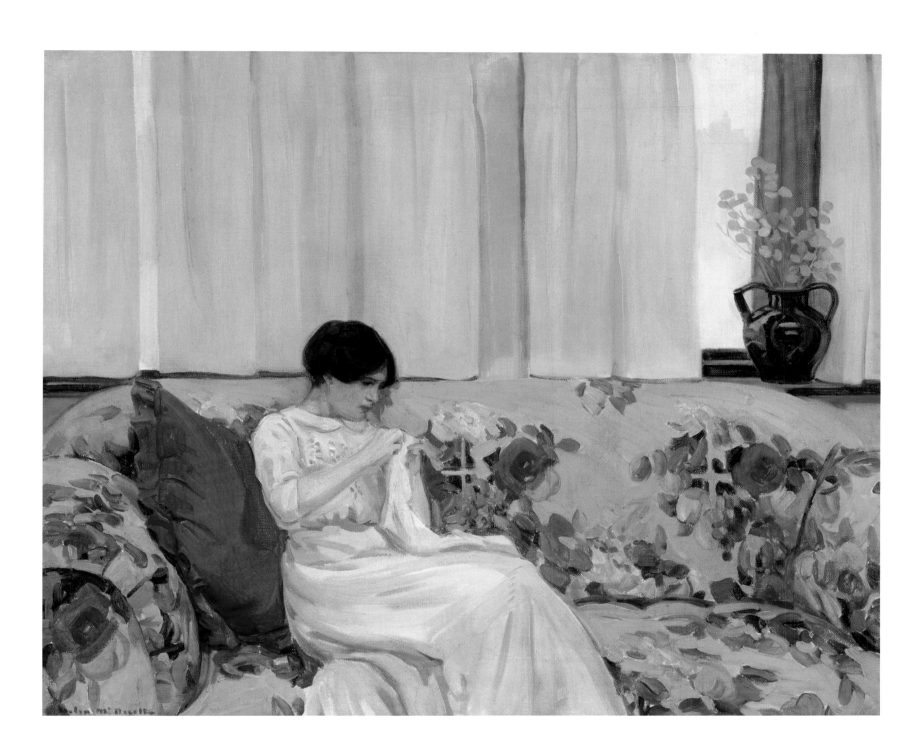

Sunbathing was considered a cure for most ailments in the eighteenth century. By the mid-nineteenth century, it had come to represent luxury and taste – a lifestyle free from the mundane, replete with pleasure. No wonder, then, that Impressionist painters intent on immortalizing fleeting moments found a popular subject in beach scenes.

Helen McNicoll was influenced by the philosophy of Nabis painter Maurice Denis, who had proclaimed in 1890: "Remember that a picture, before being a battle horse, a nude, an anecdote or whatnot, is essentially a flat surface covered with colours assembled in a certain order."

McNicoll understood how to handle colour to create the effect of sunlight suffusing the scene and enveloping the figures and how to crop a seemingly expansive space without truncating it: both skills are evident in *On the Beach*. Space is filled with a sense of human activity extending beyond the viewer's eye, with the artist exercising a bold asymmetric composition. The focus, however, is clearly on the figures of mother and child: the little girl sits turned towards the sea with the woman beside her, absorbed in her knitting. Their presence in this busy scene acknowledges the woman's need to balance domestic burdens with personal freedom, a constellation of the brave new world.

Above all, the painting is a tender interpretation of female entitlement during the *belle époque* before the First World War. This was a world of gentle light and air in a society intent on cultivating the blandishments of the Victorian era in the glamour of a new day.

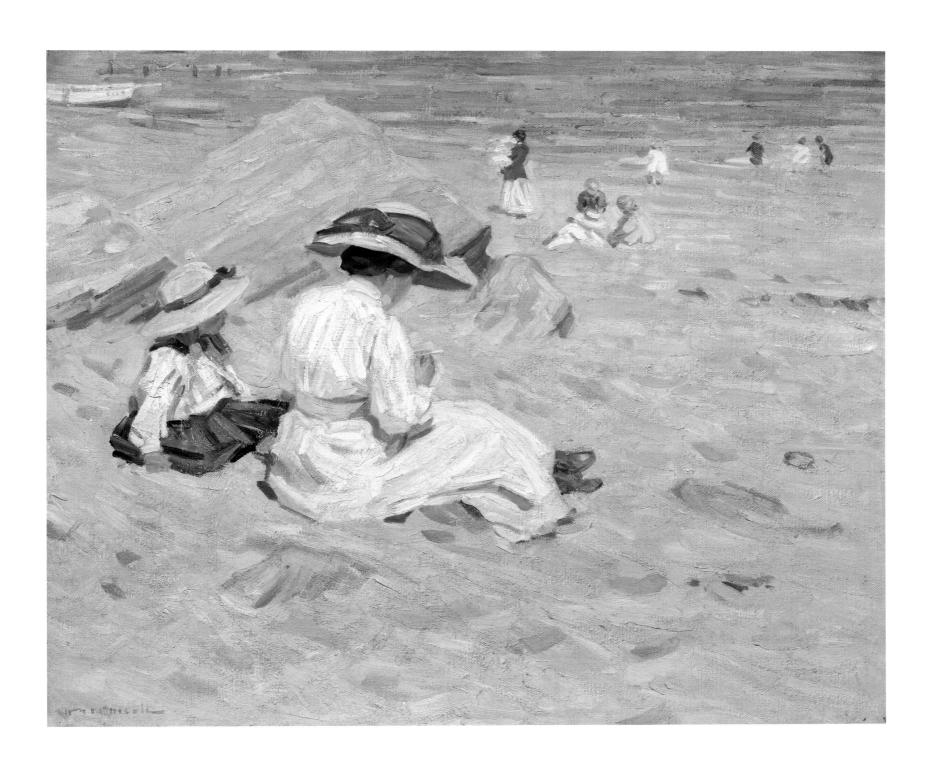

It is one of the enigmas of Canadian art that Helen McNicoll should have been neglected for the first three-quarters of the twentieth century. When she appeared in literature on art, it was only as a casual entry until 1974, when Jerrold Morris, an art dealer in Toronto, exhibited a number of her paintings that had remained with the artist's family from the time of her death.

McNicoll's paintings reflect a world of order and tranquility. Unlike Emily Carr or her contemporaries in Montreal, such as Maurice Cullen and Marc-Aurèle de Foy Suzor-Côté, she did not employ nature to express a spiritual quest, but as a vehicle to give pleasure to the eye. She loved art, and while the love of art will not, of itself, produce good art, McNicoll's commitment to originality of expression gave her a place among the most accomplished painters of Canada.

McNicoll's short life was passed, for the most part, in Europe. She astonished her contemporaries with the boldness of her invention and the lightness and ease with which she painted. Her ability to modify tones in the subtlest transitions from light to dark operated freely in her compositions.

In the Market, Montreuil displays the skill she applied with impartial zeal to ordinary subjects, instilling in them a sense of genuine animation. Painting as she lived, McNicoll's development is the story of the enrichment of a woman's art by direct experience. She was, in her own way, a landscape painter, a student of atmospheric effect and natural light approximating the evanescent light and broken tone of the Impressionists.

In the Market, Montreuil

c. 1912

Oil on canvas

16 x 18 inches (40.6 x 45.7 cm)

Private Collection, Alberta

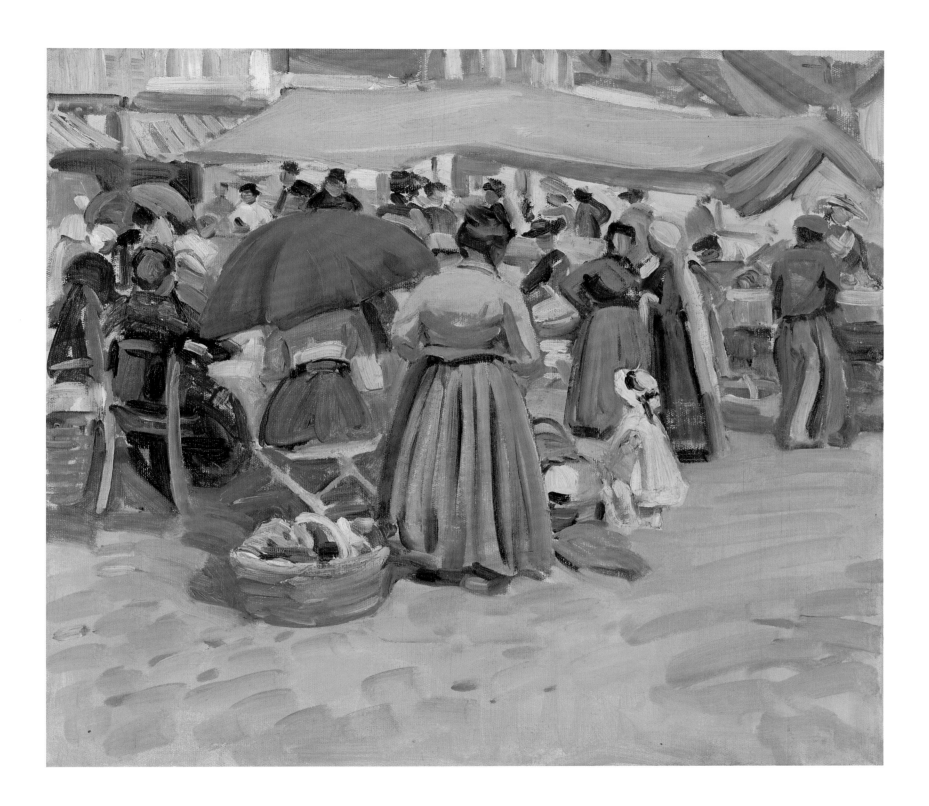

The brilliance of McNicoll's handling of the paint medium is shown to stunning effect in *Sunny September*. Painted after her election to the Royal Society of British Artists in 1913, it features one of her favourite models holding a parasol to protect her delicate skin, with a toddler and a girl holding onto her hat in the autumn breeze. The scene takes place on a cliff overlooking a misty shoreline. The young woman holds her skirt so that folds of cloth and shadows form. The brushwork, lively and playful, seems to flicker over the scene.

McNicoll would have intended the parasol to create an effect of reflected light on her attractive model. Together with the children, the young woman forms a triangle of white combined with pale colours that arrest the eye of the viewer. McNicoll was particularly attracted to the light on sunny days. The setting in which she placed her models is something like a stage set within which they exist for a moment, stressing the impermanence of youth. All seem about to move – the youngest child is reaching to pick a nearby flower. The work seems to be rapidly executed, but in fact would have required careful reworking of her initial perception to achieve the desired effect of spontaneity.

The Impressionists set the standard for this kind of painting; Monet excelled at it, and in Canadian art, McNicoll alone painted to this level.

Helen McNicoll
1879–1915

Helen McNicoll painted with the courage and conviction of an innocent eye, transcribing nature chromatically through dots and dashes; the pure pigment, when viewed from a certain distance, suggests the vibrant liveliness of nature itself. Deaf since early childhood, she seems to have benefited from especially acute vision.

The sensuous play of light and colour reflects the delight of the painter in the bounty of a summer's day. Reading inside a tent where the light is diffuse, filtered through the canvas, must have had a particular appeal to McNicoll after enduring long Canadian winters. Reading encourages the imagination to wander freely, allowing the reader to identify with the emotions of another and thus expanding the reader's potential.

In the Tent is related to one of McNicoll's most famous canvases, *Under the Shadow of the Tent*, which is in the collection of the Montreal Museum of Fine Arts. McNicoll must have enjoyed painting the attractive young girl who is at the centre of *In the Tent*. In both pictures, she wears the same gauzy white dress and has beside her a handsome hat with a blue scarf wound around its crown. The filtered light, the ultimate challenge to a painter, is masterfully captured in both these paintings. *Under the Shadow of the Tent* was awarded the Women's Art Society Prize in 1914 and acclaimed as "a triumphant study in reflected light, pure painting." Works of polished artistry, these paintings took Canadian art to a new level.

In the Tent
1914
Oil on canvas
32 x 25 inches (81.3 x 63.5 cm)
Private Collection, Ontario

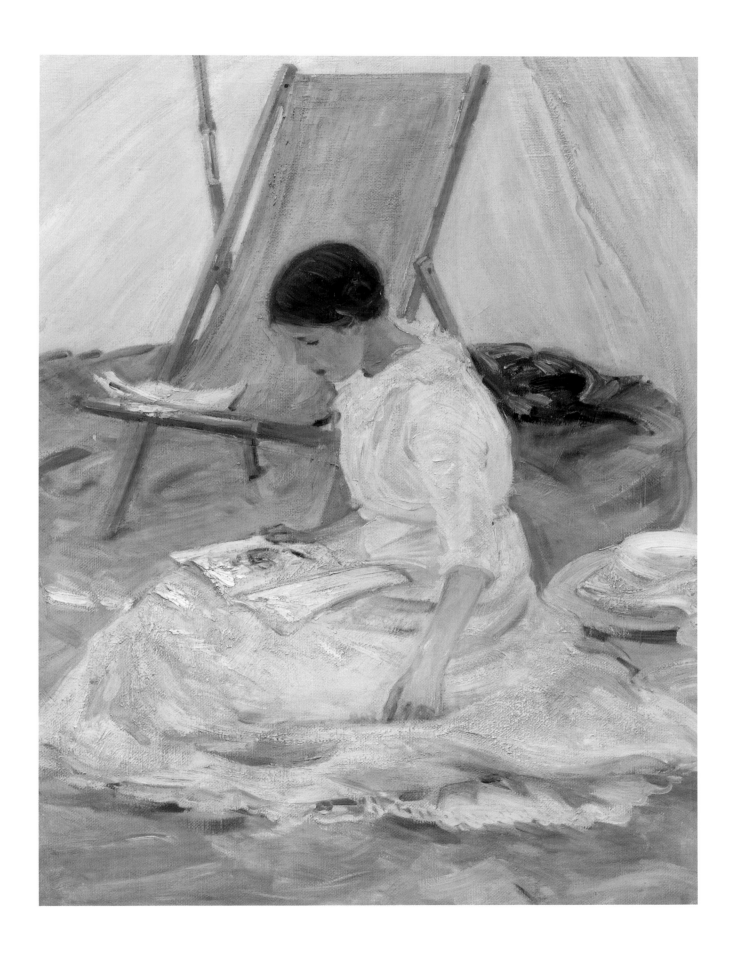

In 1873, *The Gilded Age: A Tale of Today* by Mark Twain and Charles Dudley Warner was published and almost overnight became an American classic. The book echoed the rising aspirations of Americans during the economic boom following the Civil War. The "Gilded Age" quickly became part of the lexicon to denote the period from the 1870s to the beginning of the twentieth century, a time of dazzlingly rapid accumulation of wealth and astonishing economic growth rooted in industrialization.

Both of Henrietta Shore's teachers, Laura Muntz Lyall and the American painter Robert Henri, had witnessed the new world of the privileged and the sudden attention that children gained as inheritors of the new prosperity. *Little Girls* is a vivid portrayal of the privileged children of this Gilded Age. The conventions in portraiture of children called for the depiction of cheerful children in costumes reflecting the fashion of the day, signifying the status of their parents. Wealth was further suggested by the inclusion of appropriate accoutrements: books, flowers, and pets. Following the tradition of her teachers, Shore painted young girls at play, skipping rope and feeding pigeons. The inclusion of the birds is a reminder of the swift passage of time and thus the brevity of childhood itself.

Shore later abandoned this boldly representational style of painting to move into abstraction. In both modes, she received acclaim.

Little Girls

c. 1915

Oil on canvas

38½ x 28½ inches (97.8 x 72.4 cm)

Private Collection, California

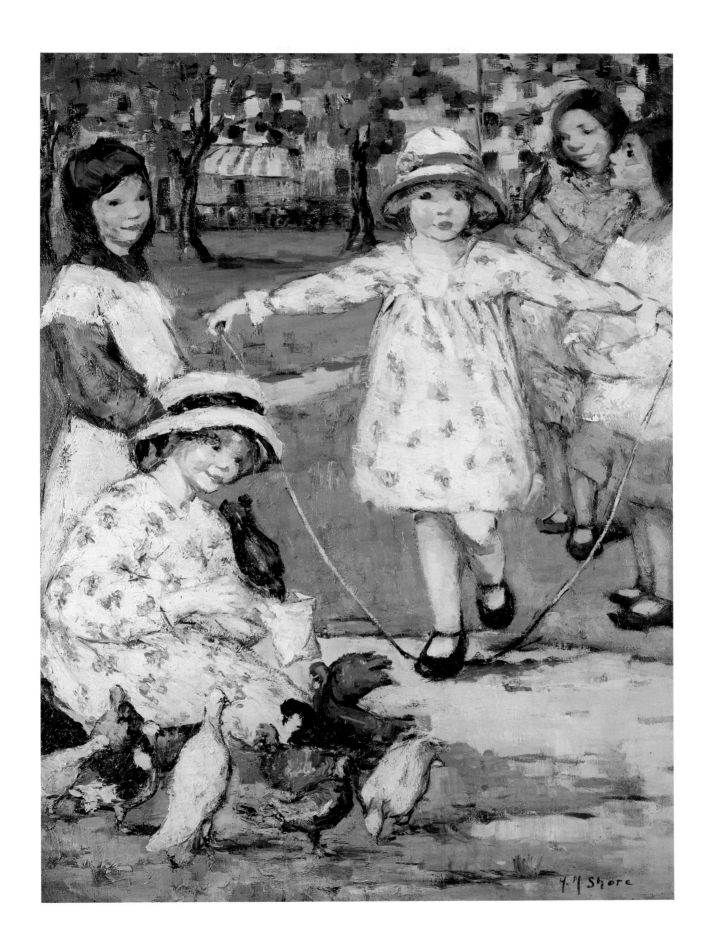

Henrietta Shore
1880–1963

Henrietta Shore was one of the important early modernists in Canada. Unlike other Canadian artists who travelled to the ateliers of the masters, she did not concentrate her studies on the specifics of anatomy but instead focused on the secrets of achieving warmth and clarity of subject matter within a restrained palette.

Nannies is a brilliant example of her representational work and marks the beginning of her transition to abstraction. Paintings of the seaside were popular during the decades following the Civil War when American beaches first became established as family resorts. From her home in Carmel, California, Shore catalogued the activity on the seashore, depicting children at play with their nannies standing nearby.

The seven figures on the broad expanse of sand are bathed in the reflected light of the sea. The elongated figures of the nannies, in particular, are abstracted, their individual identities obscured. They stand like mannequins, devoid of movement. Like Vincent van Gogh, who exhibited immediate changes in his palette when faced with the southern climate of the Mediterranean, Shore was responding to California light and colour.

Shore's work evolved to explore the meaning of life through intimate studies of inanimate objects such as flowers, informing them with vitality using a deeply felt artistic language. The move to this subject matter points to the complex nature of her work. Abstraction may have better expressed her isolation and self-imposed withdrawal from the artistic mainstream, her diminished contact with other artists, and the increasingly private direction to her life.

Nannies
c. 1918
Oil on canvas
19½ x 23½ inches (49.5 x 59.7 cm)
Private Collection, Ontario

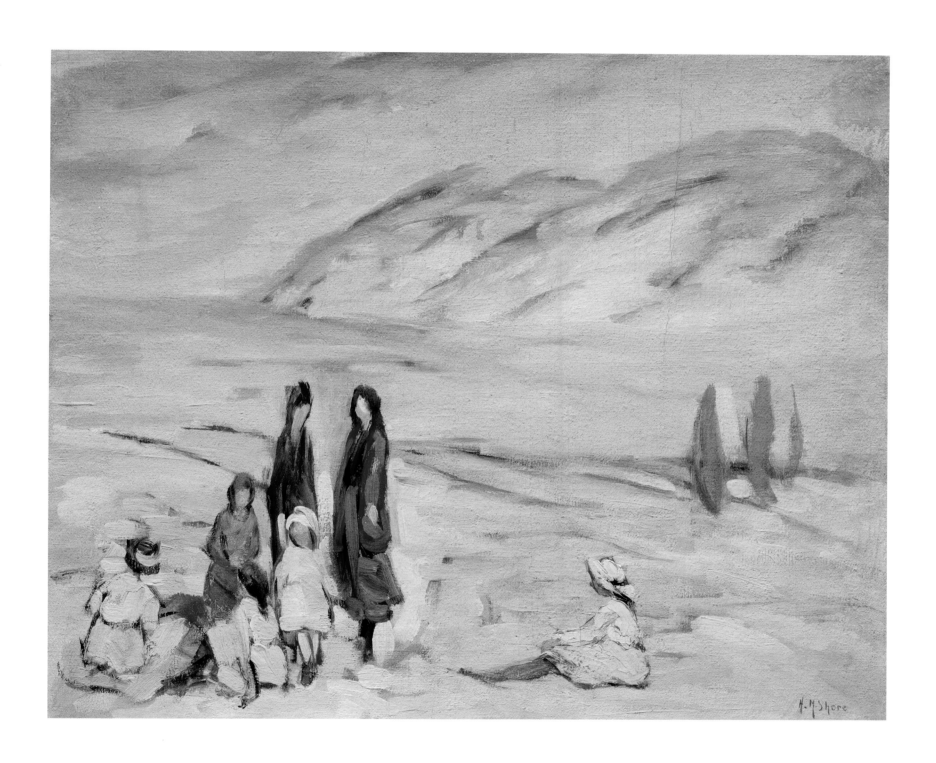

With her training under Robert Henri at the New York School of Art complete and no desire to return to Canada, Henrietta Shore decided to move to California. By 1930, she had settled in Carmel, a picturesque town on the California coastline, where she set up a home and studio. Self-supporting, she lived in relative isolation, somewhat fearful and uncertain. Until her death in 1963, Shore painted a complex range of subject matter with audacious energy. She painted portraits and figurative work under the influence of Henri, but it was in the subtle analysis and inventive design of her abstracted still-life paintings that she distinguished herself.

Irises is a masterpiece painted at the height of her powers. The subject was important to her and contributes to an understanding of her *oeuvre*. Even in still life, she chose subjects hitherto proscribed or unpopular. *Irises* epitomizes Shore's inventive approach to simple subjects. The painting is also a reflection of her belief that beneath the surface, everything is pure energy – abundant, naked, and alive. Whirling, embryonic forms, expanding and contracting, characterize Shore's rich imagination.

It is not known if Shore ever met Emily Carr. Both women were intimately connected with the environment in which they lived – both on the Pacific coast, but in different climes. If they had ever met, they would have immediately sensed an affinity in each other's work. Like Carr, Shore faced life and extracted from it an art that may justly be termed "her own."

Paintings such as this proclaimed that Canadian women artists had not only arrived in the modernist era, but also forged a pathway for artists to follow.

Irises, or *Gloxinia by the Sea*
c. 1930–1935
Oil on canvas
26 x 26 inches (66 x 66 cm)
Private Collection, California

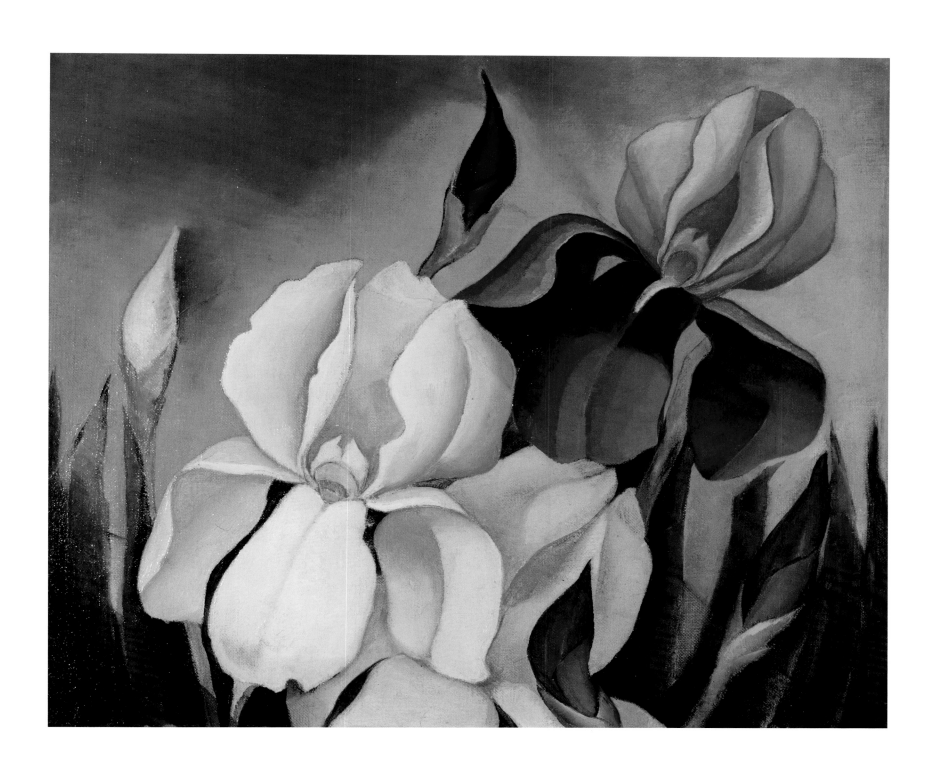

Mabel May

1884–1971

The Regatta is bathed in light: brilliant tones of white predominate in the women's dresses, and billowing clouds veil the sky. This sun-filled Impressionist work reflects Mabel May's fascination for tonal painting and her method of defining figures through the delicate use of colour. She employed this technique to direct the viewer's eye towards the principal focus of the work – people gathering excitedly to watch a boat race. The painting celebrates a care-free summer interlude within a prosperous community. Flowered dresses and tailored suits are proudly worn at the seaside. In May's work, the intimacy of the interior domestic image has been replaced with a lively portrayal of women in the open air, enjoying a public event.

Though the compositional simplification shows the clear influence of such artists as Claude Monet, *The Regatta* is marked by May's profound ability to capture a moment in time. Appearing weightless, the figures exude a lighthearted playfulness. In the middle foreground, interwoven brush strokes lend rhythm, unifying and at the same time disrupting the images. The hazy atmosphere is emphasized by the luminous cloud formations, a morphological nucleus that not only sets the tonal scale but also gives rise to the vanishing point. Finally, the manner in which light envelops the figures lends the scene a celestial aura. Women and children serve as an allegory of the fragility of humanity and a nexus joining the mystery of existence with the eternity of the sea.

The Regatta

c. 1913–1914

Oil on canvas

18 x 22 inches (45.7 x 55.9 cm)

National Gallery of Canada, Ottawa

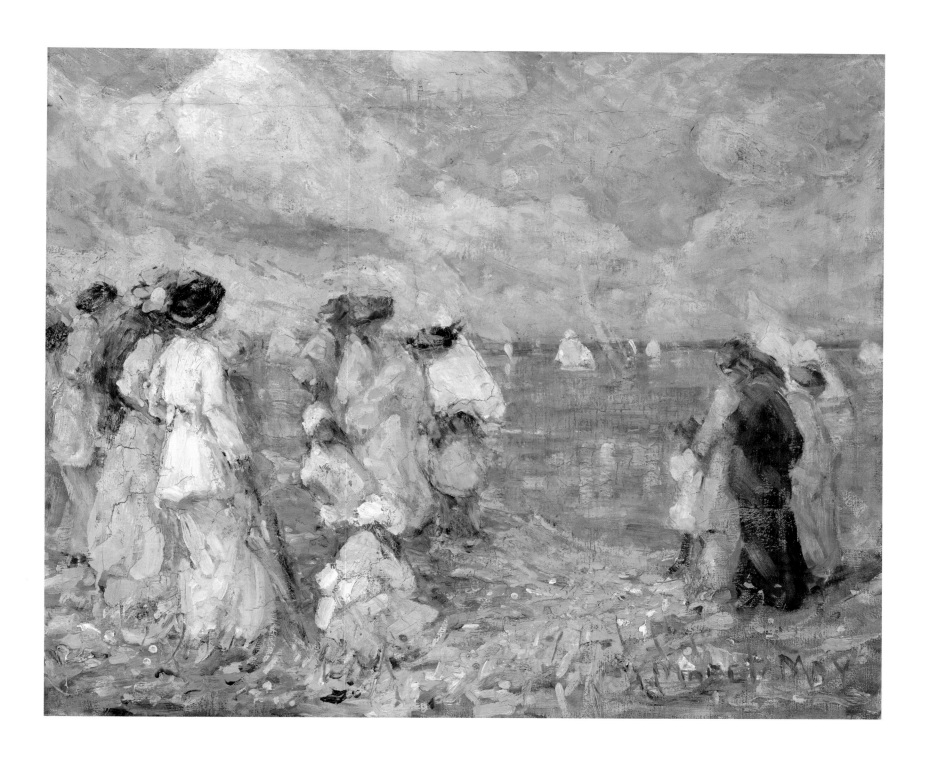

Mabel May

1884–1971

The image of two young sisters, Violet and Rose, in a moment of shared emotion, each with a flower in her hands, offers a visual feast of remarkable freshness. The expression on the face of the younger girl as she thinks of her father, who is fighting in the war in Europe, is one of longing mingled with sorrow. Her older sister touches her on the shoulder in a reassuring way. We recognize the tender bond between them; both share the same thoughts and dreams. The painting conveys the necessary loss of innocence when a family member must fight in defence of the country, leaving children behind.

The images of the two sisters are almost sculptural: Mabel May painted them using a blend of sharp focus and softness to attain a sense of dramatic intensity. The strong, loving faces are animated by a hint of spiritual luminosity.

There are many other paintings of sisters in Canadian art, but this work by May visually defines the complex relationship between the two young women by binding their bodies together in a shape that recalls a cross. May also employed a rich colour palette to heighten the emotional resonance of the work.

Violet and Rose

c. 1918

Oil on canvas

28 x 24 inches (71.1 x 61 cm)

Private Collection, Ontario

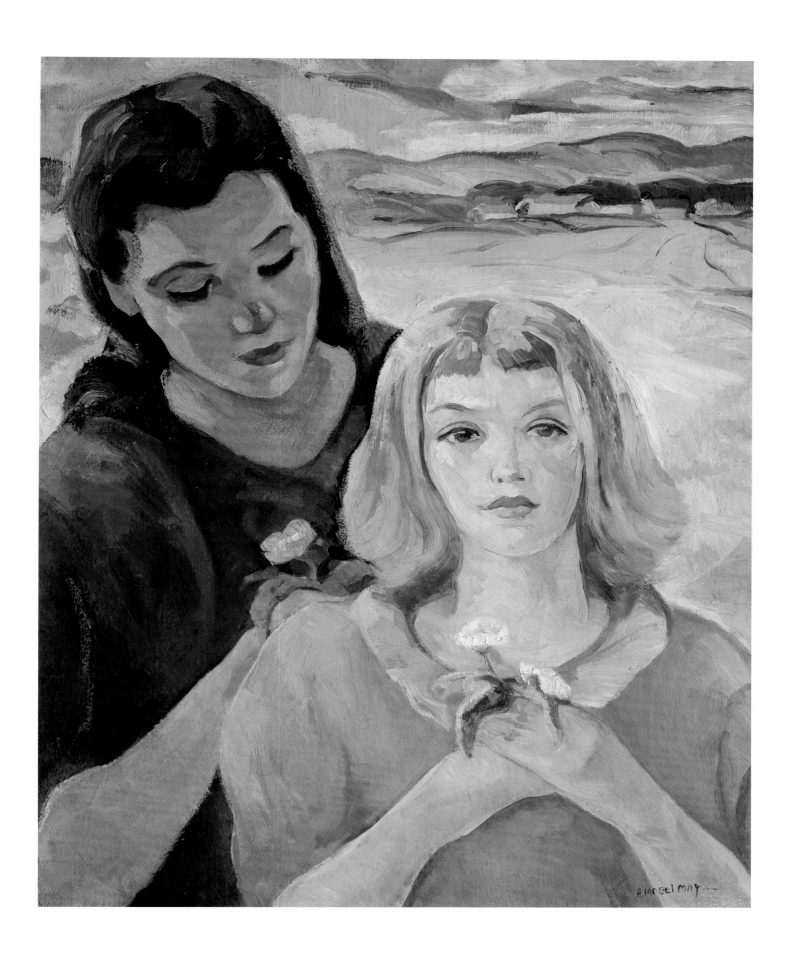

Emily Coonan
1885–1971

In *Visiting a Sick Child*, the clear geometry and carefully balanced internal order, though enveloped with a gentle flickering light, enhance the interior domestic scale. All attention is directed towards the child lying in bed. The delicacy of the picture is partially a result of the soft brushwork, a technique reflecting the early influence of Coonan's mentor, Canadian painter William Brymner. She took to heart Brymner's admonition to paint in a manner truthful to one's personal vision. Coonan was also influenced by the work of James Wilson Morrice, of whom she was a great admirer. Morrice had been a frequent exhibitor at the annual exhibitions of the Art Association of Montreal in the city where she lived and studied. Like Morrice, she handled colour in a tonal manner, with delicacy and reserve.

Although Coonan assimilated ideas from both Brymner and Morrice, she brought to painting her own delight in pattern-making. Later in her work, she would continue to explore the formal and material possibilities of art-making, but in recording her subjects, she always retained something of the melancholy spirit found in the subjects of Morrice – and likely in herself.

In her art, Coonan reflected many of the values held by Canadians in the early twentieth century. Nursing a sick child, for example, was believed to be a privilege of parenthood rather than a distraction from the pursuit of personal happiness.

Visiting a Sick Child
c. 1911
Oil on board
12¼ x 8¼ inches (31.1 x 21 cm)
Private Collection, Ontario

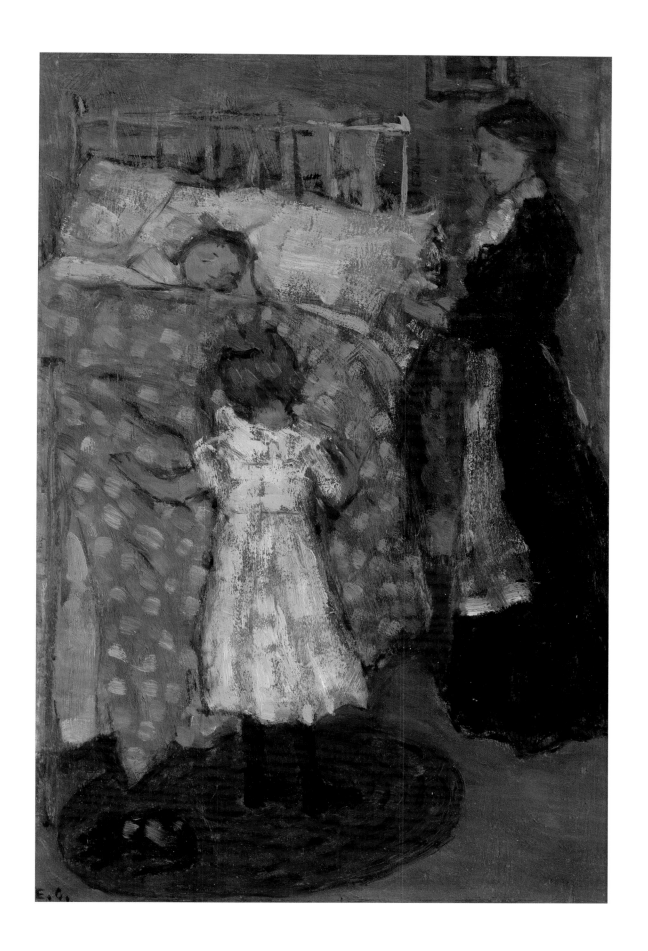

Of all the artists associated with the Beaver Hall Group, Emily Coonan was the most reserved and the one whose artistic vision was most nearly a reflection of the representational world. Stylistically, she was akin to the Post-Impressionist painter who achieved a harmonious resolution of subject matter with broken and feathery brushwork, free from ornamentation. In its illusion of light and space, her work expressed her detached point of view. Coonan believed in the power of natural form and a deliberate lack of expressive content.

En Promenade displays Coonan's art as one of stark simplicity, allowing the viewer to experience all the more strongly the pure qualities of colour, form, space, and materials. Today, this kind of thinking in art may be commonplace, but to Canadians of the Edwardian era, it was provocative. Here is a painting that contains all Coonan had to say: the journey of life is shown as a trio of young girls, moving forward into the future in a late summer landscape. Their destination is obscure, but the mood or promise is clear. It combines certainty and diffidence, shyness and awareness. This poetic masterpiece touches both the mind and the spirit.

En Promenade

c. 1915

Oil on board

12 x 10½ inches (30.5 x 26.7 cm)

Private Collection, Ontario

Emily Coonan
1885–1971

After decades of neglect, Emily Coonan is being recognized as one of the country's early modernists. Her aims were similar to those of James Wilson Morrice, Canada's first pioneer of modernism: to render the subject in subtle rhythms, creating a quiet mood. Like Morrice, she evolved a technique that reflected European styles in its preference for flat, decorative colour and broad handling of paint, combined with an interest in subjects that seem to reverberate with subtle, indefinable drama.

In *Still Life*, Coonan emphasized the physical presence of the objects in a relatively simple composition – a basket, two lemons, and a bean pot arranged on a wooden table. Rather than a purely representational approach to proportions and colour, her skillful treatment of paint teeters on the edge of abstraction, offering a new vision within the still-life genre. As such, Coonan's work is a clear precursor to achievements by Canadian artists in Montreal and Toronto decades later.

Still Life
c. 1940
Oil on canvas
24 x 21 inches (61 x 53.3 cm)
Private Collection, Quebec

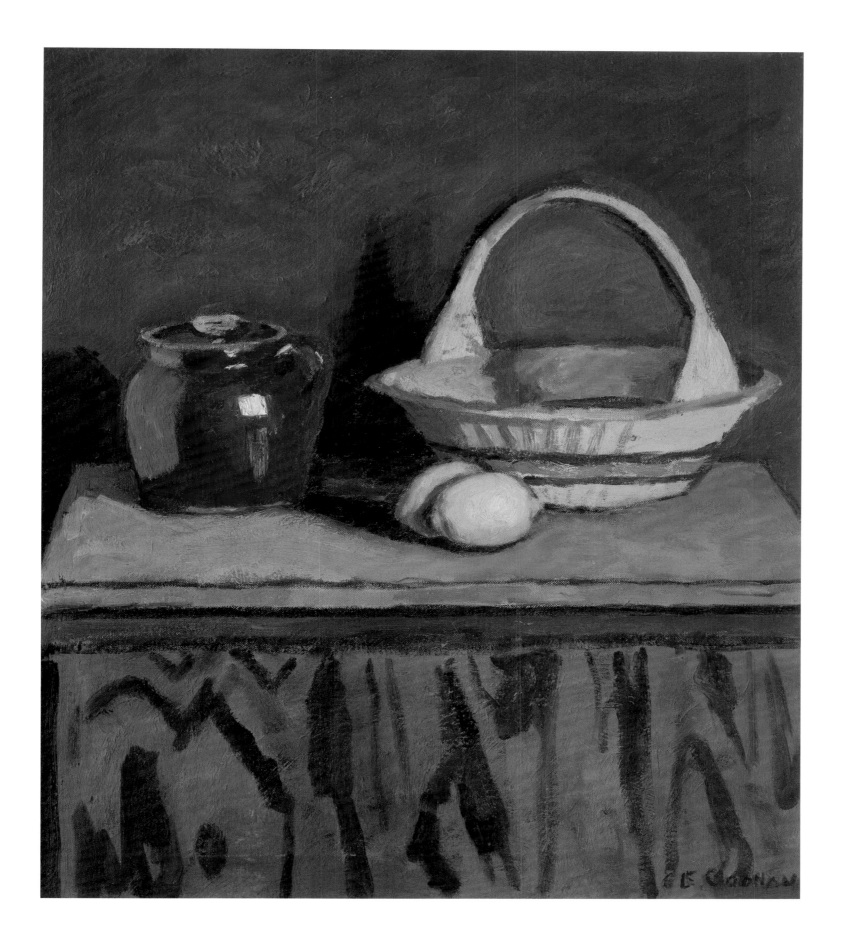

During the 1920s in Canada, debate was still raging between traditionalists and modernists, and to express an opinion on painting was to take sides with one against the other. Within this climate, some innovative women painters assembled in Montreal; they called themselves the Beaver Hall Group.

Affiliated with the Beaver Hall Group, Prudence Heward was most gifted in exploring the psychological forces that animate the human soul. Painted with directness, Heward's portraits embody a sensual relish for the battle of life. She limited her subjects, usually women and children, to people she knew, painting them with a depth of feeling not approached by many of her contemporaries. Heward synthesized the dark experiences of human life – illness, poverty, sorrow, alienation, and misfortune – to express in her work a sense of pathos. In this, she was without equal.

Tonina exemplifies Heward's skill in constructing the figure by condensing the infinite number of planes comprising the human body, reducing them to a minimum of planes of pure colour. By using exaggeration, Heward expressed the solitary existence of a woman similar in age and station to herself. The figure is visually integrated with her environment, yet psychologically aloof and apart. We sense that Tonina is confident, despite the challenges life has thrown her way, but is she content?

The Group of Seven and particularly Lawren Harris admired the canvas so much that they included it, along with another painting by Heward, *Jones Creek*, in the Group of Seven show at the Art Gallery of Toronto in 1928. It was the first time Heward exhibited with the Group of Seven as an "Invited Contributor."

Tonina
1928
Oil on canvas
27 x 27 inches (68.6 x 68.6 cm)
Private Collection, Ontario

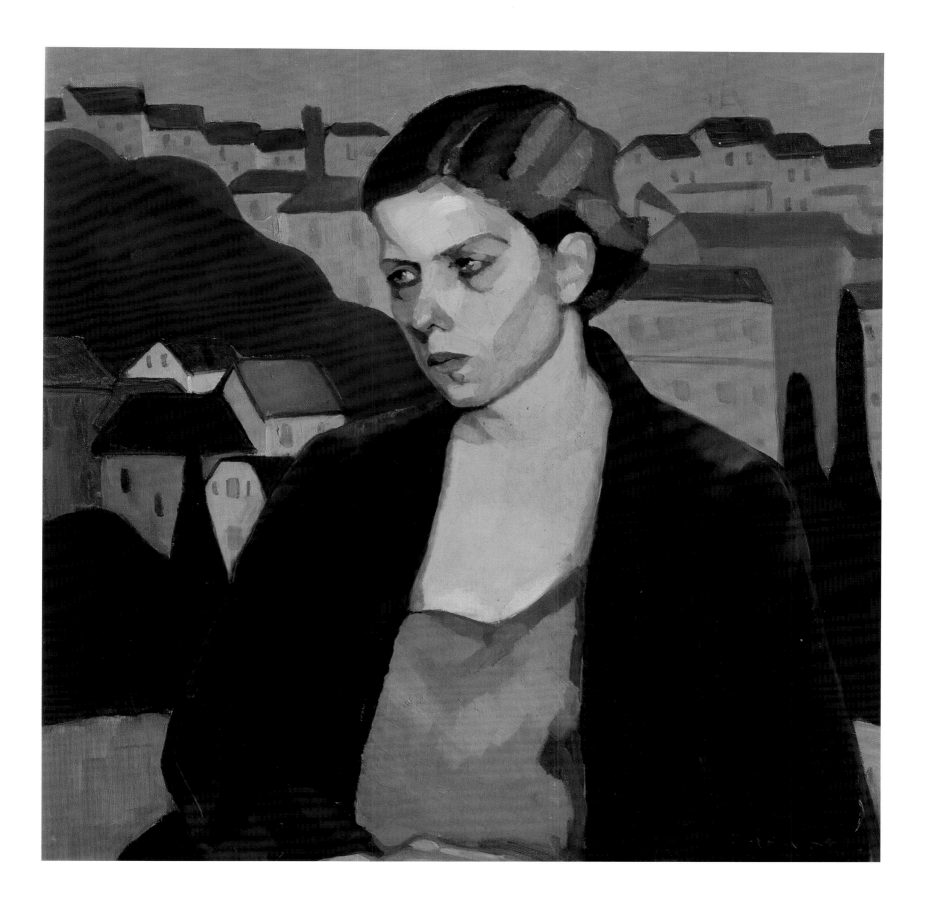

Prudence Heward
1896–1947

During the Depression, the working class suffered a life of grinding poverty that infected the spirit, leaving a wound that, in the traumatic upheavals of the Second World War, was reopened with further virulence. Although Prudence Heward came from a wealthy family, she could not escape witnessing the desperate poverty of the working class.

Heward painted *Italian Woman* using an almost surgically explicit anatomy to depict an immigrant woman who has suffered greatly and whose character has been moulded by her suffering. The portrait is a critique of the dreadful neglect of the working poor and raises the question of the relationship of art to society.

What is most powerful in the painting is not the social message, but the absence of the graceful illusions commonly associated with womanhood that usually appear in art. The subject is stripped of not only identity but of gender. *Italian Woman* is remarkable for the way in which Heward has personified the exhausted spirit of a human being. One may not be moved by the work's social commentary or feel uneasy at the exploitation of the individual to convey a message, but one cannot forget it.

Italian Woman
c. 1930
Oil on canvas
24 x 20 inches (61 x 50.8 cm)
Private Collection, Alberta

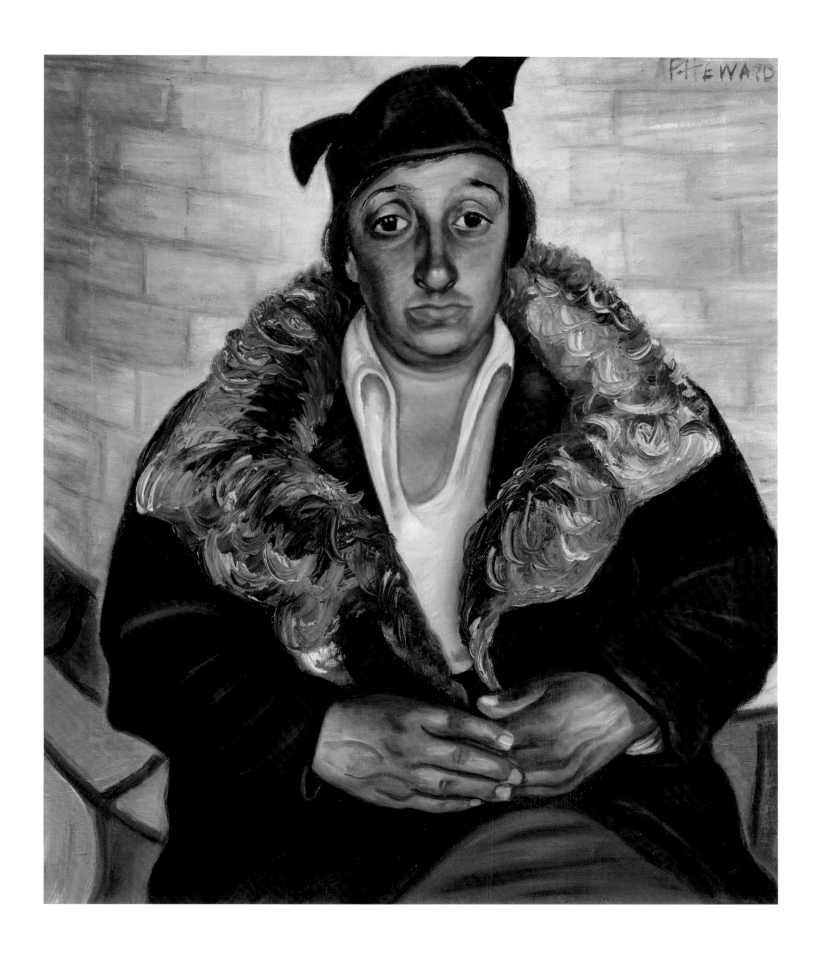

Prudence Heward

1896–1947

In her paintings, Prudence Heward revealed the fragmented nature of the individual torn between social constraints and inner conflicts. The static, carefully scrutinized and calculated poses of her subjects were part of the unique vocabulary of expression that she used to articulate the human condition.

In Heward's world, everyone concerned, the painted figure as well as the viewer, is isolated and momentarily frozen in position. We admire the powerful rhetoric of *Girl Under a Tree*, which is perhaps Heward's most compelling painting, and note the strong angular planes in the background, reflecting the artist's knowledge of Paul Cézanne's work. Certainly, this treatment is in keeping with her special brand of descriptive formalism.

The entire pictorial surface is painted so that the figure is not integrated into its surroundings, but appears instead as a fully modelled, powerful, voluptuous nude goddess. The viewer feels keenly the tension of the uncomfortable angle of the body – it may indicate the uneasiness Heward felt in painting what could have been a difficult subject for her. The twist of the head, the gaze of the young woman, and the suggestion that she may at any moment rise from the pose, suggest the subject's inner fire and may signify Heward's attitude towards herself. The position, however contrived and artificial, as well as every undulation of the form, conveys a longing for freedom. Most likely, our best reading of the painting is as an unambiguous symbol in the iconography of sexuality and a desire for freedom from the prevailing constraints of the age.

Girl Under a Tree
1931
Oil on canvas
48¼ x 76¼ inches (122.5 x 193.7 cm)
Art Gallery of Hamilton

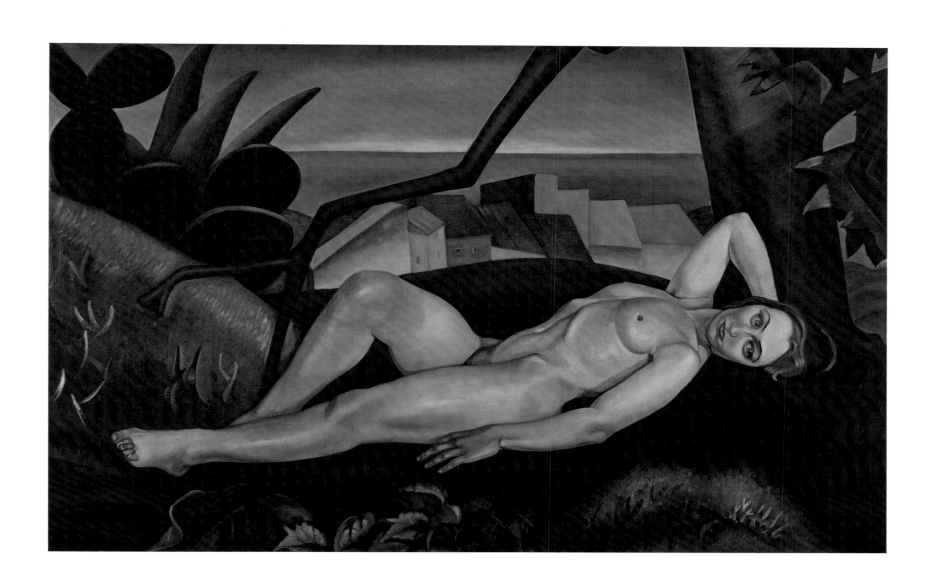

Prudence Heward

1896–1947

Rejecting both academic naturalism and the atmospheric subtleties of the Impressionists, Prudence Heward focused her art on the inner truth of her subjects. She distilled the ferment of human emotions in penetrating images using simplified forms bounded by strong contour lines and broad colour fields. The strained face of the young boy, utterly lacking in self-consciousness, integrated but aloof from his environment, suggests a note of vulnerability.

With the passage of time, Heward's paintings, especially her portraits of the 1920s and 1930s, have come to be recognized as a consummate representation of the human spirit. Without resorting to artful evasion, her approach was a precise instrument for synthesizing earthiness and refreshing clarity. Thoughtfully conceived and meticulously painted, these paintings are difficult to accommodate for those who demand a superficially pleasing visual encounter with a work of art. They are, however, deeply satisfying for those who seek a deeper understanding of the human condition through art.

Portrait of the Artist's Nephew
1936
Oil on canvas
18¼ x 18¼ inches (46.4 x 46.4 cm)
Private Collection, New York

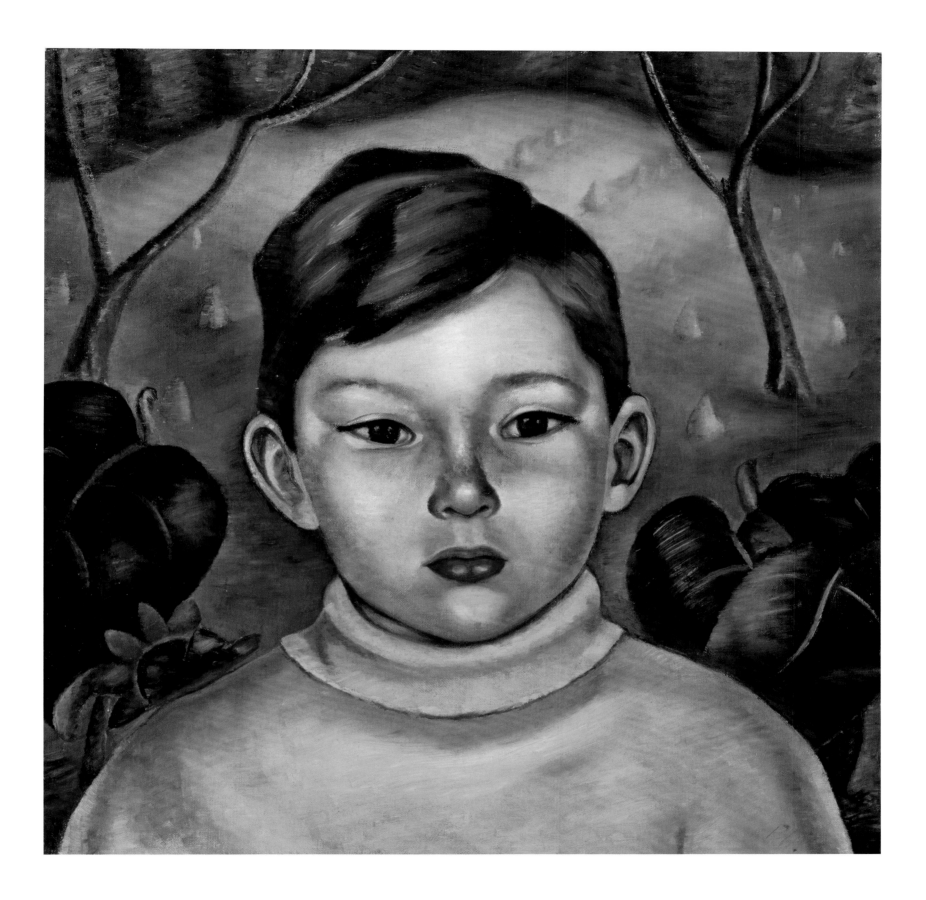

Simone Hudon-Beaulac
1905–1984

Although printmaking flourished in Europe as early as the sixteenth century, graphic arts in Canada did not gain public acclaim until the period between the two world wars. Simone Hudon-Beaulac was among the early successful printmakers in Canada. She taught engraving at the École des beaux-arts in Quebec City until 1945.

As a specialized field of fine arts, printmaking involves a variety of techniques. These range from block printing with woodcuts and linocuts, to engraving and lithography. For etching, a type of engraving, the artist draws with a needle on a coated metal plate and then uses acid to produce an image. This technique allows more refined effects such as greater depth and the use of perspective. The addition of colour to the medium further enhanced the technique and offered a new way for artists to keep abreast of their painting colleagues. In this process, Hudon, one of the most distinctive printmakers of Canada, played an important role.

Hudon had a style all her own. Her work is characterized by a shimmering quality of light created from the spaces above and between innumerable webs of interwoven black lines. This quality is particularly effective in her prints of Quebec City. She delighted in the port and the old streets, depicting them in picturesque ways. Her depictions are quite controlled in one sense and yet appear pleasantly unpredictable.

Fortunately, Hudon's professionalism was matched by that of her printers. A print such as *Québec vu du port* is characteristic of her acute observation and solid formal mastery of the etching medium. The prints not only preserve Hudon's line and surface in their rich variety, but also render the atmosphere as she captured it – enchanting and enveloping. Her prints were intended to have the quality of drawings with the advantage of duplication to reach a wide market. As major works of art by any standard, they are a record of Hudon's mastery of the art of omission and suggestion.

Québec vu du port
c. 1930
Etching on paper
14 x 11 inches (35.5 x 27.9 cm)
Private Collection, Ontario

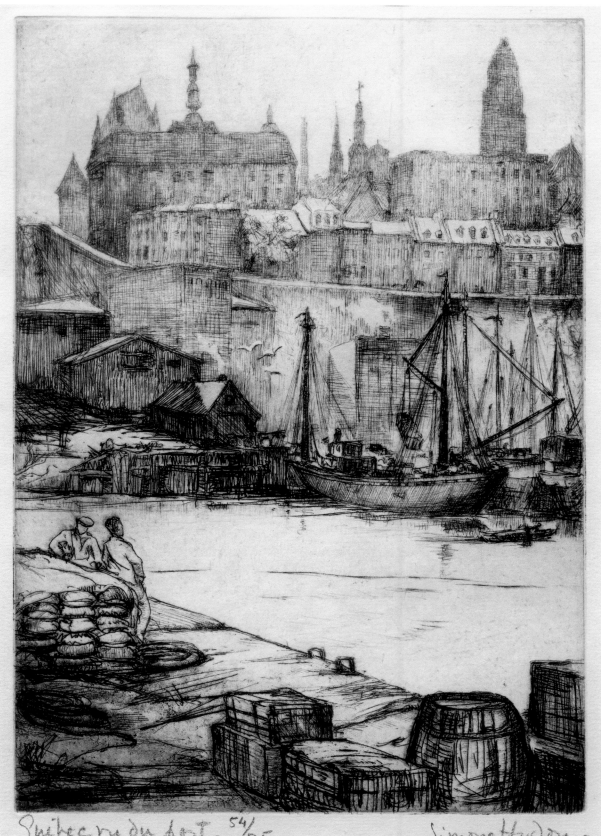

Québec vu du port — 54/75 Simone Hudon —

Christiane Pflug
1936–1972

Self-taught, Christiane Pflug developed her special brand of realism in Paris through the encouragement of her husband, Michael Pflug, and the Portuguese artist Vieira de Silva. Her early work consists of paintings, gouaches and oils of city scenes that convey architectural and landscape forms in strongly designed painterly shorthand. In Tunisia, where she lived from 1957 to 1959 and where her two daughters were born, her work began to show greater attention to light and shade as well as to detail and clearer colour. In 1959, she moved to Canada, to Toronto, where she painted views from the window of her home (1960–1962 on Yonge Street) and a series of interiors, doors, and windows with dolls from a house on Woodlawn Avenue (1962–1967), followed by a series of large portraits of her two daughters and her dealer, Avrom Isaacs, in a similar setting. In a house on Birch Avenue to which she moved in 1967, she produced a series of cityscapes.

At Night is a study related to one of Pflug's better-known paintings, *Interior at Night,* in the McMichael Canadian Art Collection in Kleinburg. In both works, the artist depicted two dolls, one black and the other white, placed in such a way that a quality of uncertainty hovers over what is real, what is artificial. Pflug's forté was her ability to transform tranquil scenes from ordinary life into an intensely personal and psychologically complex reality. Here, she creates a complex emotional tone from the distance between the viewer and the dolls, the contrast between light and dark, and the balanced composition. Both works may be read as coded messages about freedom and entrapment. The uneasy symbolism may reflect the influence of Vincent van Gogh, but within Pflug's work it is given new direction. *At Night* provides disturbing evidence of Pflug's struggle for freedom and identity, both in the outside world and within herself.

At Night
1962
Graphite on paper
12½ x 9½ inches (31.8 x 24.1 cm)
Private Collection, Ontario

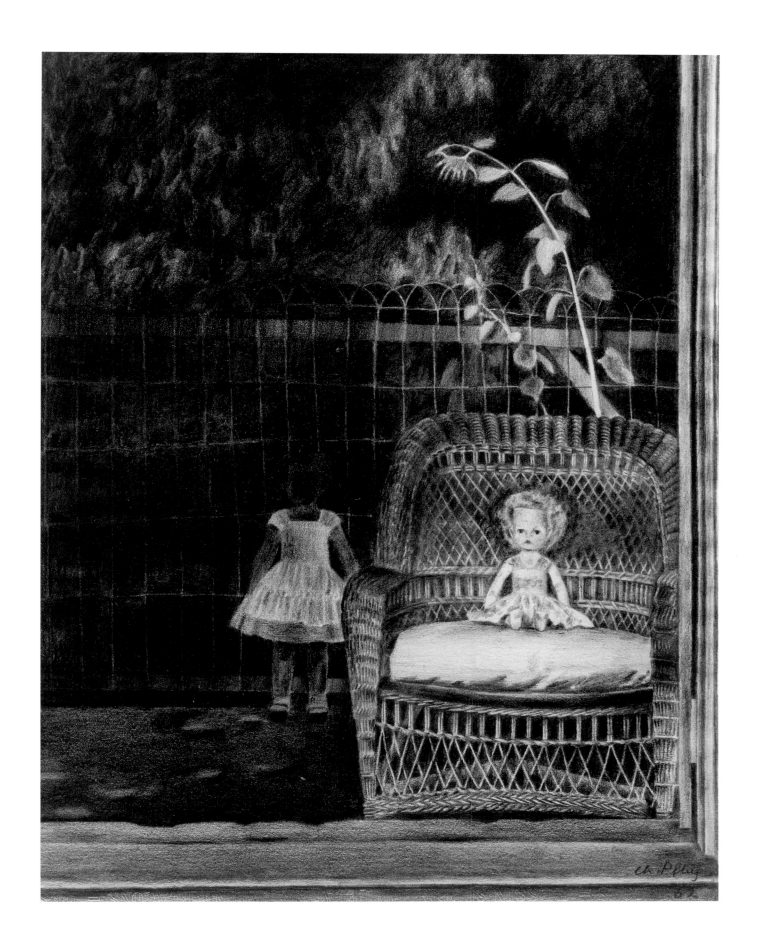

Christiane Pflug

1936–1972

Few painters in Canada have left a body of work that is so intensely autobiographical as Christiane Pflug. Making an emotional assault on the viewer, her work is at once tender and powerful. Links to Surrealism are evident, yet her art is so distinctive that it transcends all influences.

Although abstract art had become dominant among painters of the postwar generation, some still reached out to representation and figurative work of a traditional kind, depending upon the presence of a model or on observable circumstances. In many of her works, Pflug evoked emblematic scenes of domestic life, but she imbued them with a complex emotional tone, rich in psychological overtones.

Still life was prominent in her limited body of work, and *Roses and Dead Bird* is one of her finest and most subtle paintings in this genre. The faded roses symbolize mortality: the flowers retain their bloom for only a short period. Using a smoothly polished surface, Pflug employs a brilliant arrangement that distances the dead bird, abandoned in its death, from the lifeless flowers. The viewer's anxiety is raised as a connection between the forms is sought.

Tragically, this painting seems to foreshadow Pflug's own fate: less than ten years after painting *Roses and Dead Bird,* she brought an end to her short life one afternoon on Toronto Island at Hanlan's Point. We may ask if the painting in some way refers to the artist herself. Could there be a more pious vein in creativity as truthful as that expressed in the image before us?

Roses and Dead Bird

1963

Oil on canvas

15¾ x 18½ inches (40 x 47 cm)

Private Collection, Ontario

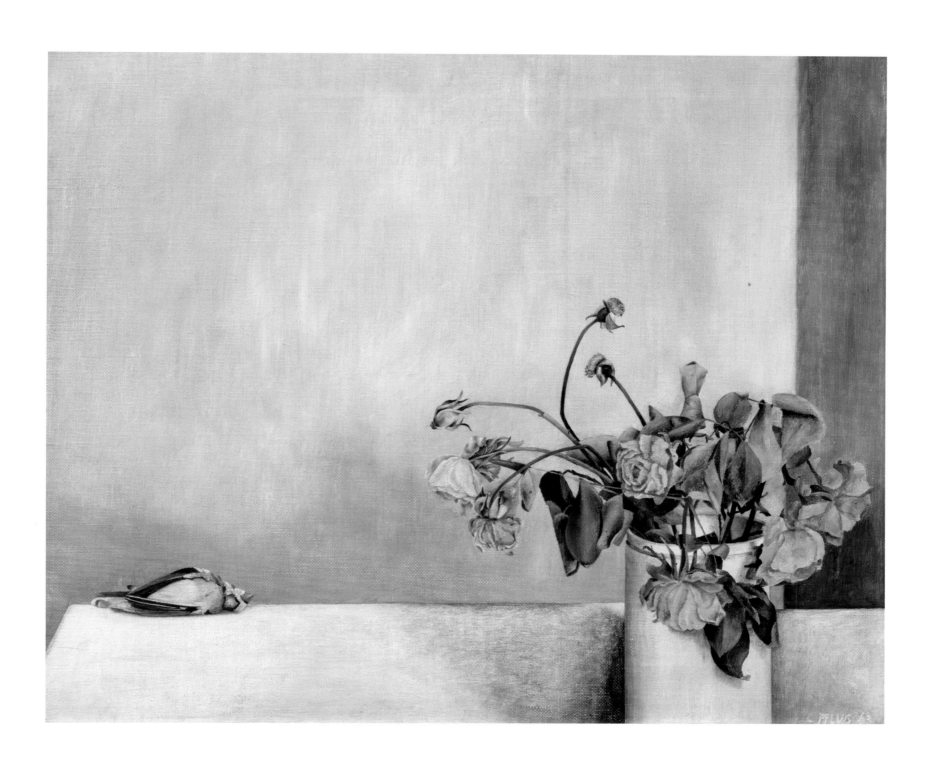

Christiane Pflug
1936–1972

Unlike several works by Christiane Pflug that offer disturbing views of interiors, *Kitchen Door with Ursula* seems straightforward until we realize that we see an outdoor winter world, but the reflection in the glass of the door shows us a child reading on a late spring day. This composition has certain similarities with works by Jan Vermeer, who used a map on the wall of his interior scenes as a reference to the outside world, a world awaiting discovery. Even the young girl, sitting outside absorbed in her reading, is only visible through her reflection within the glass door panes. Her curved form softens the sharp angular aspects of the architecture, but she too, in a sense, is a door that refers only to self.

The painting appeals to the longing to retreat into a corner, even for a moment. It speaks of a need to break from the intimacy of the protected space out into the freedom of the outside world. The image leads us in but is not an end in itself. The unique power of the painting stems from its unusual viewpoint; an outside view, but from an interior space.

Pflug was one of the few artists in Canada who was able to transfer into her work her personal experience of life. The uneasy symbolism she employed in her paintings may have been influenced by Vincent van Gogh, but she gave any such reference a new direction.

Kitchen Door with Ursula
1966
Oil on canvas
65 x 76 inches (164.8 x 193.2 cm)
Winnipeg Art Gallery, Winnipeg

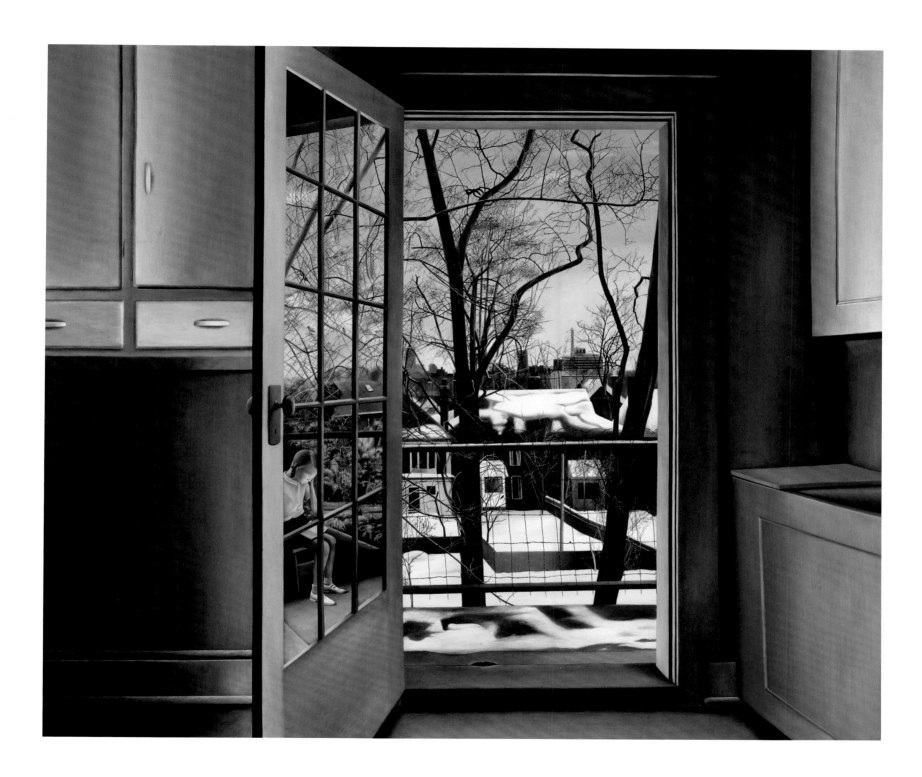

Christiane Pflug
1936–1972

Throughout her career, Christiane Pflug painted the view from her window, recreating the scene in careful detail. As she explained to Avrom Isaacs, she was attempting to reach "a certain clarity, which does not exist in life."

Cottingham School After the Rain is one of a series of paintings of the elementary school across from the house on Birch Avenue, where the Pflug family moved in 1967, the same year she created this painting. Pflug's two young daughters attended the school, and the household was abuzz with the comings and goings of the girls. For the first time, Pflug had a proper studio, on the third floor of their house. Looking back, Michael Pflug says it was perhaps the happiest period in their lives in Canada. The new sense of relative security and promise may be seen in the Canadian flag, waving in a stiff breeze – a flag that had been adopted in Canada only a few years earlier.

Although it took Pflug five months to complete this painting, she succeeded in capturing the moments after a rainfall, when the roof of the school became a shiny surface, reflecting the houses and trees beyond. A slightly surreal impression is created by the winter trees and wisp of smoke from a chimney on the right, while a primitive tree in full leaf strikes an unlikely pose on the left.

*Cottingham School
After the Rain*
1969
Oil on canvas
49¾ x 39 inches (126 x 99 cm)
Pflug Family Collection

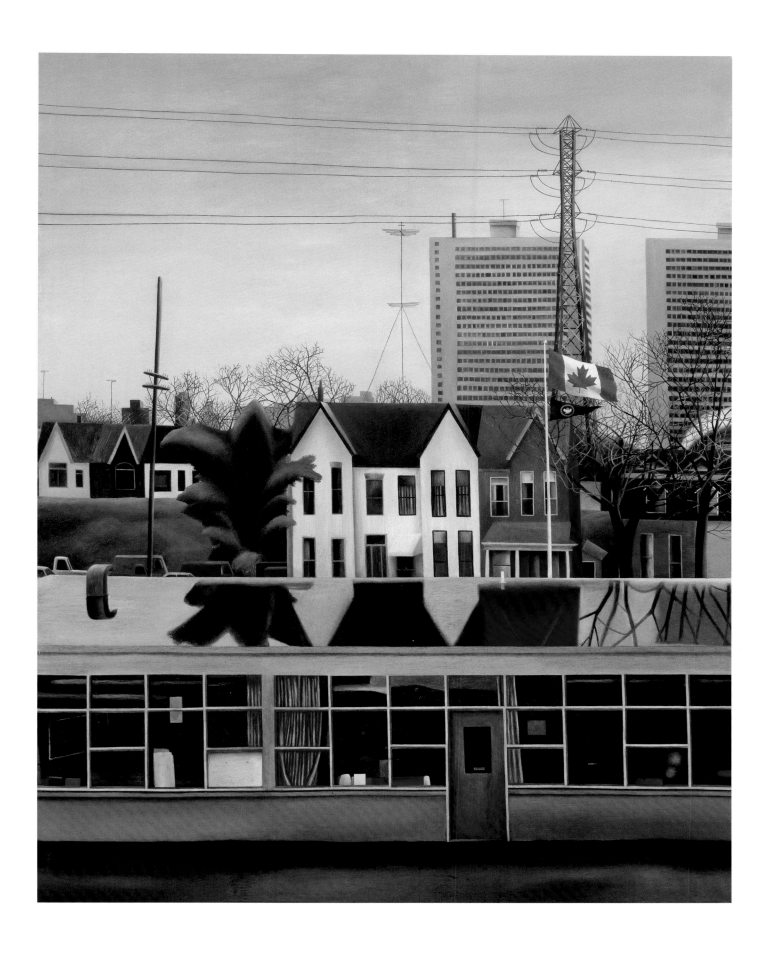

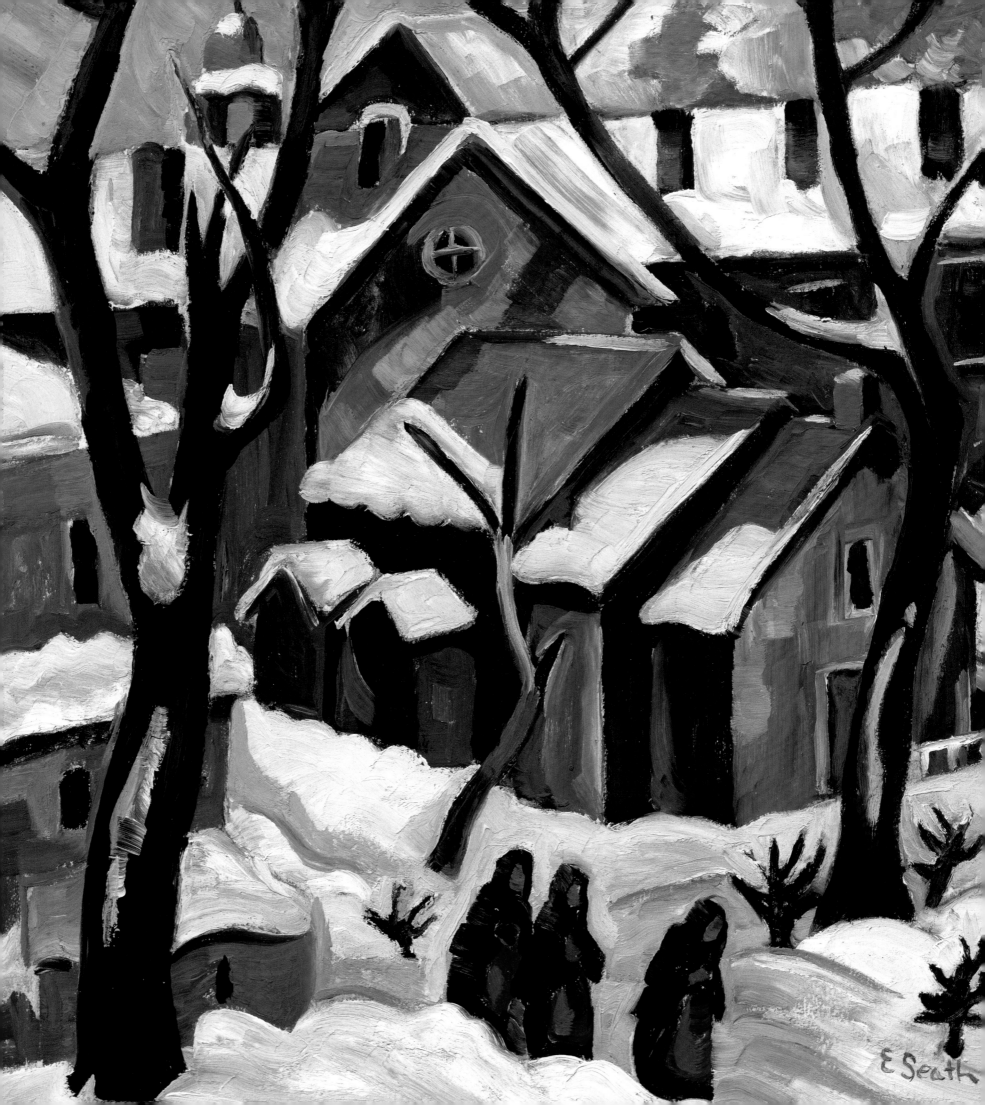

MASTERS OF THEIR CRAFT

"Masters of Their Craft" are artists who worked with strength and authority. Consummate professionals, they produced work that is aesthetically sound and technically impressive. The second part of the "Visual Journey" features the artwork of twenty-four early women artists who were masters of their craft, arranged in chronological order.

Ethel Seath
Nuns, St. Sulpician Garden
See page 135.

Although painters and teachers like William Brymner and Maurice Cullen encouraged young Canadian women painters and painted along with them, many of these women have received little recognition from critics, and artists such as Frances Jones (Bannerman) continue to be relegated to the background.

In the Conservatory is a magnificent example of a Canadian painting that combines spontaneity and formal portraiture. The painter's interest clearly lies with the sitter. The entire scene is informal. The sitter, the natural focal point, occupies the entire right corner of the painting while the large pot behind her, centred and surrounded by luxuriant flowers, creates a compositional counterpoint.

The face of the sitter is illuminated by the pages of her book acting as a mirror of her world. Warm light and colour perfectly link the figure with the background through tones of blue, green, and pink. The composition recalls certain paintings from the early period of Édouard Manet. Bannerman was obviously inspired by Manet's ability to perfectly capture the world of women, so misunderstood in their time, through a relaxed moment of amenity.

In the Conservatory was painted almost three decades before Helen McNicoll painted her well-known Impressionist works, yet it already manifests the concepts of Impressionism in the treatment of the subject matter and the diffused light that envelops the scene. Note a remarkable aspect of the composition – the left background is filled with intense colour in contrast to the area of whitish sky illuminating the scene on the right. This contrast accentuates the immediacy of the scene, a technique that Tom Thomson was to explore, some thirty years later, in his sketches of Algonquin Park.

In the Conservatory
1883
Oil on canvas
18¼ x 31¾ inches (46.5 x 80.6 cm)
Nova Scotia Archives and Records
Management, Halifax

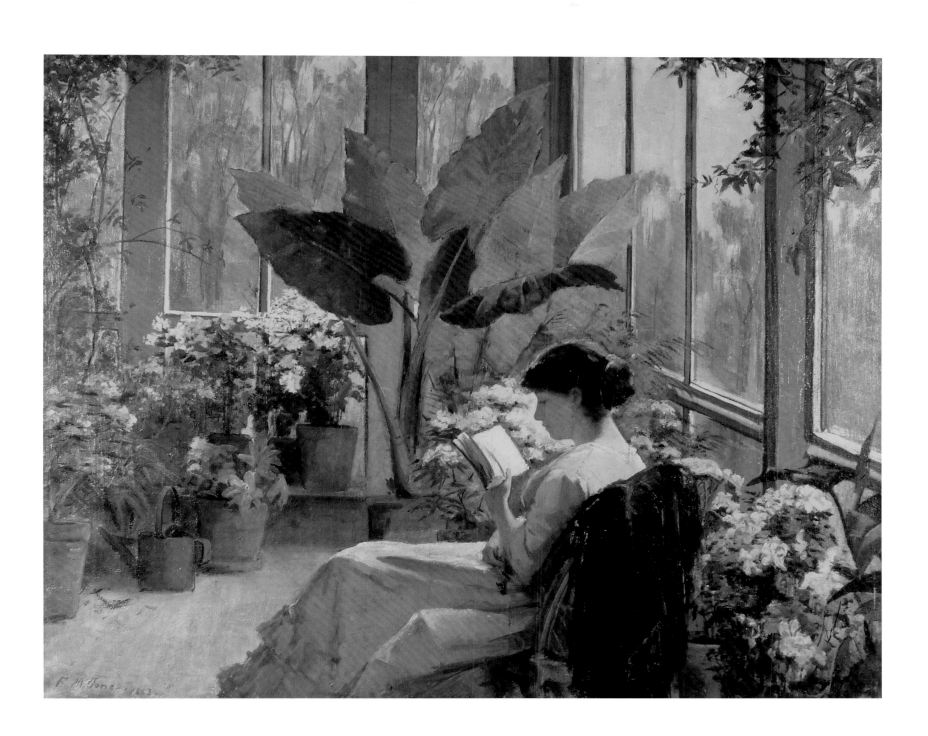

Margaret Campbell Macpherson
1860–1931

Consistent with the tone of her art, the details of Margaret Campbell Macpherson's life are veiled in uncertainty. Macpherson, Frances Jones, and Charlotte Schreiber could well be considered female co-founders of Canadian painting, gifting Canada with their ability to combine the formal art of painting with the movement towards transforming the physical attributes of reality into the world of the senses. Macpherson's paintings, avoiding the implication of movement, are the embodiment of the use of form and colour to create lyrical moods.

One of the earliest women painters in Canada to travel abroad for professional training, she left St. John's, Newfoundland, in her teens to study in Edinburgh, Scotland, and then in 1878 went to Neuchâtel, Switzerland, and later to Paris for further training. Macpherson sought to achieve harmony between the physical reality she experienced and her abstract or poetic conception of the ideal. *Lake Como* is the vision of a poet, painted with the utmost simplicity and a touch of melancholy. Its location is of no importance; the identity of the figures is irrelevant. Here is a subject appealing to the deep-seated romantic aspirations lurking in the human experience.

Macpherson could not conceive of landscape except in human terms and most of her paintings are, broadly speaking, harmonious adjustments of nature to the activities and scale of humanity. In all her work, Macpherson remained a Victorian painter, incapable of indifference or detachment, gracing her compositions with her own quiet personality. In *Lake Como*, a specific moment is reproduced as expeditiously as possible, providing a visual image of nature, neither detached nor literal, that remains unsullied by human avarice or servility. Could one find a more sympathetic landscape in Canadian painting, in which structure is balanced with sentiment? *Lake Como* speaks of the quick processing of reality through the eye and hand of the artist, resulting in the imperturbable repose that comes to an artist only after she has conquered her own afflictions.

Lake Como
c. 1905
Oil on canvas
32 x 26 inches (81.3 x 66 cm)
Private Collection, Newfoundland

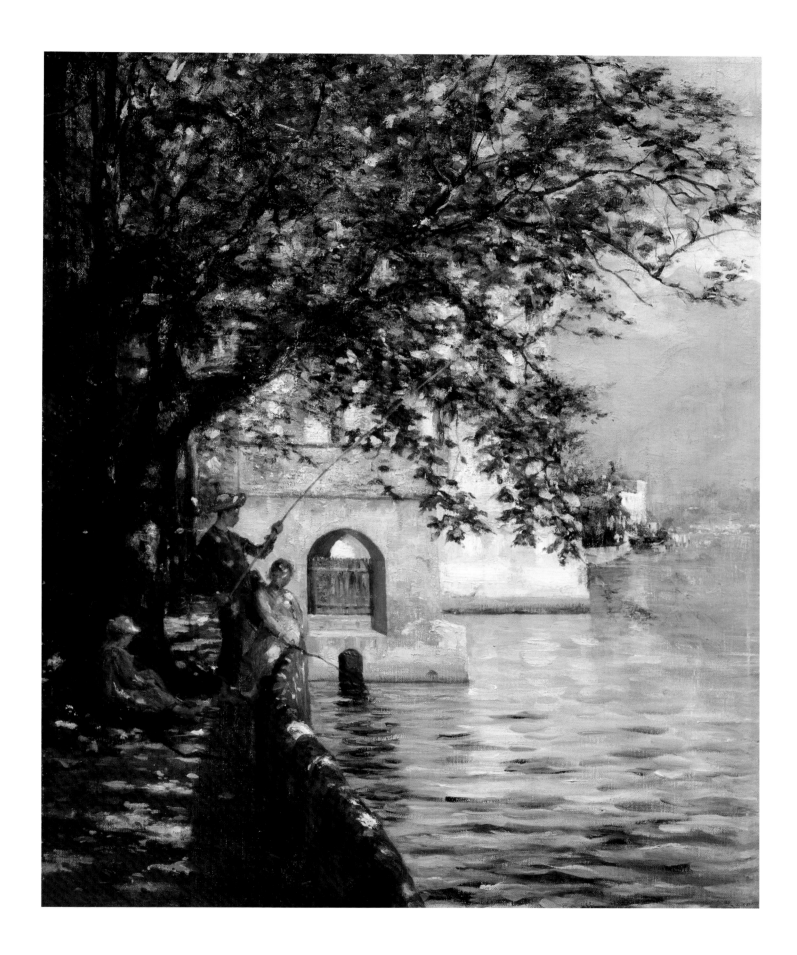

Mary Bell Eastlake

1864–1951

Immediately following her marriage to English landscape painter Charles Eastlake in 1897, Mary Bell Eastlake settled as a willing exile in an artist colony in St. Ives, England. Living and painting with the Cornish artists and their families offered the Eastlakes not only evocative remnants of a traditional pastoral culture and a modest life as bohemians, but also an escape from the crowded and noisy studios of Paris and London. The convivial atmosphere afforded by the rudimentary living conditions in the colony engendered a quality of tenderness, which is visible in her painting.

Market Scene, Bruges reflects Eastlake's interest in movement, a theme shared by such Fauve painters as André Derain and Expressionists such as Emil Nolde. Like the Fauves, Eastlake used large areas of pure colour populated by fragmented figures. And in the manner of the Expressionists, she spontaneously revealed feeling and emotion, over and above considerations of style or technique. Even in a transitional work leading to her mature style, the triumph of expression over technique was a rare accomplishment for a painter who had been trained in the academies of Paris.

Market Scene, Bruges
c. 1891
Oil on panel
5¾ x 8¾ inches (14.6 x 22.2 cm)
Private Collection, Ontario

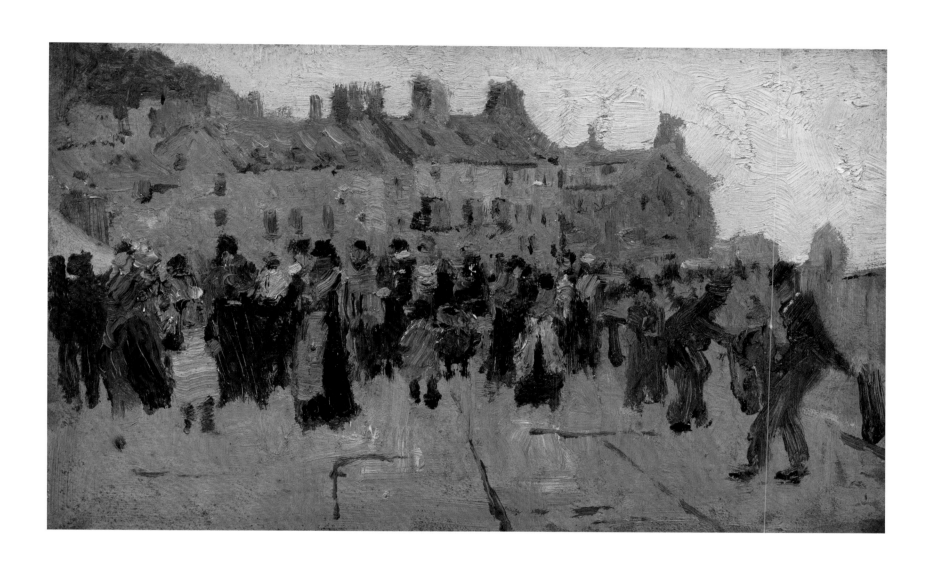

Mary Bell Eastlake

1864–1951

The works of Mary Bell Eastlake appear only occasionally in the art market and, her achievements notwithstanding, she is little known in the art world in Canada. Although her paintings are found in collections ranging from the National Gallery of Canada to the National Gallery of New Zealand, details of her life are obscure and there are few records of her professional career.

Avoiding the representation of human conflict and inner discord, Eastlake chose instead to work along well-defined modes of expression. The guidelines that became her artistic credo can be seen in the works of Francisco de Goya and Pierre-Auguste Renoir. With a similarity to the subject matter of Mary Cassatt that is superficial at best, Eastlake's paintings featuring children removed child imagery from the grip of Victorian sentiment and elevated it to a stronger, more individual plane. Her point of view differed from that of painters of formal portraiture featuring the children and adults of wealthy families.

Girl with Butterfly has a quietness of tone, a reserved simplicity of style, and a suggestion of pathos. Inspired by the traditional iconography of the child in religious art, it explores the use of symbols to create meaning while working in an academic vernacular. The painting challenges us to understand youth in the context of modernity.

Girl with Butterfly
c. 1910
Oil on board
13¼ x 9½ inches (33.7 x 24.1 cm)
Private Collection, Ontario

Mary Bell Eastlake

1864–1951

Religious transcendence is the spirit captured in Mary Bell Eastlake's *Mobilization Day 1914: French Fisherwomen Watching the Departure of the Fleet*. A sense of spirituality links the rhythmic forces of the composition. Eastlake does not attempt to capture a concrete spontaneous moment; instead she creates a sense of greater expressive force that clearly renders the attitude, character, and circumstances of the women in the painting. The three generations of women on the shore, gazing out on the sea that has taken their men away, constitute a counterpoint to the void of the unforgiving waters.

The expectant gaze of the three women signifies the soul, avid for the very essence of life. The melancholy of those who wait is dominant; the figures symbolize the dichotomy between what is now and what is to come. *Mobilization Day 1914* is a painting about waiting – of hope, spirit, and faith. This unexpected element of romanticism injected into the composition sets the work apart from pure Impressionism. The sense of their solitude emphasizes the supporting role women have played throughout history in the lives of men.

Mobilization Day 1914:
French Fisherwomen Watching
the Departure of the Fleet

c. 1917

Oil on canvas

34 x 43 inches (86.3 x 109.5 cm)

National Gallery of Canada, Ottawa

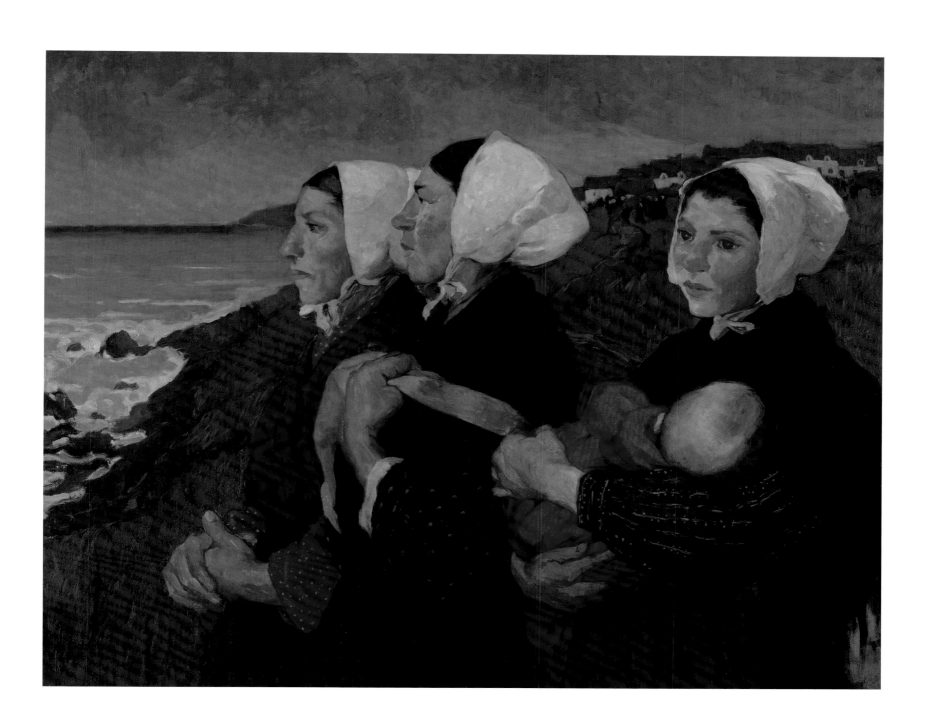

Florence McGillivray

1864–1938

Florence McGillivray's *Canal, Venice* is the sketch for one of the artist's major paintings of the city that had so captivated her on a visit in 1914. It was shown in 1918 at a joint exhibition by the Royal Canadian Academy of Arts and the Ontario Society of Artists at the Art Museum of Toronto.

The scene is of gondolas tied to colourful *paline* with a group of nuns and gondoliers in the background. McGillivray applied a formal order that imbues the work with substance combined with brilliant but fleeting effects of light on roughened walls, dark and mysterious doorways, and turbulent water. McGillivray's artistic temperament can be sensed from the way she explored the infectious energy of Venice, revealing its secrets and mysteries, its spirituality, and its blessings. Her method of rendering forms in massed areas of colour applied in places with the palette knife was a first for Canadian art, a technique that was used later by Tom Thomson.

In works such as *Canal, Venice,* McGillivray applied paint so assertively that we may wonder if she was influenced by the paintings of Vincent van Gogh. Throughout her career, she continued this vigorous approach, composing her subjects so that the results have both clarity and weight. McGillivray's paintings often took several years to complete, but her scintillating application of paint gives them an appearance of spontaneity.

Canal, Venice

1917

Oil on panel

13 x 16 inches (33 x 40.6 cm)

Private Collection, Ontario

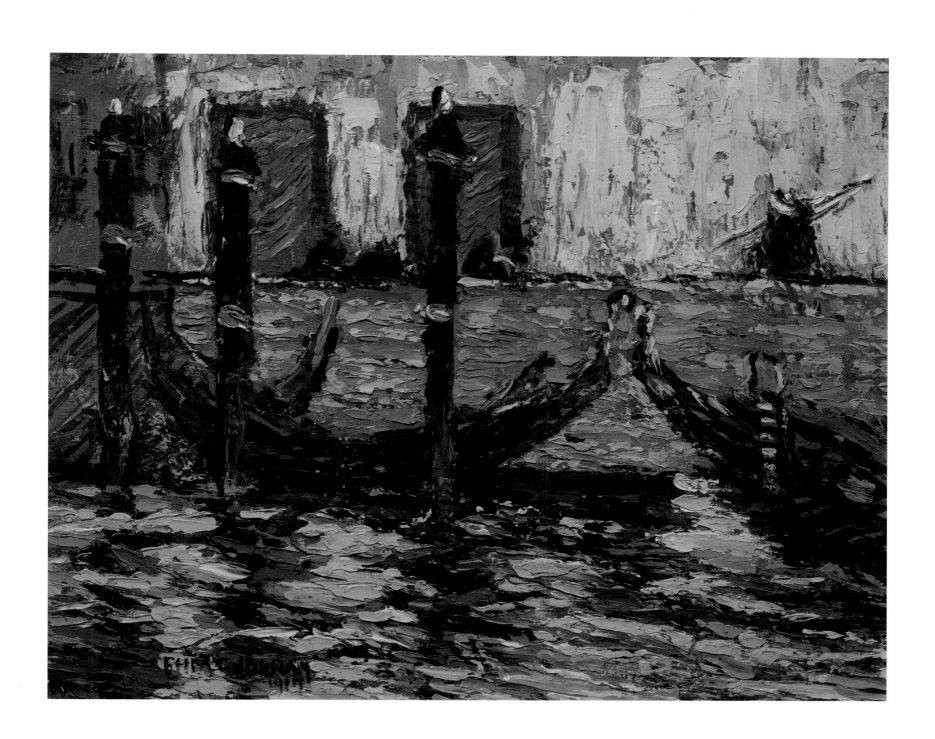

Sophie Pemberton's development as an artist was directed by the maturing influences of life experience. Artists of every period have searched for a balance between their experiences and their means of expression. The two approaches, emotional and formal, arrived on common ground in Pemberton's best portraits painted during her years in Paris. Her work succeeded, in spite of the formal qualities, because her subjects seem reflections of herself. Pemberton astonished her contemporaries and masters with the likeness and ease with which she modelled her figures. She was the first woman to win the coveted Prix Julian in Paris in 1899, and one might infer from such a notable achievement that she was a well-known painter in Canada. However, like so many other Canadian women artists, her achievements have been overlooked.

Nothing is so difficult to capture in painting as the relaxed earthliness of reflected light. In rendering it, the artist is unable to present continuous narrative on canvas and is thus limited to contemplation. *Un livre ouvert* attests to Pemberton's technical skill in dissecting reflected light. Yet this is not a record of her own physical or emotional adventure, but her best conception of portraiture in which classical poise is united with a composite of graceful attitude and serenity of mood. In contrast to the more deliberate and lymphatic images executed after her return home to Victoria, B.C., *Un livre ouvert,* with its intricate weaving of lines and beautiful patterns of folded fabric against a dark background, is Pemberton's masterpiece in portraiture.

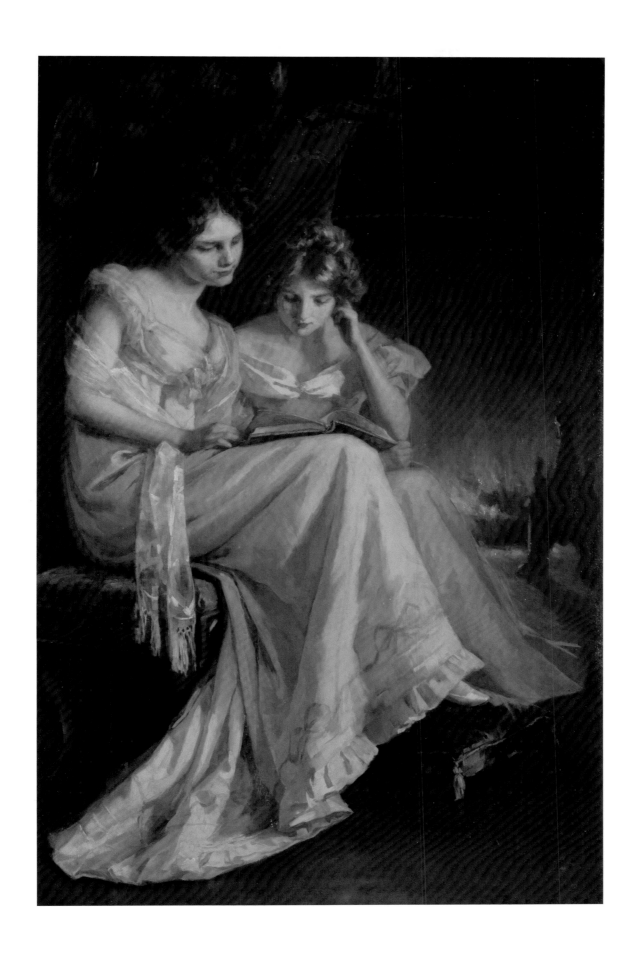

Sophie Pemberton

1869–1959

Sophie Pemberton's work acquired a Pre-Raphaelite consciousness as a result of her early training in England. In particular, she adopted certain romantic elements when painting subjects in an expressive stance. *Woman by the Fire* is an example of such a combined style, with the Victorian mores of the period as its underlying motif.

The attention of the viewer is gained through a studied distribution of reflected light. On the right side of the figure, reflected light illuminates the colours of the dress, and the viewer's eye ascends until it reaches the tenuous clarity of the face. The combination of different grounds of light is common in Pemberton's portraits, producing a visual path through the pictorial space. Though there is fluidity in the dress, the background is structured not only to complement the stance of the figure, but also to break the chromatic monotony of the background on the left. This aesthetic in painting recalls works by such Pre-Raphaelite painters as John Everett Millais and Dante Gabriel Rossetti.

Woman by the Fire

c. 1902

Oil on canvas

38 x 20 inches (96.5 x 50.8 cm)

Private Collection, British Columbia

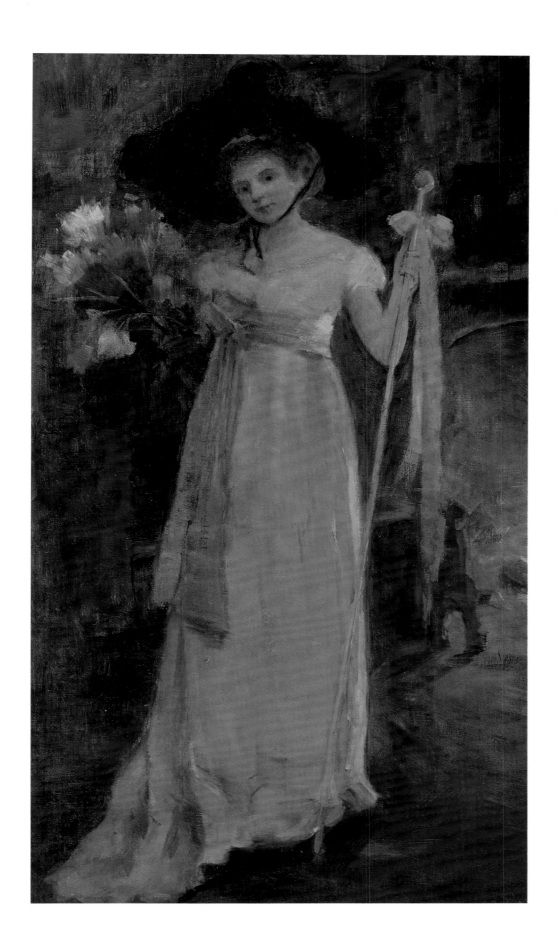

Mary Riter Hamilton

1873–1954

One of the earliest Canadian Impressionists, Mary Riter Hamilton fully absorbed the tenets of the French Impressionists, but not until after her second sojourn in France. Hamilton was an immediate and vibrant painter, yet somewhat inconsistent, with two styles, one before and one after her trip to Paris in 1907. In her work from the earlier years in Europe, her treatment of form is laced with emotional nuance; her style, though en route to modernism, remained entrenched in classicism.

Market Scene, Giverny is a brilliant example of Hamilton's understanding of Impressionism. Painting outdoors, Hamilton overlaid the forms with the vibration of light. To achieve vibration, she used broken brushwork like that of Claude Monet. The subject is framed in an abrupt compositional format suggestive of the paintings by Camille Pissarro of peasant women at work. The central importance of the figures is heightened by the deliberate modelling of solid forms that delineate them from the abstract design of the background. Natural light accentuates the spontaneity with which Hamilton speckled the figures, a characteristic that aligned her with the development of modernism in Canadian art. A private showing of her work in 1949 so impressed Lawren Harris that he organized an exhibition in her honour at the Vancouver Art Gallery.

Market Scene, Giverny

1907

Oil on canvas

15 x 18 inches (38.1 x 45.7 cm)

Private Collection, Paris

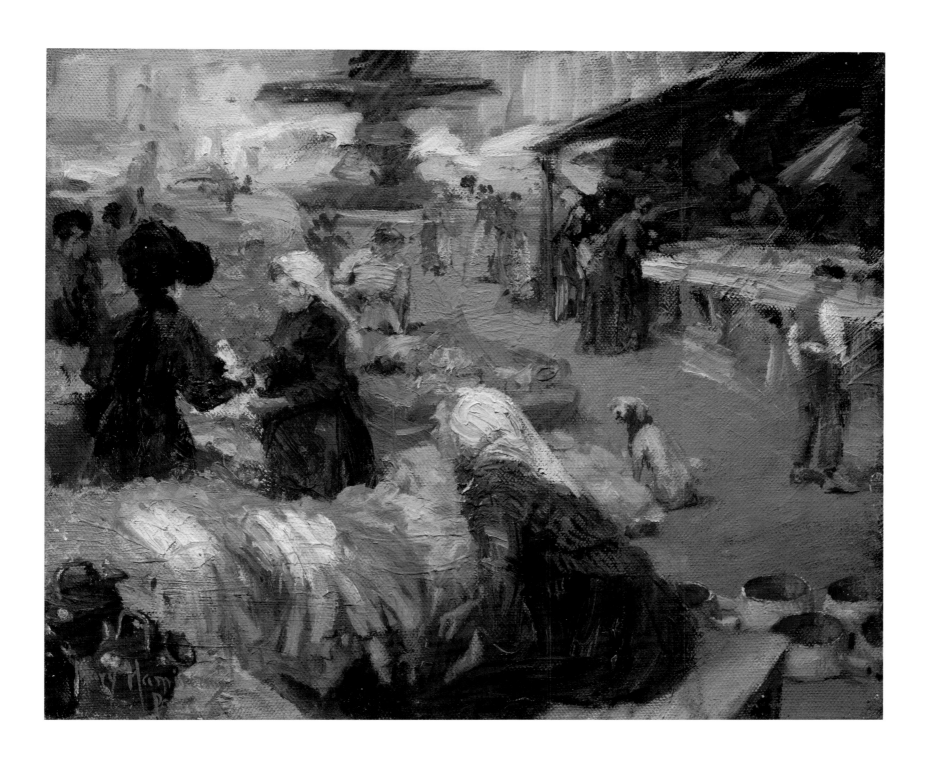

Ethel Seath

1879–1963

Producing work that is soft but resilient, Ethel Seath experimented with bold renderings that challenged the conventions of Victorian art. She worked in two genres: landscape, particularly the Eastern Townships southeast of Montreal, and still life.

Nuns, St. Sulpician Garden is a telling example of Seath's poignant, mature style. In spite of the serene overtones of the landscape, her figures are isolated and masked in sullen gravity. The composition is charged with a finely tempered spiritual quality, a feeling of subdued melancholy that conveys a vein of petulant adulation. Seath herself may not have been robust enough to submit to the burden of monastic life, but she did lead a solitary existence as an artist and teacher withdrawn into her own introspection. These nuns, detached in the cold winter landscape, venturing out of the safety of their home, are but a reflection of the artist's own journey. With the exception of a painting excursion to Nova Scotia in 1948, Seath never ventured outside Quebec, the environment she knew best.

Nuns, St. Sulpician Garden
1930
Oil on panel
16 x 12 inches (40.6 x 30.5 cm)
Private Collection, Ontario

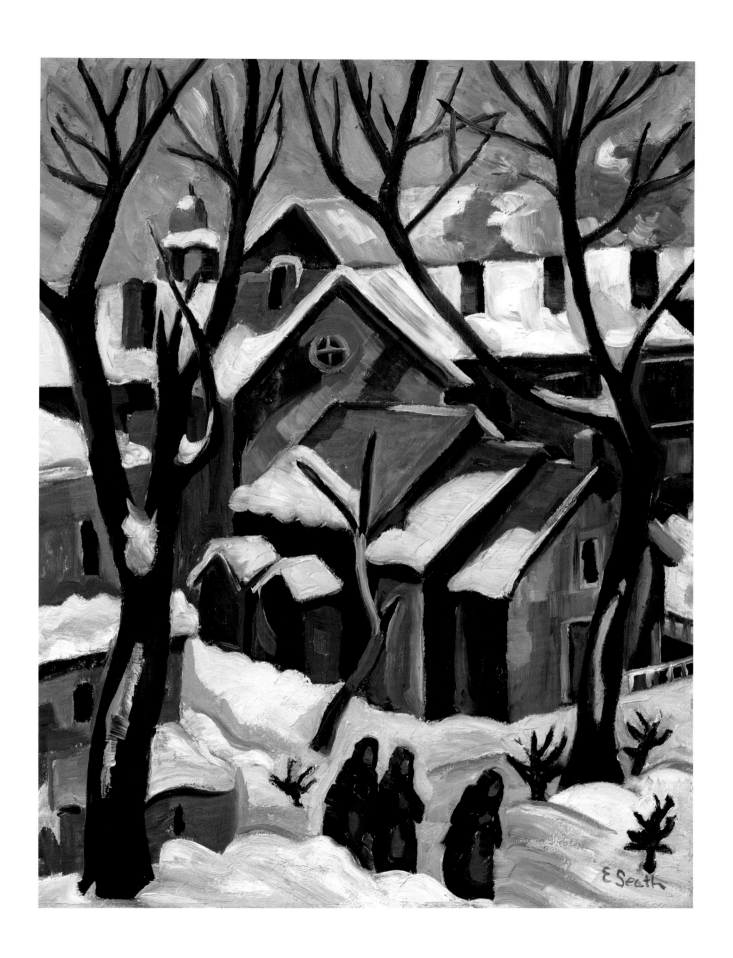

Ethel Seath's art transcends the confines of sentimentality and pathos and she exercised her imagination in painting subjects withdrawn from their environment. Seath inherently understood the principles of arranging elements in a composition – the proportions, placement, empty spaces, and colour. Her art is, therefore, not the work of a traditionalist, but the product of a skill that creates feeling purely from a vision defined – a sensuous vision.

Still-Life with Apples is not about what is painted. Divesting the objects of their proportionate representation, Seath reduces them to simplified geometric planes and angles, thereby infusing them with a combative sensuality. The hidden drama of life is revealed – love, lust, repentance. These symbols of the human story are all within striking distance of mortality. This expertly composed painting, a sumptuous embodiment of all the fullness of the world, is unsurpassed in its power and stands alone as one of the finest still lifes produced in Canada.

Still-Life with Apples,
or *Flower Study*
1934
Oil on canvas
22 x 20 inches (55.9 x 50.8 cm)
Private Collection, Alberta

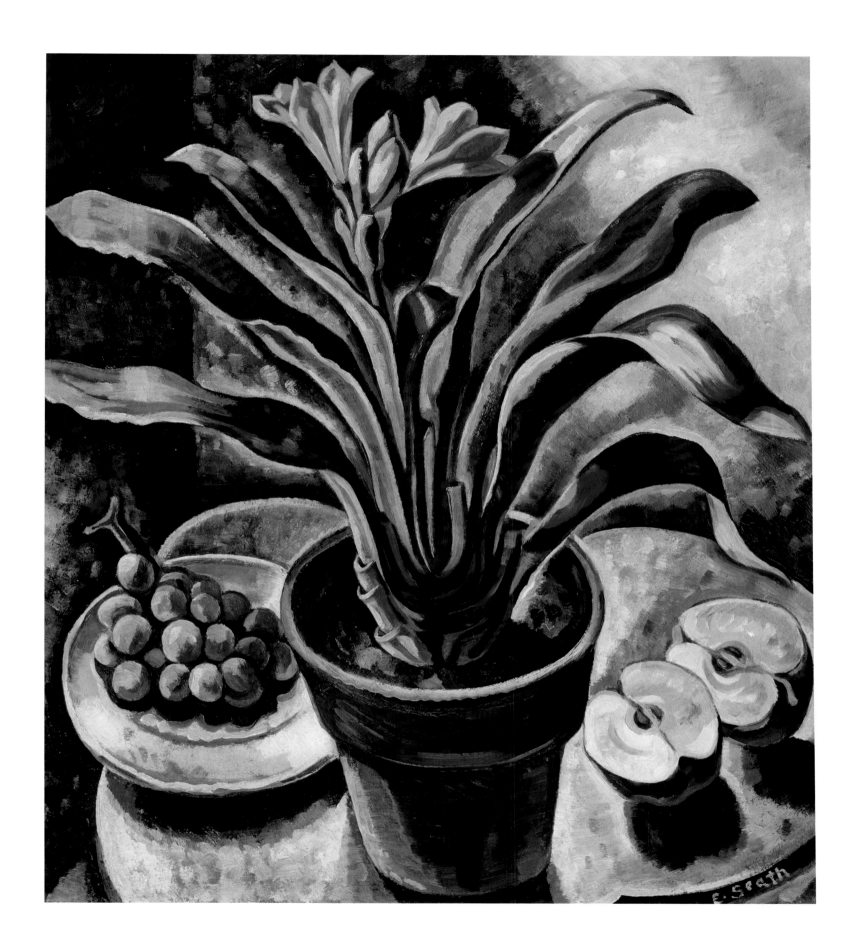

Ethel Seath was essentially an artist with a keen interest in the factual. She lived a secluded life, and that seclusion made a profound impression on her art. Her finest works bring painting down to earth and proclaim the arrival of an artist who faced life on her own terms, and extracted from it an artistic vision.

Quebec Village is a powerful image in Seath's most representative mood – a mood engendered by experiences that taught her that life is neither classical or pretty nor sordid or repellent.

The village scenes that A.Y. Jackson and Clarence Gagnon made famous with nostalgic charm convinced Canadians of the eternal tranquility of the small communities in Quebec. Seath approached them in another vein and revealed a strange, rich bleakness that surrounded them with an atmosphere that speaks of barren living. *Quebec Village* evokes the melancholy of rural Canada and expresses the artist's view of life in the monotonous villages, farm fields, and forlorn vistas of unoccupied land that was Quebec in the early decades of the twentieth century. Her view, although a complete antithesis to that of her male colleagues, was nevertheless essential to a complete understanding of the Canadian reality.

Quebec Village
1948
Oil on panel
16 x 12 inches (40.6 x 30.5 cm)
Private Collection, Alberta

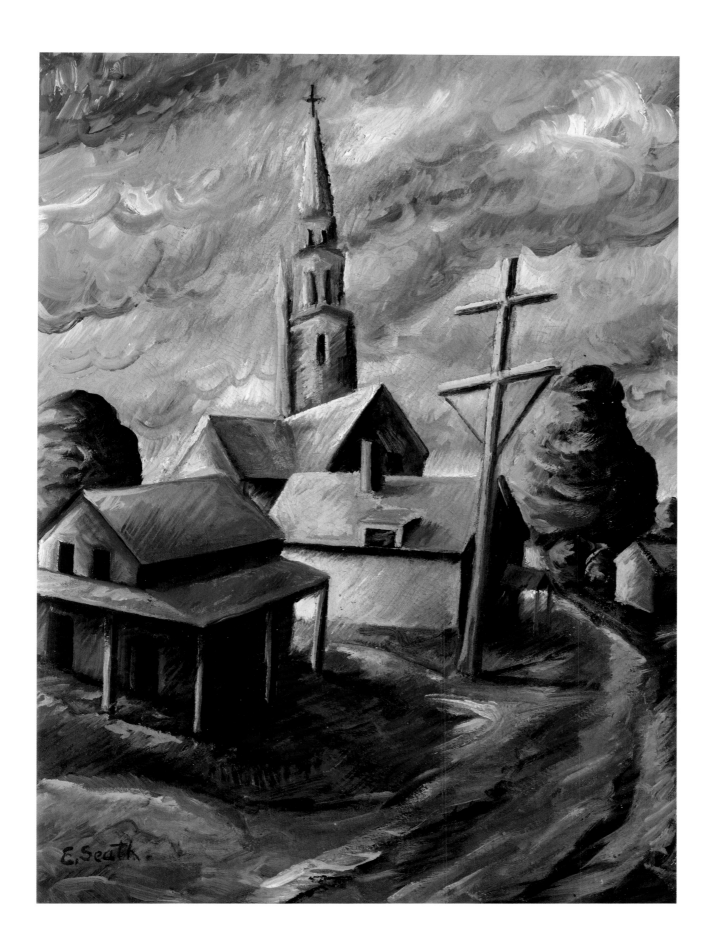

In classical Greece, Plato encouraged sculptors to develop ideal forms beyond the sensory world. In response, sculptors established a canon of proportional relationships to inform their art. These classical proportions, especially in sculpture, were critical in achieving the universal significance we now associate with Greek art and architecture.

Study of a Girl by Florence Wyle combines naturalism in execution with the subtlety of modelling. The idealized figure is shown not in movement, but eternally poised: an essay in equilibrium. Naturalism and idealism are combined through minimal distortion of the figure. That there is only a hint of the sensual quality ascribed to the embodiment of the female form encapsulates the fundamental differences between Canadian sculpture and the seductive female nude reoccurring in European sculpture. Wyle's figure is less provocative. It is a Canadian subject, reticent and shy, much like the artist herself: a character study more than a tactile experience.

Finding her way in Canada, her newly adopted home, Wyle brought the art of sculpture forward from the time of Marc-Aurèle de Foy Suzor-Coté and Alfred Laliberté into the present. The figures in the works of Suzor-Coté and Laliberté were inspired by actual people they knew. Deeply rooted in their environment by the activities they are performing, these figures look to be emerging right out of the ground. At a time when art celebrated humanity's conquering of the land in the newly settled Canada, Wyle's figures, in contrast, have an ethereal quality that needs no background or setting. Her sculptures forge a path towards modernism, lighting the way for the next generation of sculptors such as Leo Mol.

Wyle's work is a unique statement. She brings together all the influences in her life but creates a new language. Yet, as idealism prevails through the distortion of line and modernism seeks its voice, we see more reticence than aggression. Her sculpture conforms to the established values instead of challenging them. She searches for the ideal but still holds back, a manifestation of the social values of Wyle's Canada.

Study of a Girl

c. 1931

Painted plaster

22 [h] x 7 [w] x 7 [d] inches

(55.9 [h] x 17.8 [w] x 17.8 [d] cm)

Private Collection, Ontario

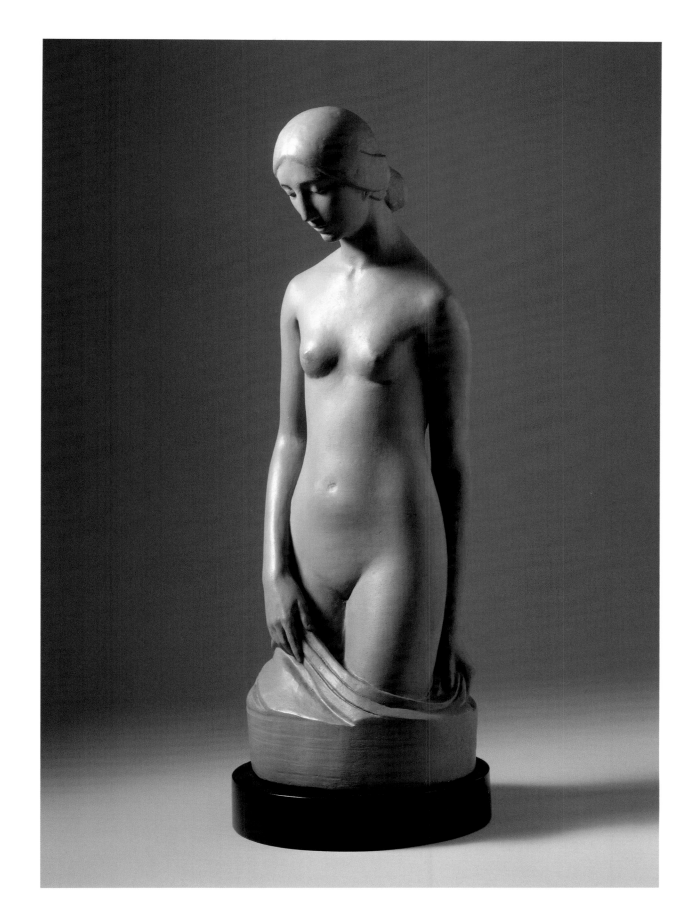

The paintings of Marion Long are characterized by quiet observation and careful technique. She immersed herself in both nature and works of the past, which deepened her spirit and enriched her own creative efforts. As early as 1905, Marion Long had begun to search different areas of Toronto for models and subjects for her work. Her interest in painting in the city intensified further with her training in New York at the Art Students League. She studied with Robert Henri, one of the members of the American Ashcan School, who repudiated academic subject matter and challenged his students to pay attention to the artistic material in the everyday world. Henri's teachings sensitized Long to investigate the phenomena of colour, light, and shadow in defining the atmosphere peculiar to urban street scenes.

Bay Street, Looking South is a characteristic work that reveals the aesthetic feeling Long brought to her art. In this small sketch, she evocatively captures Toronto's Bay Street in the midst of fog. The figures at the left offer a sense of narrative, but one that is as muted and restrained as the colours of the picture. The silhouette of one of the buildings in the distance, obscured but ethereal, recalls a castle in the sky, mystique added to a mundane subject by enveloping it in veils of atmospheric tones. Long said that she found the urban street scene rich in values of light and shadow, personality, colouring, and background, all qualities found here, combined with her powerful ability to convey location.

Bay Street, Looking South

c. 1930
Oil on canvas
10 x 12 inches (25.4 x 30.5 cm)
Private Collection, Ontario

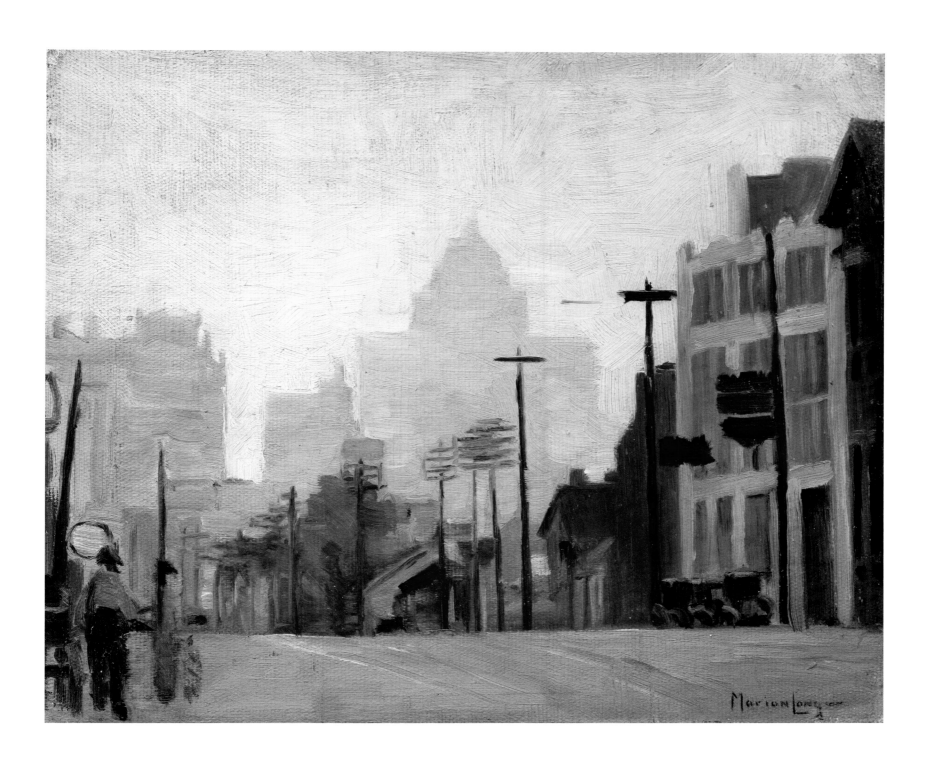

Mabel Lockerby

1882–1976

Art history has neglected the work of Mabel Lockerby. The predominance of interior figurative compositions and the lesser quality of her later work have all contributed to this neglect. But whenever Lockerby ventured to paint out of doors, her work achieved a level comparable to the best of her colleagues of the Beaver Hall Group.

Lockerby's compositions, favouring unorthodox points of view, tend to have a dramatic spatial definition. *On the Canal* displays her preferred bold perspective through the use of abrupt foreshortening. Like most of her friends in the Beaver Hall Group, Lockerby lived most of her life in Montreal and could easily use its activity-filled streets as subject matter. In *On the Canal*, she adopted the everyday imagery embraced by Kathleen Morris. The clear juxtaposition of leisure and labour, readily apparent in the images of the nuns strolling along the street and the cab driver, is similar to the market scenes of Morris. The canal spans the distant horizon revealing Lockerby's emphasis on the linear combined with broken applications of colour. The figures in the foreground, larger in scale and thickly painted, stand in contrast to the houses in the background, which are painted in quick strokes with a barely loaded brush. The line of recession into depth thus achieved suggests the frailty and vulnerability of life forced to endure the damp and freezing winters of Montreal. The rapidity of execution clearly suggests that this work was painted on site.

On the Canal
1926
Oil on panel
9 x 12 inches (22.9 x 30.5 cm)
Private Collection, Ontario

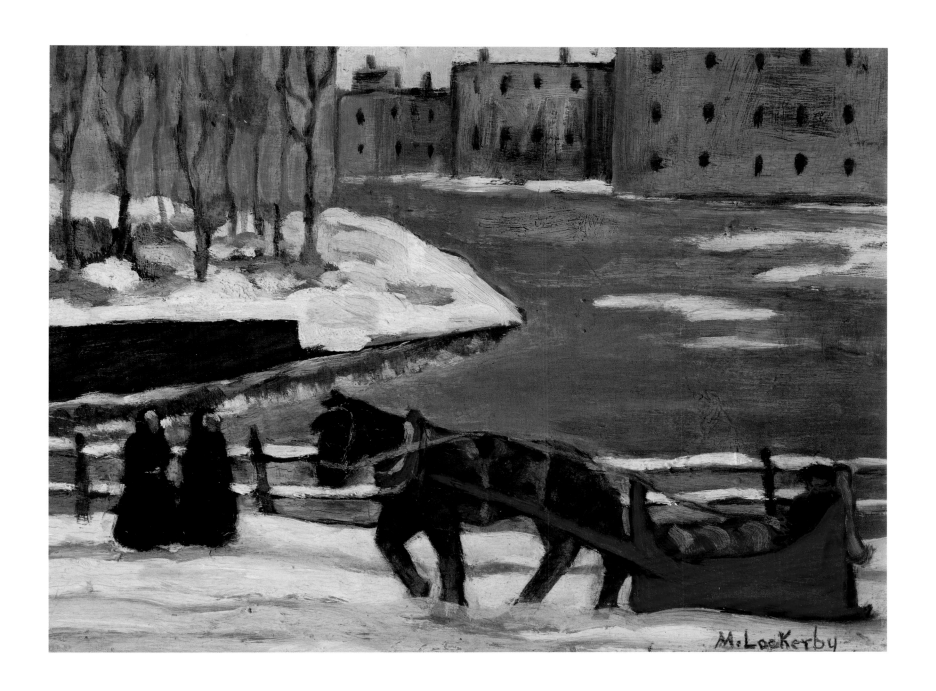

Mabel Lockerby

1882–1976

The totality of Mabel Lockerby's vision and her eye for detail make her paintings almost seem like movie stills. She made optimum use of slowly unfolding action in relatively stable landscape settings, enhancing the intimacy of the scene by a searching scrutiny of natural forms. Lockerby had a special brand of descriptive formalism, abbreviating the world into arrangements of spare images combined with rich colour.

The Haunted Pool, painted in 1947, is a sketch for the canvas of the same title in the collection of the National Gallery of Canada. Only an artist with Lockerby's defiant temperament could have painted this powerful landscape with its controlled vitality and dramatic force. With a few basic lines she bound the landscape into a strong composition. She communicated movement and created a living organism consistent with her own feelings of revolt against conventional taboos – a revolt that she expressed in her personal life through a secret, lifelong relationship with her cousin Ernest McNown. As were her friends in the Beaver Hall Group, she was testing the possibilities of painting, but perhaps more than any of them she expressed her inner agitations in her art, particularly in the animated landscapes of her later years. *The Haunted Pool* is animated by imaginative delight, and the effect is powerfully intense.

The Haunted Pool

c. 1947

Oil on board

12 x 15 inches (30.5 x 38.1 cm)

Private Collection, Alberta

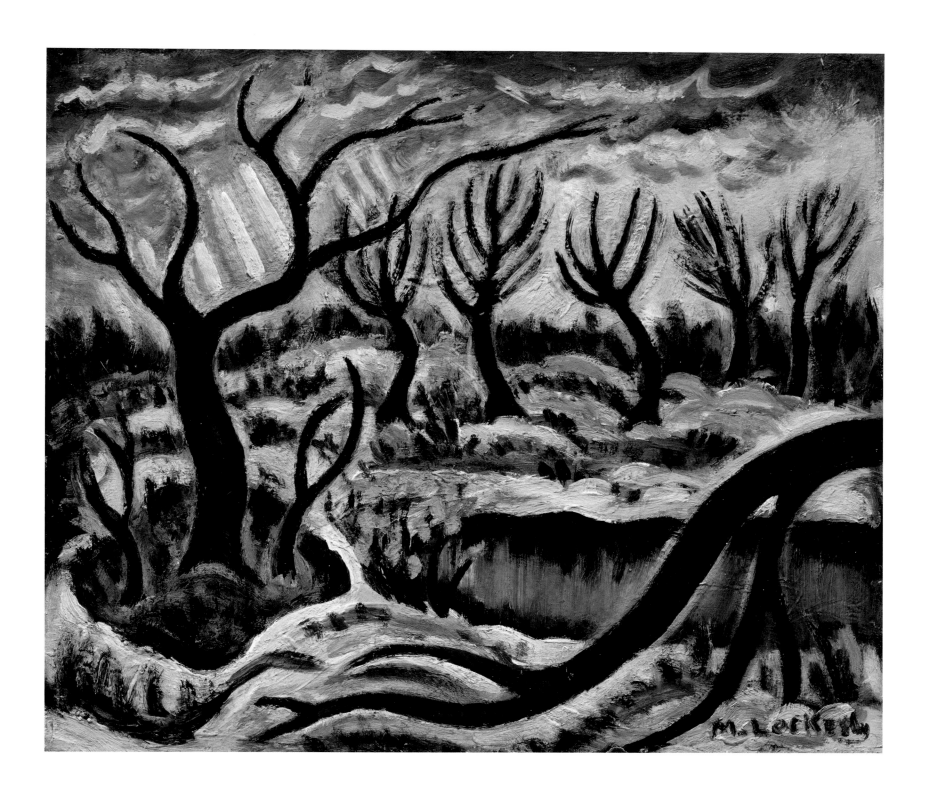

Sarah Robertson

1891–1948

A shy and reticent woman, Sarah Robertson applied her own vision to the same subjects that preoccupied many of her male contemporaries, including A.Y. Jackson and Albert Henry Robinson, among others. It was the vision of a recluse removed from the common experiences of her painting friends – the women of the Beaver Hall Group.

In *The Red Sleigh*, Robertson deals with nothing less than design and is concerned more with the architecture of the composition than with conveying visual information of a passing moment. Robertson is not trying to reproduce life here, rather, she is applying colour to represent the design of the natural world. Like Paul Cézanne, she refused to submit to nature. Instead, she created an image of pictorial logic reminiscent of the work of Lawren Harris that was derived by synthesizing a central vanishing point with utterly authoritative bands of colour in the sky.

This pictorial logic, rhythmic but provocative, reflects Robertson's own anxiety about time running out. There is an autobiographical element to the painting showing an artist seeking to enjoy a full life, not one in which the battle has already been lost and resignation is the only option. The symbolic employment of colour, the simplification of shapes, and the deliberate placement of the incomplete side by side with the complete represent a crucial bond between the painter and the world she perceived. Equally, it is a style that is suited to its message and encompasses the inexpressible – a wish to freeze time forever. Even if the viewer does not fully hear it, *The Red Sleigh* symbolizes one woman's longing to realize a full life that was sadly cut short by death at the age of fifty-seven.

The Red Sleigh
c. 1924
Oil on board
15 x 18 inches (38.1 x 45.7 cm)
Private Collection, Ontario

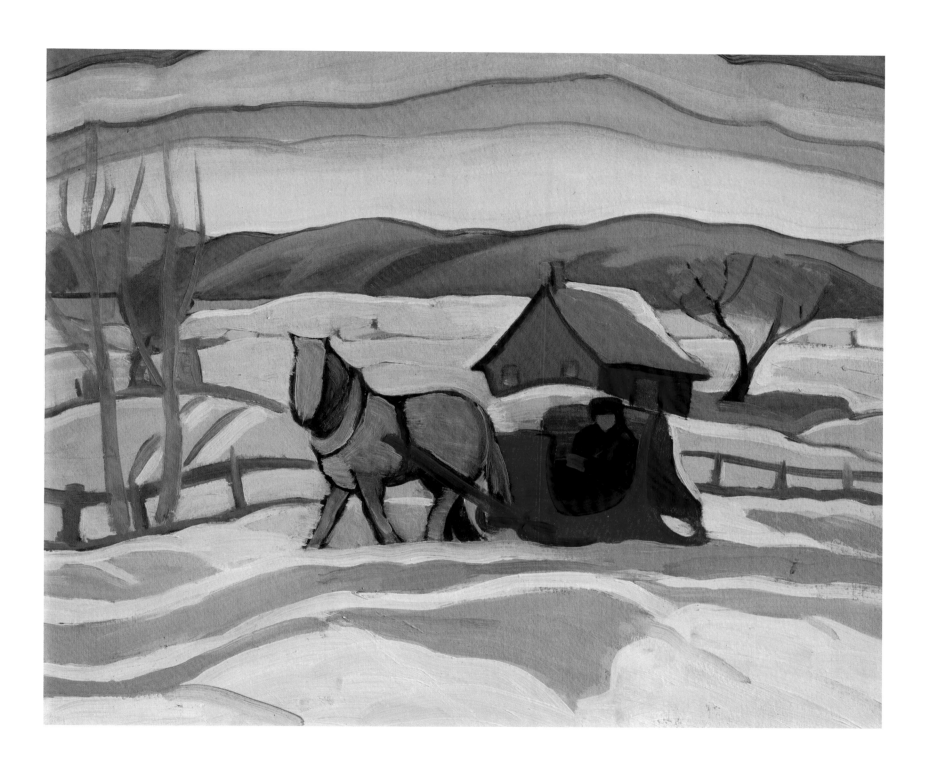

Sarah Robertson
1891–1948

In the variety of her work and her ability to convey the spirit of her vibrant inner life, Sarah Robertson ranks amongst the foremost members of the Montreal school of painters of the 1930s. Her approach transformed scenes of everyday into a visual language centred on form and supported by strong design and elegant colour. It is likely that Robertson was influenced by folk art, but from it she evolved her own scaled-down version of decorative colour and simplified figures.

Mother House, Nuns of the Congregation is a complex painting. For the world at large, it would simply have been a painting of nuns in a garden. For Robertson, it may have embodied homage to the spiritual life that, with its infinite forbearance and sacrifice, was in some ways similar to her own life as an artist.

In the Nun's Garden, the canvas painted from this sketch, was exhibited in 1933 at the Art Gallery of Toronto at the founding exhibition of the Canadian Group of Painters, a group of twenty-eight artists that was a direct outgrowth of the Group of Seven. In the finished painting, Robertson firmed up many details of the panel, transforming the scene into one with rhythmic patterns. She obviously relished a subject that could be painted to look at the same time recognizable and semi-abstract.

Later, A.Y. Jackson recalled that *In the Nun's Garden* caused a stir as both the Art Gallery of Toronto and Hart House, at the University of Toronto, wanted to acquire it for their collections.

Mother House,
Nuns of the Congregation
c. 1932
Oil on panel
10 x 12 inches (25.4 x 30.5 cm)
Private Collection, Ontario

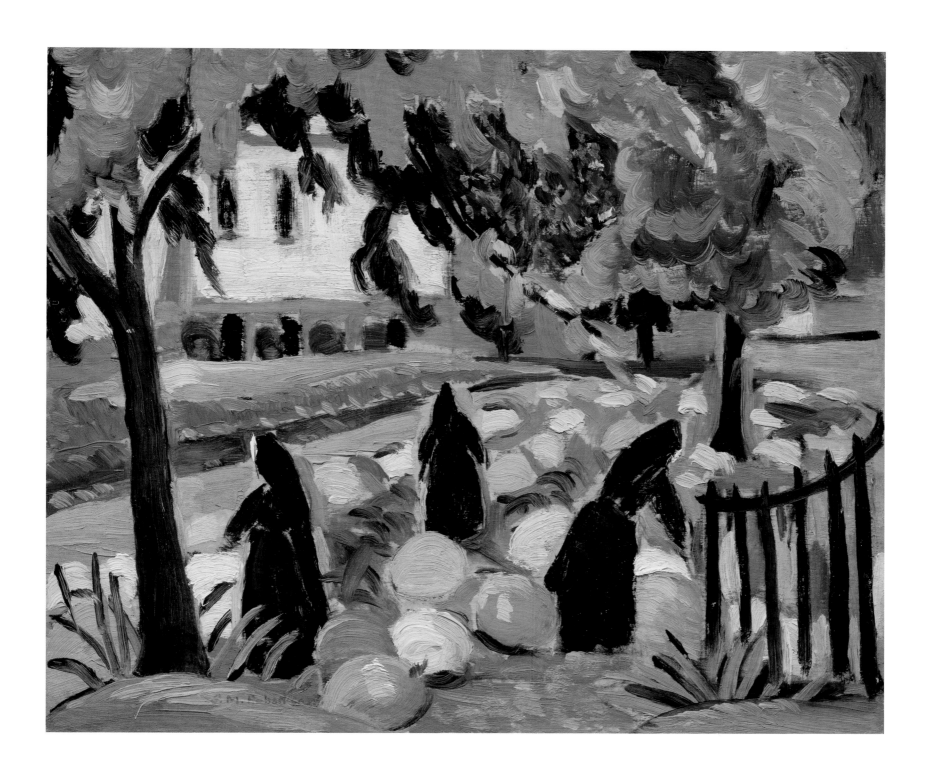

In *The Game*, Rody Kenny Courtice used her imagination to make a political comment on the Cold War and sound a note of unease. This is her vision of the world, inspired by her insight into the actualities of the geopolitical troubles of her age that absorbed her in later life. Having already lived through two world wars, Courtice, a pacifist in the late 1940s, must have felt the need to express her dissatisfaction in her art.

Courtice inflated the scale of some of the chess pieces, particularly the knights, to suggest the opposing factions. On the chessboard near the large red knight, she displayed the USSR's sickle; the black knight to the right symbolizes the West. The red knight has a smug, self-satisfied look, while the black knight is all readiness, its mouth open as if to speak.

Clearly, Courtice was familiar with Cubism and Surrealism but combined that knowledge with her own individual form of representation. The asymmetrical arrangement of the figures and the seriousness of their expressions create a unique composition and a striking statement about the world in which the reckless human comedy is still played out.

The Game

c. 1949

Oil on canvas

18½ x 20 inches (47 x 50.8 cm)

The Robert McLaughlin Gallery, Oshawa

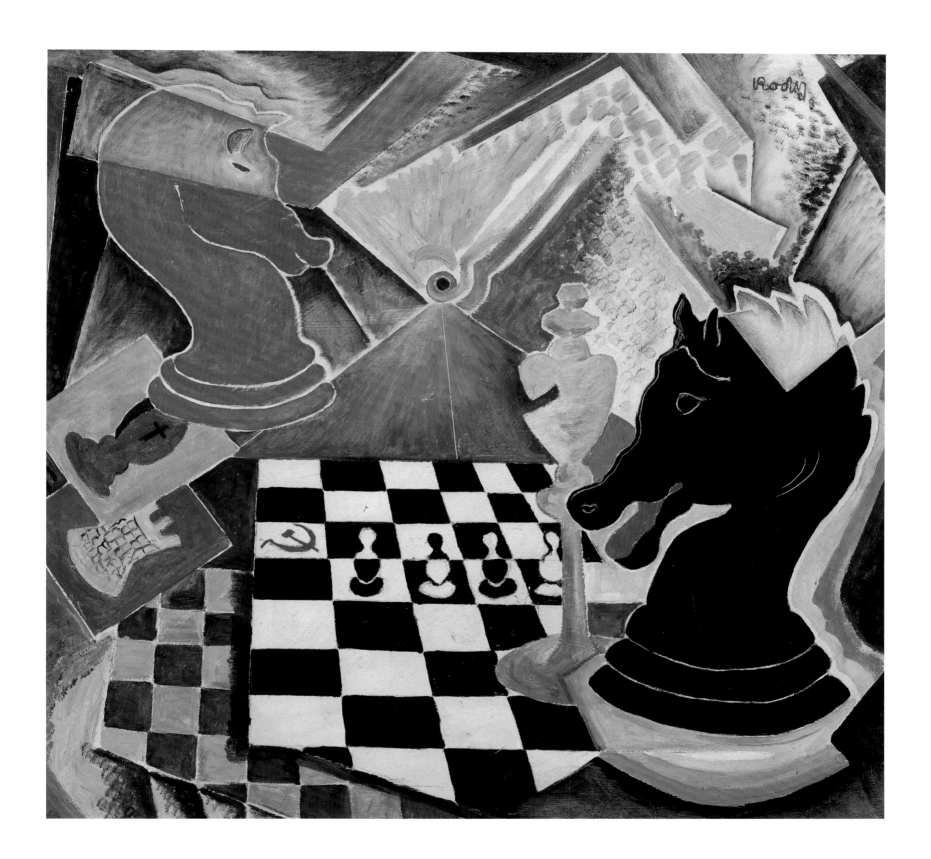

Kathleen Moir Morris

1893–1986

Kathleen Moir Morris recorded the colourful everyday life of Quebec in her paintings. Using strong compositions and a powerful brush stroke, she was able to transform visible experience into a living art form. *Sunday Service, Berthierville* is a bravura painting that delights the viewer by its economy of means, its masterful execution, and its authenticity.

The scene seems frozen in time: the patient sleigh-horses waiting for the villagers who are celebrating Mass; the massive church signalling the dominance of religion in village life. Only the bright colours of the horses' blankets enliven the composition.

Disabled from birth, Morris overcame obstacles that might have prevented others less courageous from even picking up a paintbrush. She painted outdoors in all seasons and went on sketching trips in summer and winter. In fact, she considered herself a "winter painter."

Morris's passion for life and love for her subject matter enlivened her work; the street scenes she celebrated conveyed the *joie de vivre* that prevailed in the seemingly mundane world of small-town Quebec in the early twentieth century. Kathleen Morris held up a mirror to Canada, and presented the country with her vision, finding quiet joy in life wherever she looked.

Sunday Service, Berthierville
1924
Oil on canvas
14 x 18 inches (35.5 x 45.7 cm)
Private Collection, Colorado

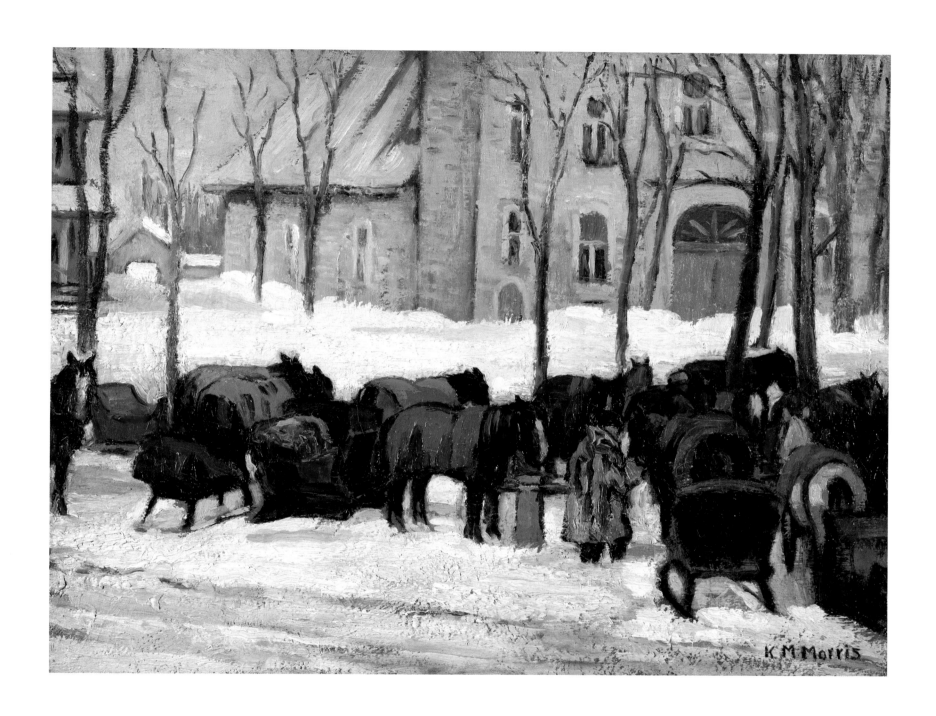

Kathleen Moir Morris

1893–1986

Kathleen Morris's place in the history of Canadian art has never been more secure than at the present. Time itself has rendered her art symbolic of "Canada of old." Each painting is a window on the past, offering visions of pioneer fortitude to modern generations seeking inspiration and a refuge from the present. Romantic overtones do not detract from the gleaming intensity of Morris's convictions – she immortalizes her experience through the imagination of a poet.

McGill Cab Stand is painted with an infallible sense of placement and originality of design. The image is bathed in an atmospheric lustre that is not denatured by a classical formula or falsified by romantic colouring. This scene is satisfying in every respect because of its objective truth – fragile as the artist who created it and indestructible as the poetry within it.

Morris's artistic inspiration came from the street scenes of Montreal and Ottawa and small-town Quebec. Within these scenes, she also portrayed the timeless companionship shared between humanity and the horse. Animals stirred her compassion and she painted them regularly and with increased simplification over time.

Morris was a rightful member of an aesthetic coterie including amongst its leaders James Wilson Morrice and Maurice Cullen. She astonished her colleagues of the Beaver Hall Group with the magical quality of her images, although her work seemed to lose its edge after the 1920s.

McGill Cab Stand is a vision of Morris's world with images pondered over and infused with substance by the nervous hand of a painter telling a story. It is an invitation, expressed in synchronized harmonies of colour, to a world frozen in time.

McGill Cab Stand
c. 1927
Oil on canvas
18 x 24 inches (45.7 x 61 cm)
Private Collection, Alberta

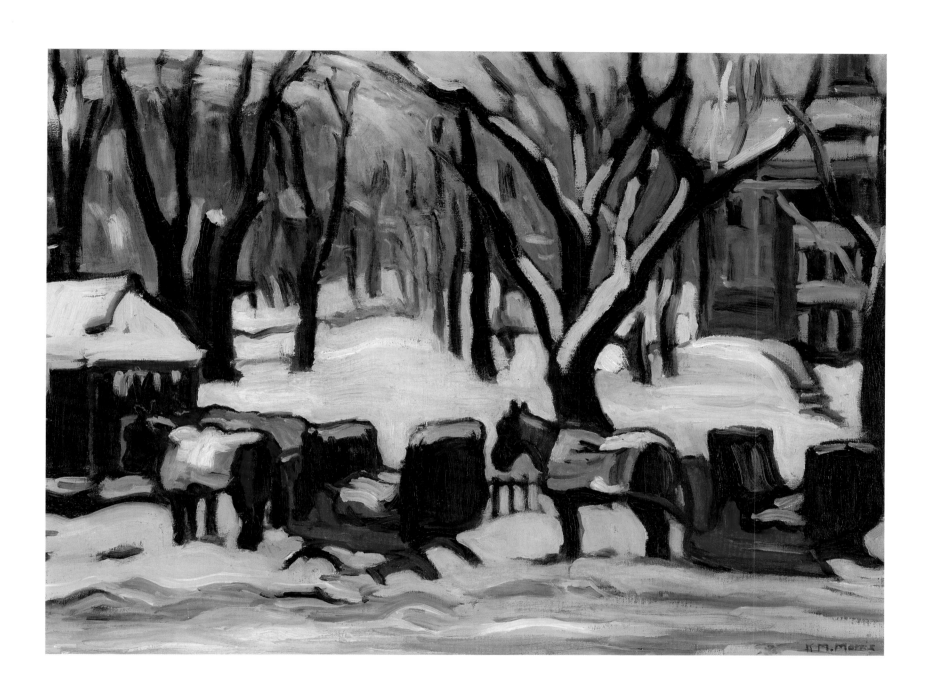

Anne Savage

1896–1971

A.Y. Jackson may have encouraged Anne Savage to join the trip organized by Marius Barbeau in 1927 to the First Nations peoples on the Skeena River in British Columbia. Savage was accompanied by painter Pegi Nicol MacLeod and sculptor Florence Wyle. The three women would have considered the trip a vital adventure, and they took the opportunity to record a new world of people and landscape. That they undertook the trip at all underscores their commitment to the development of a new art for the twentieth century.

In contrast to Emily Carr, who emphasized the spirituality of the forests of British Columbia, Savage created work that looks solid and sculptural with the lines of the land sharply defined. The influence of the Group of Seven may have led her to be bold and abrupt in her handling of paint. Works such as *Paradise Lost* retain their freshness over time. They convey Savage's finest moments of inspiration and suggest that she was an artist transfixed by the process of looking and transcribing. In her later work, when she was absorbed in her position as a full-time teacher, she became somewhat repetitive, if not derivative of the Group of Seven.

In *The Downfall of Temlaham* (1928), Marius Barbeau wrote that the scene for the canvas Savage developed from this sketch was from a site on the Upper Skeena River near Hazelton, British Columbia. He described the place as part of an Indian legend, "Paradise Lost, where the Indian Golden Age came to an end and the people were scattered around the country to gain a livelihood."

Paradise Lost
1927
Oil on panel
9 x 12 inches (22.9 x 30.5 cm)
Private Collection, Ontario

Anne Savage's work can be placed in the gap between representation and the modernist vision of the Group of Seven. *Owl Totem, Kispiax*, developed from one of her on-site sketches of the Skeena River country, is proof that the trip she took there in 1927 provided her with a rich vein of poetic inspiration. The painting is a scaled-up image of a scene Savage saw in Kispiox (today's spelling of the name Kispiax), a prosperous Gitxsan village, like a native Garden of Eden, located on the banks of the Upper Skeena in Northwest British Columbia.

Savage had been invited on the trip by ethnologist Marius Barbeau to record the totem poles of the First Nations people and we can see in the painting the care Savage took to create an accurate record. The works she produced from her trip were displayed, along with the work of other "moderns" such as Emily Carr, as part of the 1927 exhibition *Canadian West Coast Art, Native and Modern* at the National Gallery of Canada in Ottawa.

Savage may not have advanced beyond the threshold established by Carr, who had also painted in Kispiox in 1912, but she certainly contributed to Canadian art a symbolic portrayal of the blissful existence of the native people in the area.

Her career inscribes an arc from works such as this canvas to the paintings she created at Lake Wonish in the Laurentians. This earlier work is surprising in its variety: smart and adventurous Fauvist colour, drama, and the appearance of fascinating people and scenes. Her interest later shifted to the effects of light in a peaceful landscape setting and she repeatedly offered tributes in paint to the countryside of Lake Wonish, her chosen "painting place."

It is time for a new look at Savage's work. Paintings such as *Owl Totem, Kispiax*, *Paradise Lost*, and *Quebec Village* affirm the significance of the place Anne Savage invented for herself in twentieth-century Canadian art.

Owl Totem, Kispiax

1927

Oil on canvas

23¼ x 28¼ inches (59.1 x 71.8 cm)

Private Collection, British Columbia

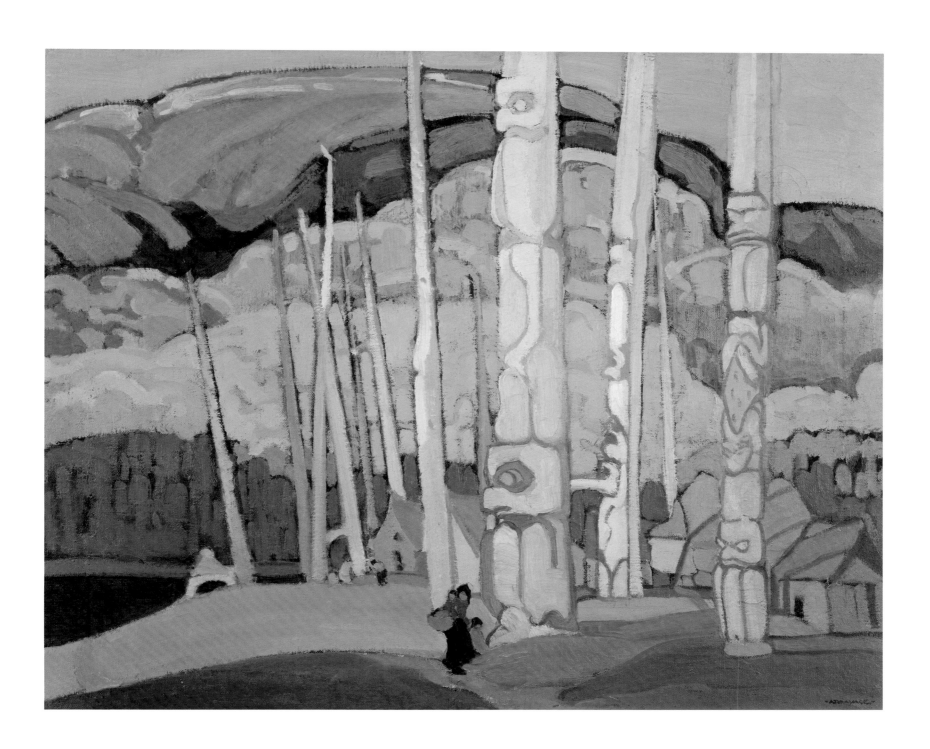

Anne Savage
1896–1971

It is difficult to speak of Anne Savage, a member of the Beaver Hall Group, without thinking of A.Y. Jackson, a member of the Group of Seven. Both gave themselves to painting as if sacrificing their lives to a faith. Jackson did it with the detachment of a loner buried in the solitude of his own convictions, working feverishly but living humbly in spite of the formidable recognition he was to achieve. Savage did it with the resolve of a soldier who calls upon fresh resources after each new battle. Painting became her only mission in life, and her determination helped her through difficult times without falling into despair. These two artists, kindred souls, prototypes of the "possessed painter," and connected by faith, let nothing of the emotional and moral turmoil that assailed them appear in their art. Jackson, in his restlessness and impetuosity, imposed rhythmic distortions on nature, and Savage, learning from Jackson, but not content with submission, introduced extra-pictorial features into her painting. At every stage of her career, Savage painted landscape. The landscapes she did in 1927 on her first journey west in the company of Marius Barbeau are particularly notable for the deftness of the brushwork and use of sensuous colours.

In the middle period of her career, from the 1930s to the 1940s, Savage made her greatest contribution to Canadian art, combining strong design and restrained colour into powerful symbols of the land. One of Savage's indisputable masterpieces, *Quebec Farm* preserves the spontaneous quality of a sketch. We sense the fleeting moment, life in the open air. Space is suggested less by perspective than by colour. A sort of melancholy rises above the mundane rural landscape with the urgency of a lyrical appeal.

Quebec Farm
1935
Oil on canvas
25 x 30 inches (63.5 x 76.2 cm)
Private Collection, Quebec

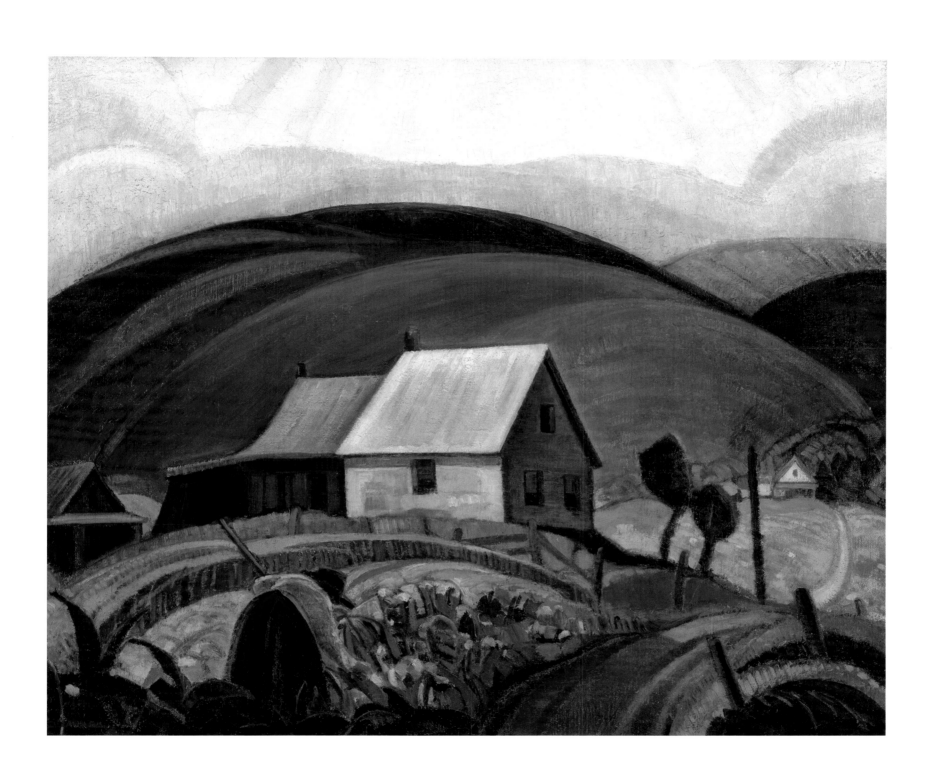

Self-Portrait earned Lilias Torrance Newton a place in Canadian art history that has not been sufficiently acknowledged. The human body is a central theme in Newton's work, and her formal portraits, of sitters elaborately clad or casually dressed, nude or semi-nude, reflect her personal interest in painting the body as a symbol of human aspiration. This aspect of portraiture was popular with female painters during the inter-war years, but came to an end with the advance of technology and the progress towards greater gender equality.

Self-Portrait is painted to show the artist as a self-sufficient woman: independent, modern, and urbane. The sophisticated air and studied gesture speak of her freedom from the conventions of society. Self-confidence radiates from her gaze; her chosen profession is her destiny. Artists often represented their engagement with the modern in art by reference to the symbols of the post-industrial world, characterized as novelty, movement, and colour. In these terms, the colourful stripes of Newton's blouse serve as an emblem of her modernity.

In *Self-Portrait*, Newton has constructed a pictorial figure from symbolic, tailor-made forms. Such a skilful transfer of form into content catapulted Newton into the mainstream of modernism. This composition is a showcase of the artistic strategies that made Newton one of the most successful portrait painters in Canada when many of her contemporaries were struggling to survive.

Self-Portrait

c. 1929

Oil on canvas

24 ¼ x 30 inches (61.5 x 76.6 cm)

National Gallery of Canada,

Ottawa

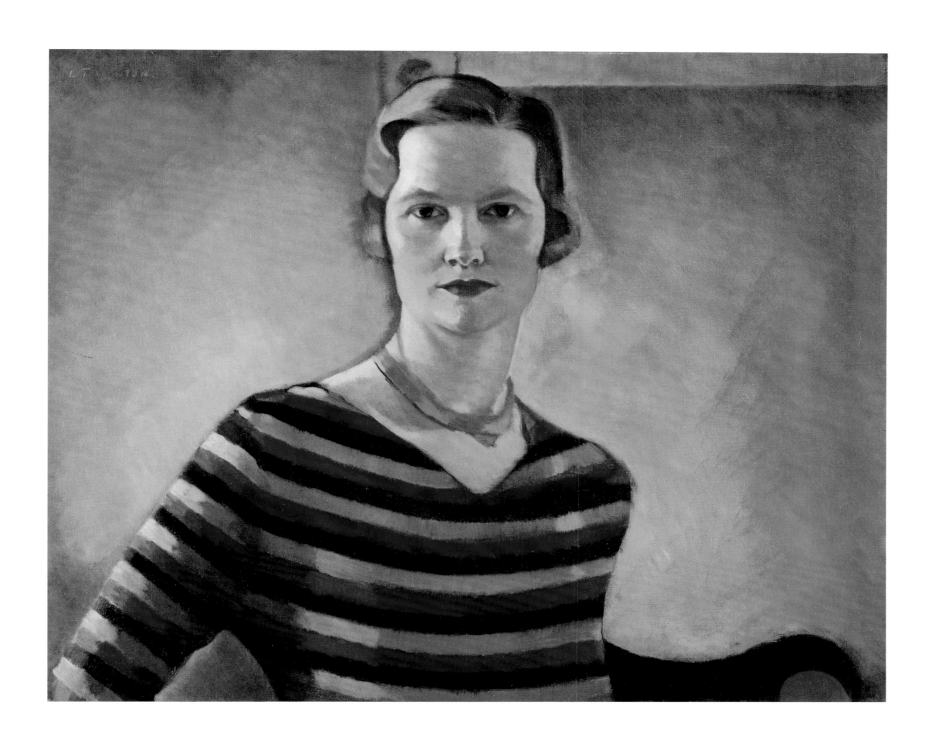

Lilias Torrance Newton

1896–1980

In Lilias Torrance Newton's self-portraits, we are told the story of a woman who sacrificed her marriage in pursuit of her art but gained ineffable comfort in the conquest of her dreams. Her self-portraits reveal how self-restraint reflects the various moods and passions of a human being.

Nude in the Studio shows us a woman, a Russian model, with a mature imagination gained as a result of her tribulations and self-discipline. The painting is a revelation of a character that stands like a rock before the world: physically naked, but emotionally uncontaminated. Newton worked on it with resolve, pushing its shock value further and further. By laying her soul bare with the strokes of her brush, she created a Venetian mask through coloured pigment and defied a world she wouldn't let defeat her.

Nude in the Studio is a statement of Newton's feelings, or, more exactly, the idolatrous confidence induced in her by her profession. It is among the few nudes in Canadian art whose meaning extends beyond its subject. More than studio exhibitionism, Newton created a symbol out of the naked body – a symbol of her delight in living her life as an artist. When the painting was first shown in 1935, the woman's nudity was judged "offensive" because of her fashionable green shoes. A classic nude would have proven acceptable; it is the immediacy of this modern woman that critics could not countenance.

Nude in the Studio
(undated)
Oil on canvas
80 x 36 inches (203.2 x 91.5 cm)
Art Gallery of Ontario, Toronto
The Thomson Collection

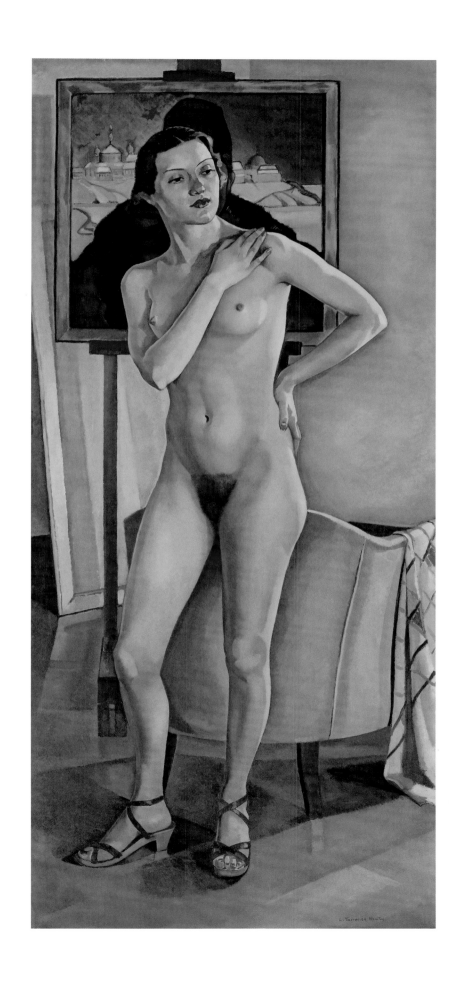

Regina Seiden

1897–1991

Regina Seiden was one of the earliest female Canadian painters to turn her attention to symbolism. *Children with Nuns* proves that it is not subjects to be painted that are lacking, but eyes to see them.

In this work, Seiden left the foreground empty while placing the figures upstage, the colourful dresses of the children providing contrast to the grey tonality of the background. The ceremonious procession of children being taken for daily instruction to the convent evokes the harmony and peace found in the Garden of Eden. Seiden heightened certain aspects of this symbolism, imbuing this veritable jewel of a painting with a meditative air. The children, the continuation of humanity, seem to rise like flowers from the earth. The nurture and protection afforded them by the nuns, their gardeners, complete their connection with nature. Nature is represented here not by a flux of colour, but rather by the opalescent shift of light abstractly brushed outside the gates of the convent.

In *Children with Nuns*, Seiden's approach allows meaning to emerge from the abstract treatment of the subject, and one experiences her emotion in the presence of the scene. The viewer feels a symbolist painter's synthesis with the emergence of the essence of inner life.

Children with Nuns

c. 1920

Oil on canvas

21¼ x 29½ inches (54 x 75 cm)

Private Collection, Alberta

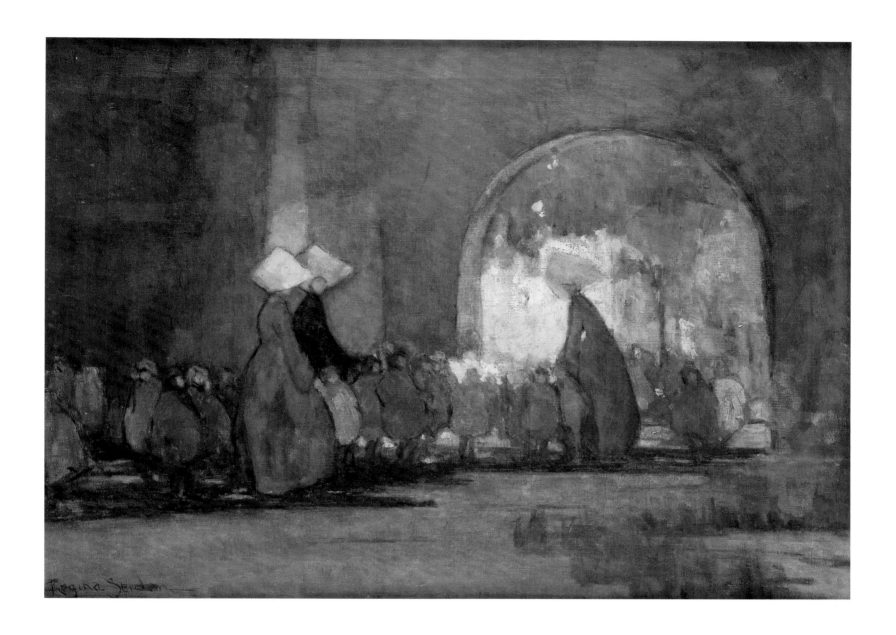

Paraskeva Clark

1898–1986

Throughout her career, Paraskeva Clark devoted herself to portrait painting. In the portraits from her earlier years, she revealed a singular power to acutely analyze human individuality and showed a strong, if somewhat cold and unsympathetic, objectivity. She chose her subjects from the world she knew and understood, idealizing her forms but preserving, specifically, the characteristics of figure and costume much in the tradition of French portraiture of the early twentieth century.

To this early period belongs the coldly serene and admirably true *Myself*, full of individuality and unapologetically revealing the subject. Painted with a freedom, and even looseness, of touch, the personality is characterized, while at the same time the artist gives equal prominence to the decorative effect.

In the work of her later years, Clark's point of view shifted. She aimed to explore new problems of colour and decorative effect in pictorial arrangements, seemingly under the influence of Paul Cézanne. His influence was detrimental to her earlier vigorous expression. Withdrawn from the harsh, competitive struggles of her contemporaries, Clark settled into domestic life and the painting of inanimate objects. Yet the facility of her artistic vision still places her amongst the accomplished painters of her time.

Myself
1933
Oil on canvas
40 x 30 inches (101.6 x 76.2 cm)
National Gallery of Canada,
Ottawa

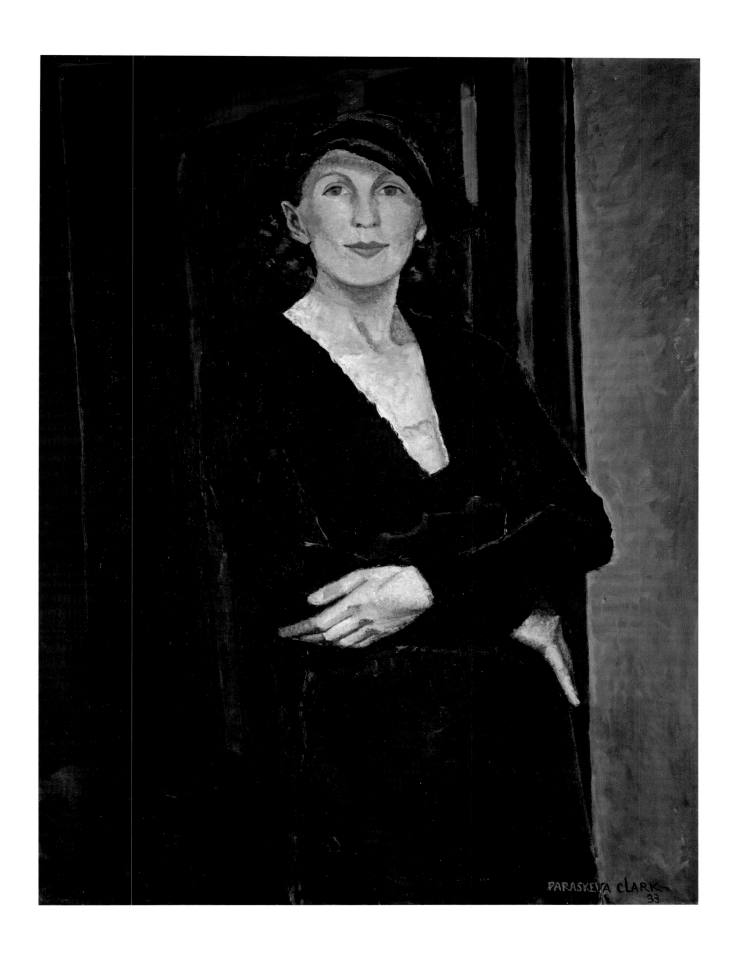

Kathleen Daly
1898–1994

Travelling to the remote communities of Canada, Kathleen Daly painted many portraits of Inuit and First Nations children. Unafraid to portray her subjects as she found them in their sometimes unflattering surroundings, her work was not always complimentary.

Indian Playmates is a portrait that records the psychological relationship between the painter and the subject. The deliberately "squirmy" paint handling, accented with raw hues, combines with the awkward poses of the children to reinforce their confrontational stare. Their provocative pose speaks directly to their being ill at ease, if not their predicament. Theirs is the story of a shameful and unresolved tragedy in the history of North America.

It is not, however, her subject matter that compels admiration, but the emotion aroused by the meditation on the subject. In its own sphere, her art is without sentimentality and fanciful artifice and has the force of a living representation. Her work was long overshadowed by the dominant male painters of her time, including her husband, George Pepper, with whom she shared a studio space at the Studio Building in Toronto. With the resurgence of interest in the art of women, her work has, deservedly, begun to gain attention.

Indian Playmates
c. 1938
Oil on canvas
30 x 25 inches (76.2 x 63.5) cm
Private Collection, Alberta

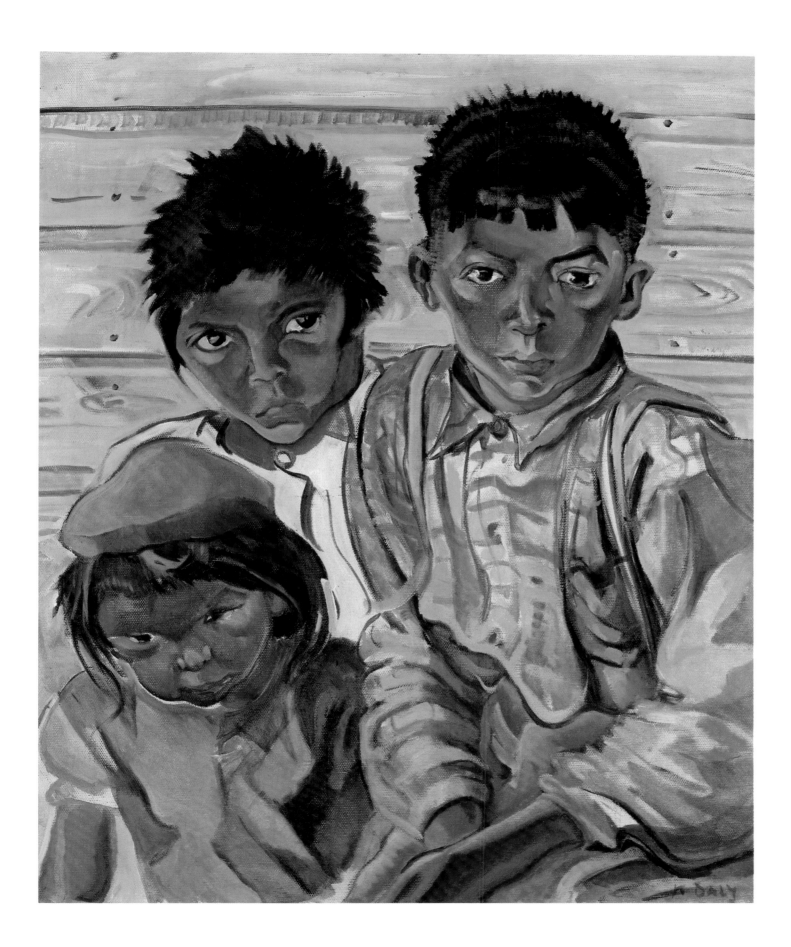

Yvonne McKague Housser

1898–1996

Although Yvonne Housser never became a professional portrait painter, she did paint many images of friends and acquaintances. *Sisters* is an example of her sensitivity to pose and the subtleties of facial expression. While the identity of the sitters is not known, in all likelihood, the title of the work aside, the traditional typology of the double portrait suggests they were sisters.

Housser has painted the two girls in a style popular in the 1930s that captures children and women whose ambiguous sensuality fuses innocence and modesty. What is unique about the composition is the languorous softness resulting from a restricted palette of reds and blues. Refraining from the influences of the Impressionists in Claude Monet's circle who favoured bright colours, Housser has chosen the darker tonalities used by Édouard Manet combined with the contrast of hot and cold. The asymmetrical arrangement of the figures, the spatial progression, and the seriousness of their expressions make a striking statement about the often overlooked joys and anxieties of childhood.

Sisters

c. 1934

Oil on canvas

30 x 24 inches (76.2 x 61 cm)

Private Collection, Alberta

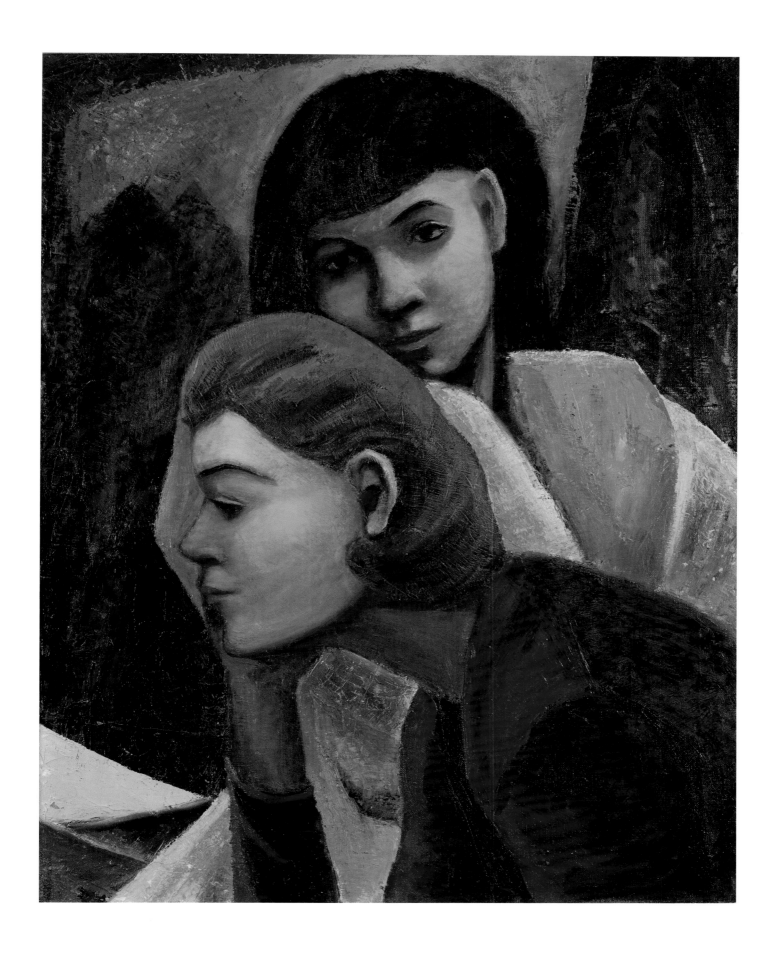

Yvonne McKague Housser often painted lichen and mosses on rocks; the exquisite beauty of their colour and pattern delighted her and provided a good example of design close to hand. From early in her career, she had been aware of the exciting work of Georgia O'Keeffe, and found her romantic, naturalistic art intensely sympathetic. Housser was fascinated by O'Keeffe's new way of seeing and the way she created semi-abstractions by painting enlarged flowers and plants. On a trip to New York in 1946, Housser spent many hours at an O'Keeffe exhibition at the Museum of Modern Art.

Housser had always been reticent about revealing much of herself in her art, but due to O'Keeffe's influence, feeling and intuition became part of her aesthetic strategy and she began to experiment with abstraction, alternating it with realism. Late in the 1940s, she taught in Oshawa at the studio of painter Alexandra Luke, with whom she had been friendly for years. In 1949 Luke gave her the book *Search for the Real*, published in 1948 by Hans Hofmann, the most influential teacher of abstract art of the day. Housser read it with great interest, and in 1952 and 1956, she and Luke went to Provincetown to study with Hofmann. Subsequently she produced decorative paintings such as *Spring Pattern*, of trilliums, tree stumps, and ferns on the forest floor that unmistakably reveal her development into an abstract artist.

Spring Pattern

1955

Oil on masonite

30 x 40 inches (76.2 x 101.6 cm)

The Robert McLaughlin Gallery,

Oshawa

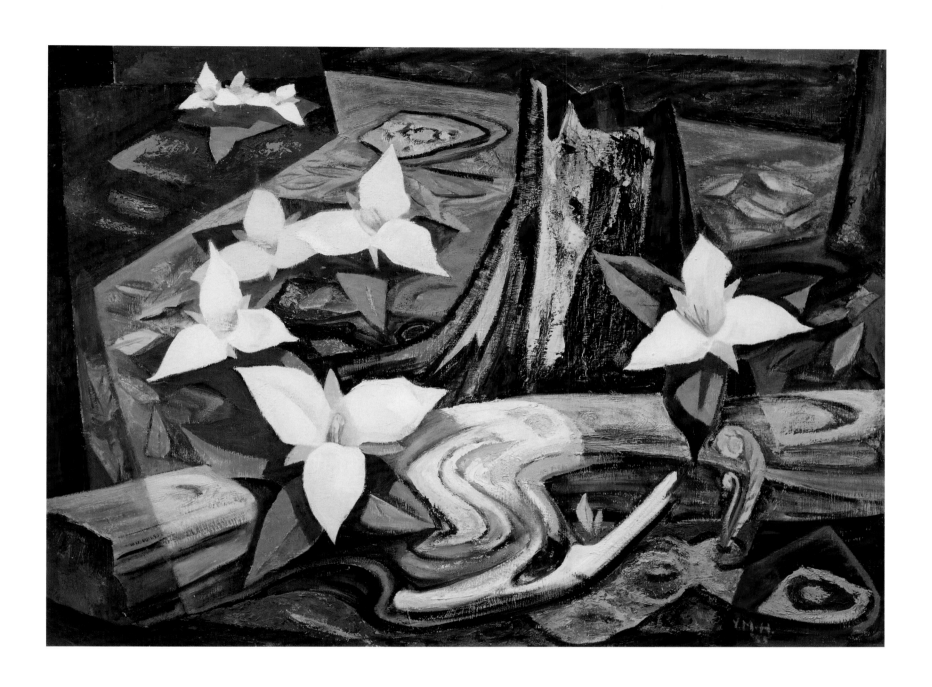

Elizabeth Wyn Wood
1903–1966

Working at the Art Students League in New York in 1926, Elizabeth Wyn Wood became fascinated with the sculpture of Constantin Brancusi. She had also seen Brancusi's work at New York's Brummer Gallery and at the International Exhibition of Modern Art from the collection of Société Anonyme at the Brooklyn Museum in 1927. This significant exhibition also included Wassily Kandinsky and Pablo Picasso, along with other leading modernists of the twentieth century. Lawren Harris brought the show to Toronto later that year, believing that it was the most stimulating exhibition of advanced modern art in North America.

Upon her return to Canada, Wood sought a personal and modern mode of expression in sculpture, exploring unusual materials and new visual forms through the juxtaposition of masses abstractly conceived. Her distinctive style was based, like that of Brancusi, on the belief that the real existed not in external form, but in the essence of things. She simplified shapes and smoothed surfaces into immaculate pure forms. These were a fundamental departure from the classic Greco-Roman forms of such Paris-trained sculptors as Marc-Aurèle de Foy Suzor-Coté, who made bronzes that showed the texture of material with atmospheric effect and a feeling of action.

In 1927, influenced by the Group of Seven, Wood distilled nature to its essentials and gave sculptured form to her drawings of Georgian Bay. Using pared-down three-dimensional form and the shining surface of highly polished bronze to convey a euphoria of movement, she produced *Northern Island*. She was immediately dubbed the Lawren Harris of Canadian sculpture. Like Harris, she was driven by an exploratory and original approach, sometimes using unusual material in her work, such as cast tin. It has been suggested that a wash of pure gold, which protects the bronze from tarnish, gives this sculpture its uniquely warm patina.

In 1928, Wood and her husband, Emanuel Hahn, along with a small group of other sculptors, founded the Sculptors Society of Canada to increase opportunities for the exhibition and purchase of their work. As part of her arts advocacy, Wood worked for international postwar reconstruction through the arts and served as one of two Canadian delegates to the founding of UNESCO in Paris in 1946.

Northern Island
1927
Bronze mounted on
black Belgian marble base
8 [h] x 15 [w] x 8¼ inches
(20.5 [h] x 37.7 [w] x 20.8 [d] cm)
without base
Private Collection, New Brunswick

Maud Lewis
1903–1970

Images one might find on a family quilt, scenes of traditional life immortalized with raw colour and simple brushwork – this is the work of Maud Lewis. Her fresh, naive style filtered out the painful and the unnecessary, leaving only highlights and delights for the eye to celebrate. Her works are a cheerful retort to the more studied style and serious subjects of much of twentieth-century Canadian art.

Fording the Stream, with its red barn, horse-drawn carriage, and flower-filled foreground, evokes life in a small community. Under a clear blue sky, with leafy trees and flowers aplenty, this lovely work announces, "seize the day." Its simplicity offers a holiday to the mind as well as gently reminding the viewer of the beauty of nature.

Lewis's art is accessible. She found beauty in everyday life: the subject might be oxen, horses, a neighbour's cat, a flock of birds gathering to announce spring's arrival, or boats on the water anticipating the day's catch. To buy one of her paintings, one had only to stop by a small cabin along the roadside, bid "Hello!" and walk away delighted with a memento of days gone by.

Lewis painted in her small cabin, seated in a chair with a wobbly television table as her easel. Though she suffered from disabilities as a result of childhood polio and she lived most of her life in poverty with her husband in rural Nova Scotia, she painted life at its sunniest.

Fording the Stream
(undated)
Oil on board
12 x 14 inches (30.5 x 35.5 cm)
Art Gallery of Nova Scotia,
Halifax

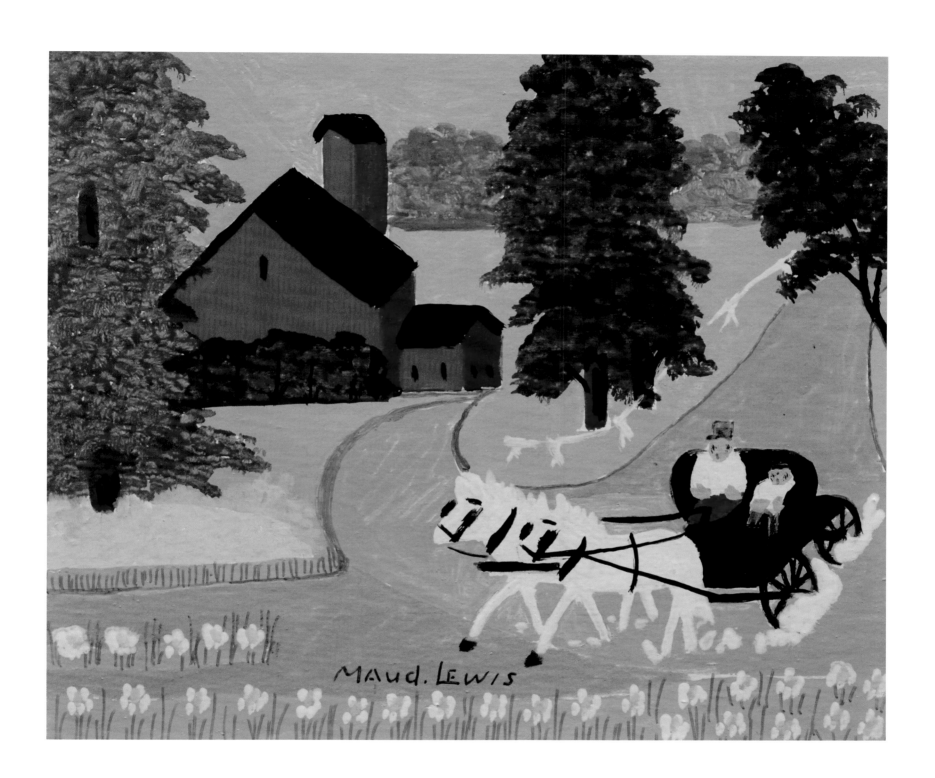

Maud. Lewis

Pegi Nicol MacLeod

1904–1949

Pegi Nicol MacLeod was animated, vivacious, and uninhibited. In this self-portrait, painted during her years in Ottawa where she grew up in a comfortable brick house on Second Avenue in the Glebe, the viewer can feel MacLeod's intensity as she stares fixedly into a mirror to paint herself. The handling of space, almost a vortex into the distance, reveals the psychological detachment she must have felt that separated her attic studio from the rest of the home of her youth, a household with which she was not in sympathy.

This early work by MacLeod reveals the influence of Franklin Brownell, a Canadian Impressionist painter with whom she had studied at the Ottawa Art School, who had made her aware of light. In the painting, light from the window animates the forms, especially MacLeod's outfit and the bottle on the table. At this early stage in her career, MacLeod admired the Group of Seven, especially the forcefulness with which they set down paint. The influence of the Group is clearly visible in the painting's vigorous handling and hard, clear forms.

*Costume for Cold Studio
(Self-Portrait)*
c. 1925–1930
Oil on canvas
21 x 15 inches (53.5 x 38.3 cm)
The Robert McLaughlin Gallery,
Oshawa

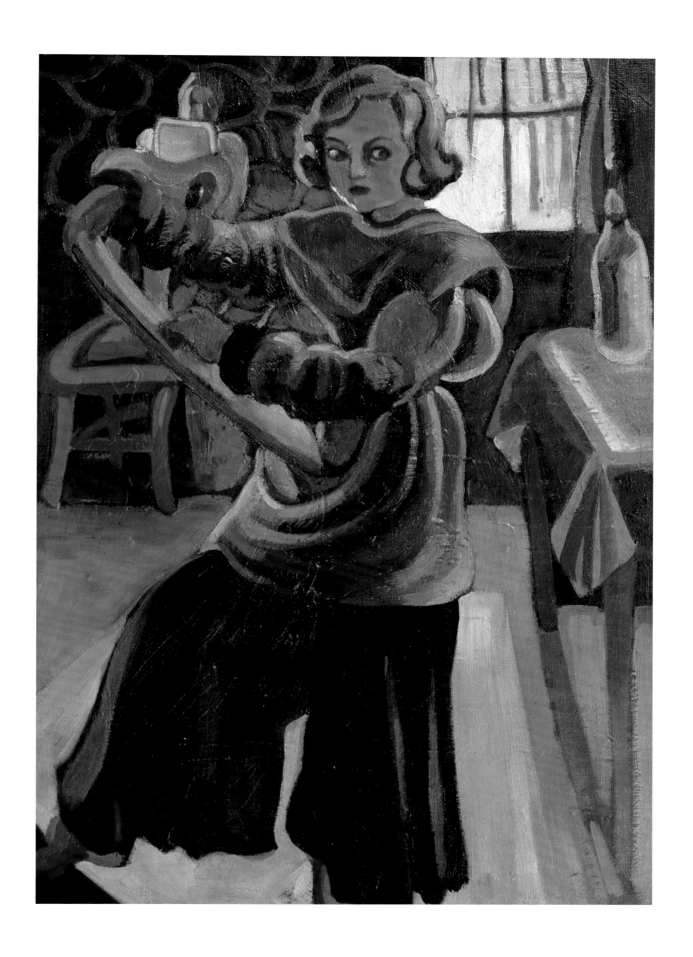

From the generation of Canadian women artists who emerged during the twentieth century, Pegi Nicol MacLeod stands apart as a painter who turned her back on the aesthetic whims of the day. Conventional views of reality left her cold and she engaged her art with a fighting rage, exploring the submerged orders of society and dissecting them as aggressively as did Alfred Pellan and Jean Dallaire. Clearly an artist of an anxious temperament, MacLeod was a consummate observer of the elements of life, and from these elements, something agitated her soul.

Market Scene, New York City is an irrepressible animation of an urban scene, in a style first witnessed in her watercolours of school children painted at Fredericton in 1933. Conspicuous in her art is her unsettling mood of conflicting emotions that expressed an easy familiarity and, at the same time, a discomfort with the urban scene. By dealing unreservedly with her environment, she created a self-referential picture of the purest type. For the viewer, it is a painting of a market scene in New York. For MacLeod, it is an essay on her darkened world: a carnival with an unstoppable flow of time and energy. Working directly from reality, she instilled into the composition her restless quest to seize all she could, caused by her inextinguishable fear of losing the race against the great enemy, time. Time, which did indeed run out on her at the young age of forty-five.

Market Scene, New York City
c. 1940
Oil on canvas
19¾ x 11¼ inches (50.2 x 28.6 cm)
Private Collection, Ontario

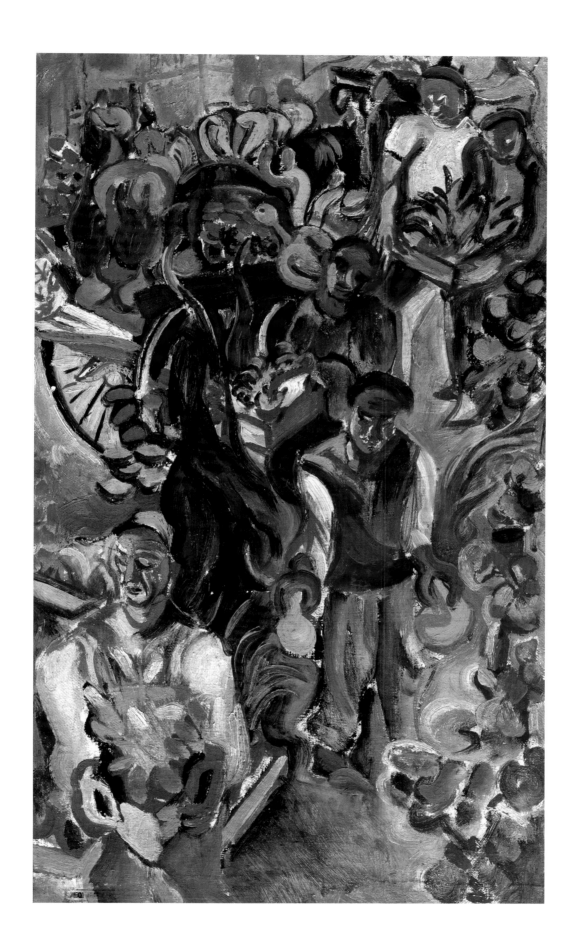

Jori Smith

1907–2005

Most significant about Jori Smith is the fact that she was the first woman painter to introduce Expressionism into Canadian art. Differing from the movement that originated in Germany in the early twentieth century, her Expressionism was rather a reflexive quality that manifests the subjective personality of the artist in the artwork. The legacy of the European modernists, in particular Paul Cézanne, Pierre Bonnard, and Pablo Picasso, was fluent in her work of the 1930s.

Seated Nude, an ambitious self-portrait painted with vigorous colour to stress important detail, has the distortions of Cézanne, the wedge-like contours of African sculpture, and an intimation of cubism. All vestiges of allegorical disguise have been abandoned. It is as though Smith has just flung off her clothes and sits there eager for admiration, utterly unrestrained. The aura of sin about a nude, once seen as sinuous and carnal, has been replaced by a blunt expression of an evocative woman filled with pure self-confidence. This painting is Smith's emphatic response to those who considered nudity improper and its suppression a mark of respect for the prevailing Anglo-Saxon values in Canada at the time.

In her finest paintings, such as *Seated Nude*, one senses the forceful impact of her subject; it is an atmosphere of special circumstance missing in her later works. By the 1950s, Smith had drifted towards a more cautious, restrained style.

Seated Nude
c. 1931
Oil on canvas
22 x 16 inches (55.9 x 40.6 cm)
Private Collection, Ontario

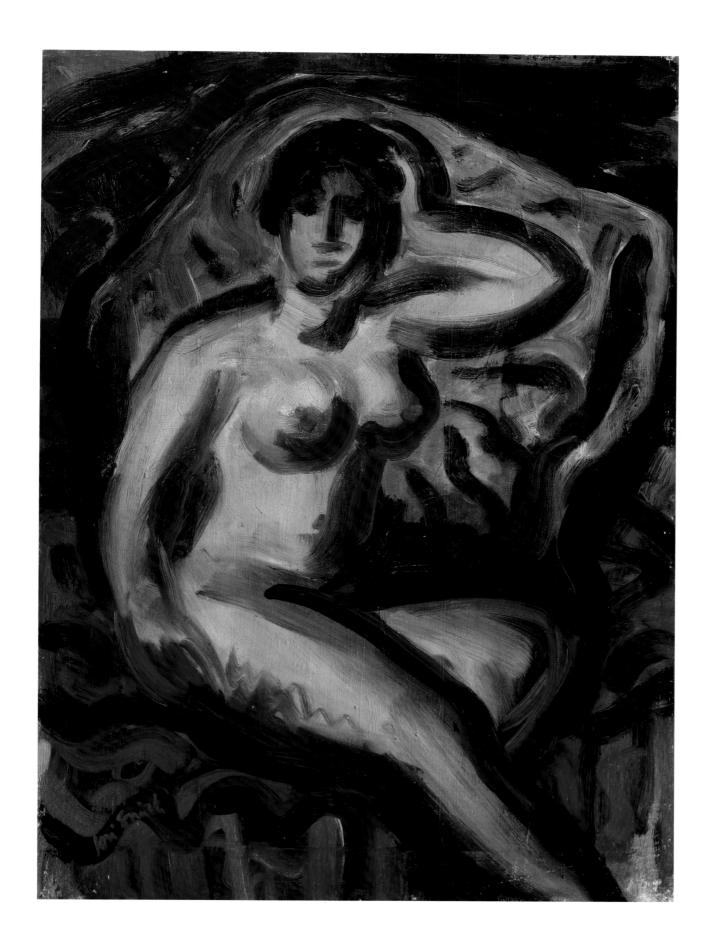

Jori Smith's work has long been eclipsed, first by the dominant modernism heralded by her male contemporaries, and then by the attention accorded the women of the Beaver Hall Group. Only now, with the resurgence of the human figure in art, has Smith's work begun to receive attention.

Mlle Anna Tremblay – Rang de la décharge, Pointe-au-Pic, Charlevoix displays Smith's sensitivity to narrative and the subtleties of facial expression. Anna, the daughter, dominates the work not only by occupying pictorial space, but also by her attitude. The mother sits remotely in the background: a symbol with a watchful eye. As an investigation into the themes of rural domesticity, the composition personifies the characteristic struggle between the contending values of two generations. The daughter manifests an air of entreaty, uncertainty, and anxiety; the mother is a counterpoint of confidence, repose, and authority. The painting conveys the sense of alienation common to rural Canada between the wars, alienation that is perhaps difficult to identify with today. Between the two figures, differing values are based purely on point of view and if the scene were painted today, we might see the alienation reversed as the forces acting on the pair are no longer external, but more intimate as the struggles and expectations are internalized between the generations.

*Mlle Anna Tremblay –
Rang de la décharge,
Pointe-au-Pic, Charlevoix*
1936
Oil on panel
23 x 15 inches (58.5 x 38.1 cm)
Private Collection, Quebec

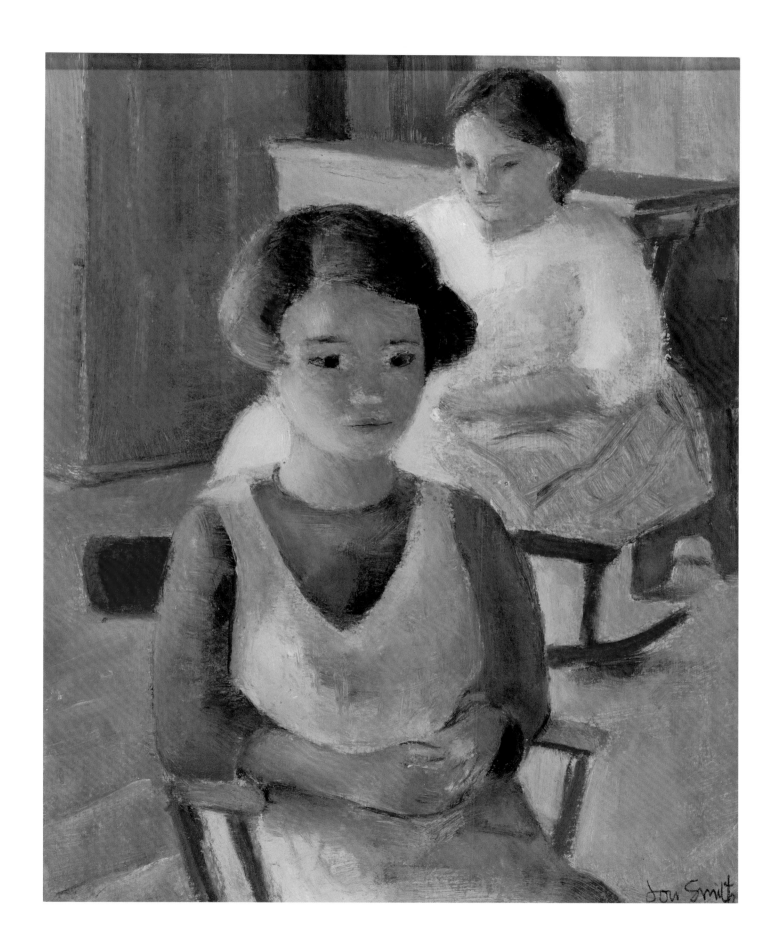

Marcelle Ferron

1924–2001

The idea that painting has a language all its own found its most powerful Canadian advocates in a group of painters called the Automatistes. Like Wassily Kandinsky, the first abstract painter of the twentieth century, the members of this group, led by Paul-Émile Borduas, declared that painting should be a result of the abstract workings of the inner psyche released through the subconscious without any preconceived ideas.

Marcelle Ferron was a member of the Automatiste painters. After the influence of Jean-Paul Lemieux's symbolism had run its course in her early work, Ferron turned to Borduas who, by transferring the ingredients of traditional painting to abstraction, had revived the Surrealist attitudes of André Breton and Sigmund Freud. The colour and turbidity of Ferron's work was already a reflection of her own struggles and aspirations. It was only after her involvement with Borduas in 1946 that she liberated herself from the hieroglyphics of the subconscious and transformed her art into a ritual of sweeping brush strokes on canvas, a technique emphasizing emotional response rather than rationality.

Sans titre is best viewed from a distance without any prejudices. A large, decorative composition, it reflects autumn without actually suggesting landscape. Ferron's technique was to use pigment as calligraphy to define form. There is no focal point, only an equal distribution of formal structure with a palpable tension that creates a special movement in and out of depth – a crucial reason why scale in abstract painting determines the degree to which the viewer is absorbed by it. The larger the scale, the deeper the involvement of the viewer. Artists like Ferron opened the way for a new generation of painters in Canada by liberating them from the restraints of the past.

Sans titre

1962

Oil on canvas

63¾ x 51 inches (161.9 x 129.5 cm)

Private Collection, Ontario

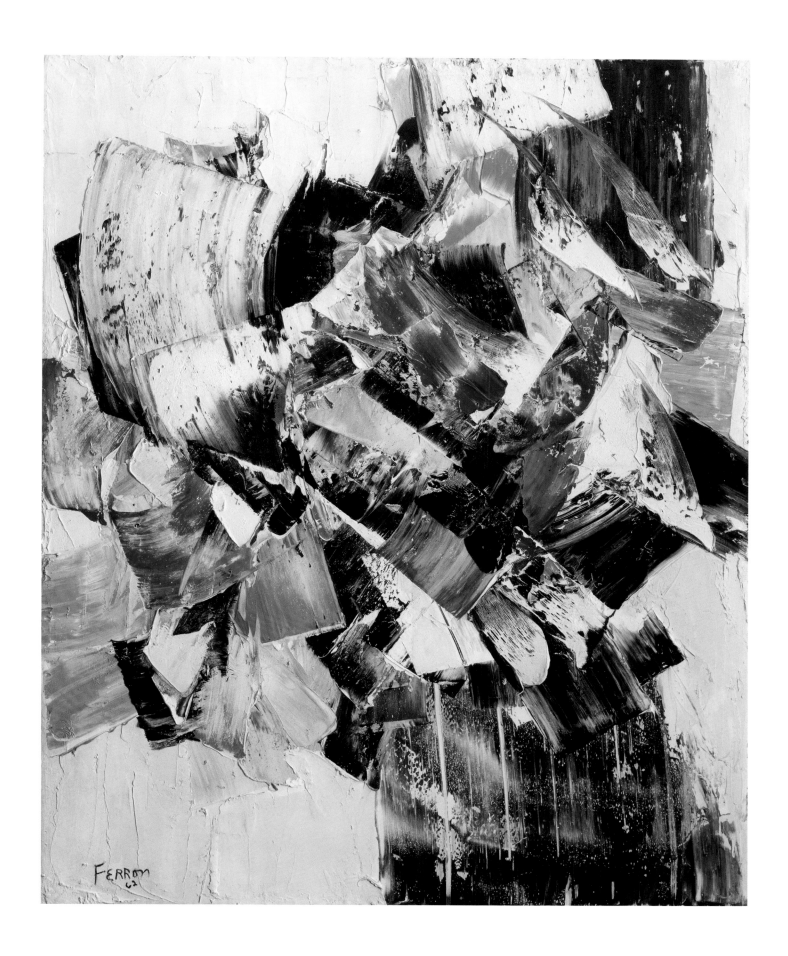

Marcelle Ferron

1924–2001

The work of Marcelle Ferron reminds us of the significance of spontaneity and adventure in Canadian art. *Autoportrait* is a mirror of Ferron's soul in which nothing is arbitrarily concealed: it projects a note of profound disquiet, distilled from her life. Ferron masterfully played the gamut of nuances with her paint. Sharp and swiftly applied, it reveals sumptuousness in juxtaposition, but melancholy in the discordant colour that unites it. In her painting one sees Ferron's very personal manner of apprehending existence with certainty and self-assurance. Under any ordinary painter's brush the work would have lapsed into mere imagery, but her power of imagination enables her to render the "interiority" of her subject.

The willful coldness of this painting confers on Ferron a clearly defined personality. Her conception of art inspired her to paint a self-portrait by reinventing herself for the viewer. Pierre Gauvreau, a well-known member of the Automatistes, was so moved by *Autoportrait* that he purchased it for his own collection from an exhibition of her work at Galerie Gilles Corbeil in Montreal. Executed with unrestrained imagination, *Autoportrait* will endure and will contribute, like the figurative abstractions of Borduas from the early 1940s, to the moral reconstruction of her era.

Autoportrait
1974
Oil on linen mounted on board
27 x 22 inches (68.6 x 55.9 cm)
Private collection, Alberta

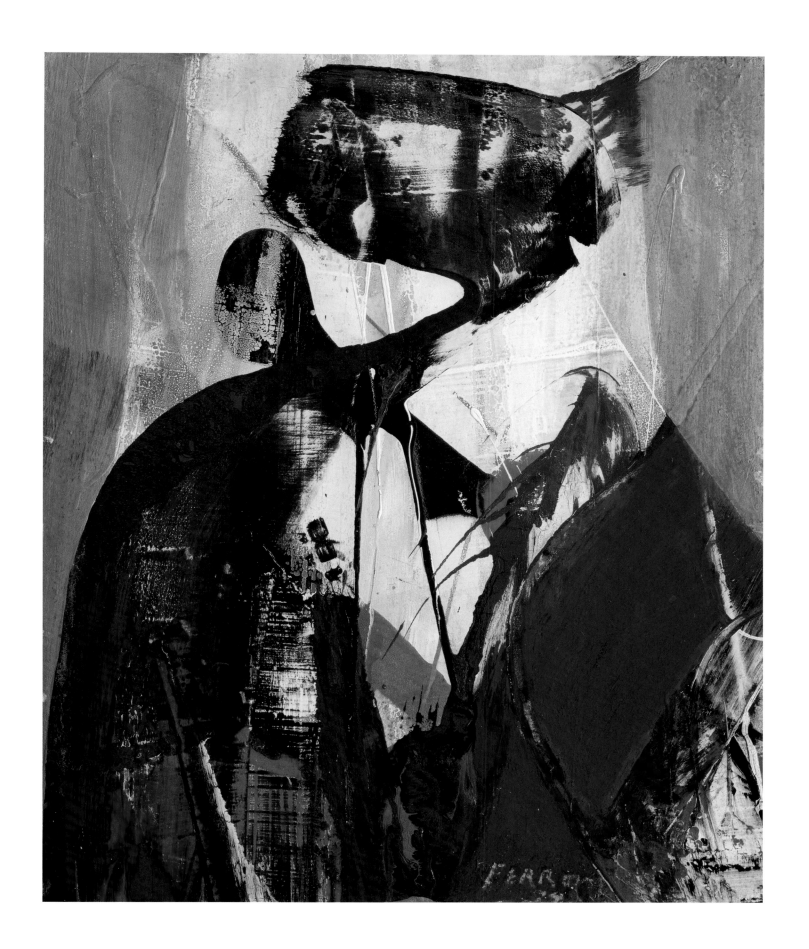

PART II

LIVES OF THE ARTISTS

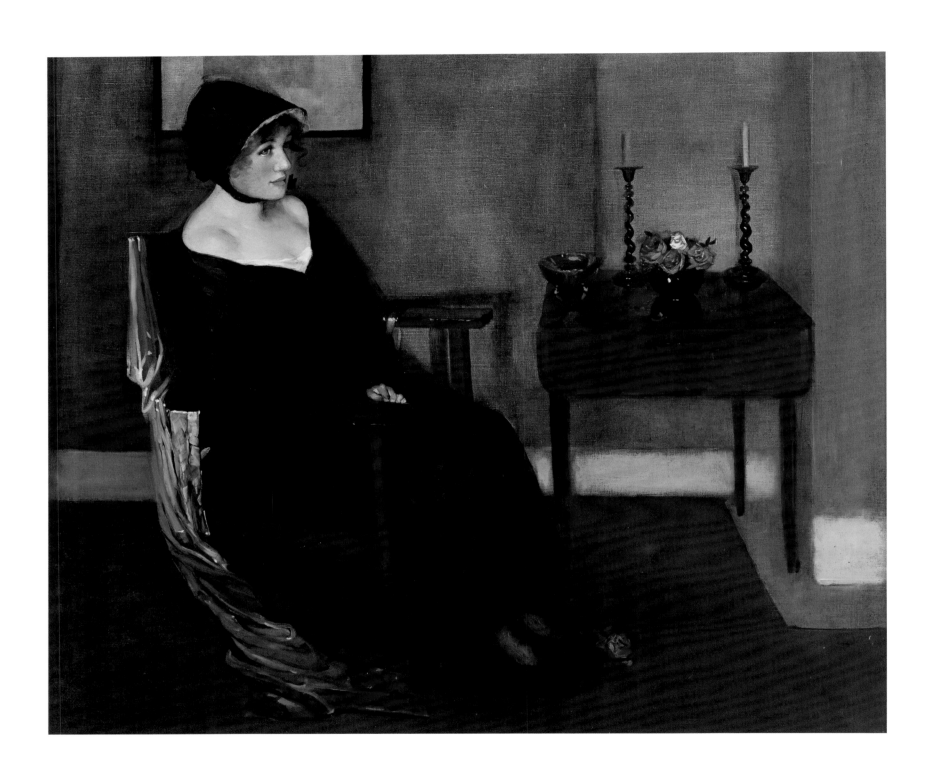

After the Party
c. 1914
Oil on canvas
30 x 36 inches (76.2 x 91.4 cm)
Private Collection, British Columbia

Carlyle, Florence Emily

1864–1923

"I remember … the first time I saw colour. Our nurse brought in a branch of pink apple blossoms. It was my first keen impression of beauty. It seemed so large to me and so pink. I have never seen apple blossoms like those since."

Florence Carlyle, quoted by Katherine Hale, *Toronto Star Weekly*, June 16, 1923

EARLY LIFE

Florence Emily Carlyle was born in Galt, Ontario, in 1864, the second of seven children. When she was three, the family moved to Woodstock, Ontario, residing at "Englewood," 146 Wilson Street, where the house still stands today. With her mother's encouragement, Carlyle took classes with guest artists such as the painter William Lees Judson. Circa 1883, Paul Peel met Carlyle and recognized her potential; he encouraged her to pursue art studies in Europe. Seven years later, after saving money from teaching and with the help of her family, Carlyle was able to go to Paris to study art.

EDUCATION, MENTORS, INFLUENCES

Together with Paul Peel and his sister Mildred, Carlyle travelled to France in 1890 and settled in Paris, studying art for six years. She attended the Académie Julian and the Académie Delécluse, and studied under such instructors as Adolphe-William Bouguereau, Jules-Joseph Lefebvre, Tony Robert-Fleury, and Léon-Auguste Lhermitte. In 1893, Carlyle's work was exhibited for the first time at the Paris Salon. In 1896, she returned to Canada and began to exhibit her work at different venues and to teach.

"Monday morning comes at last … its six days possibility held out to you to use, or not, as you will. … Slipping from a warm bed into the chill of a fireless room, you light the candle and spirit lamp, placing water to boil over the latter for your morning coffee. … You are thinking, 'Today I shall strive and agonize and see truthfully.' … Who will forget the sensation of entering the studio on Monday morning. … We throng about the model stand, waiting until a supple, bronzed, broad-chested fellow … takes a pose that calls forth a ring of applause, or a girl steps nimbly on, the pearly whiteness of her young body glistening in contrast to the dull surroundings. … Scratching of charcoal begins. … The bared, outstretched arm, the supple wrist, the quick fingers, working out each line as with the workers' own heart's blood. … Some are indicating the wonderful pose, a few lines of much comprehension, and something begins to live on the canvas."

Florence Carlyle, as quoted in the *Sentinel-Review* (Woodstock), February 10, 1936

Florence Carlyle in an
undated photograph.

EARLY CAREER

Upon her return to Canada, Carlyle accepted a teaching position at Havergal College, a private school for girls in Toronto. She set up studios for herself in different locations, working at times in London, Ontario, and sometimes in Woodstock. In 1899, she opened a studio in New York to help promote her work internationally. Among Carlyle's students in New York was Eva Bradshaw, an artist from London, Ontario. Mrs. Helene Key, one of Carlyle's frequent models and also her friend, described Carlyle as a driven painter who would work until exhausted. She recalled that Carlyle's ability to capture the desired effect would directly affect her mood.

AFFILIATIONS AND AWARDS

1897	associate member, Royal Canadian Academy of Arts (re-elected 1912)
1900–1906	member, Ontario Society of Artists
1901	honourable mention, Pan-American Exposition, Buffalo, New York
1904	silver medal, Louisiana Purchase Exposition (St. Louis World's Fair)

A highlight of Carlyle's career was her commission by the Canadian Government to paint the portrait of Lady Drummond for the War Memorials Committee in Britain. Lady Drummond was the head of the Red Cross Society during the First World War. Today this painting is in the Canadian War Museum in Ottawa.

MATURE PERIOD
Circa 1890s to 1920.

PREFERRED SUBJECT MATTER
Carlyle was essentially a painter of portraits and figurative art, known for her bold brush-work and sharp eye for colour and light.

COMPOSITIONAL SUBTLETIES
Carlyle's best compositions transcend the literary references in her subjects to reveal nuances of light and colour.

LATER YEARS
Carlyle travelled frequently to Europe and in 1913 settled in Crowborough, East Sussex, England, just before the outbreak of the First World War. During the war, she worked in a convalescent hospital for servicemen until her health began to suffer. Following the war, she turned her attention to writing and painting still life, among other subjects.

Carlyle's successful career as an artist came at a time when many women painters were still considered hobbyists. Her free brushwork and fluid handling of paint were fresh for the period. Her artistic achievements helped to break barriers so that other women could follow.

Florence Carlyle remained in England with her friend Juliet Hastings. They lived together in the cottage they called "Sweet Haws" in Crowborough. She died in Crowborough on May 2, 1923, at the age of fifty-nine.

Young Woman Before the Hearth, 1902–1914, detail. See page 55.

EXHIBITION HISTORY

1892–1915	exhibited with the Art Association of Montreal
1893	Paris Salon
1895–1915	exhibited with the Royal Canadian Academy of Arts
1897–1923	exhibited with the Ontario Society of Artists
1901	Pan-American Exposition, Buffalo, New York
1904	Louisiana Purchase Exposition (St. Louis World's Fair)
1914–1923	exhibited with the Royal Academy of Arts, London
1925	memorial exhibition, Jenkins Art Galleries, Toronto
1967	Oxford County Art Association Centennial Exhibition, Centennial Art Gallery, Woodstock, Ontario
2005	*Florence Carlyle: Against All Odds*, Museum London, Ontario; travelled to Varley Art Gallery, Markham, and Woodstock Art Gallery, Ontario

Lace Maker

C. 1911

Watercolour on paper

14½ x 10½ inches (36.8 x 26.7 cm)

Private Collection, Alberta

Carr, M. (Millie) Emily

1871–1945

"What do these forests make you feel? Their weight and density, their crowded orderliness. There is scarcely room for another tree and yet there is space around each. They are profoundly solemn yet upliftingly joyous; like the Bible, you can find strength in them that you look for. How absolutely full of truth they are, how full of reality. The juice and essence of life are in them; they teem with life, growth, and expansion. They are a refuge for myriads of living things. As the breezes blow among them, they quiver, yet how still they stand developing with the universe."

Emily Carr, quoted in Susan Crean, ed., *Opposite Contraries: The Unknown Journals of Emily Carr and Other Writings*

EARLY LIFE

Emily Carr was born in Victoria, British Columbia, on December 13, 1871. She was the fifth girl born to Emily Saunders Carr and Richard Carr. A brother was born in 1875. Carr's parents were British immigrants who had moved to Canada in 1863, to Victoria, where her father ran a grocery and liquor store.

EDUCATION, MENTORS, INFLUENCES

Carr attended the California School of Design in San Francisco from 1890 to 1893. Upon her return to Victoria, the barn behind the Carr family home was turned into a studio to provide Carr with space to paint and teach.

Carr travelled to Ucluelet in 1897. It was the first time that she had visited a Native community, and she used this trip as an opportunity to sketch their daily life.

By 1899, Carr had saved enough money from teaching to go to England for further studies. She enrolled at the Westminster School of Art in London, studying under William Mouat Loudan and James Black. She also spent nearly a year in St. Ives, Cornwall, studying under Julius Olsson and Algernon Talmage. After a lengthy illness and a fifteen-month stay in a sanatorium, Carr returned to Victoria in 1904. She resumed teaching art to children and travelled to northern British Columbia to sketch every summer for the next five years. She developed an interest in Native cultures, and in 1908 visited several Kwakiutl (Kwakwaka'wakw) villages of northern Vancouver Island.

In 1910, Carr made one more trip to Europe in the company of her sister Alice. This time, she studied at the Académie Colarossi in Paris. She again became ill and travelled to Sweden to recover. Upon her return to France that same year, she joined the private studio of the Scottish artist John Duncan Fergusson. Carr found her real inspiration working with Fauvist painter Harry Gibb at Crécy-en-Brie, a little village outside Paris, and at St-Efflam in Brittany.

In 1911, she travelled to Brittany in the company of Gibb and his wife and studied under New Zealand expatriate painter Frances Hodgkins at Concarneau. The trip enriched and transformed her style of painting into a modified form of Post-Impressionism, with flat planes, strong contours, vigorous colour, and an emphasis on feeling. In the same year, her work was shown at the Salon d'Automne in Paris. In 1912, Carr returned to Victoria, where she continued to paint in a Post-Impressionist manner. Throughout this period and later, she was a great admirer of the work of Vincent van Gogh.

Carr spent six weeks in 1912 travelling to Native villages, most already abandoned, to document totem poles in their original setting before they disappeared.

EARLY CAREER

In Canada, Carr's art received little attention and she became discouraged and stopped exhibiting – even stopped painting for the next fourteen or fifteen years. With an inheritance that was split between the sisters, Carr built a small apartment building, "The House of All Sorts"; with the income that resulted, she supported herself. She raised sheepdogs and also made and sold pottery using her own kiln.

Recognition came to her in middle age through the great anthropologist Marius Barbeau, who told others about her work. In the early 1920s, Eric Brown, the founding director of the National Gallery of Canada, Ottawa, travelled west to visit her. It was through Brown and his wife that Carr learned about the Group of Seven. Brown invited Carr to participate in an exhibition of Canadian West Coast Indian Art in 1927. For the show, Carr loaned a number of her works to the National Gallery. She then travelled east to Ottawa for the opening of the exhibition and went on to Toronto, where she met Lawren Harris.

After her initial meeting with Harris on her fifty-sixth birthday, and subsequent communication by letter, she felt encouraged to start painting again. Harris was interested in theosophy, a sense of God in nature, and he influenced Carr with his philosophy. It was through Harris's encouragement that Carr began to see the forests around her as subject matter. This time, she painted using a language in art that was truly her own.

Emily Carr in an undated photograph.

Dawson City, Yukon
1920
Watercolour on paper
13¾ x 10 inches (35 x 25.4 cm)
Private Collection, New York

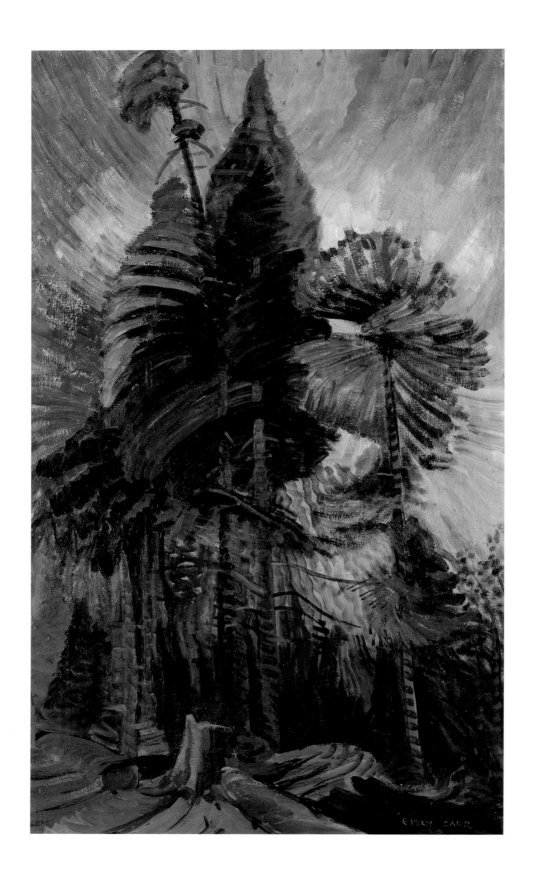

Wind in the Tree Tops

c. 1930

Oil on canvas

36 x 21 inches (91.4 x 53.3 cm)

Private Collection, Ontario

1933–1942 founding member, Canadian Group of Painters

1941 Governor General's award for non-fiction for her book *Klee Wyck*

1971 Canada Post issued a stamp of Carr's *Big Raven*

Member, British Columbia Society of Artists

MATURE PERIOD

Circa 1911 to 1945.

PREFERRED SUBJECT MATTER

Using the forest as her subject, Carr painted the forces that govern nature and, ultimately, connect life with death.

COMPOSITIONAL SUBTLETIES

In her best work, Carr's rhythm of free-flowing brushwork captures the energy and power of nature.

LATER YEARS

In 1933, Carr bought a caravan, which she named "The Elephant." During the summer, she would travel outside Victoria, setting up camp in the forest to paint during the day and write at night.

By the late 1930s, as she approached her seventies, Carr had a number of heart attacks. She moved to a nursing home in 1939 and painted less but began to write more. Emily Carr died in Victoria on March 2, 1945, at the age of seventy-three.

EXHIBITION HISTORY

1911 Salon d'Automne, Paris

1927 *Canadian West Coast Art, Native and Modern*, National Gallery of Canada, Ottawa

1933 began exhibiting with the Canadian Group of Painters, Toronto

1939 *Exhibition by the Canadian Group of Painters*, New York World's Fair

1940 four-person show, Art Gallery of Toronto

1944 Dominion Gallery, Montreal

1945 memorial exhibition, National Gallery of Canada, Ottawa
memorial exhibition, Dominion Gallery, Montreal

1958 *Oil Paintings from the Emily Carr Trust Collection*, Art Gallery of Greater Victoria

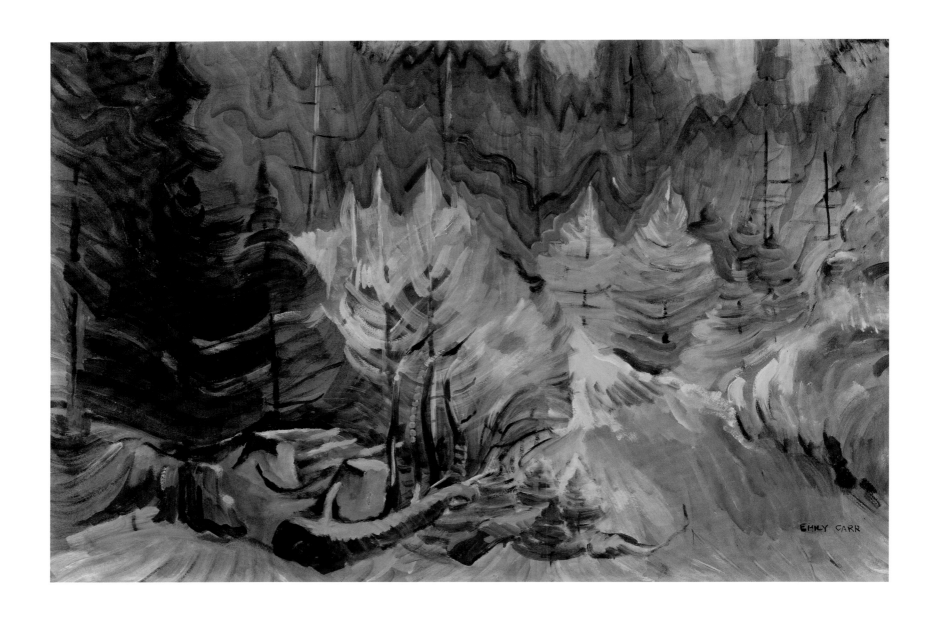

Light of Spring

1935

Oil on paper

24 x 36 inches (61 x 91.4 cm)

Private Collection,

British Columbia

1972	*Emily Carr,* Art Gallery of Windsor; travelled to London (Ontario) and Hamilton
1986	*Emily Carr: Native Portraits,* McMichael Canadian Art Collection, Kleinburg, Ontario
1988	*Dr. Max Stern, 1904–1987: Selected Works from a Prophetic Collection,* Dominion Gallery, Montreal
1990	*Emily Carr,* National Gallery of Canada, Ottawa
1991	*Emily Carr in France,* Vancouver Art Gallery
1996	*The Innocence of Trees: Agnes Martin and Emily Carr,* Morris and Helen Belkin Art Gallery, University of British Columbia, Vancouver
1997	*Three West Coast Women: Emily Carr, Sophie Pemberton, Vera Weatherbie,* Art Gallery of Greater Victoria
1999	*To the Totem Forests: Emily Carr and Contemporaries Interpret Coastal Villages,* Art Gallery of Greater Victoria; travelling exhibition
2000	*Emily Carr: Framing the Century,* Yukon Arts Centre Gallery, Whitehorse
2001	*Carr, O'Keeffe, Kahlo: Places of Their Own,* McMichael Canadian Art Collection, Kleinburg, Ontario; travelled to Museum of New Mexico, Santa Fe, and Vancouver Art Gallery
	Emily Carr on Paper, Edmonton Art Gallery, Alberta
2002	*The Birth of the Modern: Post-Impressionism in Canadian Art, c. 1900–1920,* Robert McLaughlin Gallery, Oshawa; travelled to Montreal, London (Ontario), Fredericton, and Winnipeg
	Emily Carr Retrospective, Walter Klinkhoff Gallery, Montreal
	Heart of Darkness: Emily Carr/Jack Shadbolt, Art Gallery of South Okanagan, Penticton, B.C.
	Emily Carr: Eccentric, Author, Artist, Genius, Royal British Columbia Museum, Victoria
2006	*Emily Carr: New Perspectives on a Canadian Icon,* National Gallery of Canada, Ottawa; travelled to Vancouver Art Gallery, Glenbow Museum (Calgary), and Art Gallery of Ontario, Toronto

"Nothing is still now. Life is sweeping through the spaces. Everything is alive."

Emily Carr, quoted in Danielle Zyp, *Edmonton Journal,* February 2, 2001

*Still Life with Apples
and Grapes*

1935

Oil on canvas

29¾ x 26½ inches (75.6 x 67.3 cm)

The Thomson Collection, Ontario

Clark, Paraskeva Avdyevna (née Plistik)

1898–1986

> "Who is the artist? Is he not a human being like ourselves, with the added gifts of finer understanding and perception of the realities of life, and the ability to arouse emotions through the creation of forms and images? Surely. And this being so, those who give their lives, knowledge and their time to social struggle have the right to expect great help from the artist. And I cannot imagine a more inspiring role than that which the artist is asked to play for the defense and advancement of civilization."

Paraskeva Clark, "Come Out from Behind the Pre-Cambrian Shield," *New Frontier*, April 1937

EARLY LIFE

Paraskeva Clark was born Paraskeva Avdyevna Plistik in St. Petersburg on October 28, 1898. She took an early interest in copying illustrations available to her, and she was fortunate to have attentive parents who encouraged her in the pursuit of art.

EDUCATION, MENTORS, INFLUENCES

As a young adult, Paraskeva Plistik took an office job and attended art classes in the evenings at the Petrograd Academy of Fine Arts. From 1916 to 1918 she also took private art lessons from Savely Seidenberg, a landscape painter. After the Revolution of 1917, apprenticeship opportunities with no tuition fees became available to those interested in art. Plistik worked full-time on her art, training at the Free Studios (formerly, the Russian Academy) under Vasily Shukhayev and Kuzma Petrov-Vodkin, and sharing the latter's interest in Paul Cézanne.

EARLY CAREER

In 1922, facing difficult financial times, Plistik began working as a set decorator at a theatre in Leningrad. There she met her first husband, Oreste Allegri; they married in 1923 and had a son. Tragically, Oreste drowned in a summer boating accident soon after the birth of their son, and Paraskeva and the baby moved to Paris to live with, as well as work for, her in-laws. She stayed in Paris from 1923 to 1931. In 1929, she met her second husband,

Canadian Philip Clark. They married in 1931 and moved to Toronto, where Clark's second child was born.

Clark's domestic duties took priority over her art, but she did find time to paint, limiting her compositions mostly to household subjects. Through her participation in the exhibitions of the Canadian Group of Painters, she met Lawren Harris, Bertram Brooker, and A.Y. Jackson.

In 1944, Clark was commissioned by the National Gallery of Canada to paint the activities of the RCAF Women's Division.

AFFILIATIONS AND AWARDS

1937 member, Canadian Society of Painters in Water Colour

1937–1967 member, Canadian Group of Painters

1954–1965 member, Ontario Society of Artists, Toronto

1956 associate member, Royal Canadian Academy of Arts

1963–1965 member, Council of the Royal Canadian Academy

1966 full member, Royal Canadian Academy of Arts

Member, Canadian Society of Graphic Artists

MATURE PERIOD

Circa 1930 to 1950.

PREFERRED SUBJECT MATTER

Clark painted a variety of subjects, from landscapes to portraits. During the 1930s, her political opinions found their way into her art, often through allegory; she was one of the few artists in Canada to express social concerns.

COMPOSITIONAL SUBTLETIES

Clark employed Cubist techniques to create idealized forms, especially in her early work.

LATER YEARS

The illness of her elder son meant Clark had little time for art, and her painting and practice became sporadic. Paraskeva Clark died in Toronto on August 10, 1986, at the age of eighty-seven.

Algonquin Morning

c. 1950

Oil on board

18 x 16 inches (45.7 x 40.6 cm)

Private Collection, Alberta

"It's a hell of a thing to be a painter. I would like to stop every woman from painting, for only men can truly succeed. The majority of women who have really succeeded have not married or had children, but I don't envy them. I believe that women, by their very nature, by their mental and emotional makeup are so absorbed by their natural duties and responsibilities that they cannot truly gather that great volume of creative effort needed for truly great works of art. But I cannot complain, I have had a very good career, considering a great deal of my time has been spent on being a wife and a mother."

Paraskeva Clark, quoted in Janice Cameron, et al., *Eclectic Eve*

Paraskeva Clark in an undated photograph.

EXHIBITION HISTORY

1932–1966	exhibited with the Royal Canadian Academy of Arts
1934	exhibited with the Canadian Group of Painters, Montreal
1939	*Exhibition by the Canadian Group of Painters,* New York World's Fair
1942	*In Aid of Russia*, solo exhibition, Picture Loan Society, Toronto
1947	*Canadian Women Artists*, Riverside Museum, New York
	Picture Loan Society, Toronto
1951	Laing Gallery, Toronto
1952	Victoria College, University of Toronto
1955	Montreal Museum of Fine Arts
1956	McGill University, Montreal
	Hart House, University of Toronto
1974	exhibited with son (Ben) at the Arts & Letters Club, Toronto
1975	*Canadian Painting in the Thirties*, National Gallery of Canada, Ottawa; her work appears on the cover of the catalogue by Charles C. Hill
1982	retrospective exhibition, Dalhousie Art Gallery, Halifax

Coonan, Emily Geraldine
1885–1971

"Could the fates have planned a more impish trick than to award to a struggling artist of great promise a scholarship at a time when the hellish breath of a terrific war was rendering all but uninhabitable the happy studying ground of the enthusiastic student … In spite of much crudeness, Miss Coonan's work is original in conception, daring in colour, broad in treatment, with an unusual quality which bespeaks growth."

unidentified newspaper article, quoted in Karen Antaki, *Emily Coonan (1885–1971)*

EARLY LIFE
Emily Geraldine Coonan was born in Pointe Saint-Charles, Quebec, on May 30, 1885, the second of five children born to William Coonan and Mary Anne Fullerton. Coonan's artistic talents emerged at an early age, and she benefited from parents who encouraged all their children to follow their dreams.

EDUCATION, MENTORS, INFLUENCES
Around 1898, Coonan enrolled in art classes at the Conseil des arts et manufactures in Montreal. She also took art lessons twice a week for several years, from instructors Edmond Dyonnet, Joseph-Charles Franchère, Joseph Saint-Charles, and Charles Gill. From 1905 to 1909, she studied with William Brymner at the Art Association of Montreal along with fellow students Mabel May, Lilias Torrance, and others, who would later form the Beaver Hall Group. Coonan became known as Brymner's star pupil, and his teaching and support gave her a firm foundation on which to build her career as a painter.

In 1912, Coonan continued her education with a trip to Europe, accompanied by Mabel May, sketching in Paris, Belgium, and Holland.

One of her strongest influences was the work of J.W. Morrice.

Children by the Lake

1910

Oil on panel

8 x 11 inches (20.3 x 27.9 cm)

Private Collection, Quebec

EARLY CAREER

When she returned from Europe, Coonan visited her former classmates at their Beaver Hall Hill studio and participated in a few of their exhibitions. Coonan, along with Lilias Torrance Newton, was invited to exhibit with the Group of Seven. Her peers valued her work, but the avant-garde style of Post-Impressionist painting that she practised attracted some harsh criticism.

Coonan's work lapsed after the death of William Brymner in 1925 and later, that of her father. She exhibited her work less frequently and withdrew from the artistic community of Montreal. Due to criticism of her work, she chose to seclude herself from public life; she continued to paint, but only for herself.

Although Coonan did not maintain close friendships with them, she is associated with the informal Beaver Hall Group, the network of women artists that continued after the original group of that name disbanded.

AFFILIATIONS AND AWARDS

1907 awarded scholarship, Art Association of Montreal
1914 awarded travelling scholarship, National Gallery of Canada
1916 awarded scholarship, Women's Art Society

At an exhibition of the Royal Canadian Academy, Coonan received $50 from the sale of one of her works, one of the highest prices realized at the exhibition.

Although Coonan was the first artist to receive a travelling grant from the National Gallery, the First World War prevented her from taking the trip until 1920, when she travelled to Florence, Venice, Paris, and London along with other recipients such as Dorothy Stevens, E.R. Glenn, and Manly MacDonald.

MATURE PERIOD
Circa 1910 to 1940.

PREFERRED SUBJECT MATTER
Children and landscape.

COMPOSITIONAL SUBTLETIES
Coonan combined pattern and design with simple forms to capture a muted but expressive mood.

En Promenade, 1915, detail.
See page 93.

Still Life, 1940, detail.

See page 95.

LATER YEARS

Coonan never married and chose a lifestyle of solitude and isolation. She has been described as a recluse, and most comfortable when working alone. After 1933, she did not produce art for exhibition although she continued to paint family portraits and landscapes.

Coonan lived in the family house in which she was born until 1966, when she sold her home and went to live with her niece, Patricia Coonan. She died in Montreal on June 23, 1971, at the age of eighty-six.

EXHIBITION HISTORY

1907	student exhibition, Art Association of Montreal
1908–1933	exhibited with the Art Association of Montreal
1910–1933	exhibited with the Royal Canadian Academy of Arts
1914–1915	*Canadian Artists' Patriotic Fund Exhibition,* Public Library, Toronto; travelling exhibition
1923–1924	*An Exhibition of Modern Canadian Paintings,* Group of Seven, U.S. tour
1924	*British Empire Exhibition, Canadian Section of Fine Arts,* Wembley, England *Pictures Exhibited by the Montreal Group of Artists,* Hart House, University of Toronto
1931	*Annual Exhibition of Canadian Art,* National Gallery of Canada, Ottawa
1966	*The Beaver Hall Hill Group,* National Gallery of Canada, Ottawa
1982	*Women Painters of Beaver Hall Group,* Sir George Williams Art Gallery, Montreal
1987	*Emily Coonan (1885–1971),* Concordia Art Gallery, Montreal
1991	*The Beaver Hall Hill Group,* Kaspar Gallery, Toronto
1997	*Montreal Women Painters on the Threshold of Modernity,* Montreal Museum of Fine Arts
2002	*The Birth of the Modern: Post-Impressionism in Canadian Art, c. 1900–1920,* Robert McLaughlin Gallery, Oshawa; travelled to Montreal, London (Ontario), Fredericton, and Winnipeg

Courtice, Rody (Roselyn) Kenny

1891–1973

"There's no way of knowing the future of art;
art will find its level just like water."

Rody Kenny Courtice,
quoted in Janice Cameron et al., *Eclectic Eve*

EARLY LIFE

Rody Kenny Courtice was born Roselyn Kenny in Renfrew, Ontario, on August 30, 1891, to Bernard Carroll Kenny and Margaret Tierney. She inherited her artistic talent from her father, a tile mason, and from an early age showed an interest in drawing and painting.

EDUCATION, MENTORS, INFLUENCES

In 1920, at the age of twenty, Rody Kenny began studying art at the Ontario College of Art under Arthur Lismer, G.A. Reid, and J.E.H. MacDonald. In 1924, she travelled through Europe by bicycle with fellow artists Kathleen Daly and Yvonne McKague. While there, she attended classes at the Académie de la Grande Chaumière in Paris and also studied in London. In 1926, she married for a second time (her first husband, Mr. Hammond, had been killed in the First World War) and lived in Chicago, where her husband, Roy Courtice, worked as a lawyer. She took courses at the Art Institute of Chicago, including studying puppets and stagecraft under Tony Sarg. On their return to Canada, the Courtices purchased a home in Markham that included a separate stone building that became their studio. During the winters, they rented a furnished flat in Toronto.

Throughout the 1930s, Courtice worked as an assistant instructor with Arthur Lismer, teaching Saturday morning children's classes at the Art Gallery of Toronto.

In 1950 she attended Hans Hofmann's summer school in Provincetown, Massachusetts.

The Game, c. 1949,
detail. See page 153.

EARLY CAREER

Courtice is listed as assistant librarian in the Ontario College of Art's prospectus of 1923–1924 while she was still a student there. She also acted as assistant instructor until 1927, teaching at the college's Port Hope summer school, as well as teaching at the Doon School of Art and Teacher's Summer Course with John Alford.

In about 1942, Courtice began to paint abstractly.

AFFILIATIONS AND AWARDS

1922–1923 scholarship in applied design, Ontario College of Art
1924–1925 post-graduate scholarship, Ontario College of Art
1932–1933 president, Heliconian Club, Toronto
1937–1967 member, Canadian Group of Painters; served on the board in 1945, 1947–1948, and 1954–1955
Associate member, Royal Canadian Academy of Arts
Full member, Royal Canadian Academy of Arts
Member, Ontario Society of Artists
Member, Canadian Society of Painters in Water Colour
Member, Canadian Society of Graphic Artists
Member, Federation of Canadian Artists; served as president of the Ontario region from 1945 to 1946

MATURE PERIOD

Circa 1920s to 1940s.

PREFERRED SUBJECT MATTER

Landscape and animals, filtered through her lively imagination.

COMPOSITIONAL SUBTLETIES

Courtice often worked with the idea of scale in her work, painting small things – animals, games, toys, or plants – in poetic terms. Her paintings suggest to the viewer larger issues than mere representation; she sought to articulate her times in art.

LATER YEARS

Rody Kenny Courtice died of cancer at the age of eighty-two on December 6, 1973, in Toronto.

EXHIBITION HISTORY

1925–1964 exhibited with the Royal Canadian Academy of Arts

1925–1967 exhibited with the Ontario Society of Artists

1928–1961 exhibited with the Canadian Society of Graphic Art

1930 exhibited with the Society of Canadian Painter-Etchers and Engravers

1931 *Exhibition of the Group of Seven,* Art Gallery of Toronto

1933–1967 exhibited with the Canadian Group of Painters

1936 five-person exhibition, Malloney's Gallery, Toronto

1936–1965 exhibited with the Canadian Society of Painters in Water Colour

1938 *A Century of Canadian Art,* Tate Gallery, London

1939 *Exhibition by the Canadian Group of Painters,* New York World's Fair

1940 four-person exhibition, Art Gallery of Toronto

1947 *Canadian Women Artists,* Riverside Museum, New York

1951 solo exhibition, Victoria College, University of Toronto

1953 solo exhibition, Heliconian Club, Toronto

1984 *The 1940s: A Decade of Painting in Ontario,* London, Ontario; travelling exhibition

1998 *4 Women Who Painted in the 1930s and 1940s: Rody Kenny Courtice, Bobs Cogill Haworth, Yvonne McKague Housser and Isabel McLaughlin,* Carleton University Art Gallery, Ottawa

2006 *Rody Kenny Courtice: The Pattern of Her Times,* retrospective exhibition, Robert McLaughlin Gallery, Oshawa; travelling exhibition

by Dorothy Stevens
*Conversation Piece of
Rody Kenny Courtice*
c. 1935
Oil on canvas
43 x 34 inches (109.2 x 86.4 cm)
Varley Art Gallery of Markham

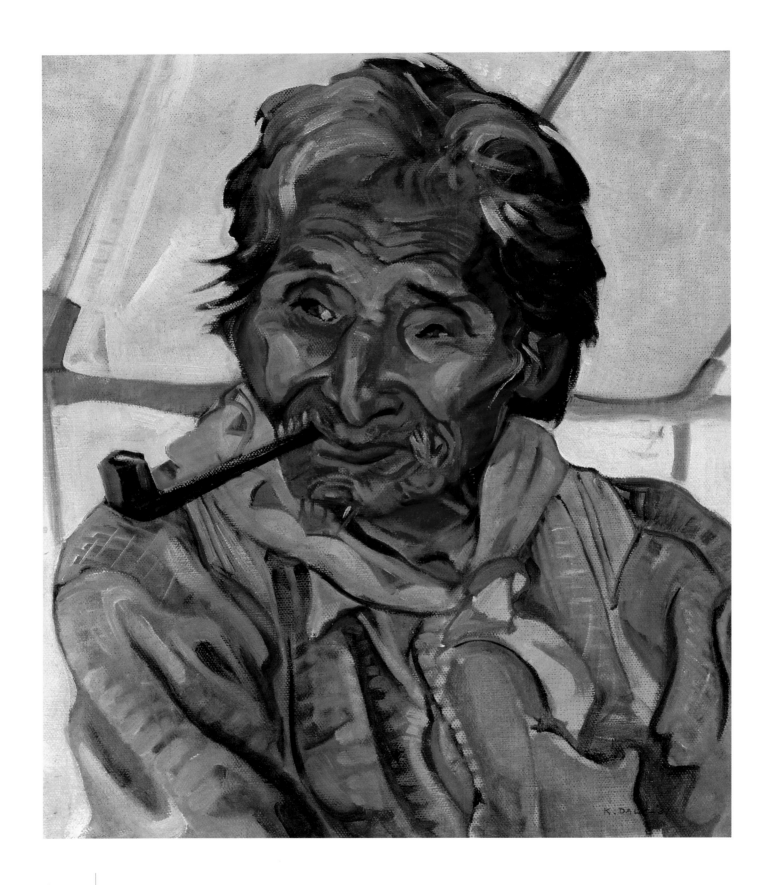

Montagnais Indian with Pipe

1937

Oil on canvas

24 x 18 inches (61 x 45.7 cm)

Private Collection, Alberta

Daly, Kathleen Frances (Pepper)

1898–1994

"Daly extracts the dramatic significance by an insistence on certain salient features, and this gives her figures and still life – which lend themselves more readily to this treatment – a distinction that is sometimes lacking in her landscapes."

Graham McInnes, *Saturday Night*, 1937, as quoted in *A Dictionary of Canadian Artists* by Colin S. MacDonald

EARLY LIFE

Kathleen Frances Daly was born in Napanee, Ontario, on May 28, 1898. Her parents, Denis and Mary Daly, came from Cork, Ireland.

EDUCATION, MENTORS, INFLUENCES

Daly graduated from the Ontario College of Art in Toronto in 1924, having studied with J.W. Beatty, G.A. Reid, Arthur Lismer, J.E.H. MacDonald, and Fred Haines. It was there that she met her future husband, George Pepper. In 1925, Daly attended the Académie de la Grande Chaumière in Paris, studying woodcuts under René Pottier. Before returning to Canada, Daly travelled and sketched in Italy and France. She continued her studies in 1926 at the Parsons School of Design in New York.

EARLY CAREER

Daly and George Pepper married in 1929 and remained childless. The couple built a studio in the Laurentians in 1933 where they spent their summers, and for seventeen years they occupied a space in the Studio Building in Toronto. They were close friends with A.Y. Jackson.

Daly Pepper was one of the illustrators of Marius Barbeau's book *The Kingdom of the Saguenay*, published in 1936.

Indian Playmates,
c. 1938, detail.
See page 173.

Using Toronto as their base, the Peppers travelled extensively throughout Canada on sketching trips. They travelled as far west as the Rockies, and took three separate trips to northern Labrador by minesweeper, icebreaker, and supply ship to sketch this remote region.

AFFILIATIONS AND AWARDS

1935	member, Ontario Society of Artists
1937–1967	member, Canadian Group of Painters
1947	associate member, Royal Canadian Academy of Arts
1965	full member, Royal Canadian Academy of Arts

MATURE PERIOD
Circa 1920 to 1940.

PREFERRED SUBJECT MATTER
Landscape and figurative work, often of Native mothers and children.

COMPOSITIONAL SUBTLETIES
Meditative forces that communicate the predicament of her subject.

LATER YEARS
Throughout her life she would return to Europe with her husband, travelling and sketching. Daly Pepper continued to travel and paint after the death of her husband in 1962. In 1966, she wrote a book on J.W. Morrice. She died at the age of ninety-six in Toronto in 1994.

EXHIBITION HISTORY

1928–1939	exhibited with the Art Association of Montreal
1929	began participating in the annual Canadian National Exhibitions, Toronto
1931	exhibited with the Group of Seven; travelling exhibition
1933–1953	participated in various art association exhibitions, including one at Hart House, University of Toronto
1938	*A Century of Canadian Art*, Tate Gallery, London
1939	*Exhibition by the Canadian Group of Painters,* New York World's Fair
1942	*Four Canadian Painters*, Art Gallery of Toronto
1945	solo exhibition, Vancouver Art Gallery
1947	*Canadian Women Artists*, Riverside Museum, New York
1958	solo exhibition, Banff School of Fine Arts, Alberta
1960	Arts & Letters Club, Toronto

Eastlake, Mary Alexandra Bell
1864–1951

> "Like an opera librettist, Mary Bell Eastlake did not create her subjects, choosing instead well-known classical themes, themes that expressed her vision in a sonorous language, with children as her indispensable inspiration."
>
> A.K. Prakash, *Mary Bell Eastlake (1864–1951)*

EARLY LIFE

Mary Bell Eastlake was born Mary Alexandra Bell in Douglas, Ontario, on June 27, 1864. Her family lived in Carillon, Quebec, while her father was engaged in the construction of the Carillon dam, and later settled in Almonte, Ontario.

EDUCATION, MENTORS, INFLUENCES

From 1884 to 1887, Mary Bell studied under Robert Harris at the Art Association of Montreal and under William Merritt Chase at the Art Students League in New York. Her training continued in Paris, where she studied at the Académie Julian and the Académie Colarossi from 1891 to 1892.

The American and European painters who may have influenced her work include Mary Cassatt, Francisco Goya, and Pierre-Auguste Renoir.

EARLY CAREER

While studying in Paris, Mary Bell met her future husband, Charles H. Eastlake, an English painter. In 1892, she returned to Canada and joined the staff of the Victoria School of Art in Montreal.

She moved to England in 1895 and married in 1897. She and her husband became associated with the group of artists at St. Ives in Cornwall, and made their home there. St. Ives provided a country setting and relaxed lifestyle; artists felt free to explore and experiment

in their work. The couple remained childless and devoted themselves to each other and to art, taking many trips throughout Europe and spending time in the United States, Canada, Japan, and New Zealand.

Girl with Butterfly, c. 1910, detail. See page 123.

AFFILIATION AND AWARDS

1893–1897 associate member, Royal Canadian Academy of Arts
Eastlake had memberships in art clubs in Boston, Chicago, and New York and was a member of the Royal Academy and the Pastel Society in London.
One of Eastlake's paintings was loaned by the National Gallery of Canada to hang in the bedroom of the King and Queen when they visited Rideau Hall in 1937.

MATURE PERIOD

Circa 1897 to 1930.

PREFERRED SUBJECT MATTER

Eastlake was a true and sympathetic interpreter of children, women, landscape, and still life.

COMPOSITIONAL SUBTLETIES

Eastlake's best paintings reveal her quest for the spiritual in art.

LATER YEARS

To supplement their income from painting, the Eastlakes designed and sold jewellery. With the threat of war looming, the Eastlakes left England in 1939 and settled in Montreal. After her husband's death in 1940, Eastlake returned to Almonte. She died there on June 27, 1951, at age eighty-seven.

EXHIBITION HISTORY

1883–1943 exhibited with the Art Association of Montreal
1887–1943 exhibited with the Royal Canadian Academy of Arts
exhibited in London with the Royal Academy, the Pastel Society, and the New English Art Club
1923 solo exhibition, Art Association of Montreal
1924 *British Empire Exhibition, Canadian Section of Fine Arts,* Wembley, England
1927 *Oils, Water Colours and Pastels by Mrs. C.H. Eastlake,* Art Gallery of Toronto
2006 *Mary Bell Eastlake (1864–1951),* Masters Gallery, Calgary

De la neige

1957

Oil on board

11 x 9 inches (27.9 x 23 cm)

Private Collection, Ontario

Ferron, Marcelle
1924–2001

"Even though, in France, where Marcelle Ferron has lived for the last ten years, her painting belongs to the Paris School, she still maintains her own touch, recalling her native country with its vast size and harsh climate, where her spirit of independence and her passionate temperament were formed."

Herta Wescher, *Vie des Arts* 43, 1966

EARLY LIFE

Marcelle Ferron was born in Louiseville, Quebec, on January 29, 1924, one of five children of Joseph-Alphonse Ferron and Adrienne Caron. Her mother died when Ferron was seven, and her father, a notary and a Liberal Party organizer, moved the family to the country. He raised the children in a liberal manner that encouraged their individuality, leading to their involvement in the transformation of Quebec society in the 1940s, and to Marcelle's life-long social and political involvement. Two of her siblings are also well known in Quebec and beyond: Madeleine, as a writer and novelist, and Jacques, as a physician, author, and one of the founders of the Rhinoceros Party.

Ferron suffered from osseous tuberculosis as a young child, and her long stays in sombre hospitals inspired her passion for not only light and colour, but for life.

EDUCATION, MENTORS, INFLUENCES

Ferron enrolled at the École des beaux-arts in Quebec City in 1941, studying for one year under Jean Paul Lemieux and Simone Hudon. She left the school before completing her studies, having clashed with her professors, and moved to Montreal. After discovering the paintings of Paul-Émile Borduas, Ferron sought him out for a critique of her work, and studied under him at the École du meuble in Montreal. She became a member of the Automatistes art movement that was started by Borduas and included Jean-Paul Riopelle.

In 1948, Ferron was one of the sixteen Automatistes who signed the *Refus global* manifesto,

a fiery theoretical and political document written by Borduas. It appeared in the form of a political tract and dismissed aspects of the Quebec social environment that the signatories found oppressive; among their targets were religion, authority, and traditional values.

In 1950, Borduas and Ferron travelled together to Paris and studied engraving under Stanley Hayter.

EARLY CAREER

In 1953, Ferron and her husband, René Hamelin, separated. She left for Paris with the couple's three daughters, where she remained until 1966. Her time in France was productive. She established her career as a painter, making valuable connections and exhibiting her abstracts throughout Europe, while continuing to participate in Canadian exhibitions. Her meeting with glassmaker Michel Blum was a turning point in her life, and the new medium allowed her to further explore light and colour.

Forced to leave France for her association with activists working against Spain's Franco, Ferron returned to Montreal. She was commissioned to design stained glass windows for public buildings in Quebec, including a glass mural for Expo '67. One of her masterpieces is the non-figurative stained glass for the Champ-de-Mars Metro station, completed in 1968. Ferron fostered a close relationship between art and architecture, and helped develop new methods of building glass walls.

AFFILIATIONS AND AWARDS

1947	member of the Automatistes
1961	silver medal, São Paulo Biennial, Brazil
1974	member, Royal Canadian Academy
1977	Prix Louis-Philippe-Hébert, Société Saint-Jean-Baptiste de Montréal
1983	Prix Paul-Émile-Borduas

Member, Contemporary Arts Society
Member, Société des artistes professionnels du Québec

MATURE PERIOD

Circa 1950s and 1960s.

PREFERRED SUBJECT MATTER

The surrounding landscape interpreted in abstraction.

COMPOSITIONAL SUBTLETIES

The free flow of form and colour, whether in oil or glass, enhances the subjective impulse of her abstraction.

Sans titre, 1962, detail.
See page 191.

LATER YEARS

From 1967 to 1979, Ferron taught art at Université Laval in Quebec. She died in Montreal at the age of seventy-seven on November 19, 2001.

EXHIBITION HISTORY

1956, 1961, 1963, 1965 Galerie Agnès Lefort, Montreal

1957–1960 Galerie Denyse Delrue, Montreal

1959 spring exhibition, Art Association of Montreal

1960 *Automatistes*, Pavillon de Marsan, Musée du Louvre, Paris

1961 Walter Moos Gallery, Toronto

1962 *6 Painters of Canada*; travelling to Paris, Turin, Milan, and Zurich

 Festival of Two Worlds, Italy

1963 *Retrospective of Automatistes*, Rome

 Canadian Biennial, Tate Gallery, London

 Artists of Montreal, Musée d'art contemporain de Montréal

1967, 1970 exhibited at Musée d'art contemporain de Montréal

1995 *Marcelle Ferron: Paintings from the 1950s and 1960s*, Galerie d'art Michel Bigué, St. Sauveur, Quebec

Autoportrait, 1974, detail. See page 193.

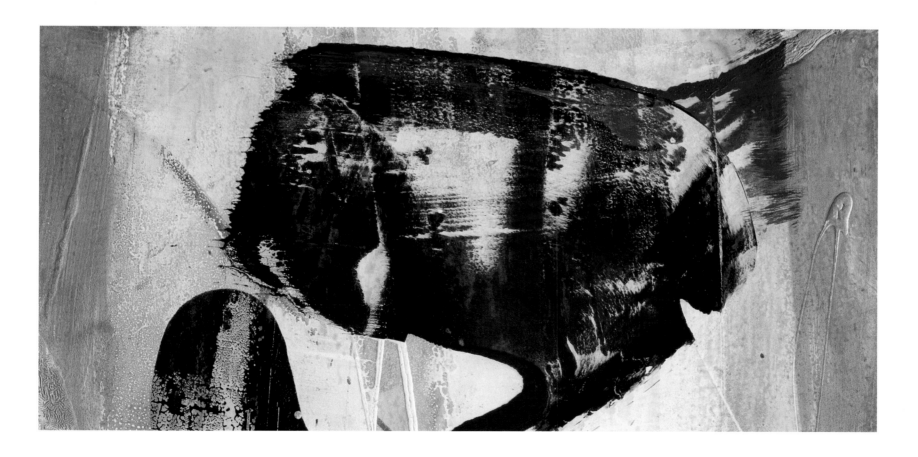

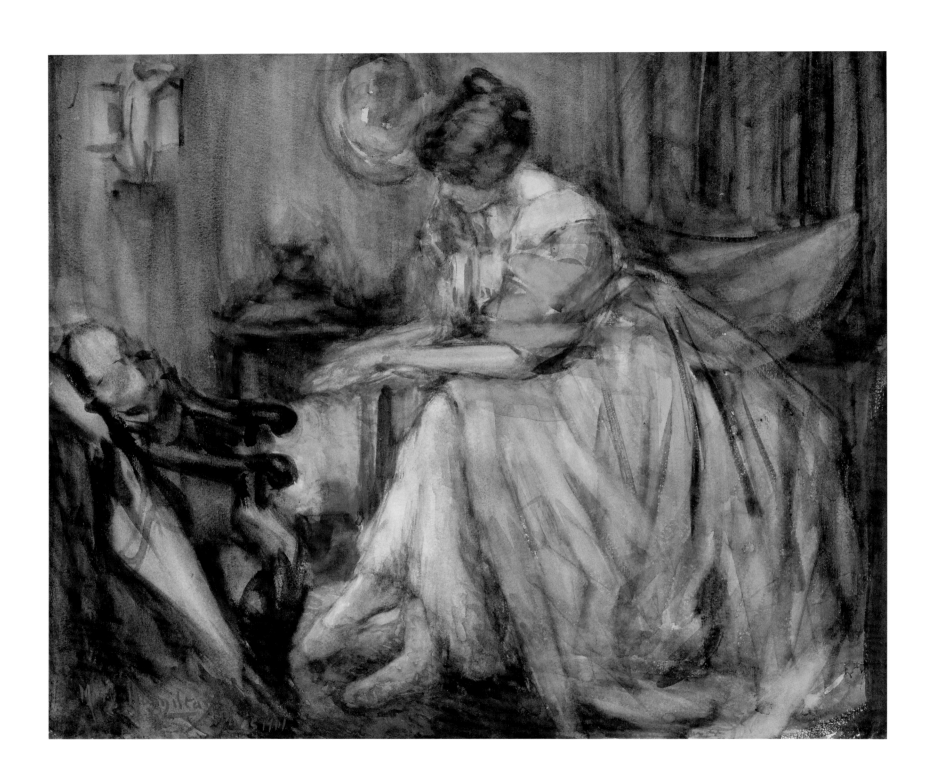

Fireside Contemplation

1901

Watercolour on paper

18 x 21¼ inches (45.7 x 54 cm)

Private Collection, British Columbia

Hamilton, Mary Riter

1873–1954

"I've been lucky, in that I've never had any disappointments about my work."

Mary Riter Hamilton, quoted in Naomi Lang, *Vancouver Sun*, March 5, 1952

EARLY LIFE

Mary Riter Hamilton was born in 1873 in Teeswater, Ontario, to John and Charity Riter. The family moved to Clearwater, Manitoba, when she was a child. In 1889, at the age of sixteen, she met and married Charles W. Hamilton. They moved to Port Arthur, British Columbia, where Charles ran a grocery store. Widowed in 1893, she returned to Manitoba, where she opened a school to teach painting on china. She remained unmarried, devoting her time to painting.

EDUCATION, MENTORS, INFLUENCES

After taking courses with Mary Hiester Reid, G.A. Reid, and Sir Wyly Grier in Toronto, Hamilton travelled to Berlin where she studied for three months under Franz Skarbina (later an instructor of Lawren Harris). In Paris she studied portrait painting with Jacques-Émile Blanche at the Vittie Academy and drawing with Paul-Jean Gervais.

EARLY CAREER

Hamilton travelled extensively throughout Europe until 1911, when her mother's poor health brought her back to Manitoba. In Europe, she painted *plein-air* landscapes and cityscapes, but her *oeuvre* also included pastel portraits of Native people and landscapes of the Rockies.

Hamilton remained in Canada during the First World War and donated paintings to

support the war effort. In 1919, she bravely accepted a commission to paint a tribute to those killed in war. From 1919 to 1922, travelling alone and living in less than comfortable conditions, Hamilton painted the battlefields of France and Belgium where Canadian soldiers fought and gave their lives. These works were shown in the foyer of the Grand Opera House in Paris. In 1925, over two hundred of her battlefield sketches were donated to the Canadian Archives in Ottawa.

The war commission took its toll on Hamilton's health. An illness in 1923 left her blind in one eye, and the subject matter of her works in Europe left Hamilton drained; she almost completely gave up painting upon her return to Canada in 1925.

AFFILIATIONS AND AWARDS

In 1912, she painted a series of portraits of the lieutenant governors of British Columbia, which hang at Government House in Victoria.

Hamilton was the only Canadian artist to be recognized by the French government for her war contributions. In 1922, France named her an Officier d'Académie and awarded her the Palmes Académiques (an honour the French government also gave to Winston Churchill).

1925 diploma and gold medal, Exposition internationale, Paris

MATURE PERIOD

Circa 1898 to 1920.

PREFERRED SUBJECT MATTER

Figurative compositions and landscapes.

COMPOSITIONAL SUBTLETIES

Although there are compositional inconsistencies in the treatment of her subjects from around 1895 to around 1920, Hamilton executed her best work *en plein air* in a style that owes much to Impressionism.

LATER YEARS

Hamilton taught art from 1925 to 1948. She settled in Winnipeg in 1929, but later moved to Vancouver. By 1948, Hamilton had lost her sight and had given up teaching. She lived the rest of her life in Victoria, B.C., and died there in 1954 at the age of eighty-one. She was buried in Port Arthur next to her husband.

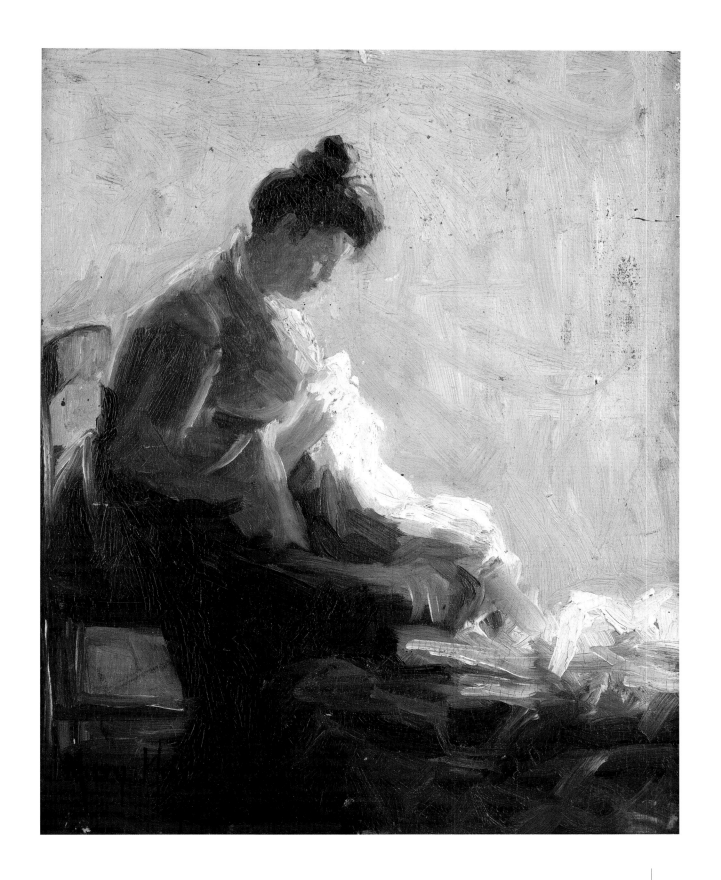

Knitting
c. 1910
Oil on board
11 x 9 inches (27.9 x 23 cm)
Private Collection, Alberta

EXHIBITION HISTORY

1905	Paris Salon (beginning of regular participation in the Salon)
1911	solo show, 150 works, Toronto; travelled to Calgary Public Library, 1913
1915	Panama-Pacific International Exposition, San Francisco
1925	Exposition internationale, Paris
1949	solo exhibition, Vancouver Art Gallery
1952	solo exhibition of landscapes and portraits, Vancouver Art Gallery
1959	memorial exhibition, with works of Sophie Pemberton (Deane-Drummond), Art Gallery of Greater Victoria
2001	*No Man's Land: The Battlefield Paintings of Mary Riter Hamilton (1919–1922)*, Thunder Bay Museum; sponsored by the Thunder Bay Museum, the National Archives, and the War Amputees

Market Scene, Giverny,
1907, detail.
See page 133.

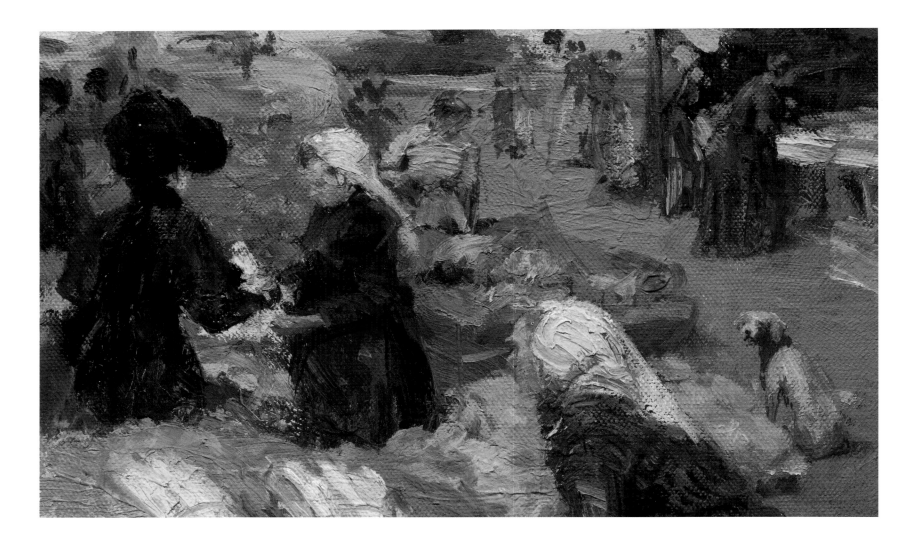

Heward, Efa Prudence

1896–1947

"As we look around the galleries tonight it is as if symphonic music was floating through the rooms – the melody and rhythm flowing and echoing from one canvas to the next – all responding to the baton of the great conductor – and as we listen we seem to hear the glad Hosannas ring – with a song of triumph in our hearts – we enter her house of many mansions and go on our way rejoicing because of Prudence Heward."

Anne Savage, *Memorial Exhibition, Prudence Heward 1896–1947*, National Gallery of Canada

EARLY LIFE

Efa Prudence Heward was born in Montreal on July 2, 1896, the sixth of eight children born to Sarah Efa Jones and Arthur Heward. Her childhood was troubled due to her struggle with asthma. In 1912, when she was only sixteen, her father and two of her sisters died within the year.

Because of her health, Heward was educated at home as a young child. She began taking drawing lessons at age twelve, but her artistic training was hampered by illness. In 1916, the Hewards moved to England and stayed there during the war. Heward and her mother volunteered with the Red Cross, and her brother enlisted. They returned to Montreal in 1918, and Heward used the third floor of their home as a painting studio.

EDUCATION, MENTORS, INFLUENCES

In 1918, Heward studied at the Art Association of Montreal under William Brymner and Randolph Hewton, along with fellow students Edwin Holgate, Sarah Robertson, Anne Savage, Kathleen Morris, Lilias Torrance (Newton), and Emily Coonan. She also took part in summer sketching trips with Maurice Cullen. Heward was not a member of the original Beaver Hall Group of 1920, but she was part of the network of women artists that continued for years informally under the same name.

After winning a scholarship in 1924, she travelled to Europe. In 1925, Heward attended the Académie Colarossi in Paris, studying under Charles Guérin, and at the École des

Woman Reading
c. 1938
Oil on panel
12 x 9 inches (30.5 x 23 cm)
Private Collection, Alberta

beaux-arts under Bernard Naudin. She returned to Europe in 1929, again to study in Paris. It was during this trip that Heward met Canadian painter Isabel McLaughlin, and the two became devoted friends. From 1929 to 1930, they attended the Scandinavian Academy, a smaller school in Paris.

Heward admired the work of artists such as Paul Cézanne, Pierre-Auguste Renoir, Henri Matisse, Pablo Picasso, and Amedeo Modigliani.

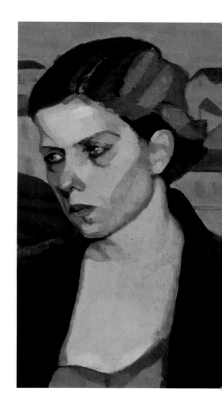

Tonina, 1928, detail.
See page 97.

EARLY CAREER

The Heward family summered near Brockville, Ontario, but after 1936 Heward vacationed with Isabel McLaughlin at the McLaughlin family home in Bermuda, often accompanied by Yvonne McKague (later Housser). Heward often painted in and around Saint-Sauveur, Quebec.

AFFILIATIONS AND AWARDS

1923	Robert Reford Prize, shared with Sybil Robertson
1924	awarded scholarship, Women's Art Society
1929	first prize for painting, Willingdon Arts Competition, for *Girl on a Hill*
1933–1946	founding member, Canadian Group of Painters
1933–1939	vice-president, Canadian Group of Painters
1939	founding member, Contemporary Arts Society

Member, Federation of Canadian Artists

MATURE PERIOD

Circa 1924 to 1946.

PREFERRED SUBJECT MATTER

Figurative and portrait painting.

COMPOSITIONAL SUBTLETIES

Heward's bold but melancholy portraits embody a sensual relish for life.

LATER YEARS

By the late 1930s, Heward's health was in decline. Difficult events took a further toll on her well-being: her hospitalization with asthma, a car accident in 1939, the loss of her friend Sarah Robertson to cancer, and the death of her sister Honor. In 1947, Heward and her mother moved to Arizona with the hope that the dry air would ease her breathing. She was hospitalized in Los Angeles and died there on March 19, 1947, at age fifty.

"The work of Prudence Heward may disturb some of our conventionally minded souls who like their pictures full of detail or painted obediently to long established formulas – but to those who have no preconceived ideas of art, this exhibition should prove very stimulating."

A.Y. Jackson, *Montreal Star*, April 27, 1932

Prudence Heward in an undated photograph.

EXHIBITION HISTORY

1914–1945	exhibited with the Art Association of Montreal
1924–1936	exhibited with the Royal Canadian Academy
1925	*British Empire Exhibition, Canadian Section of Fine Arts*, Wembley, England
1927	*Exposition d'art canadien*, Musée du Jeu de Paume, Paris
1927–1933	*Annual Exhibition of Canadian Art*, National Gallery of Canada, Ottawa
1928	*Exhibition of the Group of Seven*, Art Gallery of Toronto
1930	*Exhibition of Paintings by Contemporary Canadian Artists*, Corcoran Gallery of Art, Washington, D.C.; travelling exhibition
	Paintings by a Group of Contemporary Montreal Artists, Art Association of Montreal
1930, 1931	*Exhibition of the Group of Seven*, Art Gallery of Toronto
1931	*First Baltimore Pan American Exhibition of Contemporary Painting*, Baltimore Museum of Art
1932	solo exhibition, William Scott & Sons, Montreal
	Exhibition of Paintings by Contemporary Canadian Artists, Roerich Museum, International Art Centre, New York
1933	first exhibition of the Canadian Group of Painters, Toronto
	Paintings by the Canadian Group of Painters, Heinz Art Salon, Atlantic City, N.J.
1934	solo exhibition, William Scott & Sons, Montreal
	exhibited with the Canadian Group of Painters, Montreal
	three-woman show, Hart House, University of Toronto
1936	*Exhibition of Contemporary Canadian Paintings*, National Gallery of Canada, Ottawa
	exhibited with the Canadian Group of Painters, Art Gallery of Toronto and National Gallery of Canada, Ottawa
1937	group show of Modernists, Montreal Arts Club
	Exhibition of Paintings, Drawings and Sculpture by Artists of the British Empire Overseas (Coronation Exhibition), Royal Institute Galleries, London
	exhibited with the Canadian Group of Painters, Art Gallery of Toronto

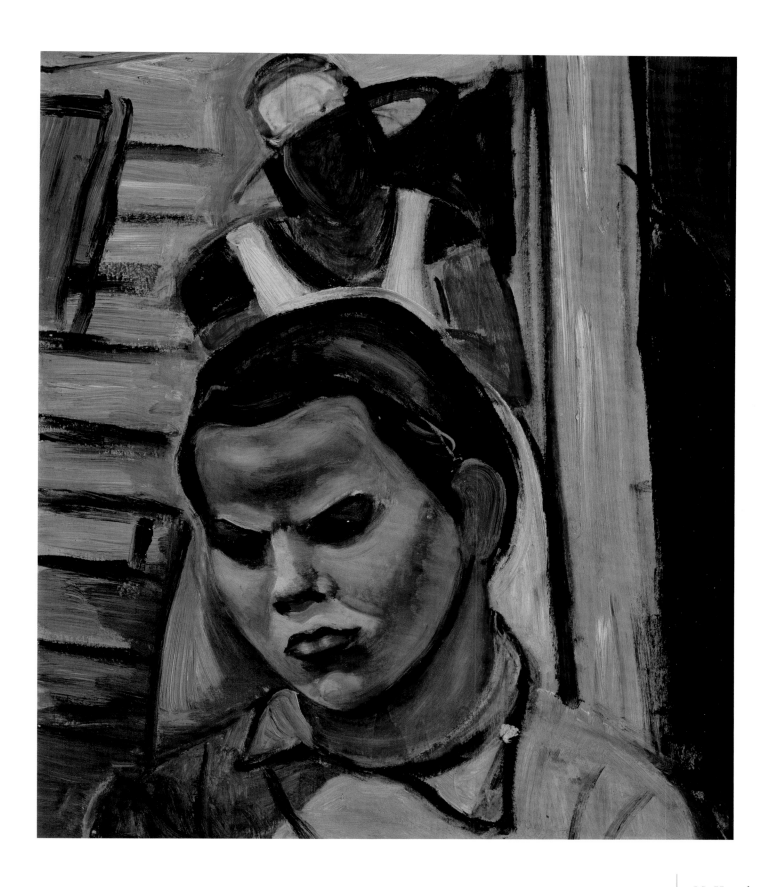

My Housekeeper's Daughter
1938
Oil on panel
12 x 9 inches (30.5 x 22.9 cm)
Private Collection, Ontario

1938	*A Century of Canadian Art*, Tate Gallery, London
	exhibited with the Canadian Group of Painters, Art Association of Montreal
	Sale Aid to Spanish Democracy, 2037 Peel Street, Montreal
1939	*Exhibition by the Canadian Group of Painters,* New York World's Fair
	Golden Gate International Exposition of Contemporary Art, Department of Fine Arts, San Francisco
	exhibited with the Canadian Group of Painters, Art Gallery of Toronto
1940	four-woman show, Art Gallery of Toronto
	Canadian National Committee on Refugees, Exhibition and Auction of Paintings, National Gallery of Canada, Ottawa
	exhibited with the Contemporary Arts Society, Art Association of Montreal
1942	exhibited with the Canadian Group of Painters, Art Gallery of Toronto, Art Association of Montreal, and National Gallery of Canada
	exhibited with the Contemporary Arts Society, National Gallery of Canada, Ottawa
1944	three-woman show, Art Association of Montreal
	exhibited with the Canadian Group of Painters, Art Gallery of Toronto and Art Association of Montreal
	Canadian Art 1760–1943, Yale University Art Gallery, New Haven
	Pintura Canadense Contemporânea, Museu Nacional de Belas Artes, Rio de Janeiro
	exhibited with the Contemporary Arts Society, Art Gallery of Toronto
	Oil Paintings by Lilias Torrance Newton, RCA, Prudence Heward, Anne Savage, and Ethel Seath, Art Association of Montreal
1945	three-woman show, Willistead Art Gallery, Windsor
	The Development of Painting in Canada 1665–1945, Art Association of Montreal and Art Gallery of Toronto
	exhibited with the Canadian Group of Painters, Art Gallery of Toronto
1946	exhibited with the Contemporary Arts Society, Art Association of Montreal
1947	*Canadian Women Artists*, Riverside Museum, New York
1948	*Memorial Exhibition, Prudence Heward 1896–1947*, National Gallery of Canada, Ottawa; travelling exhibition
1949	*Canadian Women Painters*, West End Gallery, Montreal
	Fifty Years of Painting in Canada, Art Gallery of Toronto
1964	solo exhibition, Continental Galleries, Montreal
1966	*The Beaver Hall Hill Group*, National Gallery of Canada, Ottawa

1975	*Canadian Painting in the Thirties*, National Gallery of Canada, Ottawa	*Girl Under a Tree*, 1931, detail. See page 101.
	From Women's Eyes: Women Painters in Canada, Agnes Etherington Art Centre, Kingston, Ontario	
1979	*Prudence Heward and Friends*, Art Gallery of Windsor	
1980	exhibited with the Contemporary Arts Society, Edmonton	
1982	*Modernism in Quebec Art: 1916–1946*, National Gallery of Canada, Ottawa	
1983	*Visions and Victories: 10 Canadian Women Artists*, London Regional Art Gallery, Ontario	
1986	*Expressions of Will: The Art of Prudence Heward*, Agnes Etherington Art Centre, Kingston, Ontario; travelled to McMichael Canadian Art Collection in Kleinburg, Ontario	
1997	*Montreal Women Painters on the Threshold of Modernity,* Montreal Museum of Fine Arts	

Indian Encampment,
Lake Huron

1870

Watercolour on paper

6.5 x 11 inches, (16.5 x 27.9 cm)

The Thomson Collection, Ontario

Hopkins, Frances Anne (née Beechey)
1838–1919

> "I have not found Canadians at all anxious hitherto for pictures of their own country. I sent some very nice ones out to W. Scott and Sons, Fine Art dealers – but they did not sell."
>
> Frances Hopkins, quoted in Janet Clark and Robert Stacey, *Frances Anne Hopkins, 1838–1919: Canadian Scenery*

EARLY LIFE

Frances Anne Hopkins (née Beechey) was born in England on February 2, 1838, the third of five sisters born to Charlotte Stapleton and Rear Admiral Frederick William Beechey. Admiral Beechey, an Arctic explorer and painter, passed on to his daughter the desire to make art, just as it had been passed on to him from his father, English portrait painter Sir William Beechey.

EDUCATION, MENTORS, INFLUENCES

Frances Beechey studied under her father and grandfather, both accomplished artists, but it is not known if she received further formal training in art. Young women in this period were often taught to paint by private tutors or family members who were artists themselves. An education that included art studies was acceptable for women, but a professional career as an artist was not.

EARLY CAREER

At age twenty, Frances Beechey met and married Edward Martin Hopkins, secretary to Sir George Simpson of the Hudson's Bay Company. This marriage was his second, and Hopkins became not only a new bride, but also a stepmother to his three sons. Frances Anne Hopkins followed her husband to Canada, and they settled first in Lachine, Quebec, and finally, in Montreal.

Edward Hopkins's position required extensive travel to inspect the fur trading posts along the inland water routes established by the Hudson's Bay and North West companies.

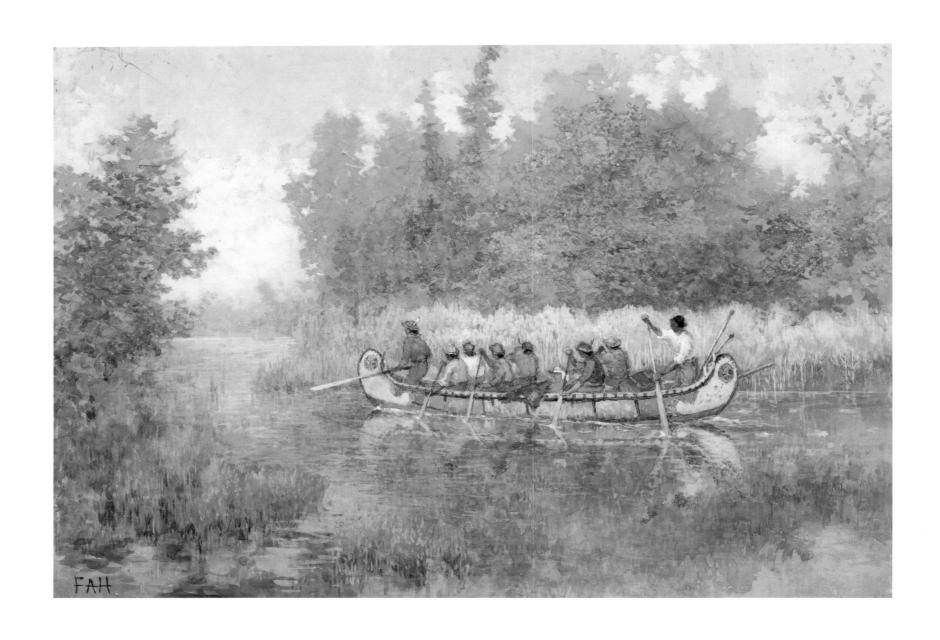

The Autumn Voyageurs

c. 1870

Watercolour on paper

14 x 21 inches (35.5 x 53.3 cm)

Private Collection, Ontario

Hopkins accompanied her husband whenever possible, and their travels by birchbark canoe gave her the opportunity for *plein-air* sketching. Her sketchbooks portray the voyageur's life as seen from the canoe at a time when a fast-disappearing Canadian frontier was giving way to the railway, which had begun cutting its path from coast to coast by the 1850s.

When Hopkins was not travelling, she cared for her family. By 1861, she had given birth to two boys, Raymond and Wifred, and in 1863, a girl, Olive. Tragedy struck the family twice however, with the death of one son in 1864, and another in 1869.

AFFILIATIONS AND AWARDS
Member, Royal Society of British Artists
Member, Royal Academy of Arts, London
1988 Canada Post issued a stamp featuring one of her paintings

MATURE PERIOD
Circa 1860s and 1870s.

PREFERRED SUBJECT MATTER
At first glance, Hopkins's compositions resemble those of her contemporary Cornelius Krieghoff, yet they differ in their psychological overtones. Hopkins introduced an element of tenderness not seen in the more rugged approach used by Krieghoff.

COMPOSITIONAL SUBTLETIES
Watercolour was Hopkins's preferred medium. In it she achieved a fluidity that is distinguishable from her work in oil.

LATER YEARS
Edward and Frances Hopkins returned to England in 1870 after Edward's retirement. They moved first to London and then settled permanently in Oxfordshire. Edward died in 1874, and Frances Hopkins, who regarded herself as a professional artist, continued her career, often sending work for sale to W. Scott & Sons in Montreal and to Goupil & Cie in Paris. Frances Hopkins died on March 5, 1919, at the age of eighty-one, in London.

EXHIBITION HISTORY
1867 Royal Society of British Artists, London
1869–1891 exhibited with the Royal Academy of Arts, London, a total of thirteen times
1870 exhibited with the Art Association of Montreal; sixteen works shown
1990 *Frances Anne Hopkins, 1838–1919: Canadian Scenery,* Thunder Bay Art Gallery,
 Ontario and the National Library and Archives

No One to Dance With,
1877, detail. See page 45.

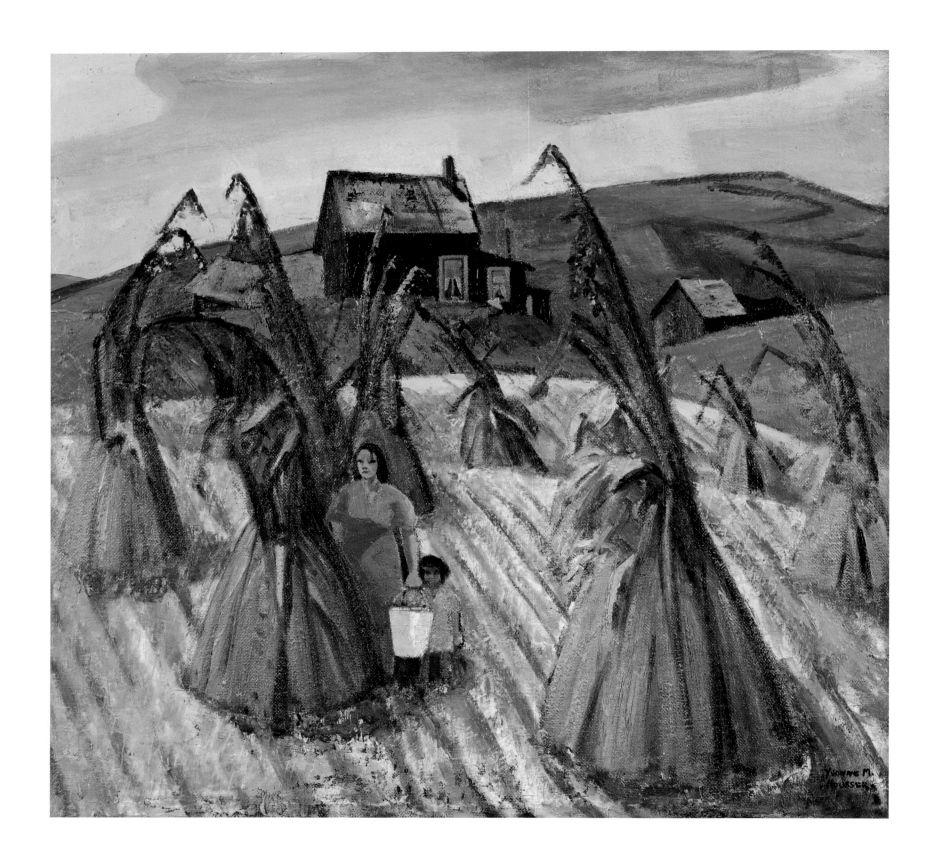

Haliburton Farm

c. 1945

Oil on board

30 x 32 inches (76.2 x 81.3 cm)

Private Collection, Alberta

Housser, (Muriel) Yvonne McKague

1898–1996

"Studying in these ateliers necessarily has a broadening effect on the sincere artist who is receptive to impressions. Here in Canada, we face the condition of working with students and masters of the same race, of the same general mental characteristics. Canadian art is as if it were sifted through one mind. In Paris, however, one is associated with students from almost every country in the world."

Yvonne McKague [Housser], quoted in "Paris – the Magnet," *Quality Street,* April 1926

EARLY LIFE

Yvonne McKague Housser was born Muriel Yvonne McKague in Willowdale, Ontario, on August 4, 1898, and spent her life in Toronto. Her parents, Hugh Henry McKague and Louise Elliott, were both artistic; it was no surprise that their daughter was naturally inclined towards the arts.

EDUCATION, MENTORS, INFLUENCES

At age sixteen, Yvonne McKague began studying at the Ontario College of Art under G.A. Reid, William Cruikshank, J.W. Beatty, and Emanuel Hahn; she graduated in 1917. She worked for F.H. Varley and Arthur Lismer as their teaching assistant in 1920 before leaving Canada to study at the Académie de la Grande Chaumière, the Académie Colarossi, and the Académie Ransom in Paris under Lucien Simon and Maurice Denis.

In her work she was influenced initially by the Group of Seven, but later became more interested in abstraction.

EARLY CAREER

Upon her return to Canada, Yvonne McKague taught at the Ontario College of Art until 1949. In 1935, she married Frederick B. Housser, a columnist for the *Toronto Star* and author of *A Canadian Art Movement: The Story of the Group of Seven* (1926). After the death of her husband only a year later, in 1936, Housser travelled throughout northern Ontario on

sketching trips with Prudence Heward, Rody Kenny Courtice, and Isabel McLaughlin. She never remarried. Housser was one of the illustrators for Marius Barbeau's *The Kingdom of the Saguenay*, published in 1936. In 1938, she and McLaughlin visited Taos, New Mexico, to study under Emil Bisttram.

Yvonne McKague Housser in an undated photograph.

AFFILIATIONS AND AWARDS

1928–1937	member, Ontario Society of Artists
1933–1967	founding member, Canadian Group of Painters
1942	associate member, Royal Canadian Academy of Arts
	member, Federation of Canadian Artists
1951	full member, Royal Canadian Academy of Arts
1955–1956	president, Canadian Group of Painters
1965	Baxter Purchase Award, Ontario Society of Artists, for *Spring Stirs the Earth*
1984	received Order of Canada

MATURE PERIOD

Circa 1920s and 1930s.

PREFERRED SUBJECT MATTER

Landscape, and later, abstraction.

COMPOSITIONAL SUBTLETIES

Volumetric elements in brooding landscapes painted in bold colour.

LATER YEARS

When her teaching ended at the Ontario College of Art in 1949, she took teaching positions at the Doon School of Fine Arts in Kitchener and the Ryerson Polytechnical Institute in Toronto. Yvonne McKague Housser died in Toronto in 1996, at age ninety-eight.

EXHIBITION HISTORY

1923	exhibited with the Royal Canadian Academy of Arts, Toronto
1924	exhibited with the Ontario Society of Artists, Toronto
	British Empire Exhibition, Canadian Section of Fine Arts, Wembley, England
1928	*Exhibition of the Group of Seven*, Art Gallery of Toronto
1930, 1931	*Exhibition of the Group of Seven*, Art Gallery of Toronto
1937	*Exhibition of Paintings, Drawings and Sculpture by Artists of the British Empire Overseas* (Coronation Exhibition), Royal Institute Galleries, London

1938	*A Century of Canadian Art*, Tate Gallery, London
1939	*Exhibition by the Canadian Group of Painters*, New York World's Fair
	Great Lakes, Albright Gallery, Buffalo
1944	*Pintura Canadense Contemporânea*, Museu Nacional de Belas Artes, Rio de Janeiro
1947	*Canadian Women Artists*, Riverside Museum, New York
1949	*Fifty Years of Painting in Canada*, Art Gallery of Toronto
1953	three-person show, Art Gallery of Toronto
1955	solo exhibition, Victoria College, University of Toronto
1975	*Canadian Painters in the Thirties*, National Gallery of Canada, Ottawa
1998	*4 Women Who Painted in the 1930s and 1940s: Rody Kenny Courtice, Bobs Cogill Haworth, Yvonne McKague Housser and Isabel McLaughlin*, Carleton University Art Gallery, Ottawa

"You have to be true to yourself but at the same time understand, or try to, the world of today in all its manifestations. … The artist is and always has been ahead of his time. … I was brought up at the beginning of this new age in painting, and it has taken me years of study, looking, reading, and experimenting to move slowly into some understanding of the many changes that have taken place in my long lifetime as a painter … "

Yvonne McKague Housser, quoted in Dorothy Hoover, "One of the Unforgettables: Yvonne McKague Housser," *Ontario College of Art Alumni Newsletter,* Spring/Summer 1979

Spring Pattern, 1955, detail. See page 177.

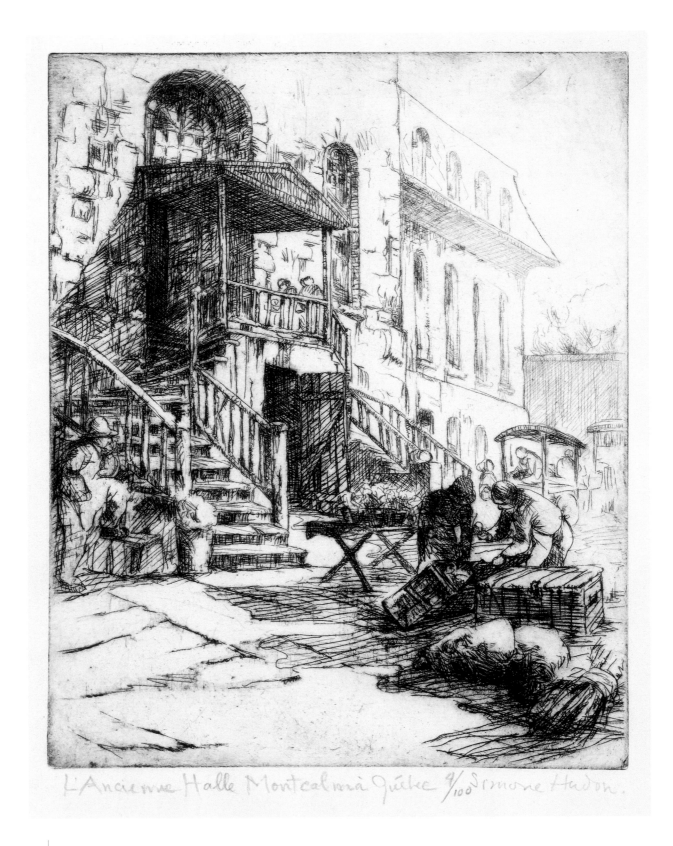

L'Ancienne Halle Montcalm à Québec ⁹/₁₀₀ Simone Hudon.

L'Ancienne Halle
Montcalm à Québec
c. 1935
Etching on paper
14 x 11 inches (35.5 x 27.9 cm)
Private Collection, Ontario

Hudon-Beaulac, Simone Marie Yvette

1905–1984

"She loves her city, its secret corners, the houses clinging to the hillside by some inexplicable law of equilibrium, its picturesque streets; she adores it all and paints it with love, sincerity, and an understanding that only a Quebec artist could achieve."

Jean Paul Lemieux, quoted in Monique Duval, *Le Soleil* (Quebec City), June 17, 1977

EARLY LIFE

Simone Hudon-Beaulac was born Simone Marie Yvette Hudon in Quebec City on September 9, 1905.

EDUCATION, MENTORS, INFLUENCES

After attending L'École des Ursulines, Simone Hudon spent five years studying at the École des beaux-arts in Quebec City, under H. Ivan Neilson and Lucien Martial, and received her diploma for teaching art. Here she met her future husband, Henri Beaulac, a furniture builder and interior decorator.

Her native city and the surrounding countryside were the greatest sources of inspiration for her art.

EARLY CAREER

In 1931, Hudon-Beaulac succeeded H. Ivan Neilson as teacher of engraving at the École des beaux-arts, and continued to teach there until 1945. She also taught classes in perspective, interior design, and illustration.

1930 member, Canadian Society of Graphic Artists

 member, Society of Canadian Painter-Etchers and Engravers

In 1951, one of Hudon-Beaulac's bronze sculptures was chosen to be made into the award given by the Association of Canada for the best news story of the year.

MATURE PERIOD

Circa 1930s and 1940s.

PREFERRED SUBJECT MATTER

Street and harbour scenes of Quebec City.

COMPOSITIONAL SUBTLETIES

Hudon-Beaulac extracted great depth and subtleness of tone in her etchings.

LATER YEARS

After leaving teaching in 1945, she settled in Montreal and illustrated several works of Canadian authors as well as many children's books. In 1967, Hudon-Beaulac produced a portfolio of etchings accompanied by a text of her own poetry, *Au fil des côtes de Québec*, which was published by the Quebec government.

Simone Hudon-Beaulac died in Quebec City on August 5, 1984, at age seventy-eight.

Simone Hudon in her studio, Montreal, c. 1948.

EXHIBITION HISTORY

1937 exhibited with the Etching and Engraving Society of Philadelphia

1938 joint exhibition with sculptor Sylvia Daoust, École des beaux-arts, Montreal

1977 retrospective exhibition, Maison Maheu-Couillard, Quebec City

1982 joint exhibition with sculptor Yvonne-Marie Gra, Galerie Crescent, Montreal

1984 retrospective exhibition; travelled to London, England, and the Metropolitan Museum of Art, New York

 Contemporary Art of the Western Hemisphere, Metropolitan Museum of Art, New York; Hudon was chosen to represent Quebec

 exhibition at the Devon Art Club, London, with artists A. Cleighton, William Walcot, Charles Simpson, and Edwin Holgate

 Women International Exhibition, New York; exhibited etchings

Jones, Frances Maria (Bannerman)

1855–1944

"Miss F.M. Jones (daughter of Hon. A.G. Jones), whose paintings attracted considerable attention at an exhibition of the Royal Canadian Academy of Arts two years ago, has for some time been pursuing her studies in Paris, and has recently won marked success in that severe school. Two of her paintings offered to the Salon this year have been accepted. When it is considered that about eight thousand paintings were offered and over five thousand of those were rejected, the fact that both of Miss Jones' were accepted shows that her work was of high merit."

Gazette (Montreal), April 24, 1883, quoted in Mora Dianne O'Neill and Caroline Stone, *Two Artists Time Forgot*

EARLY LIFE

Frances Maria Jones was born in Halifax on April 8, 1855. Her father was the Lieutenant Governor of Nova Scotia and a businessman in the horticulture, fishery, insurance, and transportation industries. She was one of six children, and art lessons were part of their education. Her first art lessons were with her mother, Margaret Wiseman Stairs. After her mother's death, her father remarried.

EDUCATION, MENTORS, INFLUENCES

Jones continued her art lessons under Forshaw Day in Halifax. In 1878, she left home to study in Paris, living with her sister Alice.

Women painters were not admitted to the École des beaux-arts, but many private ateliers took female students. Jones studied under Édouard Krug and Augustin Feyen-Perrin. To subsidize her training, she sold topical pictures to the illustrated magazines.

With her contemporary Margaret Campbell Macpherson, Frances Jones is recognized as one of the first Canadian painters to incorporate the new methods of Impressionism into her art.

EARLY CAREER

Jones, who suffered from arthritis, spent time painting in Brittany and other places that had a climate suited to her health. In 1886, she married Hamlet Bannerman, a British painter, and settled in England.

AFFILIATIONS AND AWARDS

1881 first female associate member, Royal Canadian Academy of Arts; prohibited
 from the full privileges of membership afforded to men

The painting she submitted to the 1883 Paris Salon was the first painting of a Canadian subject to be shown at an official Salon.

MATURE PERIOD

Circa 1882 to 1910.

PREFERRED SUBJECT MATTER

Frances Jones (Bannerman) signed her paintings with her initials, a common practice among women artists so as not to reveal their gender. As with Frances Anne Hopkins, Jones's subject matter was not typically "feminine." She chose subjects considered daring for women, such as the depiction of the life around her, whether abroad or in Canada. Many of her finest works were portraits of family members.

COMPOSITIONAL SUBTLETIES

Her work was Impressionist, capturing the moment without sentimentality.

LATER YEARS

Most of Frances Jones Bannerman's married life was spent in England. In 1895 her husband died, and a few years later, when the harsh climate of England affected her ability to paint, she moved to Alassio, Italy. Still needing a creative outlet, she devoted her time to writing poetry. She remained in Italy until 1940, but as the Second World War took hold, she boarded a ship back to England, settling in Chagford, Devon. Frances Jones Bannerman died four years later in Torquay, Devon, on October 6, 1944, at the age of eighty-nine.

EXHIBITION HISTORY

1881–1883	exhibited with the Royal Canadian Academy
1882, 1883	winter exhibition, Royal Society of British Artists, London
1883, 1884	Paris Salon
	exhibited with the Royal Society of British Artists, London
1885	exhibited with the Royal Academy, London
	exhibited with the Royal Society of British Artists, London
	Walker Gallery, Liverpool
1886	winter exhibition, Royal Society of British Artists, London
1887	loan exhibition, Victoria School of Art and Design, Halifax
1888	exhibited with the Royal Academy, London
	Walker Gallery, Liverpool
1889, 1890	exhibited with the Royal Society of British Artists, London
1890, 1891	exhibited with the Royal Academy, London
	Walker Gallery, Liverpool
1904	loan exhibition, Victoria School of Art and Design, Halifax
1907–1908	provincial exhibition, Nova Scotia
1949	*200 Years of Art in Halifax*, Queen Elizabeth High School, Halifax
1975	*A Selection of Works by Women Artists in Nova Scotia 1850–1950*, Centennial Art Gallery, Halifax
1976	*Through Canadian Eyes: Trends and Influences in Canadian Art 1815–1965*, Glenbow Museum, Calgary
1984	*Backgrounds: Ten Nova Scotia Women Artists*, Dalhousie Art Gallery, Halifax
1988	*Eighty/Twenty: 100 Years of the Nova Scotia College of Art and Design*, Art Gallery of Nova Scotia, Halifax
1995	*Visions of Light and Air*, The Americas Society, New York
2001	*Choosing Their Own Path: Canadian Women Impressionists*, Art Gallery of Nova Scotia, Halifax

Lewis, Maud (née Dowley)
1903–1970

> "Maud Lewis … embodies the free spirit of folk artists working outside the mainstream, liberated from preconceived notions about art. By creating work that brings joy and reflects simplicity, she succeeded in illuminating the best of the human spirit."
>
> Bernard Riordon, director of the Art Gallery of Nova Scotia, quoted in *Canadian Paintings, Prints and Drawings* by Anne Newlands

EARLY LIFE
Maud Lewis (née Dowley) was born in Yarmouth County, Nova Scotia, on March 7, 1903, the daughter of John Nelson Dowley, a harness maker, and Agnes Dowley. She grew up on a farm along with her older brother, Charles. Maud suffered from birth defects and remained diminutive. Her mother taught her to play piano and gave her art lessons. Together, Maud and her mother painted Christmas cards, which they sold door to door.

EDUCATION, MENTORS, INFLUENCES
Maud Dowley's exposure to art as a child, under her mother's tutelage, ignited the flame that inspired her to continue painting throughout her adult life.

EARLY CAREER
In 1938, Maud Dowley married Everett Lewis, a fish peddler, and moved into his small cabin in Marshalltown, just west of Digby. While Everett worked, Maud would paint and sell greeting cards. Soon she began to paint on boards of a size comfortable for her to handle. Eventually, her paintings gained in reputation, and visitors from near and far stopped by the tiny home to purchase her Nova Scotia scenes.

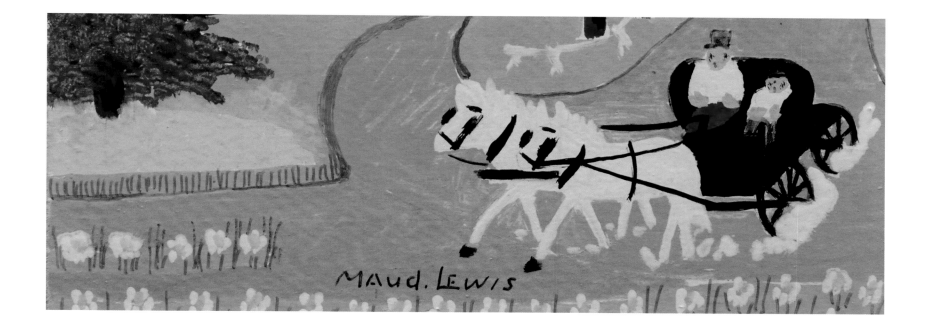

AFFILIATIONS AND AWARDS
In 1965, Maud Lewis was the subject of a nationally broadcast CBC television documentary. In the 1970s, President Richard Nixon bought two of Maud Lewis's paintings for the White House.

MATURE PERIOD
Circa 1940s and 1950s.

PREFERRED SUBJECT MATTER
Rural scenes of Nova Scotia that celebrate joy.

COMPOSITIONAL SUBTLETIES
Naive painting with fresh, bold colours and timeless themes.

LATER YEARS
Maud Lewis's marriage lasted over thirty years. In 1968, she was hospitalized for pneumonia and complications from a broken hip. She died on July 30, 1970, at age sixty-seven.

EXHIBITION HISTORY
1967 *Centennial Exhibition of Primitive Art in New Brunswick,* Beaverbrook House, Saint John

Fording the Stream, (undated), detail. See page 181.

Lockerby, Mabel Irene
1882–1976

> " ... playing fancifully with the small, intimate things of the woods."
>
> Robert Ayre, describing Lockerby in "Art in Montreal," *Canadian Art*, Autumn 1950

EARLY LIFE

Mabel Irene Lockerby was born in Montreal on March 13, 1882. She was the second of five children born to Alexander Linton Lockerby and Barbara Cox. Spending her entire life in Montreal, Lockerby never married, choosing instead to devote herself to her art. Much of her life was spent in genteel poverty.

EDUCATION, MENTORS, INFLUENCES

Lockerby studied under William Brymner at the Art Association of Montreal and took part in summer sketching trips with Maurice Cullen. Some of the artists who influenced her include Sarah Robertson, Randolph Hewton, Albert Henry Robinson, and the French Impressionists.

EARLY CAREER

Lockerby worked as a professional painter. She was a member of the original Beaver Hall Group, and she remained a part of the network of women artists that continued informally for years under the same name.

Lockerby enjoyed a lifelong companionship with her cousin Ernest McNown.

1903	awarded scholarship, Art Association of Montreal, shared with Ruth Barr
1920	founding member, Beaver Hall Group, Montreal
1929	honourable mention, Willingdon Arts Competition for *Marie et Minou*
1938	member, Contemporary Arts Society, Montreal
1939–1967	member, Canadian Group of Painters
1946	Jury II Prize, Art Association of Montreal for *Old Towers*

MATURE PERIOD

Circa 1915 to 1945.

PREFERRED SUBJECT MATTER

Still life, compositions of figures and objects in the interior and in landscape.

COMPOSITIONAL SUBTLETIES

Naivety in form and fanciful in content.

LATER YEARS

Near the end of her life, Lockerby moved in with her sister, who also had never married. She died in Montreal at the age of ninety-four on May 1, 1976, within a month of the death of her cousin Ernest.

EXHIBITION HISTORY

1914–1956	exhibited with the Art Association of Montreal
1915–1929	exhibited with the Royal Canadian Academy of Arts
1921	first annual exhibition of Beaver Hall Group, Montreal
1922	Beaver Hall Group, Montreal
1924–1925	*British Empire Exhibition, Canadian Section of Fine Arts*, Wembley, England
1925	special exhibition of the Royal Canadian Academy, National Gallery of Canada, Ottawa
	Contemporary Canadian Artists, Chowne Art Dealer, Montreal
1926	*Special Exhibition of Canadian Art* (first annual), National Gallery of Canada, Ottawa
1927	*Exposition d'art canadien*, Musée du Jeu de Paume, Paris
1928–1929	*Annual Exhibition of Canadian Art*, National Gallery of Canada, Ottawa
1930	*Exhibition of Paintings by Contemporary Canadian Artists*, Corcoran Gallery of Art, Washington, D.C.; travelling exhibition

On the Canal, 1926, detail.
See page 145.

1930	*Paintings by a Group of Contemporary Montreal Artists*, Art Association of Montreal
1932	*Annual Exhibition of Canadian Art*, National Gallery of Canada, Ottawa
1933	*Exhibition of Paintings by Canadian Group of Painters*, Art Gallery of Toronto
1934	exhibited with the Canadian Group of Painters, Montreal
	Canadian Paintings, The Collection of the Hon. Vincent and Mrs. Massey, Art Gallery of Toronto
1936	*Exhibition of Contemporary Canadian Paintings*, National Gallery of Canada, Ottawa
	exhibited with the Canadian Group of Painters, Art Gallery of Toronto and National Gallery of Canada, Ottawa
1937	group show of Modernists, Montreal Arts Club
	Exhibition of Paintings, Drawings and Sculpture by Artists of the British Empire Overseas (Coronation Exhibition), Royal Institute Galleries, London
	exhibited with the Canadian Group of Painters, Art Gallery of Toronto
1938	*A Century of Canadian Art*, Tate Gallery, London
1939	*Exhibition by the Canadian Group of Painters*, New York World's Fair
	exhibited with the Canadian Group of Painters, Art Gallery of Toronto
1940	*Canadian National Committee on Refugees, Exhibition and Auction of Paintings*, National Gallery of Canada, Ottawa
	exhibited with the Contemporary Arts Society, Art Association of Montreal
1941	four-woman show, Art Gallery of Toronto
1942	exhibited with the Canadian Group of Painters, Art Gallery of Toronto, Art Association of Montreal, and National Gallery of Canada, Ottawa
1944	exhibited with the Canadian Group of Painters, Art Gallery of Toronto and Art Association of Montreal
	Canadian Art 1760–1943, Yale University Art Gallery, New Haven
	Pintura Canadense Contemporânea, Museu Nacional de Belas Artes, Rio de Janeiro
1946	exhibited with the Contemporary Arts Society, Art Association of Montreal
1947	*Canadian Women Artists*, Riverside Museum, New York
1949	*Canadian Women Painters,* West End Gallery, Montreal
	exhibited with the Canadian Group of Painters, Art Gallery of Toronto, Montreal Museum of Fine Arts; travelling exhibition
1950	*Six Montreal Women Painters*, Montreal Museum of Fine Arts
	exhibited with the Canadian Group of Painters, Art Gallery of Toronto

Summer Shadows

c. 1921

Oil on panel

9 x 12 inches (23 x 30.5 cm)

Private Collection, Quebec

1952	three-woman show, Montreal Museum of Fine Arts
1954	400th Anniversary Exhibition, São Paulo
1955	exhibited with the Canadian Group of Painters, Art Gallery of Toronto and Montreal Museum of Fine Arts
1958	exhibited with the Canadian Group of Painters, Art Gallery of Toronto and Vancouver Art Gallery
1960, 1962	exhibited with the Canadian Group of Painters, Art Gallery of Toronto
1965	exhibited with the Canadian Group of Painters, Art Gallery of Greater Victoria and Agnes Etherington Art Centre, Kingston, Ontario
1966	*The Beaver Hall Hill Group*, National Gallery of Canada, Ottawa
1982	*Women Painters of the Beaver Hall Group*, Sir George Williams Art Gallery, Montreal
1989	*Mabel Irene Lockerby: Retrospective Exhibition*, Walter Klinkhoff Gallery, Montreal
1991	*The Beaver Hall Hill Group*, Kaspar Gallery, Toronto
1997	*Montreal Women Painters on the Threshold of Modernity,* Montreal Museum of Fine Arts

The Haunted Pool, 1947, detail. See page 147.

Long, Marion

1882–1970

> "I determined that nothing like makeshift would find its way into my work. I made up my mind that I was not going to be another of those painters who, when they have difficulty in painting the feet of cattle, bury those feet in long grass, or cover a difficult neck with a scarf. There was going to be no slighting in my work."
>
> Marion Long, quoted in Muriel Miller, *Famous Canadian Artists*

EARLY LIFE

Marion Long was born in Toronto on September 19, 1882, to William Edwin Long and Elizabeth Marion Morehouse.

EDUCATION, MENTORS, INFLUENCES

Long first became interested in art at Model School in Toronto. She completed her schooling at St. Margaret's College in Toronto before continuing her studies at the Central Ontario School of Art under G.A. Reid and F.S. Challener. In 1905, Laura Muntz came to the studio Long shared to give her weekly instruction and offer criticism of her work.

From 1907 to 1908, Long studied in New York at the Art Students League under Robert Henri, Kenneth Hayes Miller, and William Merritt Chase, and then in 1913, under Charles Hawthorne in Provincetown, Massachusetts. Hawthorne's instruction led her to use colour in a higher key.

EARLY CAREER

Upon her return to Toronto in 1913, Long opened a studio. Between 1915 and 1926, she occupied Studio One in the Studio Building, where she became a good friend of Tom Thomson. She bought what would become one of his most famous paintings, *In Algonquin Park* (now in the McMichael Canadian Art Collection, Kleinburg). From 1928 to 1937, she had a studio on Grenville Street. Long painted many portraits – among them is one of Florence McGillivray done in 1936. With her portraits, streetscapes, and still lifes, she sought to earn a living.

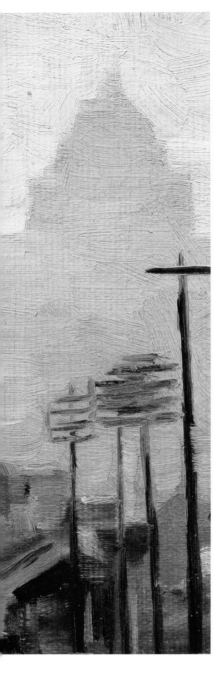

Bay Street, Looking South, c. 1920, detail.

See page 143.

1916–1970	member, Ontario Society of Artists
1919	president, Heliconian Club, Toronto
1922	associate member, Royal Canadian Academy of Arts
1933	full member, Royal Canadian Academy of Arts

Member, Ontario Institute of Painters

Long was commissioned to do portraits of the Royal Norwegian Air Force, for which she was awarded the King Haakon VII medal of liberation in 1948 "for services to the Norwegian cause during the war."

MATURE PERIOD

Circa 1920 to 1945.

PREFERRED SUBJECT MATTER

Street scenes, often of Toronto, still lifes, and portraits.

COMPOSITIONAL SUBTLETIES

Long's sympathetic and penetrating work was technically above reproach. She was particularly gifted as a painter of children.

LATER YEARS

Marion Long died at age eighty-seven in Toronto, August 19, 1970.

EXHIBITION HISTORY

1905–1958	exhibited with the Royal Canadian Academy of Arts
1916–1970	exhibited with the Ontario Society of Artists
1924	*British Empire Exhibition, Canadian Section of Fine Arts,* Wembley, England
1937	*Contemporary Canadian Art;* travelled to South Africa, Australia, and New Zealand
1938	*A Century of Canadian Art,* Tate Gallery, London
1939	*Exhibition by the Royal Canadian Academy of Arts,* New York World's Fair
1942	Eaton's Fine Art Galleries, Toronto
1945	*Development of Painting in Canada 1665–1945,* Art Association of Montreal and Art Gallery of Toronto
1945	Carroll Fine Arts Gallery, Toronto
1952, 1954	Mr. & Mrs. Gordon Conn's Little Gallery, Toronto

Lyall, Laura Adeline Muntz
1860–1930

"My hobbies are only two – painting and children. I don't know which I am fondest of."

Laura Muntz Lyall, quoted in Irene B. Hare, *Toronto Sunday World*, July 13, 1924

"A painter of mothers and little children – mothers with all the sweetness and spirituality of the Madonna of the ancients in their faces, and children with the sturdy happiness and fun of childhood shining out of their eyes, yet with a dreaminess and imagination of creatures of another world."

Irene B. Hare, *Toronto Sunday World*, July 13, 1924

EARLY LIFE
Laura Muntz Lyall was born Laura Adeline Muntz in Leamington Spa, Warwickshire, England, on June 18, 1860. Her family moved to Canada when she was a young girl, settling in the Muskoka district of Ontario.

EDUCATION, MENTORS, INFLUENCES
Laura Muntz was initially encouraged to study art by William Charles Forster, a public school drawing master in Hamilton, Ontario, who saw her work while on a sketching trip in Muskoka. She studied with Forster from 1873 to 1881, and he became a lifelong mentor and friend. Beginning in 1882, she attended classes at the Ontario School of Art, studying under Lucius O'Brien. She then returned to Hamilton for further study with Forster. In 1889, she travelled to London, England, and studied at St. John's Wood Art School. In 1890, she opened an art studio in Hamilton to teach art. Muntz also attended the Toronto Art School (formerly, the Ontario School of Art) to study under G.A. Reid. In 1892 she travelled to France and enrolled at the Académie Colarossi in Paris, studying under Gustave Courtois, Louis-Auguste Girardot, and Paul-Joseph Blanc.

A Florentine

1913

Oil on canvas

36½ x 26½ inches (92.7 x 67.3 cm)

Private Collection, Ontario

EARLY CAREER

Muntz spent years studying and travelling widely, often taking sketching trips in France, Holland, and Italy. At the Paris Salon in 1894, her work was hung "on the line," that is, in a central position and at eye level, which was a tribute to the merit of the artist in the crowded exhibition. She was an immediate sensation, and her work was reproduced in periodicals in France.

Upon her return to Canada in 1898, she opened a studio in Toronto. In 1906 she moved to Montreal, where she resided at 6 Beaver Hall Square. She was the first woman invited to exhibit with the Canadian Art Club, in 1909.

In 1915, Laura Muntz married Charles W.B. Lyall, her brother-in-law, when her sister died, leaving eleven children. During this period, her family responsibilities became her priority. She set up a studio in the attic of the family home, which from 1916 on was at 24 Bernard Avenue in Toronto. She began to sign her paintings using her married name, Laura Muntz Lyall. Some canvases have both signatures, suggesting that these paintings may have been started prior to her marriage.

AFFILIATIONS AND AWARDS

1896	honourable mention, Paris Salon
1891–1908	member, Ontario Society of Artists, Toronto
1893–1894	two medals for drawing at the Académie Colarossi, Paris
1895	associate member, Royal Canadian Academy of Arts
1901	silver medal, Pan-American Exposition, Buffalo, New York
1904	bronze medal, Louisiana Purchase Exposition (St. Louis World's Fair)
1924–1930	member, Ontario Society of Artists, Toronto

MATURE PERIOD

Circa 1897 to 1920.

PREFERRED SUBJECT MATTER

Children, mothers with children, and young women.

COMPOSITIONAL SUBTLETIES

The subtle expressiveness she gained through her exquisite handling of light is best in the work she painted prior to 1915.

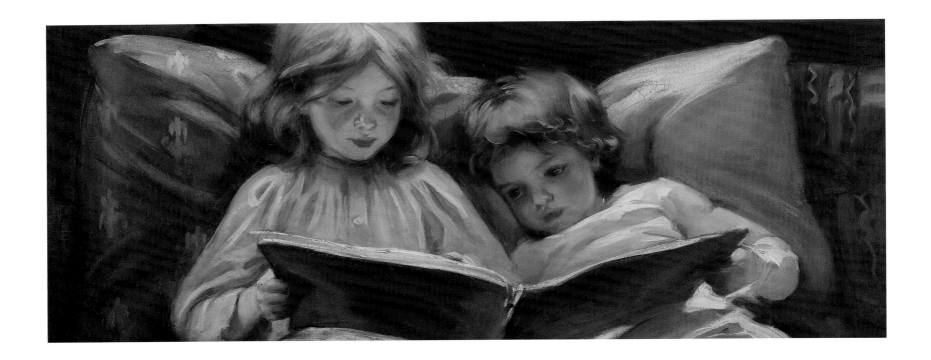

Interesting Story, 1898, detail. See page 49.

LATER YEARS

Laura Muntz Lyall died in Toronto on December 9, 1930, at the age of seventy, and was buried in Mount Pleasant Cemetery.

EXHIBITION HISTORY

1891–1930	exhibited with the Ontario Society of Artists
1893	World's Columbian Exposition (Chicago World's Fair)
1894–1898	exhibited at the Paris Salon
1901	Pan-American Exposition, Buffalo, New York
1903–1928	exhibited with the Art Association of Montreal
1903–1929	exhibited with the Royal Canadian Academy of Arts
1904	Louisiana Purchase Exposition (St. Louis World's Fair)
1926	exhibition of Canadian paintings, Art Gallery of Toronto; artists include Lawren Harris and Tom Thomson
1984	*Canadian Classics,* Masters Gallery, Calgary

The Enchanted Pool,
previously titled *By the Lake*
1925
Oil on canvas
39 x 29 inches (99 x 73.7 cm)
Private Collection, Ontario

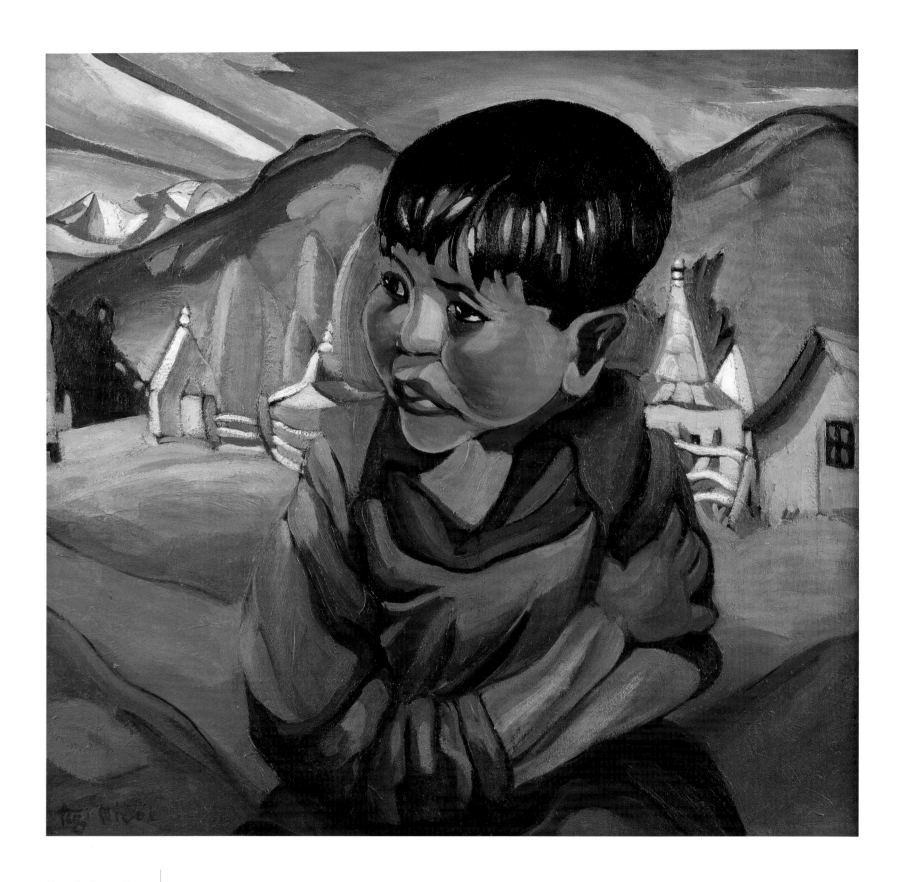

Fort St. James Boy

1928

Oil on board

24 x 24 inches (61 x 61 cm)

Private Collection, Alberta

MacLeod, Pegi (Margaret Kathleen) Nicol
1904–1949

"It was a happy day when we first met Peggy Nicol. She was then about eighteen and was studying at the Beaux-Arts in Montreal. Peggy was an astonishing person. ... Bursting with vitality and ideas, she was always ready for a discussion. She could act, dance, and ski, and was fearless in water. She was like a very much younger sister, and our house was her second home. We had special fun when Arthur Lismer was in Ottawa. Usually Harry and Dorothy McCurry, Kathleen Fenwick, Peggy, and often one or two others would come in the evening. As Arthur's pencil simply could not stay in his pocket, he would begin to sketch, perhaps Eric with the cats or Peggy with locks of her hair getting into her eyes ... We laughed and chatted all evening till it was time for a late snack in the kitchen."

F. Maud Brown, *Breaking Barriers*

EARLY LIFE

Pegi Nicol MacLeod was born Margaret Kathleen Nichol in Listowel, Ontario, in 1904, to Mr. and Mrs. William Wallace Nichol. She grew up in Ottawa. Life was not easy for this rebellious young artist who spent much of her life with scant financial resources.

EDUCATION, MENTORS, INFLUENCES

For three years during the 1920s, Pegi Nicol studied painting under Franklin Brownell at the Ottawa Art Association. Her studies continued at the École des beaux-arts in Montreal with fellow students Marian Dale (Scott), Goodridge Roberts, and Paul-Émile Borduas. Within one year, she had won five medals for her work.

EARLY CAREER

Nicol turned the attic of her parents' home into her studio and living quarters.

In 1927, she travelled to Skeena River, B.C., with anthropologist Marius Barbeau and a group of artists. There she met Emily Carr, who was also one of the artists on the trip. In 1928, Nicol went to Alberta to paint the Stoney Indians.

Pegi Nicol's friends in Ottawa included Eric Brown, the director of the National Gallery of Canada from 1913 until 1939, and his wife, Maud. Local artists, including Nicol, liked to gather at the Brown home in Ottawa to discuss art and current affairs, and to sketch each other for fun.

Nicol lived in Toronto from 1934 until 1937, when she married Norman MacLeod and moved to New York. They had a daughter, Jane, who became the subject of many of her works before MacLeod's attention was captured by the life and character of the city. Brimming with activity and stimuli, MacLeod's paintings of New York are full of wonder as well as information; she found that she liked everything about the urban scene. Later, however, her work became increasingly crowded and full, perhaps reflecting her busy life as an artist and mother, and the city in her painting took on a mournful quality.

AFFILIATIONS AND AWARDS

1923	five medals for her work, École des beaux-arts, Montreal
1929, 1931	honourable mention, Willingdon Arts Competition
1935–1936	art editor, the *Canadian Forum*
1936	member, Canadian Society of Painters in Water Colour
1937–1948	member, Canadian Group of Painters

Member, Ottawa Art Association
Founding member, Picture Loan Society, Toronto

MATURE PERIOD

Circa 1930 to 1945.

PREFERRED SUBJECT MATTER

Figurative work with strong narrative on the social conditions of the day.

COMPOSITIONAL SUBTLETIES

Animated images portraying the energy and excitement of life.

LATER YEARS

MacLeod, along with other East Coast artists, founded the Observatory Arts Centre at the University of New Brunswick in Fredericton. She taught there at the Fiddlehead Observatory every summer from 1940 to 1948. In 1944, MacLeod was commissioned by the National Gallery of Canada to record the Women's Services during the Second World War.

Pegi Nicol MacLeod died of cancer in New York City on February 12, 1949, at age forty-five. In 2005, a film about MacLeod titled *Something Dancing About Her* was released, directed by Michael Ostroff.

Costume for Cold Studio (Self-Portrait), c. 1925–1930, detail. See page 183.

EXHIBITION HISTORY

1922 exhibited at École des beaux-arts, Montreal

1926–1932 exhibited with the Royal Canadian Academy

1927 exhibited with the Ontario Society of Artists, Toronto; shows regularly with
 the group thereafter

 T. Eaton Co. Ltd., Montreal; shows regularly with the store thereafter

 Canadian West Coast Art, Native and Modern, National Gallery of Canada,
 Ottawa

1928 joint exhibition, Art Association of Montreal and Royal Canadian Academy of
 Arts, Montreal

1928? exhibited with the Ottawa Art Association; shows regularly with the group
 thereafter

1931 solo exhibition, Lysle Courtenay Studios, Ottawa, showing landscapes and a
 portrait of Marian Scott

1932 solo exhibition, T. Eaton Co. Ltd., Montreal

1934 exhibited with the Canadian Society of Painters of Water Colour, Toronto;
 shows regularly with the group thereafter

1936 exhibited with the Canadian Group of Painters, Toronto; shows regularly with
 the group thereafter

1938 *A Century of Canadian Art*, Tate Gallery, London

1939 exhibition of Canadian watercolours, Gloucester

 Exhibition by the Canadian Group of Painters, New York World's Fair

1941 four-woman show, Art Gallery of Toronto

 International Water Colour Exhibition, Brooklyn Museum, New York

1944 *Pintura Canadense Contemporânea*, Museu Nacional de Belas Artes, Rio de
 Janeiro

1947 solo exhibition, Eaton's Fine Arts Gallery, Toronto

 Canadian Women Artists, Riverside Museum, New York

1949 memorial exhibition, National Gallery of Canada, Ottawa

1984 Robert McLaughlin Gallery, Oshawa; travelling exhibition

2005 *Pegi Nicol MacLeod: A Life in Art*, Carleton University Art Gallery, Ottawa;
 travelling exhibition

"There's so much for the eye to see in front of it. I can't understand people not looking."

Pegi Nicol MacLeod, quoted in *The Times* (Moncton), July 12, 1984

Sunlight Through Shaded
Waters, Lake Como
c. 1906
Oil on canvas
32 x 26 inches (81.3 x 66 cm)
Private Collection, Alberta

Macpherson, Margaret Campbell

1860–1931

"Miss Macpherson is a painter of rare ability, being an exhibitor on many occasions at the Salons, Paris. She has a studio in Edinburgh and Paris. Her collection now on view is a grand one, all masterpieces. The collection comprises many excellent canvases including *The Beggar Girl*, a delightful oil from life, a confirmation scene, and a beautiful painting from life of Lady McCallum, wife of the governor of Newfoundland. The pictures are by far the best seen in Halifax for years, and lovers of high art should not miss the opportunity of seeing them."

Halifax Herald, January 12, 1900, as quoted in Mora Dianne O'Neill and Caroline Stone, *Two Artists Time Forgot*

EARLY LIFE

Margaret Campbell Macpherson was born in St. John's, Newfoundland in 1860, to Peter Macpherson and Susannah Euphemia Campbell. The couple had eight children, but only four survived. Macpherson's father died when she was eight years old, and her brother Campbell carried on the family business and supported her, giving her an allowance so that she could study art.

EDUCATION, MENTORS, INFLUENCES

Macpherson began her art studies in Edinburgh. She then studied in Neuchâtel, Switzerland, under Auguste-Henri Berthoud, who often painted with Eugène Boudin and Jean-Baptiste-Camille Corot. Her style developed under these influences; she had a light touch in colour and illumination.

By 1889, she was in Paris, and trained under Pascal Dagnan-Bouveret and Gustave Courtois at the Académie Colarossi, learning the basics of portraiture.

At the Académie Colarossi, Macpherson studied with two other Newfoundlanders: Maurice Cullen, in 1889, and Maurice Prendergast, in 1891. Macpherson may also have taken classes with Mary Bell Eastlake and Laura Muntz, who arrived late in 1892.

EARLY CAREER

Macpherson was a professional artist. She was dedicated to her art and travelled throughout most of her life in France, Italy, Newfoundland, and Scotland in search of subject matter. Macpherson exhibited her work in both Europe and North America.

In Scotland, she shared studio space with her classmate and lifelong friend, Josephine Hoxie Bartlett. They resided in Shandwick Place, a group of studios in a community setting that allowed free-flowing ideas and dialogue.

AFFILIATIONS AND AWARDS

1892	member, Society of Scottish Artists
1900	medal, Canadian Pavilion at the Exposition universelle, Paris; the only British North American woman to win a medal
1903	gold medal, Exposition nationale, Reims
1904	gold medal, Exposition internationale, Nantes

Macpherson did not join any women's art associations, thinking that the attention drawn to her gender might cause discrimination.

MATURE PERIOD

Circa 1890s to 1910.

PREFERRED SUBJECT MATTER

Landscapes with figures.

COMPOSITIONAL SUBTLETIES

Her style combined academic training with Impressionism.

LATER YEARS

There were no Salon exhibitions during the war years, but once the First World War ended, activities resumed and Macpherson and Bartlett settled in Versailles where they continued to paint and exhibit.

Margaret Campbell Macpherson died at age seventy-one on May 16, 1931, in Versailles, survived by her companion, Jo Bartlett.

EXHIBITION HISTORY

Of Canadian women artists, Macpherson is considered to have exhibited the most works abroad; she exhibited her work in more than two dozen Paris Salons.

1884	Dudley Art Gallery, London	
1885, 1886	exhibited with the Aberdeen Artists Society	
1885–1902	exhibited with the Royal Scottish Society, Edinburgh	
1886	International Exposition, Edinburgh	
	Dundee Fine Art Exhibition	
1892	exhibited with the Society of Scottish Artists, Edinburgh	
1893	Gordon & Keith's, Halifax	
1896	solo exhibition, Martin's Building, St. John's	
1899	solo exhibition, Colonial Building, St. John's	
1900	solo exhibition, Halifax	

1900 participated in Canadian and British pavilions at the Exposition universelle, Paris

1901 Pan-American Exposition, Buffalo, New York

1913 Carnegie International Exhibition, Pittsburgh

2001 *Choosing Their Own Path: Canadian Women Impressionists*, Art Gallery of Nova Scotia, Halifax

2006 *Two Artists Time Forgot*, Art Gallery of Nova Scotia, Halifax; travelling exhibition

Lake Como, c. 1905, detail. See page 119.

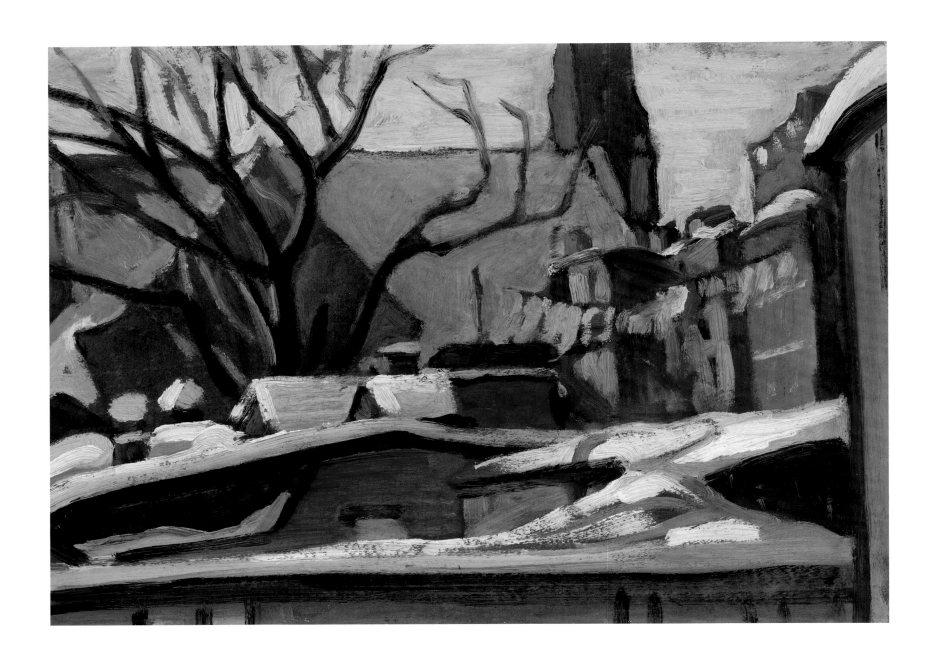

Clothesline, Montreal

c. 1945

Oil on board

10 x 14 inches (25.4 x 35.5 cm)

Private Collection, Alberta

May, Henrietta Mabel

1884–1971

"She could not follow the Group of Seven into the wilderness and she has not the penetration of an Emily Carr, but she has an intense feeling for the Canadian scene and assurance in handling it. In her earlier works, following the French Impressionists, she luxuriated in the play of dazzling light, treating her landscapes and figures with grace and tenderness but stopping short of the sentimental. Later she became more austere as her design developed in strength through solider forms. One thing she has, that most Canadian painters of her generation neglected, is a delight in people."

Montreal Star, 1950

EARLY LIFE

Henrietta Mabel May was born in Westmount, Quebec, on September 11, 1884, to Edward and Evelyn Henrietta May, who both came to Canada from England. May was actively encouraged by her parents to study art.

EDUCATION, MENTORS, INFLUENCES

May's skill in art was apparent in her teens, but it wasn't until the age of twenty-five that she began to take classes with William Brymner at the Art Association of Montreal from 1909 to 1912. Her classmates included Edwin Holgate, Adrien Hébert, and J.Y. Johnstone, among others. During this period, May won two scholarships, which helped pay for her lessons.

In 1912, she travelled with Emily Coonan throughout Europe on a sketching trip, visiting France, Belgium, Holland, England, and Scotland.

Influences can be seen in her work from French Impressionists such as Claude Monet and Pierre-Auguste Renoir, as well as such diverse influences as Henri Matisse and the Group of Seven.

EARLY CAREER

From 1914 to 1918, May had a studio on St. Catherine Street in Montreal. In 1918, May painted many canvases for the Canadian War Memorials, depicting women in munitions work.

By 1920, May and several of the women who had studied under William Brymner shared studio space for a short time on Beaver Hall Hill, along with Randolph Hewton and Edwin Holgate: they called themselves the Beaver Hall Group. A.Y. Jackson was their mentor in this venture. Although the arrangement lasted only a couple of years, the friendship among these painters never ceased; they remained a constant source of support and inspiration for each other. May was also part of the informal network of women that continued for years after the original group disbanded.

Throughout her life, May maintained close friendships with A.Y. Jackson, Edwin Holgate, Lilias Torrance Newton, and Clarence Gagnon.

The Regatta,
c. 1913–1914, detail.
See page 87.

AFFILIATIONS AND AWARDS

1910	awarded scholarship, Art Association of Montreal, shared with Adrien Hébert
1911	awarded scholarship, Art Association of Montreal, shared with A.M. Pattison
1914	Jessie Dow Prize for watercolour
1915	associate member, Royal Canadian Academy of Arts
	awarded Women's Art Society Prize
1918	Jessie Dow Prize for oil
1920	founding member, Beaver Hall Group
1929	honourable mention, Willingdon Arts Competition for *Melting Snow*
1933–1967	founding member, Canadian Group of Painters

Member, Federation of Canadian Artists
Member, British Columbia Society of Artists

MATURE PERIOD
Circa 1912 to 1938.

PREFERRED SUBJECT MATTER
Circa 1910 to 1920, beach and street scenes painted in the Impressionistic style. During the 1920s, figurative compositions painted in the Post-Impressionistic style. Thereafter, landscapes painted under the influence of the Group of Seven.

COMPOSITIONAL SUBTLETIES
May's early painting style falls within the Impressionist movement in the depiction of the artist's surroundings with spontaneity and freshness. She painted outdoors, directly from nature. A shift in the language of her work took place in the 1920s when she began to use design and colour to convey her empathy with the circumstances of her sitters.

LATER YEARS

May often lectured on the importance of teaching art to children, and from 1938 to 1947 she supervised and taught children's art classes at the National Gallery of Canada. She also taught art at Elmwood School in Ottawa from 1936 to 1947.

In the 1950s, May retired to Vancouver. She died in October 1971, at the age of eighty-seven.

EXHIBITION HISTORY

Mabel May in an undated photograph.

1910	exhibited with the Art Association of Montreal
1910–1952	exhibited with the Royal Canadian Academy of Arts
1914–1915	*Canadian Artists' Patriotic Fund Exhibition*, Public Library, Toronto; travelling exhibition
1919	*Canadian War Memorials Exhibition* (the Home Front), Art Gallery of Toronto
1921	first annual exhibition of Beaver Hall Group, Montreal
1922	exhibited with the Beaver Hall Group, Montreal
1923	*Exhibition of Canadian War Memorials*, National Gallery of Canada, Ottawa
1924	*Pictures Exhibited by the Montreal Group of Artists*, Hart House, University of Toronto
1924–1925	*British Empire Exhibition, Canadian Section of Fine Arts*, Wembley, England
1925	*Contemporary Canadian Artists*, Chowne Art Dealer, Montreal
1926	*Special Exhibition of Canadian Art* (first annual), National Gallery of Canada, Ontario
1927	*Exposition d'art canadien*, Musée du Jeu de Paume, Paris
1927–1933	*Annual Exhibition of Canadian Art*, National Gallery of Canada, Ottawa
1928	*Exhibition of Paintings by the Group of Seven*, Art Gallery of Toronto
1930	*Exhibition of Paintings by Contemporary Canadian Artists*, Corcoran Gallery of Art, Washington, D.C.; travelling exhibition
	Paintings by a Group of Contemporary Montreal Artists, Art Association of Montreal
1930–1931	*Exhibition of the Group of Seven*, Art Gallery of Toronto
1933	*Exhibition of Paintings by Canadian Women Artists*, Eaton's Fine Art Gallery, Montreal
	Paintings by the Canadian Group of Painters, Heinz Art Salon, Atlantic City, N.J.
	Exhibition of Paintings by Canadian Group of Painters, Art Gallery of Toronto
1934	*Canadian Paintings, The Collection of the Hon. Vincent and Mrs. Massey*, Art Gallery of Toronto

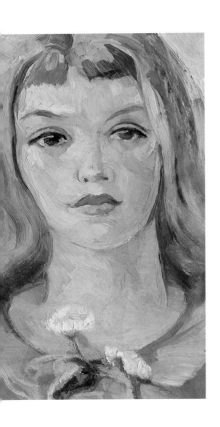

Violet and Rose, c. 1918,
detail. See page 89.

1936	*Exhibition of Contemporary Canadian Paintings,* National Gallery of Canada, Ottawa
	exhibited with the Canadian Group of Painters, Art Gallery of Toronto and National Gallery of Canada, Ottawa
1937	*Exhibition of Paintings, Drawings and Sculpture by Artists of the British Empire Overseas* (Coronation Exhibition), Royal Institute Galleries, London
	exhibited with the Canadian Group of Painters, Art Gallery of Toronto
1938	*A Century of Canadian Art,* Tate Gallery, London
1939	solo exhibition, James Wilson & Co., Ottawa
	Exhibition by the Royal Canadian Academy of Arts, New York World's Fair
	Exhibition by the Canadian Group of Painters, New York World's Fair
1940	*Canadian National Committee on Refugees, Exhibition and Auction of Paintings,* National Gallery of Canada, Ottawa
1942	exhibited with the Canadian Group of Painters, Art Gallery of Toronto, Art Association of Montreal, and National Gallery of Canada, Ottawa
1944	*Pintura Canadense Contemporânea,* Museu Nacional de Belas Artes, Rio de Janeiro
1945	*The Development of Painting in Canada 1665–1945,* Art Association of Montreal and Art Gallery of Toronto
1947	*Canadian Women Artists,* Riverside Museum, New York
	exhibited with the Canadian Group of Painters, Art Gallery of Toronto
1949	exhibited with the Canadian Group of Painters, Art Gallery of Toronto and Montreal Museum of Fine Arts; travelling exhibition
	Fifty Years of Painting in Canada, Art Gallery of Toronto
1950	*Special Sale of Paintings by H. Mabel May, ARCA,* Dominion Gallery, Montreal
1952	solo exhibition, Vancouver Art Gallery
1965	exhibited with the Canadian Group of Painters, Art Gallery of Greater Victoria and Agnes Etherington Art Centre, Kingston, Ontario
1966	*The Beaver Hall Hill Group,* National Gallery of Canada, Ottawa
1975	*From Women's Eyes: Women Painters in Canada,* Agnes Etherington Art Centre, Kingston, Ontario
1982	*Women Painters of the Beaver Hall Group,* Sir George Williams Art Gallery, Montreal
1997	*Montreal Women Painters on the Threshold of Modernity,* Montreal Museum of Fine Arts

McGillivray, Florence Helena

1864–1938

"He [Thomson] had a few canvases finished when who should call but Florence McGillivray, and I expect they discussed art for several hours. Tom was delighted and pleased to have this renowned artist call. Quite confidentially, he said she is one of the best."

Mark Robinson, in a letter dated May 11, 1930 to Blodwen Davies, Tom Thomson's biographer

EARLY LIFE

Florence Helena McGillivray was born in Whitby, Ontario, in 1864, one of twelve children of George McGillivray and Caroline Fothergill. Her grandfather was Charles Fothergill, the eminent naturalist and bird painter; at a young age she gravitated towards a career in art.

EDUCATION, MENTORS, INFLUENCES

McGillivray enrolled at the Ontario School of Art and, as did Tom Thomson, studied under William Cruikshank, among others. Later she sought out F. McGillivray Knowles and other teachers for private study. As a young woman, McGillivray taught in Whitby at the Ontario Ladies' College (now Trafalgar Castle School) and at Pickering College in Pickering, Ontario.

In 1881, she began to travel widely, exploring Canada and abroad. She went to France in 1913, where she continued her studies at the Académie de la Grande Chaumière under Lucien Simon. In Europe, she came in contact with Impressionism, which had a deep effect on her work.

EARLY CAREER

In 1913, McGillivray was elected president of the International Art Union, a group that was dissolved when the First World War started. The following year she travelled to Brittany, where she painted. She returned to Canada in 1914, and later moved to Ottawa where she lived from 1918 to 1931.

In Toronto during the winter of 1916–1917, she visited Tom Thomson in his studio shack. Due to her own experimental, independent style, his work would have struck a chord with her. Later, Thomson told others that he valued her advice: "She was the only one who understood immediately what I was trying to do," he said.

McGillivray always travelled widely, exploring and sketching various parts of Canada, including Newfoundland and the West. She also toured Trinidad, Jamaica, the Bahamas, Alaska, and the eastern United States.

AFFILIATIONS AND AWARDS

1913	president, International Art Union, Paris
1917	member, Society of Women Painters and Sculptors, New York
1917–1938	member, Ontario Society of Artists
1925	associate member, Royal Canadian Academy of Arts

Member, Canadian Society of Painters in Water Colour

MATURE PERIOD

Circa 1917 to 1930s.

PREFERRED SUBJECT MATTER

Landscape.

COMPOSITIONAL SUBTLETIES

Brilliant and evocative handling of brushwork, unusual compositions.

LATER YEARS

McGillivray travelled extensively in search of new landscape scenery to paint. She continued to paint until the end of her life. She died in Toronto on May 7, 1938, at the age of seventy-four.

Canal, Venice, 1917, detail. See page 127.

A Quiet Spot

1913

Oil on canvas,

25 x 30¼ inches (63.5 x 76.8 cm)

Private Collection,

British Columbia

McNicoll, Helen Galloway
1879–1915

"Remember, there is sunshine in the shadows."

Algernon Talmage, quoted in Natalie Luckyj,
Helen McNicoll: A Canadian Impressionist

EARLY LIFE

Helen Galloway McNicoll was born in Toronto on December 14, 1879. Her parents, David McNicoll and Emily Pashley, moved from England to Canada during the boom in railway construction. In 1906 David McNicoll became vice-president and general manager of the Canadian Pacific Railway. They moved from Collingwood to Toronto, where Helen was born, and finally settled in Westmount, now part of Montreal. David McNicoll was an amateur painter who often went on sketching trips with his friend, William Cornelius van Horne, the CPR chairman. He encouraged young Helen in the pursuit of art.

Although she became permanently deaf after being stricken by scarlet fever at the age of two, McNicoll learned to play piano, lip-read, and develop her skills as an artist. Her interest in art came at a time when Impressionism was breaking new ground. William van Horne was the first Canadian collector of French Impressionist paintings; she would have seen these paintings and seems to have readily grasped the potential in the new style.

EDUCATION, MENTORS, INFLUENCES

McNicoll attended art classes at the Art Association of Montreal from 1899 to 1902, studying under William Brymner, who encouraged his students to work directly from the model and from nature. When Brymner saw promise in one of his students, he made special efforts to help them find their way to Europe for further study. McNicoll left to study in England in 1902.

From 1902 to 1904, McNicoll studied at the Slade School of Art in London under Philip Wilson Steer. Students at the Slade were taught a more naturalistic approach to art, replacing the narrative of Victorian painting with painting *en plein air*.

After a short stay in Paris, McNicoll returned to England to study at St. Ives in Cornwall. In 1905, she enrolled in Julius Olsson's School of Landscape and Marine Painting under Algernon Talmage. It was here that she met fellow student Dorothea Sharp, a British painter, with whom she formed a lifelong bond. The two women often travelled together, shared studio space, and posed for each other.

EARLY CAREER

In 1906, McNicoll began to exhibit with the Art Association of Montreal; in 1909, William Van Horne, family friend and art collector, purchased one of her paintings from the annual exhibition. Spending much of her career in Europe, she continued to send paintings to Canada and participated in many of the annual exhibitions in Montreal and Toronto. With generous financial support from her family, McNicoll felt no pressure to sell her work and could explore her creative impulses in total freedom.

Helen McNicoll in an undated photograph.

"The older members … didn't like my things. One man got very angry and said, 'If that picture is right, then the National Gallery is all wrong.'"

Helen McNicoll, referring to her election to the Royal Society of British Artists, quoted in Natalie Luckyj, *Helen McNicoll: A Canadian Impressionist*

AFFILIATIONS AND AWARDS

1900	member, Art Association of Montreal
1908	Jessie Dow Prize, shared with W.H. Clapp
1913	member, Royal Society of British Artists
1914	associate member, Royal Canadian Academy of Arts
	Women's Art Society Prize

MATURE PERIOD

Circa 1905 to 1915.

PREFERRED SUBJECT MATTER

Children and women in gardens, at the seaside, and in market scenes.

COMPOSITIONAL SUBTLETIES

Treatment of reflected and diffused light to capture a sense of the passing moment.

The Chintz Sofa, 1912, detail. See page 71.

LATER YEARS

Helen McNicoll spent her life as an artist travelling in search of subjects. She often returned to Canada to visit her family. At the young age of thirty-five, on June 28, 1915, she died of diabetes in Swanage, England.

EXHIBITION HISTORY

1906–1914 exhibited with the Royal Canadian Academy of Arts, Ontario Society of Artists, and many other groups

1906–1915 exhibited with the Art Association of Montreal

1925 memorial exhibition, Art Association of Montreal

1926 inaugural show at the Art Gallery of Toronto

1974 *Helen McNicoll: Oil Paintings from the Estate,* Morris Gallery, Toronto

1999 retrospective exhibition, Art Gallery of Ontario, Toronto

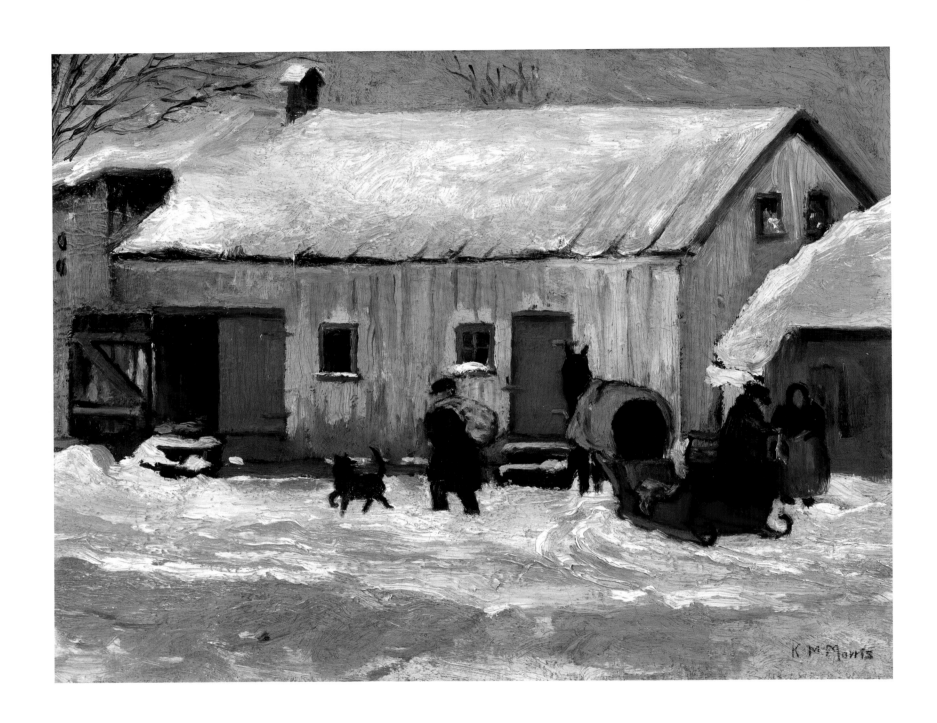

French Canadian Farm

1924

Oil on canvas

14 x 18 inches (35.5 x 45.7 cm)

Private Collection, Alberta

Morris, Kathleen Moir
1893–1986

"Rarely have I seen an exhibition in which such unity and consistency of approach were evident. Kathleen Morris's work appears all of a piece. Her solidly composed souvenirs of Old Montreal and its environs should be collectors' treasures. Particularly remarkable is the woman painter's sense of joie de vivre; her clever use of dabs and dashes of brilliant orange-red livens every canvas. Among Miss Morris's subjects are old tramcars, market scenes, snow 'burleaus' with their patient shaggy horses; old churches, as background for the sleighs of Sunday worshippers; processions of gentle nuns and lively children. … Such painting brings peace to the soul. It is humane, it is technically authoritative, it is the personal expression of the joy of life and of tangible emotion by a gifted, forthright, fearless artist."

Dorothy Pfeiffer, *Montreal Gazette*, March 3, 1962

EARLY LIFE

Kathleen Moir Morris was born in Montreal on December 2, 1893, the fourth and youngest child of Montague John Morris and Eliza Howard Bell. From birth, cerebral palsy left its mark on Morris but did not prevent her from expressing herself in art at an early age. Robert Harris, the portrait painter, was her mother's cousin, and both he and her parents were encouraging. Morris's mother often accompanied Kathleen on her painting trips and kept her company while she worked.

EDUCATION, MENTORS, INFLUENCES

From circa 1906 to 1917, Morris studied at the Art Association of Montreal under William Brymner and in the summers took sketching trips with Maurice Cullen and Robert Pilot.

She had much admiration for the work of J.W. Morrice, and the admiration was mutual: Morrice purchased a painting by Morris from art dealer William Watson in Montreal.

EARLY CAREER

Morris's immediate surroundings were her inspiration; she painted outdoors in all seasons. In the winter, she would be taken by sleigh to her painting destination and remained there, sketching until she was picked up at the end of the day.

Morris was part of the network of women artists known informally as the Beaver Hall Group, which continued after the original group of that name disbanded in the early 1920s.

In 1923 Morris moved to Ottawa, where she became friends with, and was encouraged by, Eric Brown, the director of the National Gallery of Canada. She returned to Montreal in 1929 and lived there for the rest of her life.

AFFILIATIONS AND AWARDS

1929 associate member, Royal Canadian Academy of Arts

1930 honourable mention, Willingdon Arts Competition for *Nuns, Quebec*

1940–1963, 1967 member, Canadian Group of Painters

MATURE PERIOD

Circa 1920 to 1935.

PREFERRED SUBJECT MATTER

The market and street scenes of Ottawa and Montreal.

COMPOSITIONAL SUBTLETIES

Morris had a strongly developed sense of colour that she applied spontaneously, using somewhat nervous brushwork.

LATER YEARS

Morris never married. After the death of her mother in 1949, she lived with her brother Harold. In 1978, she suffered a stroke and could no longer paint. She died on December 20, 1986, in a nursing home in Rawdon, Quebec, at the age of ninety-three.

Sunday Service,
Berthierville, 1924,
detail. See page 155.

EXHIBITION HISTORY

1914–1957 exhibited with the Art Association of Montreal

1916–1947 exhibited with the Royal Canadian Academy of Arts

1921 first exhibit with the Ontario Society of Artists, Toronto

1924–1925 *British Empire Exhibition, Canadian Section of Fine Arts,* Wembley, England; her work hung with the Group of Seven

1925 first Pan-American Exhibition, Los Angeles

 Contemporary Canadian Artists, Chowne Art Dealer, Montreal

1926 *Special Exhibition of Canadian Art* (first annual), National Gallery of Canada, Ottawa

1927 *Exposition d'art canadien,* Musée du Jeu de Paume, Paris

1927–1933 *Annual Exhibition of Canadian Art,* National Gallery of Canada, Ottawa

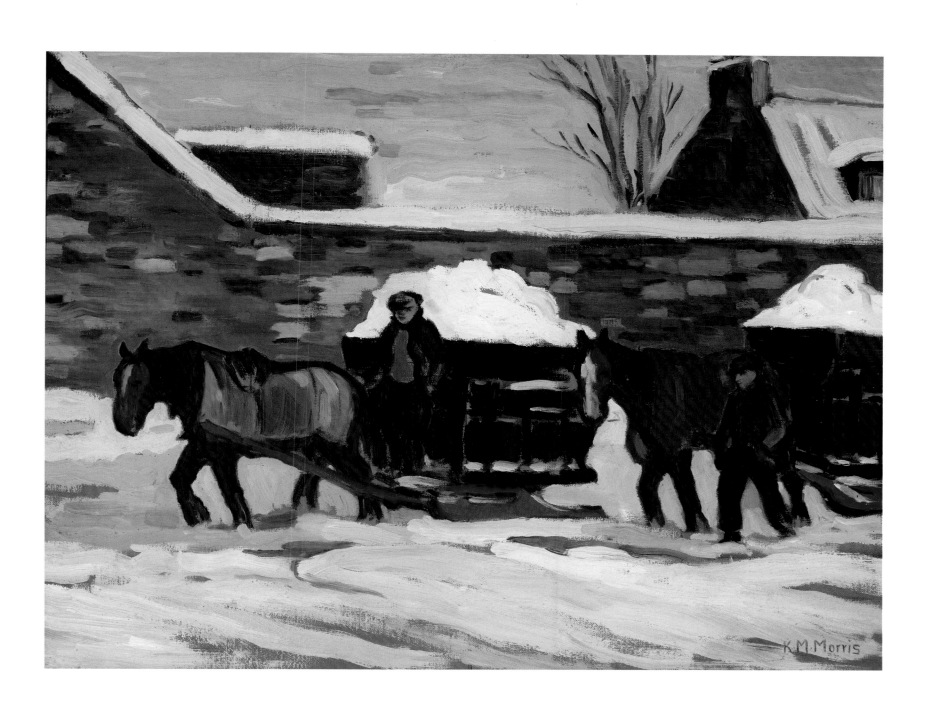

Snow Carts, Quebec

c. 1930

Oil on canvas

18¼ x 24 inches (46.4 x 61 cm)

Private Collection, Quebec

1930	*Exhibition of Paintings by Contemporary Canadian Artists*, Corcoran Gallery of Art, Washington, D.C.; travelling exhibition
	Paintings by a Group of Contemporary Montreal Artists, Art Association of Montreal
1931	participated in Canadian section of exhibition, Buenos Aires
1933	*Exhibition of Paintings by Canadian Women Artists*, Eaton's Fine Art Gallery, Montreal
	Exhibition of Paintings by Canadian Group of Painters, Art Gallery of Toronto
1934	exhibited with the Canadian Group of Painters, Montreal
	Canadian Paintings, The Collection of the Hon. Vincent and Mrs. Massey, Art Gallery of Toronto
1936	*Exhibition of Contemporary Canadian Paintings*, National Gallery of Canada, Ottawa
	exhibited with the Canadian Group of Painters, Art Gallery of Toronto and National Gallery of Canada, Ottawa
1937	*Exhibition of Paintings, Drawings and Sculpture by Artists of the British Empire Overseas* (Coronation Exhibition), Royal Institute Galleries, London
	exhibited with the Canadian Group of Painters, Art Gallery of Toronto
1938	*A Century of Canadian Art*, Tate Gallery, London
	Sale Aid to Spanish Democracy, 2037 Peel Street, Montreal
1939	solo exhibition, Art Association of Montreal
	Exhibition by the Royal Canadian Academy of Arts, New York World's Fair
	exhibited with the Canadian Group of Painters, Art Gallery of Toronto
1940	*Canadian National Committee on Refugees, Exhibition and Auction of Paintings*, National Gallery of Canada, Ottawa
	exhibited with the Contemporary Arts Society, Art Association of Montreal
1941	four-woman show, Art Gallery of Toronto
1942, 1944	exhibited with the Canadian Group of Painters, Art Gallery of Toronto and Art Association of Montreal
1944	*Pintura Canadense Contemporânea*, Museu Nacional de Belas Artes, Rio de Janeiro
1945	solo exhibition, Harris Memorial Gallery, Charlottetown
	exhibited with the Canadian Group of Painters, Art Gallery of Toronto
1947	*Canadian Women Artists*, Riverside Museum, New York
	exhibited with the Canadian Group of Painters, Art Gallery of Toronto
1949	exhibited with the Canadian Group of Painters, Art Gallery of Toronto and Montreal Museum of Fine Arts; travelling exhibition

1950	*Six Montreal Women Painters*, Montreal Museum of Fine Arts
	exhibited with the Canadian Group of Painters, Art Gallery of Toronto
1956	solo exhibition, Montreal Arts Club
	Inaugural Exhibition of Paintings, Cowansville Art Centre, Quebec
1958	exhibited with the Canadian Group of Painters, Art Gallery of Toronto and Vancouver Art Gallery
1962	joint exhibition with Lincoln G. Morris, Montreal Arts Club
	exhibited with the Canadian Group of Painters, Art Gallery of Toronto
1963	exhibited with the Canadian Group of Painters, Montreal Museum of Fine Arts
1965	exhibited with the Canadian Group of Painters, Art Gallery of Greater Victoria and Agnes Etherington Art Centre, Kingston, Ontario
1966	*The Beaver Hall Hill Group*, National Gallery of Canada, Ottawa
1975	*From Women's Eyes: Women Painters in Canada*, Agnes Etherington Art Centre, Kingston
1976	solo exhibition, Walter Klinkhoff Gallery, Montreal
1979	*Prudence Heward and Friends*, Art Gallery of Windsor, Ontario
1982	*Women Painters of the Beaver Hall Group*, Sir George Williams Art Gallery, Montreal
1983	solo exhibition, Agnes Etherington Arts Centre, Kingston, Ontario
1991	*The Beaver Hall Hill Group*, Kaspar Gallery, Toronto
1997	*Montreal Women Painters on the Threshold of Modernity*, Montreal Museum of Fine Arts
2003	retrospective exhibition, Walter Klinkhoff Gallery, Montreal
	retrospective exhibition, Arthur Leggett Fine Art, Toronto

McGill Cab Stand, c. 1927, detail. See page 157.

"You know my picture of the old cab stand with the horses and sleighs and the old stone wall. The wall is gone. The horses are gone. Do you know what's there now? A gasoline station."

Kathleen Morris, quoted in Wini Rider, *Montreal Gazette*, June 16, 1976

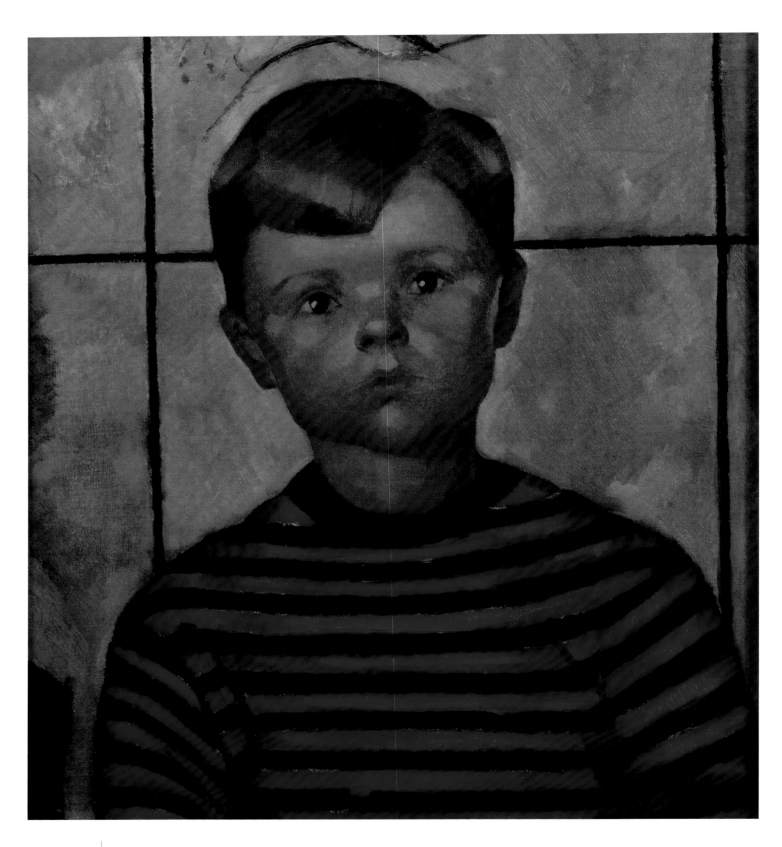

Portrait of the Artist's Son,
Winkie

c. 1929

Oil on canvas

22 x 20 inches (55.9 x 50.8 cm)

Private Collection, New Brunswick

Newton, Lilias Torrance
1896–1980

> "The impact of the sitter's personality on mine is what I paint. There must be sympathy between the subject and the artist for the portrait to be good … "

> Lilias Torrance Newton, quoted in *Montreal Herald*, August 30, 1946

EARLY LIFE

Lilias Torrance Newton was born Lilias Torrance in Lachine, Quebec, on November 3, 1896. She was the fourth child of Forbes Torrance and Alice Mary Stewart and was born after her father's death. By the age of twelve, Newton had already begun to paint.

EDUCATION, MENTORS, INFLUENCES

Lilias Torrance's education began at Miss Edgar's and Miss Cramp's School in Montreal, where she studied art under Laura Muntz. In 1914, she began taking art classes at the Art Association of Montreal with William Brymner. During the First World War, her three brothers enlisted, and Lilias and her mother volunteered with the Red Cross in London.

After the war, she studied under Russian painter Alfred Wolmark in London and later in Paris under Alexandre Jacovleff, also a Russian painter.

EARLY CAREER

After her return to Montreal, Lilias Torrance, along with Edwin Holgate, Randolph Hewton, and Mabel May, rented a studio in the Beaver Hall Hill building. She was one of the founding members of the original Beaver Hall Group in 1920, and maintained her association with the group of women that continued informally under the same name.

In 1921, Torrance married Frederick G. Newton, a stockbroker whom she had met while in London; their son, Francis Forbes Newton, was born in 1926. In 1929, following

the stock market crash, the couple separated; they divorced in 1933. With portrait commissions, Torrance Newton was able to support herself, her son, and her brother who had been wounded in the war. In 1934, she joined Edwin Holgate in teaching painting at the Art Association of Montreal School of Art, where she remained until 1940.

Portrait commissions were plentiful for Torrance Newton. She kept studios in Toronto, Ottawa, and Montreal, and painted many distinguished sitters, including fellow artists Frances Loring, A.Y. Jackson, and Lawren Harris. In 1956, she was commissioned to paint official portraits of Queen Elizabeth II and the Duke of Edinburgh to hang in the Parliament Buildings

AFFILIATIONS AND AWARDS

1914	awarded scholarship, Art Association of Montreal, shared with Annie Ewan
1920	founding member, Beaver Hall Group, Montreal
1923	honourable mention, Paris Salon, for portrait of Denise Lamontagne
	associate member, Royal Canadian Academy
1926	honourable mention, Panama-Pacific Exhibition
1933–1967	founding member, Canadian Group of Painters
1937	full member, Royal Canadian Academy of Arts, the third woman in the history of the academy given this honour

MATURE PERIOD
Circa 1925 to 1945.

PREFERRED SUBJECT MATTER
Portraits.

COMPOSITIONAL SUBTLETIES
Torrance Newton challenged the viewer through her novel use of composition and her ability to reveal the personality of her sitter.

LATER YEARS
Torrance Newton travelled throughout her life, always alone, even during her marriage. She went to Europe many times, visiting Italy and France, and she travelled across Canada, her commissions taking her to Banff, Calgary, Edmonton, Toronto, Ottawa, and Montreal. Lilias Torrance Newton painted until a few years before her death at age eighty-three on January 10, 1980, in Cowansville, Quebec.

Self-Portrait, c. 1929, detail. See page 165.

EXHIBITION HISTORY

1916–1958	exhibited with the Royal Canadian Academy of Arts
1920–1953	exhibited with the Art Association of Montreal
1921	first annual exhibition of Beaver Hall Group, Montreal
1922	Beaver Hall Group, Montreal
1923	Paris Salon
1923–1924	*An Exhibition of Modern Canadian Paintings*, Group of Seven, U.S. Tour
1924	*Pictures Exhibited by the Montreal Group of Artists*, Hart House, University of Toronto
1924–1925	*British Empire Exhibition, Canadian Section of Fine Arts*, Wembley, England
1925	*Contemporary Canadian Artists*, Chowne Art Dealer, Montreal
1926	Pan-Pacific Exhibition, Los Angeles
	Special Exhibition of Canadian Art (first annual), National Gallery of Canada, Ottawa
1927	*Exposition d'art canadien*, Musée du Jeu de Paume, Paris
1927–1933	*Annual Exhibition of Canadian Art*, National Gallery of Canada, Ottawa
1930	solo exhibition, Hart House, University of Toronto
	Exhibition of Paintings by Contemporary Canadian Artists, Corcoran Gallery of Art, Washington, D.C.; travelling exhibition
	Paintings by a Group of Contemporary Montreal Artists, Art Association of Montreal
1930–1931	*Exhibition of the Group of Seven*, Art Gallery of Toronto
1931	three-person show, Watson Art Galleries, Montreal
	First Baltimore Pan American Exhibition of Contemporary Painting, Baltimore Museum of Art
1932	exhibited drawings, Montreal Arts Club
1933	*Exhibition of Paintings by Canadian Group of Painters*, Art Gallery of Toronto
	Paintings by the Canadian Group of Painters, Heinz Art Salon, Atlantic City, N.J.
1934	exhibited with the Art Association of Montreal
	exhibited with the Canadian Group of Painters, Montreal
	Canadian Paintings, The Collection of the Hon. Vincent and Mrs. Massey, Art Gallery of Toronto
1936	*Exhibition of Contemporary Canadian Paintings*, National Gallery of Canada, Ottawa
	exhibited with the Canadian Group of Painters, Art Gallery of Toronto and National Gallery of Canada, Ottawa
1937	*Exhibition of Paintings, Drawings and Sculpture by Artists of the British Empire Overseas* (Coronation Exhibition), Royal Institute Galleries, London
	exhibited with the Canadian Group of Painters, Art Gallery of Toronto
1938	*A Century of Canadian Art*, Tate Gallery, London

Nude in the Studio,
(undated), detail.
See page 167.

1939	*Exhibition by the Canadian Group of Painters,* New York World's Fair
	Exhibition by the Royal Canadian Academy of Arts, New York World's Fair
	solo exhibition, Art Association of Montreal
1940	four-woman show, Art Gallery of Toronto
	Canadian National Committee on Refugees, Exhibition and Auction of Paintings, National Gallery of Canada, Ottawa
1942, 1944	exhibited with the Canadian Group of Painters, Art Gallery of Toronto and Art Association of Montreal
1944	*Oil Paintings by Lilias Torrance Newton, RCA, Prudence Heward, Anne Savage, and Ethel Seath,* Art Association of Montreal
	Canadian Art 1760–1943, Yale University Art Gallery, New Haven
1945	solo exhibition, Photographic Stores, Ottawa
	The Development of Painting in Canada 1665–1945, Art Association of Montreal and Art Gallery of Toronto
	exhibited with the Canadian Group of Painters, Art Gallery of Toronto
1947	*Canadian Women Artists,* Riverside Museum, New York
	exhibited with the Canadian Group of Painters, Art Gallery of Toronto
1949	exhibited with the Canadian Group of Painters, Art Gallery of Toronto and Montreal Museum of Fine Arts
	Canadian Women Painters, West End Gallery, Montreal
1950	exhibited with the Canadian Group of Painters, Art Gallery of Toronto
1958	solo exhibition, Victoria College, University of Toronto
1966	*The Beaver Hall Hill Group,* National Gallery of Canada, Ottawa
1975	*Canadian Painting in the Thirties,* National Gallery of Canada, Ottawa
	From Women's Eyes: Women Painters in Canada, Agnes Etherington Art Centre, Kingston, Ontario
1981	*Lilias Torrance Newton, 1896–1980,* Agnes Etherington Art Centre, Kingston, Ontario
1982	*Women Painters of the Beaver Hall Group,* Sir George Williams Art Gallery, Montreal
1983	*Visions and Victories: 10 Canadian Women Artists,* London Regional Art Gallery, Ontario
1991	*The Beaver Hall Hill Group,* Kaspar Gallery, Toronto
1995	retrospective exhibition, Walter Klinkhoff Gallery, Montreal
1997	*Montreal Women Painters on the Threshold of Modernity,* Montreal Museum of Fine Arts

Pemberton, Sophie (Sophia) Theresa (Mrs. H. Deane-Drummond)
1869–1959

"If I were a better artist, I should paint you as I dream of you, as 'Flora' with the four attendant golden angel heads. But much of one's life only passes in daily dreams – and too much of mine."

Sophie Pemberton, in a letter to her friend, Mrs. Burns, dated January 18, 1904

EARLY LIFE

Sophia Theresa Pemberton was born in Victoria, B.C., on February 13, 1869, the second daughter to Joseph Despard Pemberton and Theresa Jane Grautoff. Joseph Pemberton was an executive of the Hudson's Bay Company and the first surveyor-general of Vancouver Island. The family home, known as "Gonzales," was a twenty-room mansion; the corner turret became Sophie's studio.

EDUCATION, MENTORS, INFLUENCES

In 1890, Pemberton travelled to England to study at the South Kensington School of Art and the Slade School of Art in London. She went to Paris in 1896 to study at the Académie Julian under J.P. Laurens and Benjamin Constant, and in 1897 her work was exhibited at the Royal Academy in London. Upon her return to North America, she studied in San Francisco.

EARLY CAREER

In 1905, Pemberton returned to Victoria and married a widower, Arthur Beanlands, and became stepmother to his four sons. After her husband's death in 1917, Pemberton stayed in Victoria and taught art to local women. She married a second time, in 1920, to Horace Deane-Drummond, a tea and rubber plantation owner. Together they travelled to India, and eventually settled in England.

1899 Prix Julian for portraiture, Académie Julian

1906–1908 associate member, Royal Canadian Academy of Arts

MATURE PERIOD

Circa 1897 to 1915.

PREFERRED SUBJECT MATTER

Figurative compositions in interior settings.

COMPOSITIONAL SUBTLETIES

Her treatment of dissolved and reflected light, much akin to Paul Peel.

LATER YEARS

During the Second World War, Pemberton, who was then living in London, worked with the Red Cross. She returned to Victoria in 1947 to live near her older sister. She died there on October 31, 1959, at the age of ninety.

EXHIBITION HISTORY

1895 exhibited with the Art Association of Montreal

1897, 1898 exhibited with the Royal Academy, London

1899, 1900 exhibited at the Paris Salon

1901 exhibited with the Royal Academy, London

1902 Waitt's Hall, Victoria

1903 Paris Salon

 exhibited with the Royal Academy, London

1904 Louisiana Purchase Exposition (St. Louis World's Fair)

1904–1909 exhibited with the Royal Canadian Academy of Arts

1907 exhibited with the Royal Academy, London

1909 solo exhibition, Doré Gallery, London

1910 exhibited with the Art Association of Montreal

1947 retrospective exhibition, Little Centre Gallery (precursor to the Art Gallery of Greater Victoria)

1954 retrospective exhibition, Vancouver Art Gallery

1978 retrospective exhibition, Fine Arts Gallery of the University of British Columbia, organized by the Art Gallery of Greater Victoria

1997 *Three West Coast Women: Emily Carr, Sophie Pemberton, Vera Weatherbie*, Art Gallery of Greater Victoria

Woman by the Fire,
c. 1902, detail.
See page 131.

Pflug, Christiane Sybille (née Shütt)

1936–1972

> "I would like to reach a certain clarity, which does not exist in life. But nature is complicated and changes all the time. One can only reach a small segment, and it takes such a long time."
>
> Christiane Pflug, quoted in Paul Duval, *High Realism in Canada*

EARLY LIFE

Christiane Pflug was born Christiane Sybille Shütt in Berlin on June 20, 1936. From age seven to twelve she stayed with family friends in a small town in Austria while her mother, who had been a knit designer, worked in the army as a nurse. It was during this time that Christiane's desire to draw and paint was sparked.

> "I grew up in a world of adults. I had to be quiet, in a large house, and this restricted most other activities. With books, paper and crayon one could always create one's own world, which also defied intrusion by any unwanted people."
>
> Christiane Pflug, quoted in Paul Duval, *High Realism in Canada*

EDUCATION, MENTORS, INFLUENCES

After the war, Christiane was reunited with her mother and moved to Frankfurt, where she lived until she was fifteen. When her mother immigrated to Canada in 1953, she went to Paris to study fashion design. Paris ignited her imagination and passion, and with the encouragement of her new friend and future husband, Michael Pflug, she pursued painting full-time.

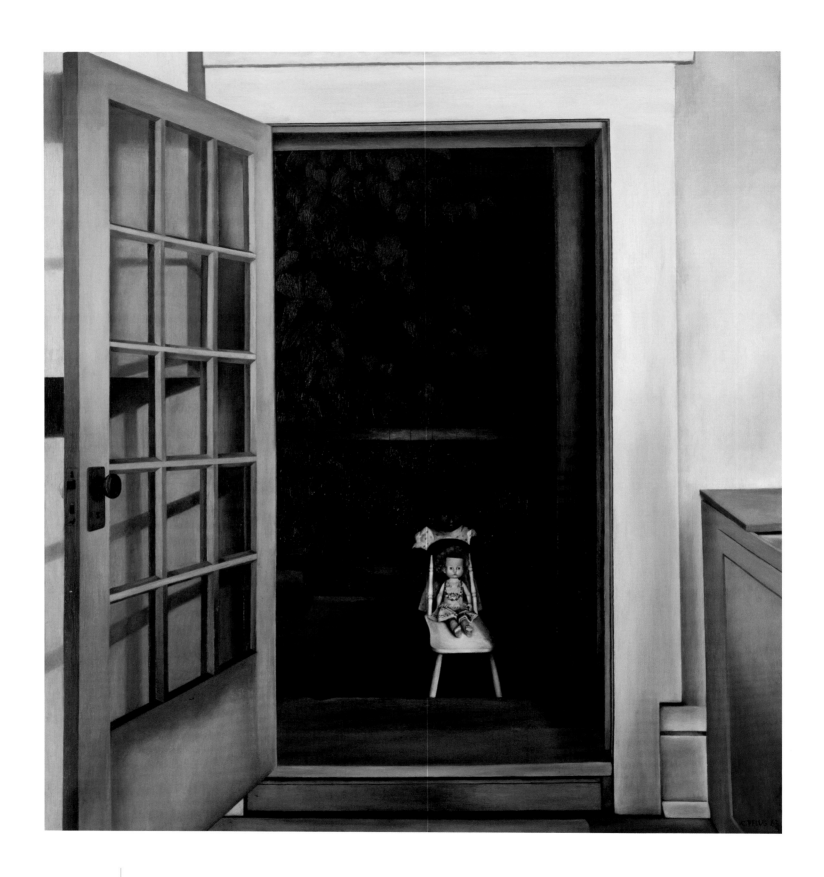

Kitchen Door at Night II
1963
Oil on canvas
43¼ x 39 inches (110 x 99 cm)
Pflug Family Collection

EARLY CAREER

After marrying in 1956, the couple moved to Tunis, where Michael continued his medical education. Both of their daughters, Esther and Ursula, were born in Tunis. This period was likely the happiest time in Pflug's life. However, as the political climate in North Africa changed, Michael felt that his family would be safer elsewhere. With one year remaining in his internship, he sent his wife and daughters to Toronto to live with her mother.

The family had a difficult time adjusting to Toronto. Pflug found the responsibilities of being a mother and wife took a great deal of time, although she still managed to paint and draw. Between 1959 and 1972, the family moved three times, and Pflug painted what she saw from her apartment window in each location. Their first home, overlooking Yonge Street adjacent to a railway yard, inspired a series of muted studies of the changing atmosphere of the abandoned land. The family's next move was to Woodlawn Avenue overlooking a lovely garden that served as the backdrop to many well-known paintings by Pflug, including those of her daughters and their dolls as models.

In 1961, Pflug met Avrom Isaacs when she took her works to his gallery for framing. Within a year of their meeting, he organized an exhibition of her work; the show sold out and gave the artist the encouragement she needed. Isaacs was important to her not only as a dealer but also as a friend, and she painted him in the kitchen of her home on Woodlawn Avenue. She continued to show at the Isaacs Gallery; in time, public galleries became interested in her work. In 1966, the Winnipeg Art Gallery gave Pflug her first retrospective, and the National Gallery of Canada purchased three of her drawings.

In 1967 the family moved to Birch Avenue, across from the Cottingham School. Pflug painted a series of cityscapes featuring the school until her death in 1972.

MATURE PERIOD
Circa 1960 to 1972.

PREFERRED SUBJECT MATTER
Interiors with her daughters and their dolls, cityscapes from the vantage of her window.

COMPOSITIONAL SUBTLETIES
Defining the boundaries between human beings and their environment, fantasy and reality.

LATER YEARS
Christiane Pflug committed suicide at age thirty-five on April 4, 1972, at Hanlan's Point on the Toronto Islands.

Christiane Pflug,
Toronto, 1971.

Kitchen Door with
Ursula, 1966, detail.
See page 111.

EXHIBITION HISTORY

1958	joint exhibition with Michael Pflug, Alliance Française, Tunis
1962	solo exhibition, Isaacs Gallery, Toronto
1964	solo exhibition, Isaacs Gallery, Toronto,
	exhibited with the Ontario Society of Artists, Ottawa
	Royal Canadian Academy Annual Show, Ottawa
1966	solo exhibition, Isaacs Gallery, Toronto
	retrospective exhibition, Winnipeg Art Gallery
1969	Hart House, University of Toronto
	Peel County Museum, Brampton
1971	Sarnia Art Gallery, Sarnia, Ontario

Robertson, Sarah Margaret Armour
1891–1948

"Her landscapes are living examples that nature is a source and not a standard and she has the courage to create landscapes, and not copy them literally."

Arthur Lismer, *Montreal Star*, May 9, 1934

EARLY LIFE
Sarah Margaret Armour Robertson was born in Montreal on June 16, 1891, one of four children of John Armour Robertson and Jessie Anna Christie. Her childhood was carefree, although she endured many difficulties as an adult.

EDUCATION, MENTORS, INFLUENCES
Robertson began her studies in art under William Brymner and Maurice Cullen at the Art Association of Montreal. From 1921 to 1924, she studied under Randolph Hewton. The influences of French Impressionism and Fauvism can be seen in her work.

EARLY CAREER
Robertson exhibited with the original Beaver Hall Group in the early 1920s and was part of the network of women artists that continued for years informally under that name.

Due to her own ill health and the time she spent caring for her sick mother, Robertson found little time to make art. As a result, her output was small; she painted only a few canvases a year. Robertson did not have the means to travel, but she often spent the summers painting in Brockville at the family cottage of her close friend Prudence Heward.

Robertson drew happiness and a sense of community from her circle of artist peers. One of her closest friends was A.Y. Jackson, who gave Robertson both spiritual and financial support – sometimes even buying her paintings. Robertson also received support and encouragement from other members of the Beaver Hall Group.

Quebec Village
c. 1938
Oil on board
16 x 18 inches (40.6 x 45.7 cm)
Private Collection, Alberta

AFFILIATIONS AND AWARDS

1910	awarded Wood Scholarship, Art Association of Montreal
1919	awarded Women's Art Society Scholarship
1920	Kenneth R. Macpherson Prize, shared with Donald Hill
1921	member, Beaver Hall Group, Montreal
1933–1949	founding member, Canadian Group of Painters

Member, Women's Art Association of Canada

MATURE PERIOD

Circa 1920 to 1945.

PREFERRED SUBJECT MATTER

Still life and landscape.

COMPOSITIONAL SUBTLETIES

Robertson recorded nature boldly with her brush, deliberately stressing the design of her subject for powerful effect.

LATER YEARS

Besides painting canvases, she was commissioned to paint murals in private residences. She also helped organize exhibitions, such as the memorial exhibition for Prudence Heward in 1947.

Sarah Robertson died in Montreal on December 6, 1948, of bone cancer. She was fifty-seven years old.

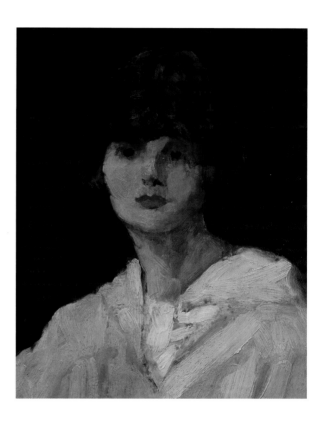

by Emily Coonan
Portrait of Sarah Robertson
c. 1916
Oil on panel
10 x 8 inches (25.4 x 20.3 cm)
Private Collection, Alberta

EXHIBITION HISTORY

1912–1945	exhibited with the Art Association of Montreal
1920–1934	exhibited with the Royal Canadian Academy of Arts
1922	exhibited with the Beaver Hall Group, Montreal
1924	*Pictures Exhibited by the Montreal Group of Artists*, Hart House, University of Toronto
1924–1925	*British Empire Exhibition, Canadian Section of Fine Arts*, Wembley, England
1925	*Contemporary Canadian Artists*, Chowne Art Dealer, Montreal
1926	exhibited with the Group of Seven
	Special Exhibition of Canadian Art (first annual), National Gallery of Canada, Ottawa

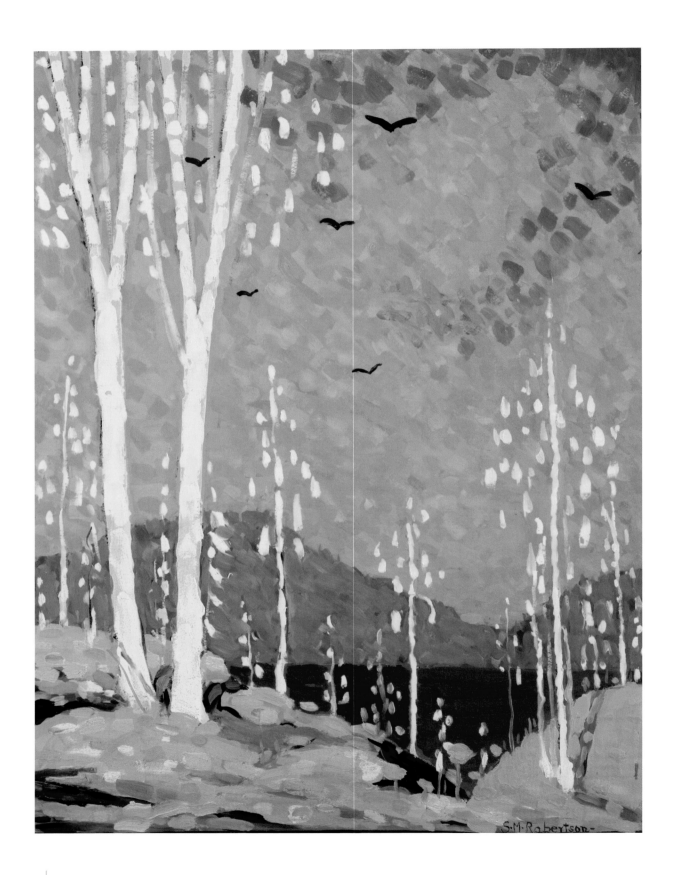

Autumn in the Laurentians

c. 1935

Oil on board

39½ x 29½ inches (100.3 x 74.9 cm)

Private Collection, British Columbia

1927	*Exposition d'art canadien*, Musée du Jeu de Paume, Paris
1927–1929	exhibited with the Ontario Society of Artists, Toronto
1927–1930	*Annual Exhibition of Canadian Art*, National Gallery of Canada, Ottawa
1928	*Exhibition of Paintings by the Group of Seven*, Art Gallery of Toronto
1930	*Exhibition of Paintings by Contemporary Canadian Artists*, Corcoran Gallery of Art, Washington, D.C.; travelling exhibition
	Paintings by a Group of Contemporary Montreal Artists, Art Association of Montreal
1930, 1931	*Exhibition of the Group of Seven*, Art Gallery of Toronto
1931	*First Baltimore Pan American Exhibition of Contemporary Painting*, Baltimore Museum of Art
1932	*Exhibition of Contemporary Canadian Artists*, Roerich Museum, International Art Centre, New York
	Annual Exhibition of Canadian Art, National Gallery of Canada, Ottawa
1933	*Exhibition of Paintings by Canadian Women Artists*, Eaton's Fine Art Gallery, Montreal
	Paintings by the Canadian Group of Painters, Heinz Art Salon, Atlantic City, N.J.
	Exhibition of Paintings by Canadian Group of Painters, Art Gallery of Toronto
1933–1949	exhibited with the Canadian Group of Painters
1934	three-woman show, Hart House, University of Toronto and William Scott & Sons, Montreal
	Canadian Paintings, The Collection of the Hon. Vincent and Mrs. Massey, Art Gallery of Toronto
1936	*Exhibition of Contemporary Canadian Paintings*, National Gallery of Canada, Ottawa
	exhibited with the Canadian Group of Painters, Art Gallery of Toronto and National Gallery of Canada, Ottawa
1937	group show of Modernists, Montreal Arts Club
	Exhibition of Paintings, Drawings and Sculpture by Artists of the British Empire Overseas (Coronation Exhibition), Royal Institute Galleries, London
	exhibited with the Canadian Group of Painters, Art Gallery of Toronto
1938	*A Century of Canadian Art*, Tate Gallery, London
1939	*Exhibition by the Canadian Group of Painters*, New York World's Fair
	Golden Gate International Exposition of Contemporary Art, Department of Fine Arts, San Francisco
	exhibited with the Canadian Group of Painters, Art Gallery of Toronto

"She loved the rhythm and warmth and colour of the earth, and its fruits and flowers, and painted them with love."

Robert Ayre, *Montreal Star*, February 23, 1952

The Red Sleigh, c. 1924, detail. See page 149.

1940	four-woman show, Art Gallery of Toronto
	Canadian National Committee on Refugees, Exhibition and Auction of Paintings, National Gallery of Canada, Ottawa
	exhibited with the Contemporary Arts Society, Art Association of Montreal
1942	exhibited with the Canadian Group of Painters, Art Gallery of Toronto and Art Association of Montreal
1944	*Canadian Art 1760–1943,* Yale University Art Gallery, New Haven
	Pintura Canadense Contemporânea, Museu Nacional de Belas Artes, Rio de Janeiro
1945	*The Development of Painting in Canada 1665–1945,* Art Association of Montreal and Art Gallery of Toronto
1947	*Canadian Women Artists,* Riverside Museum, New York
1949	*Canadian Women Painters,* West End Gallery, Montreal
1951	memorial exhibition, National Gallery of Canada, Ottawa; travelling exhibition
1957	YWCA, Montreal
1966	*The Beaver Hall Hill Group,* National Gallery of Canada, Ottawa
1975	*Canadian Painting in the Thirties,* National Gallery of Canada, Ottawa
	From Women's Eyes: Women Painters in Canada, Agnes Etherington Art Centre, Kingston, Ontario
1979	*Prudence Heward and Friends,* Art Gallery of Windsor, Ontario
1982	*Modernism in Quebec Art (1916–1946),* National Gallery of Canada, Ottawa
	Women Painters of the Beaver Hall Group, Sir George Williams Art Gallery, Montreal
1983	*Visions and Victories: 10 Canadian Women Artists,* London Regional Art Gallery, Ontario
1991	*The Beaver Hall Hill Group,* Kaspar Gallery, Toronto
	retrospective exhibition, Walter Klinkhoff Gallery, Montreal
1997	*Montreal Women Painters on the Threshold of Modernity,* Montreal Museum of Fine Arts

Savage, Anne Douglas
1896–1971

"The outstanding quality that a teacher must have is [an] absolute belief in the power of the child to find his own way ... No mistakes are possible, no criticism, only appreciation and delight in the doing."

Anne Savage, National Gallery of Canada, Library and Archives, Artists' Files

EARLY LIFE

Anne Savage was born in Montreal on July 27, 1896. She was the second of three children born to John George Savage and Helen Lizars Galt, and the twin of Donaldson Savage.

EDUCATION, MENTORS, INFLUENCES

Savage studied from 1914 to 1918 at the Art Association of Montreal under William Brymner and Maurice Cullen. She continued her studies at the Minneapolis School of Design. Savage chose a career in teaching in order to assist her family after her twin brother was killed in action.

EARLY CAREER

Savage was a painter, teacher, and spokesperson for art. Her teaching began at the Commercial and Technical High School in Montreal in 1921; the following year, she transferred to Baron Byng High School to become its first art teacher, where she taught from 1922 to 1948. While teaching, she continued to paint and exhibit her work. She was a member of the original Beaver Hall Group, and remained part of the network of women artists that continued for years under that name.

In 1927, Savage travelled to Skeena River, B.C., with anthropologist Marius Barbeau, Florence Wyle, and Pegi Nicol MacLeod, to record the totem poles of northwest coast Natives.

Her parents had a farm property at Lake Wonish, Quebec, north of Montreal; Savage built a studio there in the 1930s. It became her favourite "painting place."

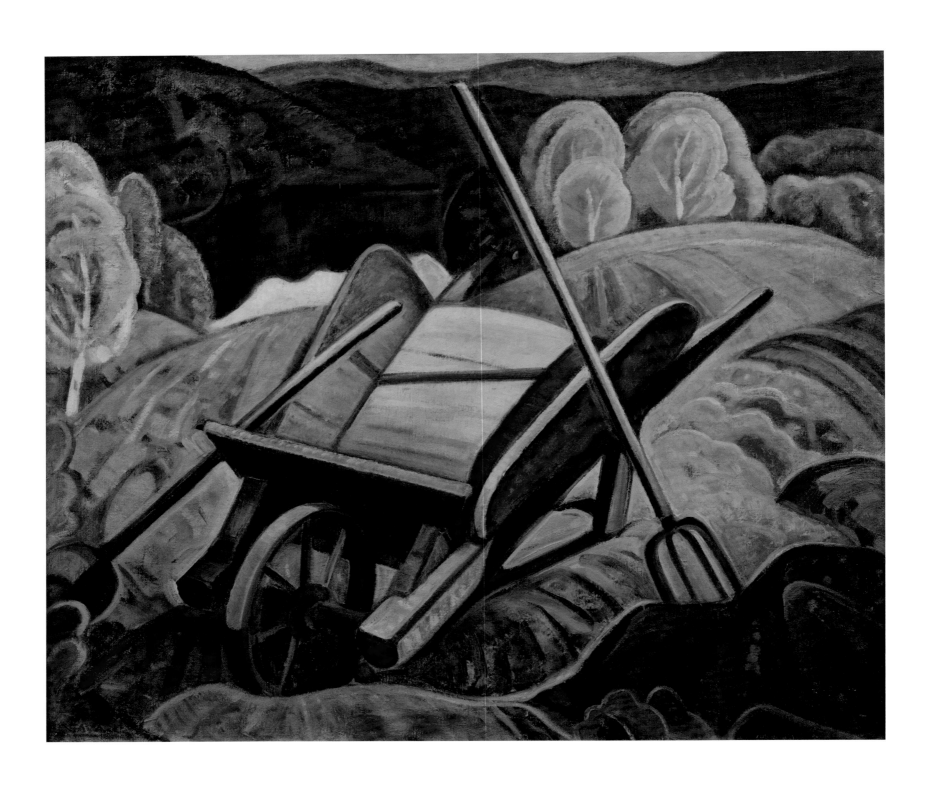

The Wheelbarrow, Wonish

c. 1936

Oil on canvas

25 x 30 inches (63.5 x 76.2 cm),

Private Collection, New Brunswick

Throughout her career, Savage spoke publicly about art and society. She wrote essays on the subject, including "The Development of Canadian Art," delivered in 1935 to audiences at the YMCA and the National Gallery of Canada and later included in the CBC series *Canadian Painting*.

Savage retained friendships with all her painting colleagues from the Beaver Hall Group. She enjoyed a particularly intimate lifelong bond with A.Y. Jackson, with whom she frequently corresponded.

AFFILIATIONS AND AWARDS

1919	Kenneth R. Macpherson Prize
1920	founding member, Beaver Hall Group, Montreal
1933–1967	founding member, Canadian Group of Painters
1939	executive, Canadian Group of Painters
1943	awarded Order of Scholastic Merit for Art Teaching from Montreal Protestant School Board
1949	president, Canadian Group of Painters
1960	president, Canadian Group of Painters

MATURE PERIOD

Circa 1925 to 1938.

PREFERRED SUBJECT MATTER

Landscapes of Montreal and the surrounding area, including the family farm at Lake Wonish.

COMPOSITIONAL SUBTLETIES

Rhythmic distortions united with lyrical undertones.

LATER YEARS

Savage taught full-time for twenty-eight years until her retirement in 1948, painting only in her spare time. In 1937, for four years, she had also taught Saturday morning art classes at the Art Association of Montreal, and in 1949, she taught courses at the Banff Summer School. After retiring, she worked as supervisor of art education for the Montreal Protestant School Board until 1953, and taught art education at McGill University from 1954 to 1959.

Anne Savage died in a nursing home on March 25, 1971, of breast cancer, at the age of seventy-four.

EXHIBITION HISTORY

1918	exhibited with the Art Association of Montreal
1918–1931	exhibited with the Royal Canadian Academy of Arts
1921	first annual exhibition of Beaver Hall Group, Montreal
1922	Beaver Hall Group, Montreal
1924	*Pictures Exhibited by the Montreal Group of Artists,* Hart House, University of Toronto
1924–1925	*British Empire Exhibition, Canadian Section of Fine Arts,* Wembley, England
1926	*Special Exhibition of Canadian Art* (first annual), National Gallery of Canada, Ottawa
	Exhibition of the Group of Seven, Art Gallery of Toronto
1927	*Exhibition of Canadian West Coast Art, Native and Modern,* National Gallery of Canada, Ottawa
	Exposition d'art canadien, Musée du Jeu de Paume, Paris
1927–1933	*Annual Exhibition of Canadian Art,* National Gallery of Canada, Ottawa
1930	*Exhibition of Paintings by Contemporary Canadian Artists,* Corcoran Gallery of Art, Washington, D.C.; travelling exhibition
	Paintings by a Group of Contemporary Montreal Artists, Art Association of Montreal
1931	*First Baltimore Pan American Exhibition of Contemporary Painting,* Baltimore Museum of Art
	Exhibition of the Group of Seven, Art Gallery of Toronto
1933	*Paintings by the Canadian Group of Painters,* Heinz Art Salon, Atlantic City, NJ
	Exhibition of Paintings by Canadian Group of Painters, Art Gallery of Toronto
1934	*Canadian Paintings, The Collection of the Hon. Vincent and Mrs. Massey,* Art Gallery of Toronto
1936	*Exhibition of Contemporary Canadian Paintings,* National Gallery of Canada, Ottawa
	exhibited with the Canadian Group of Painters, Art Gallery of Toronto and National Gallery of Canada, Ottawa
1937	*Exhibition of Paintings, Drawings and Sculpture by Artists of the British Empire Overseas* (Coronation Exhibition), Royal Institute Galleries, London
	exhibited with the Canadian Group of Painters, Art Gallery of Toronto
1938	*A Century of Canadian Art,* Tate Gallery, London
	Sale Aid to Spanish Democracy, 2037 Peel Street, Montreal
1939	*Exhibition by the Canadian Group of Painters,* New York World's Fair
	Golden Gate International Exposition of Contemporary Art, Department of Fine Arts, San Francisco
	exhibited with the Canadian Group of Painters, Art Gallery of Toronto

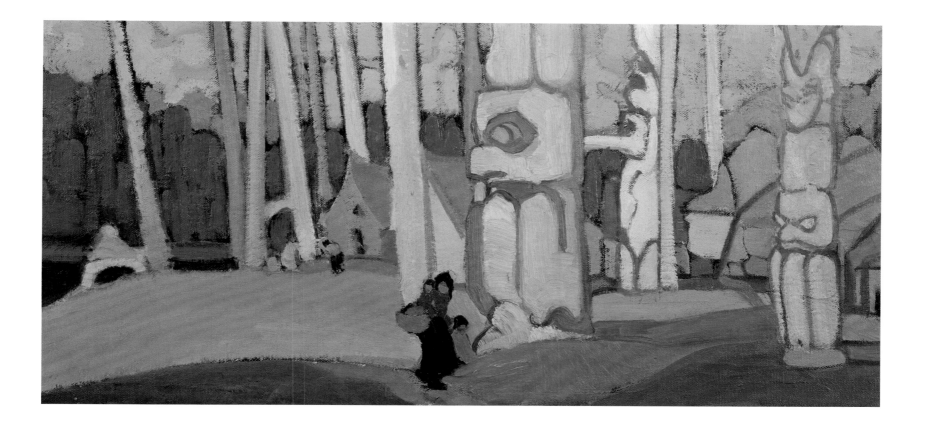

Owl Totem, Kispiax, 1927, detail. See page 161.

1940	four-woman show, Art Gallery of Toronto
	Canadian National Committee on Refugees, Exhibition and Auction of Paintings, National Gallery of Canada, Ottawa
1942	exhibited with the Canadian Group of Painters, Art Gallery of Toronto, Art Association of Montreal, and National Gallery of Canada, Ottawa
1944	*Oil Paintings by Lilias Torrance Newton, RCA, Prudence Heward, Anne Savage, and Ethel Seath,* Art Association of Montreal
	exhibited with the Canadian Group of Painters, Art Gallery of Toronto and Art Association of Montreal
	Canadian Art 1760–1943, Yale University Art Gallery, New Haven
1945	three-woman show, Willistead Art Gallery, Windsor, Ontario
	The Development of Painting in Canada 1665–1945, Art Association of Montreal and Art Gallery of Toronto
	exhibited with the Canadian Group of Painters, Art Gallery of Toronto
1947	*Canadian Women Artists,* Riverside Museum, New York
	exhibited with the Canadian Group of Painters, Art Gallery of Toronto
1949	exhibited with the Canadian Group of Painters, Art Gallery of Toronto and Montreal Museum of Fine Arts; travelling exhibition

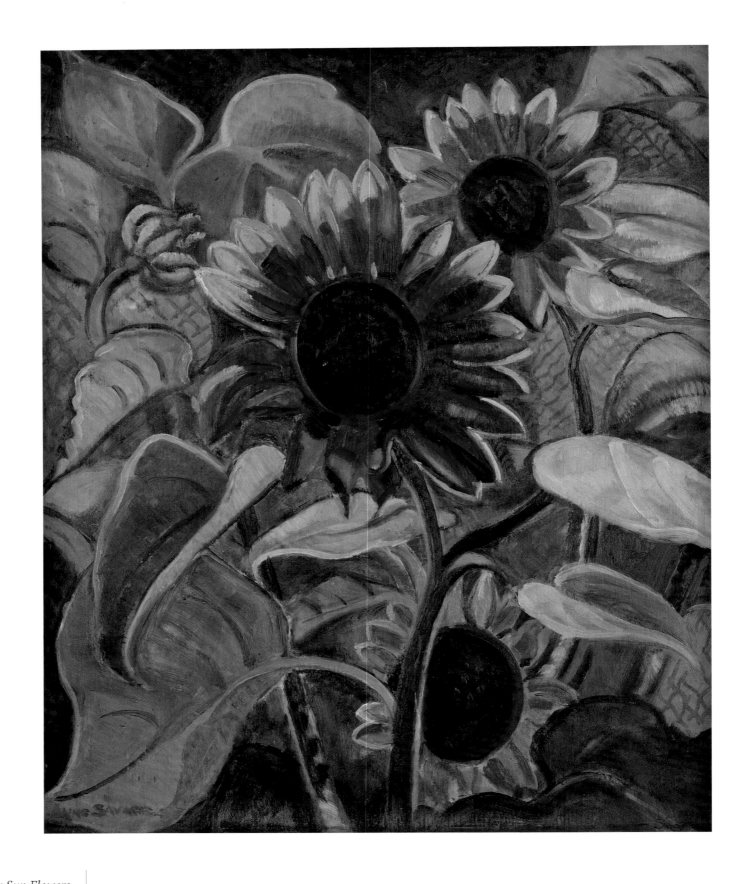

Dark Sun Flowers

c. 1938

Oil on panel

18 x 15 inches (45.7 x 38.1 cm)

Private Collection, Alberta

1949	*Canadian Women Painters*, West End Gallery, Montreal
1950	*Six Montreal Women Painters,* Montreal Museum of Fine Arts
	exhibited with the Canadian Group of Painters, Art Gallery of Toronto
1956	solo exhibition, YWCA, Montreal
	Inaugural Exhibition of Paintings, Cowansville Art Centre, Quebec
	exhibited with the Canadian Group of Painters, Art Gallery of Toronto
1957	exhibited with the Canadian Group of Painters, Montreal Museum of Fine Arts
1958	exhibited with the Canadian Group of Painters, Art Gallery of Toronto and Vancouver Art Gallery
1959	exhibited with the Canadian Group of Painters, Art Gallery of Toronto
1960	exhibited with the Canadian Group of Painters, Montreal Museum of Fine Art
1963	joint exhibition with André Biéler, Artlenders Gallery, Montreal
	exhibited with the Canadian Group of Painters, Montreal Museum of Fine Arts
1965	exhibited with the Canadian Group of Painters, Art Gallery of Greater Victoria and Agnes Etherington Art Centre, Kingston, Ontario
1966	*The Beaver Hall Hill Group*, National Gallery of Canada, Ottawa
1967	exhibited with the Canadian Group of Painters, Montreal Museum of Fine Arts
1969	retrospective exhibition, Sir George Williams University, Montreal
1974	*Annie D. Savage: Drawings and Watercolours,* Sir George Williams Art Gallery, Montreal
1975	*Canadian Painting in the Thirties*, National Gallery of Canada, Ontario
1982	*Women Painters of the Beaver Hall Group,* Sir George Williams Art Gallery, Montreal
1991	*The Beaver Hall Hill Group*, Kaspar Gallery, Toronto
1992	retrospective exhibition, Walter Klinkhoff Gallery, Montreal
1997	*Montreal Women Painters on the Threshold of Modernity*, Montreal Museum of Fine Arts
2002	*Quiet Harmony: The Art of Mary Hiester Reid and Anne Douglas Savage,* Concordia University, Montreal

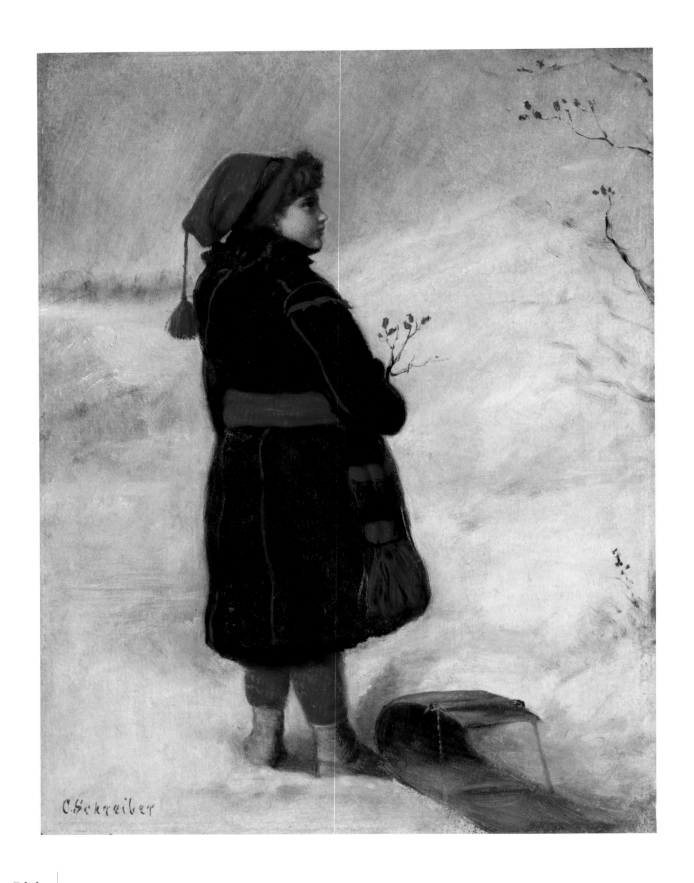

Edith

1876

Oil on panel

12½ x 9½ inches (31.8 x 24 cm)

Private Collection, Ontario

Schreiber, Charlotte Mount Brock (née Morrell)

1834–1922

> "The human hand, the finger nail, the foot, every portion of the living body, the parts of a flower, are divinely beautiful … it is a joy to paint them as they are in reality."
>
> Charlotte Schreiber, quoted in *The Globe*, March 2, 1895

EARLY LIFE

Charlotte Schreiber was born Charlotte Mount Brock Morrell in Essex, England, on May 31, 1834. Her maternal grandfather was related to Sir Isaac Brock. Her father, Rev. Robert Price Morrell, the rector of the local parish, encouraged her in the study of art.

EDUCATION, MENTORS, INFLUENCES

Charlotte Morrell attended Mr. Carey's School of Art in London before studying figurative and landscape painting under John Rogers Herbert. It was Herbert who encouraged her to submit her work for publication, and as a result, she received commissions for book illustration.

EARLY CAREER

In 1871, Charlotte Morrell was commissioned to illustrate Edmund Spenser's *The Legend of the Red Crosse Knight*, the first book of *The Faerie Queene*, and in 1873, she illustrated Elizabeth Barrett Browning's *The Rhyme of the Duchess May*.

Her life changed in 1875 when she married her cousin Weymouth George Schreiber and moved to Toronto along with his three teenaged children. They first lived in Deer Park, then settled into a house near the Credit River, an area now known as Erindale. Their house is presently owned by the University of Toronto and is the residence of the principal of Erindale College.

Schreiber continued to make art and began teaching in her new community. Among her students were artists Ernest Thompson Seton, G.A. Reid, and Lucius O'Brien, among others.

AFFILIATIONS AND AWARDS
1876–1889 member, Ontario Society of Artists
1880–1886 member, Royal Canadian Academy of Arts
Schreiber was the first woman elected a member of the Royal Canadian Academy, yet she was barred from meetings and could not participate in policy making. It was not until 1933, with the election of Marion Long, that a woman was elected a member with the full privileges of an academician.

Schreiber was the only woman on the council of the Ontario School of Art (now the Ontario College of Art and Design) and was a founding member of the Woman's (now Women's) Art Association of Canada, the oldest women's club in Canada, presently located on Prince Arthur Avenue in Toronto.

MATURE PERIOD
Circa 1875 to 1895.

PREFERRED SUBJECT MATTER
Figurative work and portraiture in the realist manner showing specific attention to detail. Landscape embellished by the lighthearted activities of its inhabitants.

COMPOSITIONAL SUBTLETIES
Exquisite surface tension, with illumination of her subject reflecting the beauty of the day rather than defining the personality of the sitter.

LATER YEARS
Schreiber was an active member of her church, playing the organ and fundraising through the sale of her art and the sale of animals she raised.

After the death of her husband in 1898, Charlotte Schreiber moved back to England. She died in South Devon on July 3, 1922, at the age of eighty-eight.

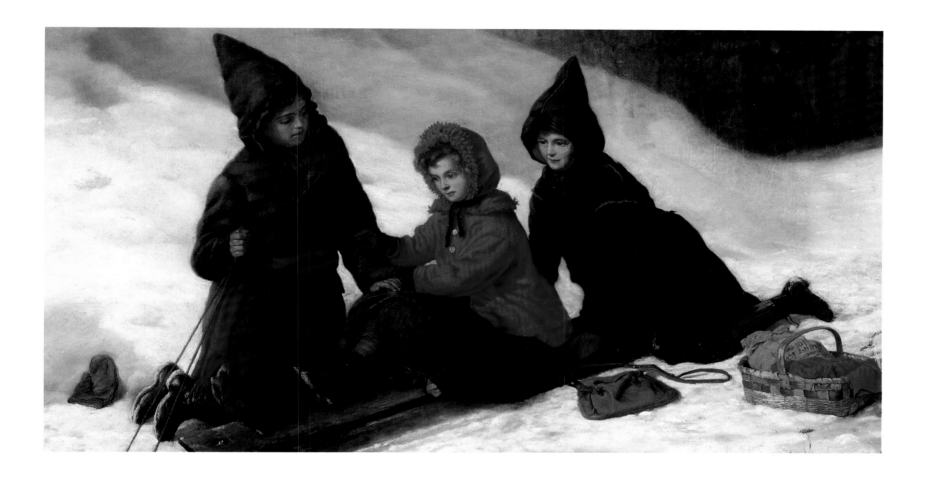

EXHIBITION HISTORY

Springfield on the Credit, c. 1880, detail. See page 39.

1855–1874	exhibited at the Royal Academy, London, under maiden name, Morrell
1870–1880	annual Toronto Industrial Exhibition, exhibited in the Fine Art Section
1870–1883	exhibited with the Art Association of Montreal
1876	Sesqui-Centennial Exhibition, Philadelphia
1876–1888	exhibited with the Ontario Society of Artists
1880–1898	exhibited with the Royal Canadian Academy of Arts, Toronto
1892	exhibited with the Lyceum Club, Toronto
1893	exhibition, Chicago
1903	Canadian National Exhibition, Toronto
1967	exhibited with the Lyceum Club and Women's Art Association, Toronto Erindale College, University of Toronto
1985	retrospective exhibition, Erindale Campus, University of Toronto

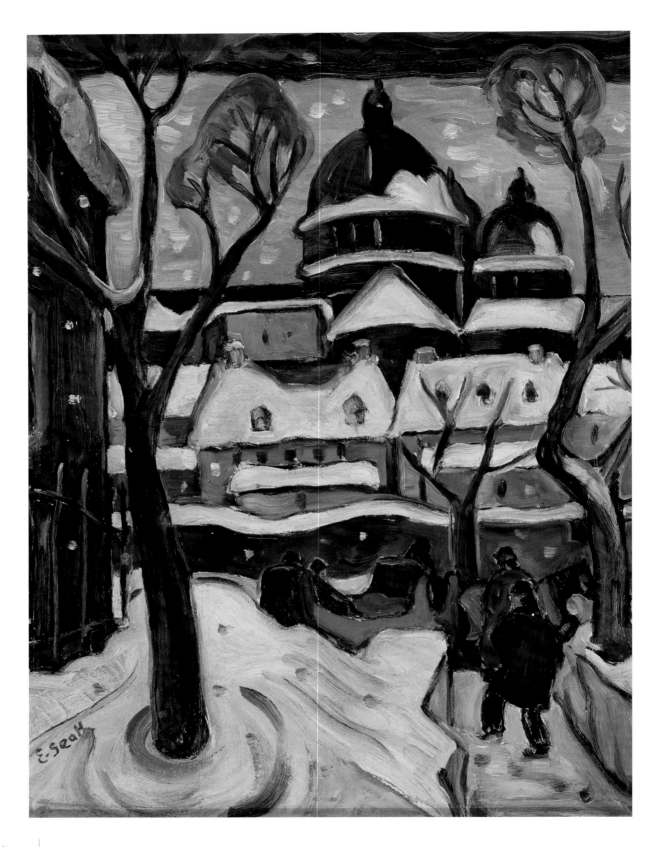

St. James Cathedral from
La Gauchetière Street

c. 1925

Oil on panel

15¾ x 11½ inches (40 x 29.2 cm)

Private Collection, Quebec

Seath, Ethel
1879–1963

> " … a simple flower, a stone, an interior, abstracted from the world at my doorstep on to canvases … I love my own country. I have never wanted to paint anywhere else."
>
> Ethel Seath, quoted in Laureen Hicks, *Montreal Star*, October 26, 1962

EARLY LIFE

Ethel Seath was born in Montreal in 1879, the second of five children of Alexander Stuart Seath and Lizetta Annie Foulds. Her parents divorced and as a result, her family struggled financially. Seath, however, was determined to follow her heart as an artist.

EDUCATION, MENTORS, INFLUENCES

Seath attended the Conseil des arts et manufactures, studying drawing under Edmond Dyonnet and lithography under Robert Harris. She began work as a newspaper illustrator before taking classes with William Brymner and Maurice Cullen at the Art Association of Montreal. She also studied under Charles Hawthorne in Provincetown, Massachusetts.

EARLY CAREER

Seath spent almost twenty years working as a commercial illustrator for some of the newspapers in Montreal, including the *Witness* and the *Montreal Star*. It was a difficult profession, particularly for a woman, but she was able to earn enough income for herself and her family.

While working for the newspapers, Seath took art classes, painted, and exhibited her work. She was part of the network of women artists known as the Beaver Hall Group that continued for years after the original group of that name disbanded.

1938–1962 member, Canadian Group of Painters

1939–1948 founding member, Contemporary Arts Society

MATURE PERIOD

Circa 1920 to 1945.

PREFERRED SUBJECT MATTER

Still life and landscape.

COMPOSITIONAL SUBTLETIES

Seath's work tended towards simplification, stylization, and abstraction.

LATER YEARS

When she retired from commercial illustrating in 1917, Seath began a second career teaching art to children, working with her friend Margaret Gascoigne, founder of The Study, a private school for girls. She also taught Saturday morning classes at the Montreal Museum of Fine Arts, helping to introduce a successful program to teach art and inspire individual creativity through awareness of art, combined with literature and music.

While teaching, Seath and Gascoigne spent time travelling through the Eastern Townships and painting. Seath submitted her work to many exhibitions.

Her teaching career lasted forty-five years, by which time she was teaching the grandchildren of the young students she had taught in her early years. Seath retired from teaching in 1962 and moved in with her sister. She died in Montreal on April 10, 1963, at the age of eighty-four.

Nuns, St. Sulpician Garden, 1930, detail. See page 135.

EXHIBITION HISTORY

1905–1956 exhibited with the Art Association of Montreal

1906 exhibited with Royal Canadian Academy of Arts

1925 *British Empire Exhibition, Canadian Section of Fine Arts,* Wembley, England

1927 *Exposition d'art canadien,* Musée du Jeu de Paume, Paris

1927, 1928 *Annual Exhibition of Canadian Art,* National Gallery of Canada, Ottawa

1930 *Paintings by a Group of Contemporary Montreal Artists,* Art Association of Montreal

1931–1933 *Annual Exhibition of Canadian Art,* National Gallery of Canada, Ottawa

1933 *Exhibition of Paintings by Canadian Group of Painters,* Art Gallery of Toronto

1934 exhibited with the Canadian Group of Painters, Montreal

1934	*Canadian Paintings, The Collection of the Hon. Vincent and Mrs. Massey*, Art Gallery of Toronto
1936	*Exhibition of Contemporary Canadian Paintings*, National Gallery of Canada, Ottawa
	exhibited with the Canadian Group of Painters, Art Gallery of Toronto and National Gallery of Canada, Ottawa
1937	*Exhibition of Paintings, Drawings and Sculpture by Artists of the British Empire Overseas* (Coronation Exhibition), Royal Institute Galleries, London
	exhibited with the Canadian Group of Painters, Art Gallery of Toronto
1938	*A Century of Canadian Art*, Tate Gallery, London
1939	*Exhibition by the Canadian Group of Painters*, New York World's Fair
	exhibited with the Canadian Group of Painters, Art Gallery of Toronto
1940	four-woman show, Art Gallery of Toronto
	Canadian National Committee on Refugees, Exhibition and Auction of Paintings, National Gallery of Canada, Ottawa
	exhibited with the Contemporary Arts Society, Art Association of Montreal
1942	exhibited with the Canadian Group of Painters, Art Gallery of Toronto, Art Association of Montreal, and National Gallery of Canada, Ottawa
1944	*Oil Paintings by Lilias Torrance Newton, RCA, Prudence Heward, Anne Savage, and Ethel Seath*, Art Association of Montreal
	Canadian Art 1760–1943, Yale University Art Gallery, New Haven
	Pintura Canadense Contemporânea, Museu Nacional de Belas Artes, Rio de Janeiro
1945	three-woman show, Willistead Art Gallery, Windsor, Ontario
	exhibited with the Canadian Group of Painters, Art Gallery of Toronto
1947	*Canadian Women Artists*, Riverside Museum, New York
	exhibited with the Canadian Group of Painters, Art Gallery of Toronto
1949	exhibited with the Canadian Group of Painters, Art Gallery of Toronto and Montreal Museum of Fine Arts
	Canadian Women Painters, West End Gallery, Montreal
1950	*Six Montreal Women Painters*, Montreal Museum of Fine Arts
	exhibited with the Canadian Group of Painters, Art Gallery of Toronto
1952	three-woman exhibition, Montreal Museum of Fine Arts
1954	exhibited with the Canadian Group of Painters, Art Gallery of Toronto
1955	*Art from The Study,* sale of work by Seath and her students
	exhibited with the Canadian Group of Painters, Art Gallery of Toronto and Montreal Museum of Fine Arts

Still-Life with Apples, or *Flower Study,* 1934, detail. See page 137.

1956	*Inaugural Exhibition of Paintings*, Cowansville Art Centre, Quebec
	exhibited with the Canadian Group of Painters, Art Gallery of Toronto
1957	solo exhibition, YWCA, Montreal
	exhibited with the Canadian Group of Painters, Montreal Museum of Fine Arts
1958	exhibited with the Canadian Group of Painters, Art Gallery of Greater Victoria and Agnes Etherington Art Centre, Kingston, Ontario
1960	exhibited with the Canadian Group of Painters, Montreal Museum of Fine Arts
1962	exhibited with T.R. MacDonald, Montreal Museum of Fine Arts
1966	*The Beaver Hall Hill Group*, National Gallery of Canada, Ottawa
1982	*Women Painters of the Beaver Hall Group*, Sir George Williams Art Gallery, Montreal
1987	retrospective exhibition, Walter Klinkhoff Gallery, Montreal
1997	*Montreal Women Painters on the Threshold of Modernity*, Montreal Museum of Fine Arts
2007	retrospective exhibition of Beaver Hall Group, Walter Klinkhoff Gallery, Montreal

"Don't be shy, fill the pages, make a mess."

Ethel Seath, quoted in Barbara Meadowcroft, *Ethel Seath: Retrospective Exhibition*

Quebec Village, 1948, detail. See page 139.

Seiden, Regina (Goldberg)
1897–1991

"When we went to live in Montreal, I took three years of high school and then said, 'I can't stand it. I have to learn about art.' … I used to go alone, with my paint box, and wander around. If something appealed to me, I would stop and paint it."

Regina Seiden Goldberg, interview by Joan Murray, November 15, 1989

EARLY LIFE
Regina Seiden was born in Rigaud, Quebec, in 1897, the youngest of five children born to Wolfe Seiden and Jente Rosenbaum. Her parents ran a grocery store until 1905, when they moved to Montreal. Seiden was encouraged to paint.

EDUCATION, MENTORS, INFLUENCES
From 1914 to 1918, Seiden studied art under William Brymner, Edmond Dyonnet, and Maurice Cullen at the Art Association of Montreal. In 1921, she travelled to Paris and studied at the Académie Julian.

EARLY CAREER
Seiden was one of the original members of the Beaver Hall Group in 1920, but she did not remain part of the network of women artists that continued for years and was associated with the name. She married artist Eric Goldberg in 1928 and gave up her career as a professional artist to support that of her husband. However, along with her husband, she did teach art at their Westmount synagogue for twenty years, beginning in 1949.

AFFILIATIONS AND AWARDS

1917 awarded two scholarships for drawing and outdoor painting, Art Association
 of Montreal

1920 founding member, Beaver Hall Group

1939 member, Contemporary Arts Society

MATURE PERIOD

During the 1920s.

PREFERRED SUBJECT MATTER

Figurative work.

COMPOSITIONAL SUBTLETIES

The use of colour to render the psychological forces behind her subject matter.

LATER YEARS

After her husband's death in 1969, Seiden was encouraged to paint again. She continued to teach until 1976, when she began spending her winters in Florida. Regina Seiden died in January 1991, at the age of ninety-three.

EXHIBITION HISTORY

1915–1930 exhibited with the Art Association of Montreal

1916–1927 exhibited with the Royal Canadian Academy of Arts

1921 first annual exhibition of Beaver Hall Group, Montreal

1922 exhibited with the Beaver Hall Group, Montreal

1924 *British Empire Exhibition, Canadian Section of Fine Arts,* Wembley, England

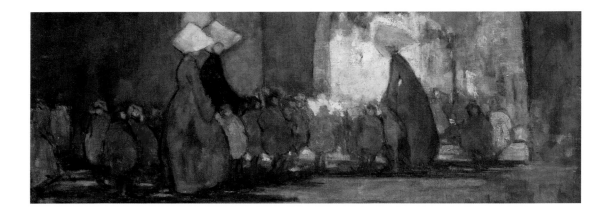

Children with Nuns,
c. 1920, detail.
See page 169.

Shore, Henrietta Mary

1880–1963

"I was on my way home from school and saw myself reflected in a puddle. It was the first time I had seen my image completely surrounded by nature, and I suddenly had an overwhelming sense of belonging to it – of actually being part of every tree and flower. I was filled with a desire to tell what I felt through painting."

Henrietta Shore, *Monterey Peninsula Herald*, October 19, 1946

EARLY LIFE

Henrietta Mary Shore was born in Toronto on January 22, 1880, the seventh and youngest child of Henry Shore and Charlotte Hull. At an early age, and with the encouragement of her parents, Shore chose to become an artist.

EDUCATION, MENTORS, INFLUENCES

Shore, who grew up in Toronto, became a student of Laura Muntz Lyall at St. Margaret's College. As Shore's interest in art developed, so did her desire for more training, and she looked beyond Toronto for inspiration. In 1900, she enrolled in the New York School of Art, studying under William Merritt Chase and Robert Henri. She also took classes at the Art Students League in New York with Frank Vincent DuMond, but Henri's instruction proved to be most in harmony with Shore's views on painting. She and Henri believed art to be a form of expression that constantly changed and grew.

Shore travelled to Europe for study, enrolling in the Heatherly School of Fine Art in London, where she was influenced by John Singer Sargent. She also travelled to Holland, Italy, and Spain.

Irises, or *Gloxinia by the Sea,* c. 1930–1935, detail. See page 85.

EARLY CAREER

After her training, Shore returned to Toronto where she taught art and participated in national and international exhibitions.

Shore, restless and wanting to develop her work, left Canada in 1913, travelling to the West Coast of the United States with her brother and sister-in-law. She settled in Los Angeles, and in 1921 she became an American citizen. Her work was well received, and she exhibited regularly with the California Art Club. She helped to found the Los Angeles Modern Art Society in 1916.

In 1920, Shore moved back east and opened a studio in New York. From there she often travelled to Canada, sometimes spending summers in Newfoundland. She found the East Coast to be a source of inspiration. During this time in New York, she became interested in abstraction; her show at the Ehrich Galleries in 1923 was of semi-abstract work.

Shore returned to Los Angeles in 1924, where she established herself as a successful international artist, honoured by her peers. Art critic Reginald Poland wrote in a catalogue of an exhibition in 1927 that Shore was "unquestionably one of the most important living painters of this century."

In 1927 in Carmel, California, Shore met Edward Weston, a pioneering photographer; the meeting was the beginning of a lifelong friendship. Weston saw in her work a synthesis with nature, and although they expressed themselves in different media, the two collaborated and exhibited together. In 1930, she made Carmel her permanent home.

AFFILIATIONS AND AWARDS

1909–1915	member, Ontario Society of Artists
1914	member, California Art Club
1915	silver medal, Panama-California Exposition, San Diego
1916	founding member, Modern Art Society, Los Angeles
1918	member, Oregon Society of Artists
1928	first prize, Society of Women Artists, San Francisco
1931	first prize, San Francisco Art Association
1934	founding member, Carmel Art Association

Member, Society of Women Painters and Sculptors, New York

MATURE PERIOD

Circa 1900 to 1945.

PREFERRED SUBJECT MATTER

Nature – still life and figurative work in harmony with its organic surroundings.

COMPOSITIONAL SUBTLETIES

Expressing mysticism in her subjects in a manner similar to Emily Carr's.

LATER YEARS

Shore owned a painting by her mentor Robert Henri, and in 1930 when she settled in Carmel, she sold the painting to finance a studio for herself, located where the Pine Inn stands today. She taught art to supplement her income. Shore instructed her students to not simply paint what they saw but to paint "the idea" of the subject.

Between 1936 and 1937, Shore was commissioned by the U.S. Treasury Relief Art Project to paint six murals. Four were done for the post office in Santa Cruz; two for public buildings in Monterey.

Although she managed to support herself as an artist, she always struggled financially. By the late 1950s, suffering from depression, Shore was admitted to a sanitarium in San Jose, California, where she remained until her death at age eighty-three on May 17, 1963.

"To be true to nature one must abstract. Nature does not waste her forms."

Henrietta Shore, letter to Edward Weston, January 8, 1939

Tiger Lilies

c. 1938

Oil on canvas

26 x 26 inches (66 x 66 cm)

Private Collection, California

EXHIBITION HISTORY

1914, 1917 solo exhibition, Los Angeles Museum of History, Science and Art

1923 solo exhibition, Ehrich Galleries, New York

1924 exhibition of American artists, Paris; one of twenty-five artists chosen to repre-
 sent American art

 British Empire Exhibition, Canadian Section of Fine Arts, Wembley, England

1926 solo exhibition, Ehrich Galleries, New York

1927 Fine Arts Gallery of San Diego

 solo exhibition, Los Angeles Museum of History, Science and Art

1928 exhibited with the Society of Women Artists, San Francisco

1928, 1931 California Palace of the Legion of Honor, San Francisco

1933 M.H. de Young Memorial Museum, San Francisco

1939 Georgette Passedoit Gallery, New York

1946 exhibited with the Carmel Art Association

1963 memorial exhibition, Carmel Art Association

1986 *Henrietta Shore: A Retrospective Exhibition, 1900–1963*, Monterey Museum of Art

Shore's work was exhibited at the Canadian National Exhibition and with the Royal
Academy of Canada. Her work was included in Canadian art exhibitions in London
and Paris.

"There are moments in our lives, there are moments in a day, when we seem to see beyond the
usual. Such are the moments of our greatest happiness. Such are the moments of our greatest
wisdom. If one could but recall this vision by some sort of sign, it was in this hope that the arts
were invented. Sign-posts on the way to what may be. Sign-posts toward greater knowledge."

Henrietta Shore, from the preface to Robert Henri, *The Art Spirit*

Portrait
c. 1948
Oil on panel
12 x 10 inches (30.5 x 25.4 cm)
Private Collection, Ontario

Smith, Jori (Marjorie) Elizabeth Thurston (Palardy)

1907–2005

> "I paint as some people sing, well or badly as the case may be, but always with joy. For me, it is the only way I have of expressing the satisfaction of being alive."

Jori Smith, exhibition catalogue, Agassiz Galleries, Winnipeg, 1984

EARLY LIFE

Jori Smith was born in Montreal on January 1, 1907, the daughter of James Thurston Smith and Naomi Neal. Although her relationship with her parents was not a close one, Smith was encouraged to pursue art.

EDUCATION, MENTORS, INFLUENCES

Smith's art studies began at the Art Association of Montreal in 1922 with Randolph Hewton and Edwin Holgate. There she met and became lifelong friends with Anne Savage and Prudence Heward. Smith also studied at the Conseil des arts et manufactures under Joseph Saint-Charles and J.Y. Johnstone, and she studied in England and France. After the Art Association of Montreal school closed, Smith studied for two years at the École des beaux-arts in Montreal, where she became friends with artists such as Jean Paul Lemieux, Marian Dale (Scott), and Goodridge Roberts. There she also met her future husband, fellow student Jean Palardy.

Smith was influenced by French Post-Impressionists, such as Pierre Bonnard. Through the influence of Alfred Pellan, she discovered a new form of expression and a freer use of colour.

Seated Nude, c. 1931,
detail. See page 187.

EARLY CAREER

Smith and Palardy married in 1930. Although they had exhibited their work together, Palardy soon gave up painting to pursue filmmaking, eventually becoming a director and cameraman with the National Film Board of Canada.

During the 1930s, Smith and Palardy explored the Charlevoix region of Quebec. They got to know the people of the area by renting rooms and staying with families for the summers and even a few winters. The newly married couple lived on very little money, but in 1940 they set up a home at Petite-Rivière-Saint-François and a studio on Ste. Famille Street in Montreal, renting it from the sculptor Alfred Laliberté.

Remaining childless, the two artists commuted back and forth between Ottawa, Montreal, and Petite-Rivière-Saint-François. Smith spent much time apart from her husband and welcomed the solitude, dedicating herself to her painting. When they were not working, the couple entertained a large circle of friends.

AFFILIATIONS AND AWARDS

1926	named one of three best students, student exhibition, École des beaux-arts
1938	member, Eastern Group of Painters (precursor to the Contemporary Arts Society)
1939	member, Contemporary Arts Society
1955	Jessie Dow Prize for *Still Life with Green Apples*
2003	received Order of Canada

MATURE PERIOD

Circa 1930s and 1940s.

PREFERRED SUBJECT MATTER

Women and children of rural Quebec.

Mlle Anna Tremblay –
Rang de la décharge,
Pointe-au-Pic,
Charlevoix, 1936, detail.
See page 189.

COMPOSITIONAL SUBTLETIES

Explored her identity through the situations of the people she painted.

LATER YEARS

Smith travelled extensively with and without her husband. Smith and Palardy kept their studio in Montreal until 1964. They remained married until 1957, and Smith kept the house in Petite-Rivière-Saint-François until 1976. She continued to paint with passion and vigour until the end of her life. Jori Smith died in Montreal at the age of ninety-eight on November 12, 2005.

EXHIBITION HISTORY

1928–1956	exhibited with the Art Association of Montreal
1937	solo exhibition, Picture Loan Society, Toronto
	joint exhibition with Jean Palardy, Kerhulu Restaurant, Montreal
	exhibited with the Montreal Arts Club
	exhibited with the Canadian Group of Painters, Montreal
1938	exhibited with the Eastern Group of Painters, W. Scott & Sons, Montreal
1939	exhibited with the Contemporary Arts Society, Stevens Gallery, Montreal
1940	exhibited with the Eastern Group of Painters at the Art Association of Montreal
1941	*Exposition des indépendants,* Henry Morgan and Co., Quebec
1942	exhibited with the Canadian Group of Painters, Montreal

1942	*Aspects of Canadian Painting in Canada*, Addison Gallery of American Art, Andover, Massachusetts
1944	exhibited with Jacques de Tonnancour, Sybil Kennedy, and Allan Harrison, Dominion Gallery, Montreal
1945	exhibited with the Contemporary Arts Society, T. Eaton Co. Ltd., Toronto
	The Development of Painting in Canada 1665–1945, Art Association of Montreal and Art Gallery of Toronto
1946	Albany Institute of History and Art, Albany, New York
	Dominion Gallery, Montreal
	exhibited with the Contemporary Arts Society, Montreal
	Artes Gráficas do Canada, Museu Nacional de Belas Artes, Rio de Janeiro
1947	*Canadian Women Artists*, Riverside Museum, New York
1949	*Canadian Women Painters,* West End Gallery, Montreal
1955	spring exhibition, Montreal Museum of Fine Arts
	solo exhibition, Dominion Gallery, Montreal
1957	*Five Canadian Painters*, George Waddington Galleries, Montreal
1959	*The Arts of French Canada*, Winnipeg Art Gallery
1963	solo exhibition, Artlenders, Montreal
1964	solo exhibition, Montreal Museum of Fine Arts
1967	*Peinture vivante du Québec*, Musée du Québec
1975	*From Women's Eyes: Women Painters in Canada*, Agnes Etherington Art Centre, Kingston, Ontario
	Canadian Painting in the Thirties, National Gallery of Canada, Ottawa
	14 Women Painters, Galerie Gilles Corbeil, Montreal
1976	solo exhibition, Kastel Gallery, Montreal
	Three Generations of Quebec Art, Musée d'art contemporain, Montreal
1977	*Two Women*, 21 McGill Street, Toronto
1978	*Modern Painting in Canada*, Edmonton Art Gallery
1979	solo exhibition, Kastel Gallery, Montreal
1980	exhibited with the Contemporary Arts Society, Edmonton Art Gallery
1981	*Images of Charlevoix*, Montreal Museum of Fine Arts
	solo exhibition, Kastel Gallery, Montreal
1982	*Modernism in Quebec Art: 1916–1946*, National Gallery of Canada, Ottawa
1984	*Jori Smith: Watercolours*, Agassiz Galleries, Winnipeg
1986	solo exhibition, Kastel Gallery, Montreal
1993	*Rediscovering Jori Smith: Selected Works, 1932–1993*, retrospective exhibition, Dominion Gallery, Montreal

Wood, Elizabeth Wyn (Winnifred)

1903–1966

"We who live today have a great responsibility to the past to carry on, as we have a responsibility to the future to leave an honest record of our age, which will take its place beside the art of all time."

Elizabeth Wyn Wood, "Reef and Rainbow," *College Times*, Christmas 1935, as quoted in *Emanuel Hahn and Elizabeth Wyn Wood: Traditional and Innovation in Canadian Sculpture* by Virginia Baker

EARLY LIFE

Elizabeth Wyn Wood was born on October 8, 1903, on Cedar Island, just offshore from Orillia, Ontario, the fourth child of Edward Alfred Wood and Sarah Elizabeth Weafer. Her father was the proprietor of a large dry goods and women's store in Orillia.

EDUCATION, MENTORS, INFLUENCES

The tactile experience of playing with clay as a young child was a defining moment for Wood, and she was encouraged by her mother to read books on famous sculpture. She attended the Ontario College of Art from 1921 to 1926, studying under Arthur Lismer and J.E.H. MacDonald, specializing in sculpture, painting, and the applied arts, but she found her modelling class with sculptor Emanuel Hahn to be of particular appeal.

After completing a postgraduate year at OCA in 1926, Wood pursued further studies in New York at the Art Students League with Beaux-arts–trained American sculptor Edward McCarton and French-born American sculptor Robert Laurent. In New York, Wood had the opportunity to see an exhibition of the sculpture of Constantin Brancusi, held at the Brummer Gallery in the autumn of 1926. Wood likely also saw the International Exhibition of Modern Art organized by Katherine Dreier at the Brooklyn Museum late in 1926, which included recent work by the leading European avant-garde artists, including Brancusi. (In 1927, a modified version of the show was brought to Toronto by Lawren Harris.) When Wood returned to Toronto in 1927, the impact of the time she spent in New York was clear

in her work. She employed a new formal vocabulary and often used unorthodox materials. Her aim now was to communicate the emotional and spiritual aspects of the subject.

EARLY CAREER

Wood married Emanuel Hahn in 1926. She continued to work independently on innovative experiments with materials and sculptural form. Although influenced by the Group of Seven, she made an original contribution to Canadian art in rendering the Canadian landscape in three dimensions. *Northern Island*, executed in 1927, represents her first successful sculptural interpretation of the subject. *Reef and Rainbow*, also from 1927, is more adventurous and interprets in solid form such insubstantial natural elements as a rainbow, making space an integral part of the design. In later works, she explored the plastic possibilities of the human figure and asserted her skills as a portraitist. She often collaborated with architects on major public art projects.

AFFILIATIONS AND AWARDS

1921	awarded Rous & Mann scholarship, Ontario College of Art
1922	awarded scholarship in applied design, Ontario College of Art
1928	founding member, Sculptors Society of Canada
1929	first prize for sculpture, Willingdon Arts Competition, shared with Sylvia Daoust
	associate member, Royal Canadian Academy of Arts
1935	president, Sculptors Society of Canada
1944–1945	organizing secretary, Canadian Arts Council (now Canada Council)
1945	member, Federation of Canadian Artists, Canadian Handicrafts Guild, and Canadian Guild of Potters
1945–1948	chairman, International Relations Committee, Canadian Arts Council
1946	selected alternate Canadian delegate, first general assembly of UNESCO, Paris
1948–1949	vice-president, Canadian Arts Council
1951	full member, Royal Canadian Academy of Arts
1963	founded Canadian Society of Medallic Art

MATURE PERIOD

Circa the 1920s and 1930s.

PREFERRED SUBJECT MATTER

Abstract landscape work.

Northern Island, 1927, detail. See page 179.

COMPOSITIONAL SUBTLETIES

Elizabeth Wyn Wood succeeded in rendering the Canadian landscape in three-dimensional form.

LATER YEARS

From 1929 to 1958, Wood taught modelling at Central Technical School in Toronto. In her later years, Wood shifted her focus to small-scale work, designing medals and coins. After 1963, she suffered increasingly poor health. She died in Toronto on January 27, 1966, at age sixty-two, from cancer.

EXHIBITION HISTORY

1926–1963	exhibited with the Royal Canadian Academy of Arts
1928–1949	exhibited with the Sculptors Society of Canada
1936	exhibited with the Canadian Group of Painters (exhibited drawings)
1938	*A Century of Canadian Art*, Tate Gallery, London
1946	*Exhibition of Canadian Art*, UNESCO Conference, Paris
1947	*Canadian Women Artists*, Riverside Museum, New York
1955	joint exhibition with sculptor Sybil Kennedy, Art Gallery of Toronto
1983	*Visions and Victories: 10 Canadian Women Artists 1914–1945*, London Regional Art Gallery, Ontario
1997	exhibition with Emanuel Hahn, National Gallery of Canada, Ottawa; travelling across Canada

Head of Eleanor Koldofsky
1963
bronze, 15 [h] x 17 [w] x 6½ [d]
inches (38.1 [h] x 43.1 [w] x
16.5 [d] cm) without base,
Private Collection, Ontario

"Sculpture is harmony of mass,
as music is harmony of sound … "

Florence Wyle, quoted in Rebecca Sisler,
*The Girls: A Biography of Frances Loring
and Florence Wyle*

EARLY LIFE

Florence Wyle was born in Trenton, Illinois, on November 24, 1881, one of twins born
to Solomon B. Wyle and Libbie A. Sandford. The twins were subject to a strict Victorian
upbringing.

As a child, Wyle tended the sick or injured animals at their rural home. It seemed natural that she should enter medical school, and her father gave her a gift of $500 to establish
herself. She studied medicine from 1900 to 1903 at the University of Illinois, where she
took anatomy courses that included drawing, painting, and sculpture. The classes in sculpture changed the course of her life – she decided to dedicate herself to what was, for her,
the new world of art.

EDUCATION, MENTORS, INFLUENCES

Wyle transferred to the Art Institute of Chicago, where she studied under Laredo Taft and
Charles J. Mulligan. In 1905 she met a fellow student, Frances Loring, who became her
lifelong companion. To raise money while studying, Wyle taught art to children.

EARLY CAREER

From 1911, Wyle and Loring shared a studio in Greenwich Village in New York before they
moved to Canada in 1913, due partly to limited finances. They settled in Toronto, residing
in an old church on Glenrose Avenue that had been moved thirty years earlier from its

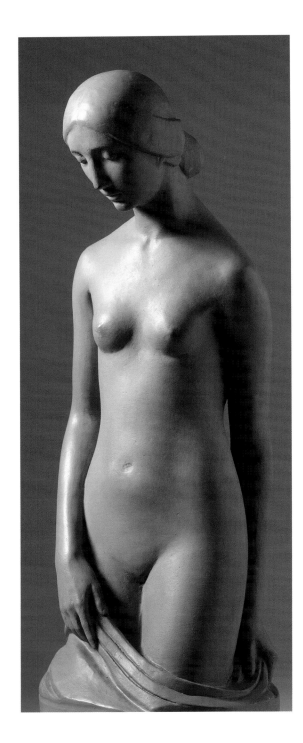

Study of a Girl, c. 1931, detail. See page 141.

original Yonge Street location. The church became a gathering place for artists in Toronto. "The Girls," as they were known, had an open-door policy: visitors were welcome as long as they brought gifts for the women's pets.

In 1927, Wyle was commissioned by the Canadian government to travel to the West Coast to document, through sketches and models, the decaying totem poles of the Haida.

In 1928, she and Loring founded the Sculptors Society of Canada, along with Elizabeth Wyn Wood, Emanuel Hahn, Henri Hébert, and Alfred Laliberté; the society was headquartered at their home and studio.

Wyle's work is evident throughout Toronto in public spaces as well as in private homes. She sculpted a coat of arms for the Rainbow Bridge of Niagara Falls, and made numerous portrait busts of people such as A.Y. Jackson, F.H. Varley, and R.S. McLaughlin. She even sculpted tombstones for Dr. Frederick Banting in Toronto and Eric Brown in Ottawa.

AFFILIATIONS AND AWARDS

1920	associate member, Royal Canadian Academy of Arts
1920–1934	member, Ontario Society of Artists, Toronto
1928	founding member, Sculptors Society of Canada
1938	full member, Royal Canadian Academy of Arts; first female sculptor to be elected full member
1942–1944	president, Sculptors Society of Canada
1948–1968	member, Ontario Society of Artists, Toronto
1953	awarded Coronation Medal

MATURE PERIOD
Circa 1930s and 1940s.

PREFERRED SUBJECT MATTER
Portrayals of adults, children, and animals with nature.

COMPOSITIONAL SUBTLETIES
Worked in plaster, bronze, and wood. Her sculpture was a synthesis of naturalism and idealism.

LATER YEARS

During the 1950s, Wyle's classicism began to seem out of date as abstract art caught the attention of a new generation of artists and the public.

In 1959, Wyle published a book of poetry, *Poems,* and later another volume, *The Shadow of the Year.*

Florence Wyle died at age eighty-six in Toronto on January 14, 1968, just three weeks before the death of Frances Loring.

EXHIBITION HISTORY

1927	*Exhibition of Canadian West Coast Art, Native and Modern*, National Gallery of Canada, Ottawa
1946	*Sculpture in the Home*, Sculptors Society of Canada, Toronto
1962	*Fifty Years of Sculpture*, London Public Library and Art Museum, London, Ontario
1969	retrospective exhibition, Pollack Gallery
1987	*Loring & Wyle: Sculptors' Legacy*, Art Gallery of Ontario, Toronto

"Sculpture has gone down very rapidly in the last few years. So much of this non-representational work looks like a child's doodlings. Young sculptors are just not studying enough. They dare to flout the things nature does so well. They don't know anatomy. A knowledge of anatomy gives vitality, vigour to sculpture."

Florence Wyle, quoted in Kay Kritzwiser, *Globe Magazine,* April 7, 1962

PART III

INDEX OF EARLY CANADIAN WOMEN ARTISTS

The women artists included in this index pursued academic training in the arts and/or they exhibited their work for critique and sale. Early Canadian is defined here as mid-eighteenth century to mid-twentieth century. The entries are arranged chronologically and divided by decades. Within each birth year, artists' names appear in alphabetical order. Although every effort has been made to verify the basic facts concerning the artists listed – full name, dates, training, membership in arts organizations, and the medium in which the artist worked – further research will no doubt continue to expand the scope of the index.

ABBREVIATIONS

AAM	Art Association of Montreal
AANFM	Association des artistes non-figuratifs de Montréal (see NFAA)
ABCSA	Associate Member of British Columbia Society of Artists
ACC	American Craftmen's Council
AGH	Art Group of Hamilton
AGQ	Association des graveurs du Québec
ALC	Arts & Letters Club, Toronto
AMSA	Associate Member of Manitoba Society of Artists
ANA	Associate of National Academy of Design, New York
APPL	Académie des peintres professionnels de Laval
ARCA	Associate Member of Royal Canadian Academy
ASA	Alberta Society of Artists
ASQ	Association des sculpteurs du Québec
AWCS	American Water Color Society
BCSA	British Columbia Society of Artists
BCSFA	British Columbia Society of Fine Arts
BHG	Beaver Hall Group
CAA	Carmel Art Association
CAC	California Art Club
CAH	Contemporary Artists of Hamilton
CAPQ	Conseil des artistes peintres du Québec
CAR	Canadian Artists Representation
CAS	Contemporary Arts Society, Montreal
CCA	Canadian Craftsmen's Association
CGP	Canadian Group of Painters
CGQ	Conseil de la gravure du Québec
CHG	Canadian Handicrafts Guild
CPQ	Conseil de la peinture du Québec
CSC	Calgary Sketch Club
CSEA	Canadian Society for Education through Art
CSGA	Canadian Society of Graphic Artists
CSMA	Canadian Society of Marine Artists
CSPWC	Canadian Society of Painters in Water Colour
CSQ	Conseil de la sculpture du Québec
EAC	Etchers Association of Canada
EAC	Edmonton Art Club
ECOAS	East Central Ontario Artists' Society
EGP	Eastern Group of Painters, Montreal
FCA	Federation of Canadian Artists
FRSA	Fellow Royal Society of Arts, London
GAC	Goderich Art Club

HASL	Hamilton Art Students League	RAA	Rochester Art Association
HC	Heliconian Club, Toronto	RAAV	Regroupement des artistes en arts visuels du Québec
HFA	Hungarian Federation of Artists, Budapest		
HPGP	High Park Group of Painters, Toronto	RBA	Royal Society of British Artists
HVAC	Humber Valley Art Club	RCA	Royal Canadian Academy of Arts
IAA	Independent Art Association	RDAC	Red Deer Art Club
IALC	International Arts and Letters Club	RDSL	Royal Drawing Society of London
IAS	Independent Art Society	RIPP	Royal Institute of Portrait Painters, England
IACS	Island Arts and Crafts Society		
LGP	London Group of Painters	RSA	Royal Scottish Academy, Edinburgh
MAA	Maritime Art Association	RSPE	Royal Society Painters and Engravers, London
MAS	Modern Art Society, Los Angeles		
MMFA	Montreal Museum of Fine Arts	SAA	Sarasota Art Association
MSA	Manitoba Society of Artists	SAFP	Société des aquafortistes français de Paris
NAC	National Arts Club, New York	SAP	Société des arts plastiques du Québec
NAWA	National Association of Women Artists	SAPQ	Société des artistes professionnels du Québec
NDAA	Niagara District Art Association		
NESA	New England Society of Artists, Connecticut	SCA	Society of Canadian Artists, Montreal
		SCPE	Society of Canadian Painters, Etchers and Engravers
NFAA	Non-figurative Artists' Association, Montreal (see AANFM)		
		SCPWC	Society of Canadian Painters of Water Colour
NOAA	Northern Ontario Artists Association		
NPS	National Portrait Society, London	SSC	Sculptors Society of Canada
NSAA	North Shore Arts Association, Gloucester	SWPS	Society of Women Painters and Sculptors, New York
NSP	National Society of Painters, England		
NSSA	Nova Scotia Society of Artists	SSA	Society of Scottish Artists
OAA	Ottawa Art Association	SSAL	Southern States Art League
OAC	Ottawa Art Club	TASL	Toronto Art Students' League
OCA	Ontario College of Art (formerly Ontario School of Art, Toronto Art School, Central Ontario School of Art and Industrial Design)	TPG	Toronto Potters' Guild
		VAA	Vernon Art Association, Victoria, B.C.
		VAC	Vancouver Art Association
		WAA	Windsor Art Association
OIP	Ontario Institute of Painters	WAA	Women's Art Association
OSA	Ontario Society of Artists	WAAC	Women's Art Association of Canada
OSPWC	Ottawa Society of Painters in Water Colour	WAAH	Women's Art Association of Hamilton
		WAAM	Women's Art Association of Montreal
OWCSC	Old Water Colours Society's Club, London	WAAR	Women's Art Association of Regina
		WAG	Winnipeg Art Group
PAC	Professional Artists of Canada	WAL	Western Art League
PCSM	Print Collector's Society of Montreal	WAL	Winnipeg Art League
PDCC	Prints and Drawing Council of Canada	WAS	Women's Art Society
P11	Painters Eleven	WGA	Willowdale Group of Artists, Toronto
PLS	Picture Loan Society, Toronto	WPO	Western Potters' Organization
PSA	Pastel Society of America	WSC	Winnipeg Sketch Club
PSC	Pastel Society of Canada		
RA	Royal Academy, London		

NAME	DATES	BACKGROUND AND TRAINING	MEMBERSHIPS	TYPE OF ARTIST
1760 TO 1769				
Allamand, Jeanne-Charlotte	1760–1839	art teacher		painter
Simcoe, Elizabeth (née Gwillim)	1762–1850	wife of John Graves Simcoe		painter
1770 TO 1779				
Hale, Elizabeth Francis (née Amherst)	1774–1826			painter
1780 TO 1789				
Hamilton, Lady Henrietta	1780–1857	wife of Sir Charles Hamilton, governor of Newfoundland; known for portrait of Beothuk woman		painter
Reynolds, Catherine Margaret	1784–1864	earliest native-born painter of Detroit River region, now part of Ontario		painter
Thresher, Eliza W.	1788–1865	art teacher		painter
Panet, Louise-Amélie	1789–1862	wife of the painter William Bent Berczy		painter
1790 TO 1799				
Chaplin, Millicent Mary	1790–1858	wife of Thomas Chaplin		painter, lithographer
Jameson, Anna Brownell	1794–1860	artist, author, and critic; accompanied husband to Great Lakes region of Canada and recorded travels in illustrated book		painter, book illustrator
1800 TO 1809				
Traill, Catharine Parr (née Strickland)	1802–1899	artist and writer; moved to Canada with her husband; sister of Susanna Moodie		painter
Moodie, Susanna (née Strickland)	1803–1885	artist and writer; moved to Canada in 1832 with her husband; sister of Catharine Parr Traill		painter
Langton, Anne	1804–1893	studied in Europe		painter
Love, Lady Mary Heaviside	active 1806–1868	studied in London		painter
Estcourt, Caroline (née Pole Crew)	1809–1886	wife of Sir James B. Bucknall Estcourt, British painter; accompanied husband on postings to Canada; known for Quebec winter scenes		painter

NAME	DATES	BACKGROUND AND TRAINING	MEMBERSHIPS	TYPE OF ARTIST
1810 TO 1819				
Finlayson, Isobel	c. 1812–1890			painter
Miller, Maria E. Morris	1813–1875	studied under W.H. Jones and Professor L'Estrange in Halifax; in 1830 she opened a drawing school for young ladies; botanical artist		painter
Bayfield, Fanny	1814–1891	art teacher		painter
Ellice, Katherine Jane	1814–1864			painter
Weber, Anna	1814–1888			painter, textile artist
Alexander, Lady Eveline-Marie (née Mitchell)	1818–1906	accompanied husband to Canada; known for Quebec and Ontario scenes		painter
1820 TO 1829				
Dunlop, Elizabeth Maria	1820–1883	married Lieutenant Franklin Dunlop and moved to Canada; sketched Ontario, Quebec, and Maritimes		painter
Bullock-Webster, Julia	1826–1907			painter
Crease, Lady Sarah Lindley	1826–1922	studied under Charles Fox and Sarah Ann Drake, London; moved to Vancouver Island with her husband in 1858; known for detailed depictions of colonial British Columbia; mother of artists Barbara, Josephine, Mary, and Susan Crease		painter
1830 TO 1839				
Kane, Harriet (née Clench)	c. 1830–1892	wife of the painter Paul Kane		painter
Fitzgibbon, Agnes Dunbar Moodie	1833–1913	studied under mother, Susanna Moodie		painter
Maynard, Hannah Hatherly	1834–1918	learned photography in Ontario; opened Mrs. R. Maynard's Photographic Gallery, Victoria; known for landscape photography and experimentation with photographic techniques		photographer
Schreiber, Charlotte Mount Brock (née Morrell)	1834–1922	studied under John Rogers Herbert, London; Mr. Carey's School of Art, London	OSA, RCA	painter
Hall, Mary G.	1835– [?]	director of the drawing academy in Saint John, New Brunswick		painter, printmaker
Killaly, Alicia	1836–1908	studied under Cornelius Krieghoff		painter
Ladds, Elizabeth	1837–1922			painter
Clarke, Louise Waldorf	1838– [?]	Albany Institute, New York; active in Montreal circa 1900; painted landscapes in oil		painter
Hopkins, Frances Anne (née Beechey)	1838–1919	studied under father, Admiral Beechey, and grandfather, Sir William Beechey	RA, RBA	painter

NAME	DATES	BACKGROUND AND TRAINING	MEMBERSHIPS	TYPE OF ARTIST
1840 TO 1849				
Cummins, Jane Catherine	1841–1893	studied under Otto Jacobi, Montreal; studied in Europe		painter
Arthurs, Annie J.	1845–1927	studied under John Colin Forbes; Académie Julian, Paris		painter
L'Aubinière, Georgina Martha de	1848–1930	studied in England; studied under Jean-Baptiste-Camille Corot and Jean-Léon Gérome, France		painter
Edwards, Henrietta (née Muir)	1849–1931	studied under Wyatt Eaton, New York; painted portrait of Sir Wilfrid Laurier		painter
1850 TO 1859				
Pinkerton, Harriett Jane (née Taylor)	1852–1936	studied under William Raphael, Montreal; under Lambert, Philadelphia		painter
Crease, Mary Maberly	1854–1915	painted watercolour views of Vancouver Island; sister to artists Barbara, Josephine, and Mary Crease; daughter of artist Sarah Crease		painter
Harris, Martha Douglas	1854–1933	Lansdowne House, England; Angela College, Victoria; studied under Georgina de L'Aubinière, Victoria; studied wood carving under George Selkirk Gibson; founded Lace Club of Victoria; cousin of artist Edith Helmcken	IACS	painter, textile artist, wood carver
Reid, Mary Augusta Hiester	1854–1921	studied under Thomas Eakins, Pennsylvania Academy of the Fine Arts; studied in Paris; married the painter G.A. Reid	ARCA, HC, OSA	painter
Crease, Susan Reynolds	1855–1947	studied under Charles and Georgina de L'Aubinière, Victoria; under Albert William Holden, King's College, London; under Lottie Aliston and Ainslie Borrow; sister to artists Barbara, Josephine, and Mary Crease; daughter of artist Sarah Crease	IACS	
Jones Bannerman, Frances M.	1855–1944	studied under Forshaw Day, Halifax; under Édouard Krug and Augustin Feyen-Perrin, Paris	ARCA	painter
Carr, Edith	1856–1919	painted on china; older sister of artist Emily Carr		china painter
Crease, Barbara	1857–1883	painted watercolour landscapes of coastal British Columbia; sister to artists Josephine, Mary, and Susan Crease: daughter of artist Sarah Crease		painter
Cutts, Gertrude Eleanor Spurr	1858–1941	studied under Albert Strange, Scarborough School of Art, London; under John H. Smith, Lambeth School of Art, London; under George Bridgman, Art Students League, New York; married the painter William Cutts	ARCA, OSA, TASL	painter
Farncomb, Caroline	1859–1951			painter
Forbes, Elizabeth Adela Armstrong	1859–1912	South Kensington School of Art, London; studied under William Merritt Chase, Art Students League, New York; married the painter Stanhope A. Forbes		painter, printmaker
Ford, Harriet Mary	1859–1938	Ontario School of Art, Toronto; St. John's Wood Art School, London; Académie Colarossi, Paris	ARCA, OSA	painter

NAME	DATES	BACKGROUND AND TRAINING	MEMBERSHIPS	TYPE OF ARTIST
1860 TO 1869				
Dignam, Mary Ella Williams	1860–1938	studied under William Merritt Chase, Art Students League, New York	HC, WAAC	painter
Lyall, Laura Adeline Muntz	1860–1930	studied under Lucius O'Brien, Ontario School of Art, Toronto; under W.C. Forster, Hamilton; under G.A. Reid, Toronto; St. John's Wood Art School, London; under Paul-Joseph Blanc, Gustave Courtois, and Louis-Auguste Girardot, Académie Colarossi, Paris; taught art in Toronto	ARCA, HC, OSA	painter
Macpherson, Margaret Campbell	1860–1931	studied in Edinburgh; under Auguste-Henri Berthoud in Neuchâtel, Switzerland; under Pascal Dagnan-Bouveret and Gustave Courtois, Académie Colarossi, Paris	SSA	painter
Tully, Sydney Strickland	1860–1911	studied under William Cruikshank, Ontario School of Art, Toronto; Slade School of Art, London; Académie Julian and Académie Colarossi, Paris; under William Merritt Chase, New York	ARCA, OSA	painter
Prat, Annie Louisa	1861–1960			painter
Wallis, Katherine	1861–1957	studied under Stephen Webb, Royal College of Art, London; Académie Colarossi, Paris; elected to the Société nationale des beaux-arts, Paris		sculptor
Helmcken, Edith Louisa	1862–1939	St. Anne's Convent, Victoria; studied art in England; cousin of artist Martha Douglas Harris	IACS	painter
Morse, Susan Mary (née Peters)	1862–1939	Victoria School of Art and Design, Halifax; Art Students League, New York; studied under Franklin Brownell, Ottawa		painter
Blake, Sarah Mary	1864–1933			painter
Carlyle, Florence Emily	1864–1923	studied under Adolphe-William Bouguereau, Jules-Joseph Lefebvre, and Tony Robert-Fleury, Académie Julian, Paris	ARCA, OSA	painter
Crease, Josephine	1864–1947	Angela College, Victoria; studied under Charles and Georgina de L'Aubinière and Sophie Pemberton, Victoria; under Albert William Holden, King's College, London; sister to artists Barbara, Mary, and Susan Crease; daughter of artist Sarah Crease	IACS	painter
Eastlake, Mary Alexandra Bell	1864–1951	studied under Robert Harris, AAM; under William Merritt Chase, Art Students League, New York; Académie Colarossi, and Académie Julian, Paris; elected to the Boston Watercolor Society and the London Pastel Society; married the painter Charles H. Eastlake	ARCA, RA	painter
McGillivray, Florence Helena	1864–1938	studied under William Cruikshank and J.W.L. Forster, Ontario School of Art, Toronto; Lucius O'Brien and F. McG. Knowles, Toronto; Académie de la Grande Chaumière, Paris	ARCA, CSPWC, HC, OSA, SWPS	painter
Adams, Lily Osman	1865–1945	studied under F. McG. Knowles and Lucius O'Brien, Toronto; under J.W. Beatty, Toronto Art School; under John Carlsen, Art Students League, New York		painter

NAME	DATES	BACKGROUND AND TRAINING	MEMBERSHIPS	TYPE OF ARTIST
Martin, Emma May	1865–1957	studied under father, Thomas Mower Martin, and Marmaduke Matthews	OSA	painter
Aitken, Melita	1866–1945	studied under Mary E. Dignam, Toronto; under John H. Vanderpoel, Art Institute of Chicago	AAM	painter
Hooker, Marion Hope (née Nelson)	1866–1946	studied under C.B. Milner, St. Catharines Collegiate Institute; under George B. Bridgman and Lucius Hitchcock, Buffalo		painter
Knowles, Elizabeth Annie McGillivray (née Beach)	1866–1928	studied under F. McG. Knowles, Toronto; wife to Farquhar McGillivray Knowles; niece to F.M. Bell-Smith	ARCA, HC	painter
Donly, Eva Marie Brook	1867–1941	studied under F.M. Bell-Smith, Alma College, Ontario; under José M. Pino, San Carlos Academy, Mexico	AWCS	painter
Elliott, Emily Louise (née Orr)	1867–1952	Ontario School of Art, Toronto; studied under William Merritt Chase and Robert Henri, Art Students League, New York	HC	painter
O'Reilly, Kathleen	1867–1945	Angela College, Victoria; Lady Murry's School, Kensington, London		painter
Pringle, Annie White (née Greive)	1867–1945	studied under Edmond Dyonnet and J.Y. Johnstone, Montreal; under Alfred Laliberté, Monument National, Montreal; under William Brymner, AAM; under Adam Sherriff Scott, Lilias Torrance Newton, and Randolph Hewton, Women's Art Studio	AAM, WAS	painter
Smith, Edith Agnes	1867–1956	Victoria School of Art and Design, Halifax; Boston Art Club; Chelsea School of Art, London	NSSA	painter
Harrington, Rebecca Christina	1869–1930	studied under Frank Vincent DuMond, Art Students League, New York; under Enid Carlson, New York		painter
Munro, Jean Elizabeth (née Cockburn)	1869–1945	studied under Robert Holmes and G.A. Reid, OCA; under Lucien Simon, Académie de la Grande Chaumière, Paris		painter
Pemberton, Sophie (Sophia) Theresa	1869–1959	Slade School of Art and South Kensington School of Art, London; studied under J.P. Laurens and Benjamin Constant, Académie Julian, Paris	ARCA	painter
Warren, Emily Mary Bibbens	1869–1956	studied under, and was last student of, John Ruskin	RA, RBA	painter

1870 TO 1879

NAME	DATES	BACKGROUND AND TRAINING	MEMBERSHIPS	TYPE OF ARTIST
Frame, Statira Elizabeth Wells	1870–1935	Vancouver's Night School; married William Frame		painter
Nutt, Elizabeth Styring	1870–1946	studied under J.T. Cook and Henry Archer, Sheffield School of Art, England; under Arthur Lismer and F.H. Varley; Sorbonne, Paris; principal of Victoria School of Art and Design, Halifax; teacher of A.H. Robinson	ARCA, NSSA	painter
Alexander, Wilhelmina	1871–1963	studied under S. John Ireland and John Sloan Gordon, Hamilton School of Art; under G. Horne Russell, Montreal	AAM, WAAC	painter
Bradshaw, Eva Theresa	1871–1938	studied under Florence Carlyle and Robert Henri, New York		painter

NAME	DATES	BACKGROUND AND TRAINING	MEMBERSHIPS	TYPE OF ARTIST
Carr, M. Emily	1871–1945	California School of Art, San Francisco; Westminster School of Art, London; studied under Algernon Talmage, St. Ives, England; Académie Colarossi, Paris; under Harry Gibb, Crécy-en-Brie and St-Efflam, France; member of Canadian Group of Painters	BCSA, CGP	painter
Hagarty, Clara Sophia	1871–1958	studied under Sir Wyly Grier and Miss Tully, Toronto; under William Merritt Chase, New York; studied in Paris	OSA	painter
Hagen, Alice Mary (née Egan)	1872–1972	Victoria School of Art and Design, Halifax	NSSA	painter, potter
Barber, Barbara Muir	1873–1966	Moulton College, Toronto; married Fred Barber	RSA, WAA	painter
Britton, Henrietta Hancock	1873–1963	studied under William Cruikshank, Toronto; Central Ontario School of Art, Toronto; under Harry Britton, St. Ives, England; married Harry Britton	HC, TASL	painter
Burrell, Louise H. (née Luker)	1873–1971			painter
Duff, Annie Elexey	1873–1955			painter
Hamilton, Mary Riter	1873–1954	studied under Mary Hiester Reid, G.A. Reid, and Sir Wyly Grier, Toronto; under Franz Skarbina, Berlin; under Jacques-Émile Blanche, Vittie Academy, Paris; under Paul-Jean Gervais		painter
Kitto, Margaret E.	1873–1925	studied in England	IACS	painter
De Montigny-Giguère, Elisabeth Louise	c. 1874–1969	studied under William Brymner, AAM; Conseil des arts et manufactures, Montreal; under Alfred Laliberté, Montreal		painter, sculptor
Armington, Caroline Helena (née Wilkinson)	1875–1939	studied under J.W.L. Forster, Toronto; Académie de la Grande Chaumière, Paris; Académie Julian, Paris, under Henri Royer, E. Schommer, and Paul Gervais; elected to Société de la gravure originale en noir, Paris; married the painter Frank M. Armington	PCSM	painter, etcher
Kingsford, Winnifred Ethel Margaret	1875–1947	studied under J. Linsey Banks, Central Technical School, Toronto; under William Cruikshank and G.A. Reid, Central Ontario School of Art, Toronto; under Antoine Bourdelle, Paris		painter, sculptor
Cleland, Mary Alberta	1876–1960	studied under William Brymner, AAM		painter
des Clayes, Berthe	1877–1968	studied under Hubert von Herkomer, Bushey, England; under Tony Robert-Fleury and Jules Lefebvre, Académie Julian, Paris; sister to painters Alice and Gertrude des Clayes; twice winner of Jessie Dow Prize		painter
Long, Beatrice Mary (née Carter)	1877– [?]	Camberwell School of Art, London; studied under Edmond Dyonnet, AAM		painter
Reid, Mary Evelyn Wrinch	1877–1969	studied under Laura Muntz; under G.A. Reid, Central Ontario School of Art, Toronto; Art Students League, New York; second wife of G.A. Reid	ARCA, HC, OSA, SCPE	painter, printmaker

NAME	DATES	BACKGROUND AND TRAINING	MEMBERSHIPS	TYPE OF ARTIST
Jost, Ottilie E. Palm	1878–1961	studied under John S. Gordon, Hamilton School of Art; summers at Old Lyme, Connecticut; founding member, Hamilton Art Students League	HASL	painter
Smith, Kate Adeline	1878–1945	Southport School of Art, England; studied under W. Frank Calderon, Edwin Noble, and William Callow, Calderon School of Animal Painting, London	BCSA	painter
Biller, Olive Allen	1879–1957			painter
des Clayes, Gertrude	1879–1949	studied under Hubert von Herkomer, Bushey, England; under Tony Robert-Fleury and Jules Lefebvre at Académie Julian, Paris; sister to painters Alice and Berthe des Clayes	ARCA, NPS	painter
Maclean, Jean Munro	1879–1952	studied under E.M. Carpenter, Boston; Heatherly School of Fine Art, London; under William Brymner, AAM	AAM, WAS	painter
McNicoll, Helen Galloway	1879–1915	studied under William Brymner, AAM; Slade School of Art, London; under Algernon Talmage, St. Ives, England	ARCA, RBA	painter
Robertson, Beatrice (née Hagarty)	1879–c. 1962	studied under Laura Muntz, Toronto; under Claudio Castellucio, Paris; Académie de la Grande Chaumière, Paris	HC	painter
Seath, Ethel	1879–1963	studied under Edmond Dyonnet; under William Brymner and Maurice Cullen, AAM; under Charles Hawthorne, Provincetown; associated with Beaver Hall Group; member of Canadian Group of Painters	CAS, CGP	painter

1880 TO 1889

NAME	DATES	BACKGROUND AND TRAINING	MEMBERSHIPS	TYPE OF ARTIST
Bain, Mabel A.	1880– [?]	studied in Los Angeles and San Diego	FCA	painter
Lamont, Laura	1880–1970	OCA		painter
Shore, Henrietta Mary	1880–1963	studied under Laura Muntz, Toronto; under Robert Henri and William Merritt Chase, New York School of Art; under Frank Vincent DuMond, Art Students League, New York; Heatherly School of Fine Art, London; OSA member 1909–1915; member, Oregon Society of Artists	CAA, CAC, MAS, SWPS	painter
Boulton, Muriel Welsh Cameron	1881–1957	studied under Hubert von Herkomer, Herkomer School of Fine Arts, Bushey, England; under Christian Krohg and Émile Renard, Académie Colarossi, Paris		painter
Hingston, Lillian Isabel (née Peterson)	1881–1967	studied under William Brymner, AAM		painter
Luke, Jane Corbus	1881– [?]	studied under William Brymner, G. Horne Russell, and Berthe des Clayes, Montreal	AAM, WAA	painter
Wyle, Florence	1881–1968	studied under Charles J. Mulligan, Art Institute of Chicago; founded Sculptors Society of Canada with Emanuel Hahn, Elizabeth Wyn Wood, Frances Loring, Henri Hébert, and Alfred Howell; published a book of poetry	ARCA, OSA, RCA, SSC	sculptor
Boswell, Hazel May	1882– [?]	studied in Paris	AAM	painter

NAME	DATES	BACKGROUND AND TRAINING	MEMBERSHIPS	TYPE OF ARTIST
Kallmeyer, Minnie	1882–1947	studied under F. McG. Knowles, Central Ontario School of Art, Toronto; under J.W. Beatty, Toronto; Académie Colarossi, Paris	OSA	painter
Lockerby, Mabel	1882–1976	studied under William Brymner and Maurice Cullen, AAM; member of Beaver Hall Group; member of Canadian Group of Painters	BHG, CAS, CGP	painter
Long, Marion	1882–1970	studied under G.A. Reid, Central Ontario School of Art, Toronto; under Laura Muntz, Toronto; under William Merritt Chase and Robert Henri, New York	ARCA, HC, OIP, OSA, RCA	painter
MacKinnon-Pearson, Cecilia	1882– [?]	Buffalo Art Students League; studied under Édouard Léon, Paris	AAM, SAFP	painter
Reid, Laura Evans	1883–1951			painter
Day, Mabel Killam	1884–1963	Mount Allison University; Robert Henri Art School, New York		painter
Foster, Hazel	1884–1974	studied under father, H. Wilson Foster, Nottingham Municipal School of Art, London	EAC	painter
Fry, Beatrice (Bessie) Emma Adelaide (Mrs. Symons)	1884–1976	studied in England	BCSA	painter, etcher
Loudon, Isabel Mary	1884– [?]	OCA; studied under F.E. Poole, London	OAC	painter, textile artist
May, H. (Henrietta) Mabel	1884–1971	studied under William Brymner, AAM; member of Beaver Hall Group; member of Canadian Group of Painters	ARCA, BCSA, BHG, CGP, FCA	painter
McClain, Helen C.L.	1884–1960	Art Students League, New York; New York School of Fine and Applied Art	OSA	painter
Armour, Phyllis (Mrs. Hertzberg)	1885–1975			painter, etcher
Black, Mary Florence	1885–1986	Central Ontario School of Art, Toronto; studied under Edwin Scott, Académie Julian, Paris		painter
Coonan, Emily	1885–1971	studied under William Brymner, AAM; Conseil des arts et manufactures, Montreal; associated with Beaver Hall Group		painter
Curry, Ethel Marie	1885–1966			painter
McAvity, E. Dorothy	1885–1958	self-taught; sold first portrait at age ten; painted portrait of Edward VIII; married Harry McAvity	RSA	painter
Proctor, Florence Evelyn Kemp	1886– [?]			painter
Judah, Doris Minette (née Trotter)	1887–1965	studied under Edmond Dyonnet and Alfred Laliberté, Monument National, Montreal; École des beaux-arts, Montreal	RAA	sculptor

NAME	DATES	BACKGROUND AND TRAINING	MEMBERSHIPS	TYPE OF ARTIST
Loring, Frances Norma	1887–1968	École des beaux-arts, Geneva; Académie Colarossi, Paris; Art Institute of Chicago; Art Students League, New York; founded Sculptors Society of Canada with Emanuel Hahn, Elizabeth Wyn Wood, Florence Wyle, Henri Hébert, and Alfred Howell; published a book of poetry	ARCA, FCA, OSA, RCA, SSC, WAAC	sculptor
Munn, Kathleen Jean	1887–1974	studied under F. McG. Knowles, Toronto; Art Students League, New York; Pennsylvania Academy of Fine Arts	HC	painter
Reid, Lorna Fyfe	1887– active 1926	studied under F. McG. Knowles, Toronto; under Kenneth Hayes Miller, Art Students League, New York		painter
Woodward, Barbara	1887– active 1948	studied under W. Edwin Tindall, Doncaster Academy of Painting, England	FCA	painter
Buller, Cecil Tremayne	1888–1973	studied under William Brymner, AAM; Art Students League, New York; under Maurice Denis, Paris	ANA	painter, printmaker
Dick, Dorothy J. (née Swan)	c. 1888–1967	studied under Alfred Gilbert, RA; studied in Holland		sculptor
Millar, Clara Louise (née Neads)	c. 1888– [?]	studied under G.A. Reid, Central Ontario School of Art, Toronto; under A. Felix, Paris		painter
Mount, Rita	1888–1967	studied under William Brymner, AAM; Académie Delécluse and Cercle internationale des beaux-arts, Paris; Art Students League, New York	ARCA	painter
Stevens Austin, Dorothy	1888–1966	studied under Wilson Steer, Slade School of Art, London; Académie Colarossi and Académie de la Grande Chaumière, Paris; elected to the Chicago Society of Etchers	ARCA, HC, OSA, RCA, SCPE	painter, printmaker
Cumming, Kate Taylor	1889–1971	Detroit College of Art; studied under F. McG. Knowles, G.A. Reid, A. Forrester, Arthur Lismer, J.W. Beatty, and Emanuel Hahn, OCA; under Clare Bice		painter
Day, Katherine	1889–1976	studied under Franz Johnston, Winnipeg School of Art; OCA; Central School of Arts & Crafts, London; under Nicolas Eckman and Henri Jannot, Paris	CSGA, SCPE	painter, printmaker
Gass, Marjorie Earle	1889–1928	studied under William Brymner and Maurice Cullen, AAM		painter
Gordon, Hortense Crompton (née Mattice)	1889–1961	Hamilton School of Art; studied under Hans Hofmann, Provincetown; member of Painters Eleven; married the painter John Sloan Gordon	ARCA, CAH, CSGA, P11	painter
McKiel, Christian	1889–1978	Art Students League, New York; studied under Frank Vincent DuMond, Cape Breton; under Charles Hawthorne, Provincetown	MAA, NSSA, SCPE	painter
Robertson, Sybil Octavia	c. 1889– [?]	founding member of the Beaver Hall Group	BHG	painter
Uhthoff, Ina D.D. (née Campbell)	1889–1971	studied under Maurice Greiffenhagen, Glasgow School of Art	BCSA, FCA, FRSA	painter, printmaker

NAME	DATES	BACKGROUND AND TRAINING	MEMBERSHIPS	TYPE OF ARTIST
1890 TO 1899				
Coombs, Edith Grace	1890–1986	OCA; New York School of Fine and Applied Art; studied under Emanuel Hahn, Toronto; married James Sharp Lawson	FCA, HC	painter, sculptor
Craig, Grace Morris	1890–1987	studied under Arthur Lismer and Yvonne Housser, OCA; author of *But This Is Our War* (1981)	BCSA, FCA, FRSA, HC	painter, printmaker
de Crèvecoeur, Jeanne	1890– [?]	exhibited with AAM and RCA; founding member of the Beaver Hall Group	BHG	painter
des Clayes, Alice	1890–1968	studied under Lucy Kemp-Welch and Rowland Wheelwright, Bushey School of Art, England; sister to painters Berthe and Gertrude des Clayes	ARCA, CSPWC	painter
Fauteux, Marie Claire Christine	1890–1988	studied under Robert Pilot, Arthur Lismer, Maurice Cullen, and William Brymner, AAM; under Guillaumat at Académie Julian, Paris		painter
Harris, Bess Larkin	1890–1969	studied under F.H. Varley, Toronto; exhibited with Group of Seven; married F.B. Housser; married the painter Lawren S. Harris.		painter
Heacock, Rebecca M.	1890– [?]	studied under H.G. Glyde and W.J. Phillips, University of Alberta	ASA	painter
Newton, Alison Houston (née Lockerbie)	1890–1967	studied under David Wallace; under Alex Musgrove and Franz Johnston, Winnipeg School of Art; under W.J. Phillips	AMSA, CSPWC, MSA, SCPE	painter, engraver
Thornton, Mildred Valley (née Stinson)	1890–1967	studied under J.W. Beatty and G.A. Reid, OCA; at Art Institute of Chicago	FRSA, SCPE	painter
Courtice, Rody Kenny	1891–1973	studied under Arthur Lismer, G.A. Reid, and J.E.H. MacDonald, OCA; Art Institute of Chicago; Académie de la Grande Chaumière, Paris; member of Canadian Group of Painters	ARCA, CGP, CSGA, CSPWC, FCA, HC, OSA	painter
Innes, Alice Amelia	1891–1970	studied under J.W. Beatty, OCA		painter
Marr, Ottavio Elizabeth Tyler	1891– [?]	studied under H.M. Rosenberg, Lewis Smith, and Arthur Lismer, Victoria School of Art and Design, Halifax	NSSA	painter
Robertson, Sarah Margaret Armour	1891–1948	studied under William Brymner, Maurice Cullen, and Randolph Hewton, AAM; associated with Beaver Hall Group; member of Canadian Group of Painters	BHG, CGP, WAAC	painter
Liebich, Kathleen Chipman Sweeny	1892– [?]	studied under Mary Wrinch, Bishop Strachan School; under G.A. Reid, School at the Grange, Toronto; under Adam Sheriff Scott, Montreal	IAA, WAAM	painter
Walker, Ella May	1892–1960	University of Saskatchewan; Chicago Art Institute	ASA	painter
Hunt, Joan Emily Gladys	1893– [?]	studied under Ruth Wainwright, Nova Scotia College of Art, Halifax	MAA, NSSA	painter

NAME	DATES	BACKGROUND AND TRAINING	MEMBERSHIPS	TYPE OF ARTIST
Morris, Kathleen Moir	1893–1986	studied under William Brymner, AAM; summer sketching trips with Maurice Cullen; associated with Beaver Hall Group; member of the Canadian Group of Painters	ARCA, CGP	painter
Boutal, Pauline (née Le Goff)	1894–1992	Winnipeg School of Art; studied under George E. Brown and André Lhote, Paris; Académie de la Grande Chaumière, Paris		painter, set designer
Depew, Verna Viola	1894–1992	OCA; studied under G.A. Reid, Toronto; under J.R. Seavey, Hamilton; Cleveland School of Art	AGH, CSGA, SCPE, WAAH	painter, printmaker
Grayson, Ellen Vaughan Kirk (Mrs. Mann)	1894–1995	studied Fine Arts at Columbia University; Curry School of Expression, Boston; under Marion Long at St. Margaret's College, Toronto; taught art at the University of Saskatchewan and in Banff, Alberta	CSPWC, SCPE	painter, printmaker
Hopkins, Elisabeth Margaret	1894–1991	career as artist began at age eighty-one; subject of National Film Board documentary; known for naive style		painter
Biriukova, Yulia	1895–1972	Imperial Academy of Art, Petrograd; Royal Academy of Art, London; rented space at Studio Building, Severn St., Toronto	CSGA	painter
Cherry, Aileen Alma	1895–1958	studied under Arthur Lismer, OCA		painter
Lefort, Agnès	1895–1973	studied under Joseph St. Charles, Charles Gill, and Edmond Dyonnet, Conseil des arts et manufactures, Montreal; under J.Y. Johnstone, Montreal; opened an art gallery in Montreal in 1950		painter
Maillet, Corinne Dupuis (pseudonyms: Rhobena Dippy, Colin Martel)	1895–[?]	studied under William Brymner, AAM		painter
Crawford, Julia Tilley	1896–1968	Pratt Institute, New York; Cape School of Art, Provincetown	CSPWC, IALC	painter
Gadbois, Marie Marguerite Louise Landry	1896–1985	studied under Edwin Holgate, Montreal; under John Lyman, AAM; mother to the painter Denyse Gadbois	CAS	painter
Heward, Efa Prudence	1896–1947	studied under William Brymner, Randolph Hewton, and Maurice Cullen, AAM; Académie Colarossi, and Scandinavian Academy, Paris; associated with Beaver Hall Group; member of Canadian Group of Painters	CAS, CGP, FCA	painter
Jarvis, Lucy Mary Hope	1896–1986	Havergal Ladies College, Toronto; School of the Museum of Fine Arts, Boston; studied under André Lhote, Paris; Académie de la Grande Chaumière, Paris; co-founded University of New Brunswick Observatory Art Centre with Pegi Nicol MacLeod in 1942		painter
Melvin, Grace Wilson	1896–1977	Glasgow School of Art; employed at Vancouver School of Art		painter
Newton, Lilias Torrance	1896–1980	studied under William Brymner, AAM; under Alfred Wolmark, London; under Alexandre Jacovleff, Paris; member of Beaver Hall Group and the Canadian Group of Painters	ARCA, BHG, CGP, RCA	painter

NAME	DATES	BACKGROUND AND TRAINING	MEMBERSHIPS	TYPE OF ARTIST
Pinneo, Georgiana Paige	1896– active 1977	Acadia University; studied under Elizabeth Styring Nutt, Nova Scotia School of Art, Halifax	CSEA	painter
Planta, Ethel Ann Carson (née Copeland)	1896– [?]	studied under Emily M.B. Warren, Peter van den Braken	AAM	painter
Porteous, Frances Esther Dudley	1896–1946	studied under William Brymner and Randolph Hewton, AAM; member of Canadian Group of Painters	AAM, CGP	painter
Savage, Anne Douglas	1896–1971	studied under William Brymner and Maurice Cullen, AAM; member of Beaver Hall Group; member of Canadian Group of Painters	BHG, CGP	painter
Ziegler, Anne Alberta (née Jaffray)	1896–1981	studied under F. McG. Knowles, J.W. Beatty, and Franz Johnston, Toronto		painter
Chavignaud, Christine F.	1897– [?]	studied under her father, Georges Chavignaud, Victoria School of Art and Design, Halifax		painter
Cheney, Anna (Nan) Gertrude Lawson	1897–1985	Newcombe Art School, Tulane University; studied under Max Broedel, School of Medical Illustration, Johns Hopkins University; under J.W. Beatty, OCA; under Franklin Brownell, Art Association of Ottawa; friend of Emily Carr	BCSA, BCSFA, FCA	painter
Coburn, Malvina Scheepers	1897–1933	studied in Antwerp; married the painter Frederick Simpson Coburn		painter
Forbes, Jean Mary Edgell	1897– [?]	Chelsea South Polytechnical School, London; married the painter Kenneth Forbes	ARCA	painter
Foster, Muriel Aileen (née Merle)	1897– [?]			painter
Jones, Phyllis Jacobine	1897–1976	studied under Harold Brownsword, Polytechnic School of Art, London; studied in Italy, Denmark, and France	ARCA, RCA, SSC	sculptor
Kerr, Estelle Muriel	1897–1971	studied under Mary E. Dignam and Laura Muntz, Toronto; Art Students League, New York; Académie de la Grande Chaumière, Paris	HC, OSA	painter
Seiden Goldberg, Regina	1897–1991	studied under Edmond Dyonnet, William Brymner, and Maurice Cullen, Montreal; at Académie Julian, Paris; married artist Eric Goldberg; member of Beaver Hall Group	BHG, CAS	painter
Andrews, Sybil	1898–1992	studied under Henry G. Massey, Heatherly School of Fine Art, London		engraver, printmaker
Beals, Helen	1898–1991		CSPWC, MAA	painter, potter
Clark, Paraskeva Avdyevna (née Plistik)	1898–1986	Petrograd Academy of Fine Arts; studied under Savely Seidenberg; under Vasily Shukhayev and Kuzma Petrov-Vodkin, Free Studios (former Russian Academy), Leningrad; member of Canadian Group of Painters; OSA member 1954–1965	ARCA, CGP, CSGA, CSPWC, RCA	painter
Collyer, Nora Frances Elizabeth	1898–1979	studied under Alberta Cleland, William Brymner, and Maurice Cullen, AAM; associated with Beaver Hall Group; member of Canadian Group of Painters	CGP, FCA	painter

NAME	DATES	BACKGROUND AND TRAINING	MEMBERSHIPS	TYPE OF ARTIST
Daly Pepper, Kathleen Frances	1898–1994	studied under J.W. Beatty, G.A. Reid, Arthur Lismer, and J.E.H. MacDonald, OCA; at Académie de la Grande Chaumière, Paris; under René Pottier, Paris; married the painter George Pepper; member of Canadian Group of Painters	ARCA, CGP, HC, OSA, RCA	painter
Gillett, Violet Amy	1898–1996	born in Liverpool		painter
Grier, Stella Evelyn (Mrs. A.E. Gould)	1898–1994	studied under father, Sir Wyly Grier; Art Students League, New York; studied in London	ARCA, HC	painter
Housser, (Muriel) Yvonne McKague	1898–1996	OCA; Académie de la Grande Chaumière and Académie Colarossi, Paris; studied under Lucien Simon and Maurice Denis, Paris; married the painter F.B. Housser; member of Canadian Group of Painters	ARCA, CGP, FCA, HC, OSA, RCA	painter
Sissons, Lynn	1898–1985	studied under Franz Johnston, Joe Plaskett, Lemoine Fitzgerald, W.J. Phillips, and George Swinton, Winnipeg School of Art	MSA	painter
Brown, Annora	1899–1987	studied under Arthur Lismer and J.E.H. MacDonald, OCA	ASA	painter
Husband, Dalla	1899–1941	born in Winnipeg		painter
Kennedy, Sybil	1899–1986	studied under William Brymner, AAM; under John Sloan, Art Students League, New York	ARCA, CAS, NAWA, RCA, SSC	sculptor
Lawrence, Mary C.	1899– [?]	studied under H.G. Glyde, Banff School of Fine Arts	ASA, RDAC	painter
Manuel, Mildred Beamish (née Brooks)	1899– [?]	studied under George Pepper, OCA; Nova Scotia College of Art, Halifax	NSSA	painter
Taylor, Jocelyn T.	1899– active 1979	Central Technical School, Toronto; OCA; studied under George Bridgman, Art Students League, New York	ARCA, CSPWC, FCA, OSA	painter

1900 TO 1909

NAME	DATES	BACKGROUND AND TRAINING	MEMBERSHIPS	TYPE OF ARTIST
Barnard, Julia (née Bingham)	1900– [?]	Winnipeg School of Art		painter
Bond, Marion	1900–1965	Nova Scotia College of Art, Halifax; Art Students League, New York	NSSA	painter
Carleton, Edith (née Cunningham)	1900– [?]	studied under father, Edward Cunningham; South Kensington School of Art, London; under W.J. Phillips, Banff School of Fine Arts	ASA, CSC	painter, sculptor
Cryderman, Mackie V. (née MacIntyre)	c. 1900–1969	studied under Franz Johnston, Winnipeg; OCA	SCPE	painter, engraver
Hook, Anne Smith	1900–1978	born in Ireland		painter
Lauterman, Dinah	1900–1945	studied under Randolph Hewton, AAM; École des beaux-arts, Montreal; under Alfred Laliberté, Edwin Holgate, and Charles Maillard		sculptor
Lindsay, Ellen Trider	1900– [?]	studied under Elizabeth Styring Nutt, Nova Scotia College of Art, Halifax	NSSA	painter

NAME	DATES	BACKGROUND AND TRAINING	MEMBERSHIPS	TYPE OF ARTIST
McFadden, Mary Josephine	1900– [?]	studied under Fred Fraser; under Arnold Hodgkins; Gordon Payne School of Fine Art	HVAC, WAAH	painter
Schneider, Mary	1900–1992	studied under husband Roman Schneider; founded the Schneider School of Fine Art, Actinolite, Ontario	HC, OSA	painter
Tozer, Marjorie Hughson	1900–1959	Victoria School of Art and Design, Halifax		painter
Bould, Kay	1901– [?]	studied under W.J. Phillips and Ernest Linder, Regina School of Art		painter
Cann, Elizabeth Lovitt	1901–1976	Philadelphia Academy of Fine Arts; New York School of Applied Design for Women; Académie Julian and Académie de la Grande Chaumière, Paris; Harvey Proctor School, England	AAM, CSGA, NSSA	painter
Crozier, Jean Murray	1901–1972	OCA; Morris Davidson Art School, Provincetown	CSPWC, OSA	painter
Findlay, Jean Ness	1901– [?]	studied under Edmond Dyonnet and J.Y. Johnstone, Monument National, Montreal; under Charles Martin, Columbia University		painter
Killins, Ada Gladys	1901–1963	studied under Franz Johnston and Carl Schaefer	CSPWC, NDAA	painter
Luke, Alexandra (Mrs. Margaret Alexandra Luke McLaughlin)	1901–1967	studied under A.Y. Jackson and Jock Macdonald, Banff School of Fine Arts; under Hans Hofmann, Provincetown; member of Canadian Group of Painters; member of Painters Eleven	CGP, CSPWC, HC, OSA, P11	painter
McNaught, Euphemia	1901–2002			painter
Rickerson, Genia Tseretelli	1901– [?]	born in St. Petersburg		painter
Russell, Mary MacDonald	c. 1901– [?]	studied under Ronald Irving, Moncton Art Society; under Lawren P. Harris and Edward Pulford, Mount Allison University		painter
Senecal, Irene	1901–1978			painter
Alfsen, Marion Beatrice Scott	1902–1990	studied under Arthur Lismer, J.E.H. MacDonald, and J.W. Beatty, OCA; married the painter John Alfsen	HC	painter, sculptor
Curry, Ethel Luella	1902–2000	Central Technical School, Toronto; studied under J.W. Beatty, Arthur Lismer, and J.E.H. MacDonald, OCA		painter, sculptor
Daoust, Sylvia Marie Emilienne	1902–2004	studied under J.C. Franchère, J.Y. Johnstone, Edmond Dyonnet, and Joseph Saint-Charles, Conseil des arts et manufactures, Montreal; under J.B. Legrace, École des beaux-arts, Montreal; under Henri Charlier, Paris	ARCA, ASQ, CSQ, RCA, SAPQ, SSC	sculptor
Pemberton-Smith, Frederica (Freda) Augusta	1902–1991	studied under Edmond Dyonnet, Monument National, Montreal; École des beaux-arts, Montreal; under Franklin White, Slade School of Art, London	CSPWC, FCA	painter
Peterson, Margaret	1902–1997	studied under Hans Hofmann and Worth Ryder, University of California, Berkeley; studied under Vaclav Vytlacil and André Lhote, Paris		painter

NAME	DATES	BACKGROUND AND TRAINING	MEMBERSHIPS	TYPE OF ARTIST
Ross, Hilda Katherine	1902– [?]	studied under Lemoine FitzGerald, Winnipeg School of Art; under F.H. Varley, British Columbia College of Art; Art Institute of Chicago		painter, potter
Wainwright, Ruth	1902–1984			painter
Ward, Kathleen (Kitty) Louise (née Campbell)	1902–1988	studied under Mary Wrinch Reid, Bishop Strachan School, Toronto; under F.S. Challener, Sam Finlay, and William Graham, Central Technical School, Toronto; under J.W. Beatty, G.A. Reid, Arthur Lismer, F.H, Varley, and A.Y. Jackson, OCA	CSGA, HC, PDCC	painter
Curtis, Carolyn	1903–1995	studied under J.E.H. MacDonald, OCA	SCPE	painter
Frame, Margaret Josephine Geraldine Fulton (Mrs. H.S. Beatty)	1903– [?]	studied under James Henderson, Saskatchewan; School of the Museum of Fine Arts, Boston; California School of Fine Arts, San Francisco; under Émile Renard, École des beaux-arts, Paris	WAAR	painter
Hazell, Eileen Long	1903– [?]	Central Technical School, Toronto; member of Canadian Group of Painters	CGP, CHG	potter, sculptor
Lewis, Maud	1903–1970	taught by mother		painter
McGeogh, Lillian Jean	1903– [?]	studied under Alfred Howell, Central Technical School, Toronto; under J.W. Beatty and G.A. Reid, OCA	HPGP, NSSA, WAAH	painter
McLaughlin, Isabel Grace	1903–2002	studied under Arthur Lismer, OCA; under Hans Hofmann, Provincetown; studied in Paris; under Emil Bisttram, New Mexico; member of Canadian Group of Painters	CGP, HC, OSA	painter
Reid, Isobelle (née Chestnut)	1903– [?]	studied under Arthur Lismer, J.E.H. MacDonald, and J.W. Beatty, OCA		painter
Wood, Elizabeth Wyn	1903–1966	studied under Emanuel Hahn, Arthur Lismer, and J.E.H. MacDonald, OCA; Art Students League, New York; married Emanuel Hahn; founded Sculptors Society of Canada with Hahn, Frances Loring, Florence Wyle, Henri Hébert, and Alfred Howell; member of Canadian Guild of Potters	ARCA, CHG, FCA, RCA, SSC	sculptor
Bradshaw, Nell Mary	1904–1997	studied under H.G. Glyde and Molly Lamb Bobak, Vancouver Art Gallery	ASA	painter
Haworth, Zema Barbara (Bobs) Cogill	1904–1988	studied under Sir William Rothenstein, Royal College of Art, London; married the painter Peter Haworth; member of Canadian Group of Painters	ARCA, CGP, CSPWC, HC, OSA, RCA	painter, potter
Hoover, Dorothy Haines	1904–1995	studied under father, the painter Frederick S. Haines	HC, OSA	painter
Legendre, Irène	1904– [?]	studied under H. Ivan Neilson and Lucien Martial, École des beaux-arts, Quebec City; under Amédée Ozenfant, New York		painter
Lent, Dora Geneva	1904–1983	studied under Victor Reid, A.C. Leighton, and Nickola de Grandmaison	CHG	painter
Leslie, Bailey	1904– [?]	studied under Peter Haworth, Central Technical School, Toronto	CHG	potter

NAME	DATES	BACKGROUND AND TRAINING	MEMBERSHIPS	TYPE OF ARTIST
MacLeod, Pegi Nicol (Margaret Kathleen Nicol)	1904–1949	studied under Franklin Brownell, Ottawa; École des beaux-arts, Montreal; co-founded University of New Brunswick Observatory Art Centre with Lucy Jarvis in 1942; member of Canadian Group of Painters	CGP, CSPWC, OAA, PLS	painter
Pigott, Marjorie	1904–1990	Nanga School, Japan	ARCA, CSPWC, OSA, RCA	painter
Ruston, Hilda Sophia (née Marquette)	1904–1984	studied under Frank Panabaker and Gordon Payne; married Alfred Ruston	OSA	painter
Zwicker, Mary Marguerite	1904–1993	Nova Scotia College of Art, Halifax; studied under Stanley Royle; under Eliott O'Hara	NSSA	painter, printmaker
Anderson, Morna MacLellan	1905– [?]	studied under Adam Sherriff Scott, AAM; under Ruth Wainwright, Halifax	MAA	painter
Berlin, Eugenia	1905– [?]	École des beaux-arts, Geneva; studied under Valentine Metein-Gilliard; under Elizabeth Wyn Wood and B. Cogill Haworth, Central Technical School, Toronto; member of Canadian Group of Painters	CGP, SSC	sculptor
Denechaud, Simone	1905–1974	École des beaux-arts, Montreal		painter
Drummond, Bernice (née Thompson)	1905– [?]	studied under J.E.H. MacDonald and Arthur Lismer, OCA; under Wilfred Flood, Ottawa		painter, etcher
Hudon-Beaulac, Simone Marie Yvette	1905–1984	studied under H. Ivan Neilson and Lucien Martial, École des beaux-arts, Quebec City	CSGA, SCPE	printmaker
Janes, Phyllis Hipwell	1905–1990	OCA; married Henry F. Janes	CSGA, OSA	printmaker
Lennie, Edith Beatrice Catharine	1905–1987	studied under F.H. Varley, Vancouver School of Art; California School of Fine Arts, San Francisco		painter, sculptor
Petchey, Winifred Florence	1905– [?]	Hornsey School of Arts and Crafts, London; married Donald Marsh		painter
Plaskett, Aileen Anne (Aileen Plaskett Duffy)	1905– [?]	studied in London; under A.F. Newlands, Ottawa Technical School; under Franklin Brownell and Ernest Fosbery, Ottawa; under André Biéler, Henri Masson, and Carl Schaefer, Queen's University, Kingston	OAA	painter
Platner, Rae Katz	1905– [?]	studied under Elizabeth Wyn Wood, Central Technical School, Toronto; under Emanuel Hahn, OCA; under Frances Loring and Florence Wyle at their studio, Toronto	SSC	sculptor
Privett, Molly (née Dowler)	1905–1981	studied under David Anderson and Herbert Siebner	BCSA	painter
Rosana, Maria Altilia	c. 1905– [?]	studied under Elizabeth Wyn Wood, Central Technical School, Toronto		sculptor
MacDonald, Elsie Amy	1906– [?]	studied under W. Hoverman and Harold Beament	IAA	painter
Scott, Marian Mildred Dale	1906–1993	studied under William Brymner, AAM; École des beaux-arts, Montreal; under Henry Tonks, Slade School of Art, London; member of Canadian Group of Painters	ARCA, CAS, CGP, RCA, SAPQ	painter

NAME	DATES	BACKGROUND AND TRAINING	MEMBERSHIPS	TYPE OF ARTIST
Whyte, Catharine Robb	1906–1979	School of the Museum of Fine Arts, Boston; married the painter Peter Whyte		painter
Aked, Elizabeth Aleen	1907–2003	studied under Arthur Lismer, F.H. Varley, and J.W. Beatty, OCA; Ringling School of Art, Sarasota	SAA, SSAL	painter
Bolduc, Blanche	1907–1998			painter
Farley, Lilias Marianne	1907–1989	studied under F.H. Varley and J.E.H. MacDonald, Vancouver School of Art	BCSA, SSC	sculptor
Porteous, Piercy Evelyn Frances (Mrs. George Robert Younger)	1907– [?]			painter
Smith, Marjorie (Jori) Elizabeth Thurston	1907–2005	studied under Randolph Hewton and Edwin Holgate, AAM; under Joseph Saint-Charles and J.Y. Johnstone, Conseil des arts and manufactures, Montreal; École des beaux-arts, Montreal; studied in England and France; married the painter Jean Palardy	CAS, EGP	painter
Brochu, Rachel	1908– [?]	studied under Jean Paul Lemieux and Jean Soucy, École des beaux-arts, Quebec City; Instituto Allende, San Miguel de Allende, Mexico; under Alfred Pellan and Jean-Paul Mousseau, Centre d'art de Ste-Adèle, Quebec		painter
Carey, Alice G.	c. 1908– active 1963	Wimbledon School of Art, London	NSP, RIPP, VAA	painter
Cleland, Isabel E.	1908–2002	OCA; Art Students League, New York	SCPE	painter, etcher, sculptor
De Groot, Andrée S.	1908– active 1970	studied in Paris under Maurice Denis	SCA	painter, sculptor
Dingle, Ruth Marion (Mrs. Peter Douet)	1908–1980	studied under Arthur Lismer, AAM; École des beaux-arts, Montreal		painter
England, Kathleen Margaret	1908– active 1999	studied under Platon Ustinof, Vancouver School of Art; under Thomas Fripp	FCA	painter
Freiman, Lillian (Lily)	1908–1986	studied under Edmond Dyonnet, AAM; Art Students League, New York; studied in Paris		painter
Green, Betty	1908– [?]	studied under Robert Norgate, Gerald Trottier, and James Boyd, Toronto	CSPWC, OAA	painter
Guard, Maria Cecilia (Mrs. Ken Phillips)	c. 1908–2000	studied under Arthur Lismer, J.E.H. MacDonald, Emanuel Hahn, and J.W. Beatty, OCA; National Academy of Design, New York		painter
Kennedy, Kathleen Cooley	1908– [?]	Royal College of Art, London	CSPWC, RDSL	painter
Lang, Byllee Fay	1908–1966	Winnipeg School of Art; studied under Emanuel Hahn, OCA; State Academy, Munich	MSA	sculptor

NAME	DATES	BACKGROUND AND TRAINING	MEMBERSHIPS	TYPE OF ARTIST
Pawson, Ruth May	1908–1994	studied under Gordon Snelgrove and Augustus Kenderdine, Emma Lake Artists' Workshops, Saskatchewan; under A.Y. Jackson, Banff School of Fine Arts	FCA	painter
Prittie, Mary Elizabeth	1908–1999		OSA	painter
Redsell, Pauline Hazel Daisy (Mrs. William Fediow)	1908–1980		SSC	painter, sculptor
Reid, Lillian Irene (née Hoffar)	1908–1994	studied under F.H. Varley and Charles H. Scott, Vancouver School of Art; Royal Academy, London; member of Canadian Group of Painters	BCSA, CGP	painter
Wiselberg, Rose	1908–1992	École des beaux-arts, Montreal		painter
Coffin, Irene	1909– [?]	studied under Ruth Wainwright, Halifax; Sorbonne, Paris	NSSA	painter
Davison, Betty (Gertrude Elizabeth Mary Young)	1909–2000	studied under Lionel Fosbery, Ernest Fosbery, and Alma Duncan, Ottawa	CAR, PDCC	painter, printmaker, sculptor
Delfosse, Madeleine	1909–1985	studied under Joseph Saint-Charles, École des beaux-arts, Montreal; daughter of the painter Georges Delfosse		painter
Flewelling, Dorena	1909– [?]	Banff School of Fine Arts; Instituto Allende, San Miguel de Allende, Mexico	ASA, FCA	painter
Grant, Beatrice	1909– [?]	studied under Arthur Lismer and Grant MacDonald, OCA; under J.W. Beatty, Port Hope; under Stanley Royle and Elizabeth Styring Nutt, Nova Scotia College of Art, Halifax	NSSA	painter
Heller, Mary Ida Clair	1909–1986	studied under Emanuel Hahn and Thomas Bowie, OCA		sculptor
Hunt, Jessie Doris	1909– [?]	studied under Euphemia McNaugh, Calgary; under Joe Plaskett, Winnipeg School of Art; Instituto Allende, San Miguel de Allende, Mexico	CSPWC, MSA	painter
Kinsman, Katharine Bell	1909– [?]	Parsons School of Design, New York; studied under Amédée Ozenfant, Paris; under Anne Savage, Montreal		painter
Mortimer Lamb, Vera Olivia (née Weatherbie)	1909–1977	Vancouver School of Art; modelled for F.H. Varley; married the art critic and photographer Harold Mortimer Lamb	BCSFA	painter
Nicoll, Marion Florence S. (née Mackay)	1909–1985	studied under J.E.H. MacDonald, OCA; under A.C. Leighton, Provincial Institute of Technology and Art, Calgary	ARCA, ASA	painter

1910 TO 1919

NAME	DATES	BACKGROUND AND TRAINING	MEMBERSHIPS	TYPE OF ARTIST
Alan, Rose Beatrice (Bea) (Bergeron O'Loughlin)	1910– [?]	studied under Adam Sheriff Scott and Albert Cloutier, École des beaux-arts, Montreal	IAS	painter
Barleigh, Barbara (Mrs. A.C. Leighton)	1910–1986	Alberta College of Art, Calgary		printmaker
Cowley, Reta Madeline (née Summers)	1910–2004	studied under Augustus Kenderdine, University of Saskatchewan; under W.J. Phillips, Charles Comfort, and H.G. Glyde, Banff School of Fine Arts	CSPWC	painter

NAME	DATES	BACKGROUND AND TRAINING	MEMBERSHIPS	TYPE OF ARTIST
Fainmel, Marguerite Paquette	1910–1981	École des beaux-arts, Montreal; Académie de la Grande Chaumière, Paris; mother of the artist Ivan J. Fainmel	CAS, FCA	painter
Groves, Naomi Jackson	1910–2001	studied under Alberta Cleland, AAM; under Harold Beament and Sarah Robertson, Montreal; under Emil Rannow and Viggo Brandt, Copenhagen; niece of A.Y. Jackson		painter
Johnston, Frances Anne	1910–1987	studied under Franz Johnston, J.E.H. MacDonald, Robert Holmes, Fred S. Haines, and Emanuel Hahn, OCA; daughter of the painter Franz Johnston	ARCA, OSA, RCA	painter
McCarthy, Doris Jean	1910– active 2008	studied under Arthur Lismer, J.E.H. MacDonald, J.W. Beatty, and Emanuel Hahn, OCA; OSA president 1964–1966	ARCA, CSPWC, OSA, RCA	painter
Meagher, Aileen Alethea	1910–1987	studied under Ruth Wainwright and Bruce Hunter, Nova Scotia College of Art, Halifax; Doon School of Fine Art, Ontario; participated in Olympic games of 1936	NSSA	painter
Rosenfield, Ethel	1910–2000	studied under Louis Archambault, Sylvia Daoust, and Armand Filion, École des beaux-arts, Montreal		painter
Stadelbauer, Helen Barbara	1910–2006	Provincial Institute of Technology and Art, Calgary; Banff School of Fine Arts; Columbia University	ASA	printmaker
Banting, Beatrice Aline Myles	1911–1998	studied under Hortense Gordon and John Sloan Gordon; OCA		painter
Greene, Marie Zoe	1911– [?]	studied under Alexander Archipenko and László Moholy-Nagy, New Bauhaus School, Chicago	FCA, NAC	sculptor
Hahn, Sylvia	1911–2001	studied under J.W. Beatty, Gustav Hahn, Emanuel Hahn, Franklin Carmichael, and Yvonne McKague Housser, OCA; daughter of the painter Gustav Hahn	HC, SCPE	painter, printmaker
Luz, Virginia Erskine	1911–2005	studied under Peter Haworth, Elizabeth Wyn Wood, and Carl Schaefer, Central Technical School, Toronto	ARCA, CSPWC, OSA, RCA	painter
Oille, Ethel Lucille (Mrs. Kenneth Wells)	1911–1997	studied under Emanuel Hahn, OCA; Royal College of Art, London	CSGA	sculptor, printmaker
Bouchard, Simone Mary	1912–1945	self-taught; sister to painters Marie-Cécile and Édith Bouchard	CAS	painter
Gilson, Jacqueline Marie-Charlotte	1912– [?]	immigrated to Canada, 1950; studied under Maurice Denis and Georges Desvallières, Ateliers d'art sacré, Paris; became professor of painting and religious embroidery		painter
Martin, Agnes Bernice (née Fenwick)	1912–2004	Columbia University; University of New Mexico	SCPE	printmaker, painter
Mitchell, Janet	1912–1998	Provincial Institute of Technology and Art, Calgary; studied under Gordon Smith, Banff School of Fine Arts	ARCA, ASA, CSPWC	painter
Prager, Eva Sophie	1912– [?]	Royal College of Art, London; École Paul Colin, Paris; painted portrait of Pierre Elliott Trudeau		painter

NAME	DATES	BACKGROUND AND TRAINING	MEMBERSHIPS	TYPE OF ARTIST
Brooks, Reva	1913–2004	Central Technical School, Toronto; married the painter Leonard Brooks		photographer
Cardiff, Kathleen May	1913– [?]	studied under George Webber	SCPE	printmaker
Eliot, Ruth Mary	1913–2001	studied under Pegi Nicol MacLeod, Goodridge Roberts, George Pepper, and F.H. Varley; under Prudence Heward and A.Y. Jackson	FCA	painter
Graham, Kathleen (Kay) Margaret Howitt	1913– [?]	self-taught; friendly with Jack Bush	ALC, ARCA	painter, printmaker
Gravel, Raymonde	1913– [?]	John P. Wicker's School of Fine Art, Detroit; studied under Pierre Eugène Montezin, Joseph Berges, Paul André Jean Eschbach, and Jules Adler, Académie Julian, Paris	AAM, OSA, WAA	painter
Holbrook, Elizabeth Mary Bradford	1913– [?]	studied under Hortense Gordon and John Sloan Gordon, Hamilton Technical Institute; under Emanuel Hahn, OCA; Royal College of Art, London	ALC, ARCA, OSA, RCA, SSC	sculptor
Hunt, Dora de Pédery	1913– active 1999	Royal School of Applied Art, Budapest; married Albert Hunt	ALC, ARCA, FCA, OSA, RCA, SSC	sculptor
Manarey, Thelma Alberta	1913–1984	studied under H.G. Glyde, Provincial Institute of Technology and Art, Calgary; under Charles Stegeman, Banff School of Fine Arts	ASA, SCPE	etcher
McClellan, Norma Harriet	1913– [?]	studied under Miss Kay and Robert Hyndman, Toronto		painter
Nisbet, Florence	1913–1998	Schneider School of Fine Arts, Actinolite, Ontario		painter
Taçon, Edna Jeanette	1913–1980	studied under husband, P.H. Taçon	OSA	painter
Barnhouse, Dorothy	1914– [?]	Vancouver School of Art; Banff School of Fine Arts; University of Alberta; Instituto Allende, San Miguel de Allende, Mexico	ASA	painter
Holmes, Betty Marion Ruth	1914–1988	studied under LeMoine FitzGerald, Winnipeg School of Art; under Richard Bowman and Robert Nelson, University of Manitoba	MSA	painter, sculptor
Horne, Jean Mildred	1914–2007	studied under Emanuel Hahn, OCA; married Clive Horne	ARCA, SSC	painter, sculptor
McCaugherty, Irene	1914–1996	began painting in later life; work reflects her interest in Alberta history		painter
Altwerger, Elizabeth (Libby) Deborah	1915–1995	studied under John Alfsen and Carl Schaefer, Central Technical School; under Charles Goldhamer; under Jock Macdonald	OSA, PDCC	printmaker
Chappelle, Margaret Morgan	1915–1992	studied under H.G. Glyde, University of Alberta; Banff School of Fine Arts, under Gordon Smith and John Ferron	ASA, FCA, SCPE	painter, sculptor
Cope, Dorothy Walpole	1915– [?]	Vancouver School of Art; studied under Lionel Thomas	BCSA, CSPWC	painter
Fugler, Grace	1915–1992	Hamilton School of Art; studied under John Sloan Gordon, Hamilton Technical Institute	SCPE	engraver

NAME	DATES	BACKGROUND AND TRAINING	MEMBERSHIPS	TYPE OF ARTIST
MacDougall, Nini	1915– [?]	studied under Adam Sheriff Scott; under F.H. Varley; under Fritz Brandtner; under Arthur Lismer; Art Students League, New York		painter
Mulcaster, Wynona Croft	1915– active 1985	studied under Ernest Lindner; under A.Y. Jackson and H.G. Glyde, Banff School of Fine Arts; Arthur Lismer, AAM	CSEA, FCA	painter
Rhéaume, Jeanne Leblanc	1915–2000	École des beaux-arts, Montreal; studied under Lilias Torrance Newton, Harold Beament, and Goodridge Roberts, AAM; won Jessie Dow Prize		painter, weaver
Ross, Susan Andrina (née Ruttan)	1915–2006	studied under J.W. Beatty and Franklin Carmichael, OCA; under Joe Manning		printmaker
Shelton, Margaret Dorothy (Mrs. Marcellus)	1915–1984	Normal School, Calgary; studied under H.G. Glyde, W.J. Phillips, and Marion Nicoll, Provincial Institute of Technology and Art, Calgary; under A.C. Leighton, Banff School of Fine Arts	ASA, SCPE	printmaker, painter
Alexander, Earla M.	1916– [?]	School of Fine Arts, Queen's University	PLS	painter, sculptor
Baird, Geneva Adair Jackson (G.A. Jackson; G.A. Jackson Baird)	1916–2006	École des beaux-arts, Montreal; MMFA; Banff School of Fine Arts; niece of A.Y. Jackson		painter
Boyer, Madeleine	1916– [?]	studied under Eric Newman; Académie de la Grande Chaumière, Paris; under Alfred Pellan; Instituto Politécnico Nacional, Mexico; MMFA		painter
Bradshaw, Alice	1916– [?]	studied under Charles Goldhamer, Peter Haworth, and Dawson Kennedy, Central Technical School, Toronto; Art Students League, New York	CSGA	engraver, painter
Galbraith-Cornell, Elizabeth Roberta	1916– [?]	studied under Miss A.B. Stone and Wildred Barnes, Weston School, Montreal; under Adam Sheriff Scott and Harold Beament, AAM	RDSL	painter
Jones, Frances (Fran) Martha Rosewarne	1916–2002	studied under John Alfsen, Franklin Carmichael, and Fred S. Haines, OCA; under Gustav Hahn, Emanuel Hahn, Charles Comfort, George Pepper, and Yvonne McKague Housser	FCA, CSGA, OAA	painter, printmaker
Koddo, Galina	1916– [?]	studied under her father; Tallinn Art School, Estonia	ASA	painter
Mayhew, Elza Edith (née Lovitt)	1916– active 2002	University of British Columbia; studied under Jan Zach, Victoria	ARCA	sculptor
Pavelic, Myfanwy (née Spenser)	1916–2007	self-taught	ARCA, RCA	painter
Simon, Ellen Rosalie	1916–2004	studied under Yvonne Housser, Franklin Carmichael, and George Pepper, OCA; Art Student's League, New York	CSGA	painter, printmaker, glass sculptor
Beaulieu, Simone Aubry	1917– [?]	studied under Fernand Léger and André Marchand, École des beaux-arts, Paris; Académie Julian, Paris		painter, sculptor
Carreau-Kingwell, Arlette	1917– [?]	studied under Alfred Laliberté and Joseph Saint-Charles, École des beaux-arts, Montreal; under Adrien Hébert		painter

NAME	DATES	BACKGROUND AND TRAINING	MEMBERSHIPS	TYPE OF ARTIST
Duncan, Alma Mary	1917– 2004	studied under Adam Sheriff Scott, Ernst Neumann, and Goodridge Roberts	AAM, CAR, CSGA, FCA, PDCC	painter
Duquet, Suzanne	1917– [?]	École des beaux-arts, Montreal		painter
Faulkner, Philippa Mary Burrows	1917–2001	Parsons School of Design, New York; studied under Hans Hofmann, New York and Provincetown; under Carl Schaefer, F.H. Varley, and Clare Bice, Doon School of Fine Art, Ontario; Instituto Allende, San Miguel de Allende, Mexico	ALC, CSPWC, OSA, SCA	painter, sculptor
Greene, Barbara Louise	1917– [?]	studied under Jack Martin and Sydney Watson, OCA; studied in Sweden on scholarship	CSPWC	painter
Johnson, Kathleen Beatrice	1917–1998	studied under Yvonne McKague Housser and Grace Coombs, OCA	OIP, OSA, WGA	painter
Reiber, Eileen	1917– [?]		ASA	painter
Ritchie, P.M. (Percival Molson MacKenzie)	1917–2004	studied under Edwin Holgate		painter
Robertson, Helen Waimel	1917–2002		SSC	sculptor
Wood Bream, Faith	1917–2005	studied under Alex Colville, Mount Allison University	HC, SCA	painter
Allport, Margaret	1918– [?]	studied under John Alfsen, Nicholas Hornyanski, Emanuel Hahn, George Pepper, and Carl Schaefer, OCA	SCPE	painter, etcher
Chisholm, Helen	1918–1975	studied under George Pepper, Charles Comfort, and Franklin Carmichael, OCA; secretary to R.H. Hubbard at National Gallery of Canada for 30 years		painter
Hicklin, Barbara Rod	1918– [?]	studied under Peter Haworth and Carl Schaefer, Central Technical School, Toronto; OCA; Phoenix School of Design, New York	ASA, EAC	painter
Maartense, Gertrude Jacoba	1918– [?]	studied in Holland; under H.G. Glyde, J.B. Taylor, and William Townsend, University of Alberta	MSA	painter
MacLaren, Frances Mary Hewson	1918– [?]	studied under Elizabeth Styring Nutt and Donald C. MacKay, Nova Scotia College of Art, Halifax; under Betty Smith; under Ruth Wainwright; married George MacLaren	NSSA	painter
Néron, Gertrude	1918– [?]	studied under Jean Paul Lemieux and Jean Dallaire, École des beaux-arts, Quebec City; École des arts et techniques, École du Louvre, Paris		painter
Raney, Suzanne Bryant	1918– [?]	studied under Franklin Carmichael and J.W. Beatty, OCA		painter, sculptor
Aitken, Margaret Walker	1919–1977	studied under Mackie Cryderman, H.B. Beal Technical School, London (Ontario); under J.W. Beatty and John Alfsen, OCA; member of Canadian Group of Painters	CGP, CSPW, OSA	painter, potter
Andersen, Helen	1919– active 1967	studied under Bob Davidson, John Koerner, Jacques de Tonnancour, and Joe Plaskett, Vancouver School of Art	FCA, VAC	painter
De Nagy, Mary	c. 1919–1998	Sculptors Society of Canada president	OSA, SSC	sculptor

NAME	DATES	BACKGROUND AND TRAINING	MEMBERSHIPS	TYPE OF ARTIST
Fitzgerald, Helena Roberta (Mrs. John Steele) (Mrs. Wilfred Bacon)	1919– [?]	studied under Reginald Marsh, Art Students League, New York; OCA	CSGA, CSPWC, OSA	painter
Mitchell, Molly Greene	1919–2000	studied under Franklin Carmichael, J.W. Beatty, and Charles Comfort, OCA	CSPWC	painter
Piché-Whissel, Aline-Marie Blanche Marguerite	1919– [?]	studied under Suzanne Duquet, École des beaux-arts, Montreal		painter
Weber, Kathleen (Kay) Murray (née Nichol)	1919– active 2002	studied under Jock Macdonald, John Alfsen, and Fred Hagan, OCA	ALC, ARCA, OSA, PDCC, SCPE	printmaker

1920 TO 1929

NAME	DATES	BACKGROUND AND TRAINING	MEMBERSHIPS	TYPE OF ARTIST
Bouchard, Marie-Cécile	1920–1973	self-taught; sister to painters Édith and Simone-Mary Bouchard		painter
Campbell, Katherine Isabelle (Kay)	1920– [?]		OAA	painter
d'Entremont, Blaise	1920–	Royal College of Art, Johannesburg; Mount Allison University; Mount Saint Vincent University; Nova Scotia College of Art, Halifax		painter
Drutz, June	1920–2007	studied under Fred Hagan, Carl Schaefer, and William Roberts, OCA	ARCA, CSGA, OSA, PDCC, RCA, SCPE, SCPWC	painter, printmaker
Dumouchel, Suzanne (née Beaudoin)	1920–	École des beaux-arts, Montreal; Sorbonne, Paris; married the artist Albert Dumouchel	SAPQ	painter
Filer, Mary Harris	1920–	studied under Arthur Lismer, Goodridge Roberts, Stanley Cosgrove, William Armstrong, and Jacques de Tonnancour, School of Art and Design, MMFA, Montreal; under John Lyman, McGill University	CAS, CSGA, FCA	painter, glass artist, sculptor
Forsyth, Mina	1920–1987	studied in Manitoba and Michigan; Emma Lake Artists' Workshops, Saskatchewan		painter
Gersovitz, Sarah Valerie Gamer	1920–2007	studied under Jacques de Tonnancour, Gordon Webber, and Moe Reinblatt, MMFA; under Louis Parent, L'Institut des arts appliqués, Montreal	ARCA, CSGA, RCA, SAPQ, SCPE	printmaker, sculptor, painter
Ivan, Edit Zilahi	1920–1962	Academy of Fine Arts, Budapest	CSGA, CSPWC, HFA	painter
Milne, Margaret E.	1920–	studied under Lemoine FitzGerald and Edith Carter, Winnipeg School of Art	WAA	painter
Bailey, Daisy	1921–1972	studied under Herbert E. Clarke and Hortense Gordon; under Herb Ariss, H.B. Beal Technical School, London (Ontario); married Robert L. Bailey		painter
Diceman, Mary Yvonne	1921–2000	Manchester School of Art; studied under Donald Stone, Rockport, Massachusetts	NSAA, OSPWC, OWCSC	painter

NAME	DATES	BACKGROUND AND TRAINING	MEMBERSHIPS	TYPE OF ARTIST
Gadbois, Denyse (Mrs. Chaput)	1921–	studied under Goodridge Roberts, AAM; Académie Julian, Paris; daughter of the painter Marie Gadbois	CAS	painter
McCormack, June Forbes	1921–1961	Bishop Strachan School, Toronto; OCA; daughter of the painter Kenneth Forbes	OIP	painter
Pratt, Mildred Claire	1921–1995	studied under Gordon Payne, Gordon Payne School of Fine Arts; School of the Museum of Fine Arts, Boston	SCPE	engraver
Rothschild, Johanna (Hanni) Eleonore	1921– active 1980	studied at H.B. Beal Technical School, London (Ontario); under B. Cogill Haworth, Central Technical School, Toronto	SSC	sculptor
Berenstein, Leah	1922–	studied under Carl Schaefer, Central Technical School, Toronto; Humber Valley Art Club, Ontario; Toronto Western Technical School; OCA	SSC	sculptor
Bobak, Molly Lamb	1922–	studied under Jack Shadbolt and Charles H. Scott, Vancouver School of Art; daughter of Harold Mortimer Lamb, art critic and photographer; married the painter Bruno Bobak; member of Canadian Group of Painters	ABCSA, ARCA, CGP, CSGA, CSPWC, SCPE	painter
Cook-Endres, Barbara	1922–	studied under Rowley Murphy, OCA; Vancouver School of Art	MSA	painter
Hall, Jeanne Patricia	1922–	studied under Toni Onley, Adrian Dingle, Aba Bayefsky, and Rowley Murphy, OCA		painter
Laliberté, Madeleine	1922–1998	École des beaux-arts, Quebec City; Académie de la Grande Chaumiére, Paris		painter
Middleton, Janet Holly Blench (Mrs. J.M. Churchill)	1922– c. 1989	studied under H.G. Glyde and W.J. Phillips, Alberta College of Art, Calgary; Slade School of Art, London	ASA, SCPE	painter, printmaker
Oxborough, Dorothy Marie (Mrs. H. Johnson)	1922– active 1979	Vancouver School of Art; Provincial Institute of Technology and Art, Calgary	NSSA	painter
Popescu, Cara	1922–1992	studied in Munich; Academy of Fine Arts, Florence; under Otto Baum, Academy of Fine Arts, Stuttgart; under Albert Dumouchel, École des beaux-arts, Montreal	ASQ, OSA, SSC	sculptor, painter
Richardson, Doris K.	1922–	married Ross R. Richardson		painter
Ary, Sylvia Bercovitch	1923– active 1981	studied under Fritz Brandtner at studio of Norman Bethune; under Edwin Holgate, Will Ogilvie, and Jacques de Tonnancour, MMFA		painter, sculptor
Brainerd, Charlotte	1923–1993	studied under Peter Aspell, Vancouver School of Art; under Frederick Hagen, OCA	CSGA, SCPE	printmaker, painter
Caiserman-Roth, Ghitta	1923–2005	studied under Harry Sternberg, American Artists School; Art Students League, New York; Nova Scotia College of Art, Halifax; Instituto Allende, San Miguel de Allende, Mexico; under Albert Dumouchel, École des beaux-arts, Montreal; member of Canadian Group of Painters	ARCA, CGP, CGQ, CSGA, FCA, SCPE	painter, printmaker
Goodwin, Betty	1923–	studied under Yves Gaucher, Sir George Williams University	CSGA, SCPE	painter, etcher, sculptor

NAME	DATES	BACKGROUND AND TRAINING	MEMBERSHIPS	TYPE OF ARTIST
Manning, Joanne Elizabeth	1923–	studied under John Alfsen, OCA	ARCA, PDCC	printmaker
Pomeroy, Constance	1923–active 2001	studied under Jack Shadbolt and Fred Amess, Vancouver School of Art	FCA	painter
Proulx, Anne	1923–1995	studied under Jean Paul Lemieux, École des beaux-arts, Quebec City	NOAA	painter
Rutherford, Erica	1923–	Slade School of Art, London		painter
Bloore, Dorothy Cameron	1924–1999	Institute of Contemporary Art, Boston; married the artist Ron Bloore		sculptor, installation artist
Bouchard, Édith	1924–	self-taught; sister to painters Marie-Cécile and Simone-Mary Bouchard		painter
Capon, Inga	1924–	OCA	SSC	sculptor
Fauteux-Massé, Henriette	1924–2005	Académie André Lhote, Paris; studied under Adrien Hébert and F.S. Coburn; married Jules Massé	AANFM, SAPQ	painter
Ferron, Marcelle	1924–2001	studied under Jean Paul Lemieux and Simone Hudon, École des beaux-arts, Quebec City; under Paul-Émile Borduas, École du meuble, Montreal; signed the *Refus Global* manifesto (1948)	CAS, RCA, SAPQ	painter, glass artist
Gage, Frances Marie	1924–	studied under Emanuel Hahn, OCA; Art Students League, New York; École des beaux-arts, Paris	ALC	sculptor
Genush, Luba	1924–	Kiev Art School; studied under Jean Cartier, École du meuble, Montreal	CSGA, SAP, SAPQ, SCPE	painter, printmaker
Hamill, Doris Pickup	1924–	Winnipeg School of Art	MSA	painter
Kahane, Anne (Mrs. R. Langstadt)	1924–	École des beaux-arts, Montreal; Cooper Union, New York	ARCA, SAPQ, SSC	sculptor
Lefkovitz, Sylvia	1924–1987	École des beaux-arts, Montreal; MMFA; Columbia University		sculptor, painter
Parent, Mimi	1924–2005	studied under Alfred Pellan, École des beaux-arts, Montreal		painter
Boyd, Joan	1925–	Vancouver School of Art	BCSA	painter
Briansky, Rita (Mrs. Joseph Prezament)	1925–	studied under Alexander Bercovitch, Jacques de Tonnancour, and M. Charpentier; Art Students League, New York	CSGA, SCPE	etcher, painter
Brodkin, Edith	1925–	School of Art and Design, MMFA	SSC	sculptor
Carrier, Louise	1925–1976	studied under Jean Paul Lemieux, Jean Dallaire, and Simone Hudon, École des beaux-arts, Quebec City		painter, engraver
Corkum, Hilda Frances	1925–	Vesper George School of Art, Boston; studied under Henry Henshie, Massachusetts; under Ernest Fiene and John Laurent, Ogunquit, Maine	NSSA	painter, sculptor
Deutscher, Joyce	1925–	Queen's University, Kingston; School of Art and Design, MMFA; Emma Lake Artists' Workshops, Saskatchewan		painter

NAME	DATES	BACKGROUND AND TRAINING	MEMBERSHIPS	TYPE OF ARTIST
Duff, Ann MacIntosh	1925–	studied under Peter Haworth, Doris McCarthy, and Dawson Kennedy, Central Technical School, Toronto; under André Biéler and Caven Atkins, Queen's University	ARCA, CSGA, CSPWC, OSA, PDCC, PLS, RCA	painter, printmaker
Greenstone Marion	1925–	Art Students League, New York; Cummington School of Art, New York; won Jessie Dow Prize	OSA	painter
James, Ann	1925–	Brighton School of Art, England; studied under Arthur McKay, Kenneth Lochhead, and Ric Gomez, University of Saskatchewan	ACC, TPG	ceramic artist
Johnston, Dorothy Paine (née Dunn)	1925–	studied under Ivan Eyre, Ron Burke, Cecil Richards, and Kenneth Butler, University of Manitoba		sculptor
Kreyes, Marie Louise (née Bodewein)	1925–1983	studied Fine Arts at University of Manitoba	MSA	painter
Milne, Rose Eleanor	1925–	studied under Gordon Webber, Jacques de Tonnancour, and Arthur Lismer, MMFA; under Sylvia Daoust, École des beaux-arts, Montreal	SSC	sculptor
Stankus, Edith (née Glanertas)	1925–1975	studied under Mary Schneider, Graham Coughtry, and Gordon Peters, OCA	OIP	painter
Steinhouse, Thelma (Tobie) (née Davis)	1925–1979	studied under Anne Savage, Montreal; Art Students League, New York; École des beaux-arts, Paris; Académie de la Grande Chaumière, Paris; member of Canadian Group of Painters	AANFM, ARCA, CGP, CSGA, PDCC, SAPQ, SCPE	painter, printmaker
Sullivan, Françoise	1925–active 2003	École des beaux-arts, Montreal; signed the *Refus Global* manifesto (1948); married the artist Patterson Ewen	ASQ	dancer, painter, sculptor
André, Françoise Marise Sylviane (Mrs. Charles Stegeman)	1926–	Académie Royale des beaux-arts, Brussels; studied in Antwerp and Paris		painter
Boehrnsen, Sylvia	1926–	studied under Annora Brown, W.J. Phillips, H.G. Glyde, and Frank Palmer, University of Calgary	ASA	painter
Cowan, Helen Aileen	1926–	studied under Wyndham Lawrence, Central Technical School, Toronto	HC, SSC	painter, sculptor
Howard, Helen Barbara (Mrs. Richard Outray)	1926–2002	studied under Will Ogilvie and Jock Macdonald, OCA; St. Martin's School of Art, London	ALC, PLS, RCA	painter
Mackie, Helen	1926–active 1975	Banff School of Fine Arts	ASA	painter
Meloche, Suzanne	1926–	studied under Paul-Émile Borduas, Montreal; studied in Paris and London	NFAA	painter
Rakine, Marthe	1926–active 1957	École des arts decoratifs, Paris; studied under Othon Friesz, Académie de la Grande Chaumière, Paris; member of Canadian Group of Painters	CGP, OSA	painter
Wertheimer, Esther	1926–			sculptor
Batdorf, Thaya Cronk	1927–	studied under Lawren P. Harris; married Luke Batdorf	NSSA	painter

NAME	DATES	BACKGROUND AND TRAINING	MEMBERSHIPS	TYPE OF ARTIST
Bates, Patrica (Pat) Martin	1927–	studied under Antoon Marstboom, Koninklijke Academie voor Schone Kunsten, Antwerp; studied at Académie de la Grande Chaumière, Paris	ARCA, SCPE	painter, printmaker, sculptor
Brooks, Ruth Emma (née John)	1927–	studied under Fred Schonberger, Lennox & Addington Guild of Fine Arts, Napanee		painter
Chivers, Denise	1927–	studied under Lemoine FitzGerald and Joe Plaskett, Winnipeg School of Art	MSA, WSC	painter
Fairhead, Patricia (Pat) Mary	1927–	OCA	ALC, CSPWC, OSA, SCA	painter
Galbreath, Janet M.	1927–	Glasgow School of Art; Winnipeg School of Art; Banff School of Fine Arts		painter
Galt, Jocelyn	1927–	School of the Museum of Fine Arts, Boston; studied under Arthur Lismer, Gordon Webber, and Goodridge Roberts, MMFA		painter
Garwood, Audrey	1927–2004		OSA	painter, printmaker
Guité, Suzanne	1927–1981	studied under László Moholy-Nagy, Institute of Design, Chicago; studied in Paris, Mexico, Italy, and Greece		sculptor, painter
Knowles, Dorothy Elsie (Mrs. W. Perehudoff)	1927–	University of Saskatchewan; Banff School of Fine Arts		painter
Leonard, Vera	1927–	studied under Ruth Wainwright and Gentile Tondino, Nova Scotia School of Community Arts	NSSA	painter
Tasker, Mary	1927–2003	art teacher, Branksome Hall	HC	painter
Axler, Gladis	1928–	École des beaux-arts, Montreal	WAG	painter
Baker, Anna P.	1928–1985	University of Western Ontario; Art Institute of Chicago		draftsperson, painter, sculptor
Betteridge, Lois Etherington	1928–		ARCA	goldsmith, silversmith
Charbonneau, Monique	1928–	studied under Alfred Pellan, École des beaux-arts, Montreal; École du Louvre, Paris; under Toshi Yoshida, Tokyo	AGQ, SAPQ	etcher, painter
Falk, Agatha (Gathie)	1928–	University of British Columbia; studied under J.A.S. Macdonald	BCSA	painter, sculptor
Le Moyne, Suzanne Rivard	1928–			painter
Leroux-Guillaume, Janine	1928	School of Graphic Arts, Montreal; studied under Madame Charlebois and Albert Dumouchel, École des beaux-arts, Montreal	SCPE	engraver
Letendre, Rita	1928–	École des beaux-arts, Montreal	AANFM	painter
Marx, May	1928–	Central Technical School, Toronto; OCA	PAC, SSC	sculptor, printmaker
Newton-White, Muriel Elizabeth	1928–	OCA		painter

NAME	DATES	BACKGROUND AND TRAINING	MEMBERSHIPS	TYPE OF ARTIST
Ondaatje, Kim (née Betty Kimbark)	1928–			painter
Richman, Francine (née Chanceberg)	1928–active 1983	studied under Gentile Tondino, Patrick Lansley, Sylvia Lefkowitz, and Jan Menses, Montreal; under Stanley Lewis and Yvette Bisson, MMFA	ASQ, CSQ, SSC	sculptor
Takashima, Shizue	1928–	Pratt Graphic Art Centre, New York; OCA; author of *A Child in Prison Camp*, 1971		painter
Voyer, Monique	1928–			painter
Walker, Ruth (née Russell)	1928–	studied Fine Arts, University of Saskatchewan; under W.J. Phillips, Banff School of Fine Arts	GAC	painter
Bruneau, Kittie Marguerite (Mrs. Serge Gilbert)	1929–	studied under René Chicoine, Jean Simard, and Maurice Raymond, École des beaux-arts, Montreal; Académie de la Grande Chaumière and Académie Julian, Paris	CGQ	painter, sculptor
Carter, Harriet Manore	1929–	Dundas Valley School of Art, Ontario	CSPWC, OSA, SCPWC	painter
Dukes, Caroline	1929–2003	studied under Sigismund de Strobl, Hungary; Academy of Fine Arts, Budapest; University of Manitoba		painter, installation artist
Kohuska, Helen	1929–	studied under Joe Plaskett, Winnipeg School of Art; Banff School of Fine Arts	CAS, WAL, WSC	painter
Mochizuki, Betty Ayako	1929–	OCA	CSGA, CSPWC	painter
Montgomery, June	1929–	Alberta College of Art, Calgary; Banff School of Fine Arts	ASA, CSPWC	painter
Rockett, Adeline (née Strelive)	1929–active 1997	University of Saskatchewan; Banff School of Fine Arts	ASA, CSPWC	painter
Tomlinson, Olga (née Kornavitch)	1929–active 2002	studied under Jock Macdonald, George Pepper, and Gustav Hahn, OCA; Vancouver School of Art; Banff School of Fine Arts		printmaker

1930 TO 1939

NAME	DATES	BACKGROUND AND TRAINING	MEMBERSHIPS	TYPE OF ARTIST
Beauchemin, Micheline	1930–	studied under Jean Benoît, René Chicoine, Alfred Pellan, and Jean Simard, École des beaux-arts, Montreal	ARCA	painter, leaded glass, textile artist
Bedard, Monique	1930–	studied under Francesco Iacurto, Helmut Gerth, and Ross Schorer, Musée des beaux-arts, Quebec City; studied at Académie de Port-Royal, Paris	CPQ, RAAV	painter
Bergeron, Suzanne (Mrs. Jean Claude Suhit)	1930–	studied under Jean Paul Lemieux, École des beaux-arts, Quebec City; École du Louvre, Paris	SAP	painter, printmaker
Brassard, Theresa	1930–	studied under Jean Dallaire, Jean Paul Lemieux, and Benoît East, École des beaux-arts, Quebec City; École des arts appliqués, Paris; won Grand Prix du Québec		painter, enameller
Brouwer, Valerie	1930–	studied under Gordon Smith and Fred Amess, Vancouver School of Art; West Vancouver Sketch Club	CSMA, FCA	painter

NAME	DATES	BACKGROUND AND TRAINING	MEMBERSHIPS	TYPE OF ARTIST
Fraser, Carol Lucille Hoorn	1930–1991	studied in Germany; studied Fine Arts, University of Minnesota	ARCA	painter, sculptor
Kilbourn, Rosemary	1930–	OCA; Chelsea School of Art and Slade School of Art, London	CSGA	painter, engraver
Doray, Audrey Capel	1931–	studied under Arthur Lismer, MMFA; under John Lyman and Gordon Webber, McGill University; under Stanley Hayter, Paris; under John Watson and Clarke Hutton, Central School of Arts and Crafts, London	ABCSA, BCSA	painter, printmaker, sculptor, filmmaker
Hamilton, Kathleen Anita	1931–	Vancouver School of Art; Royal Academy, London; studied in Italy and Amsterdam; under Arthur Lismer, MMFA	BCSA	painter
Harrington, Nola	1931–	University of Saskatchewan		painter
Lindgren, Charlotte	1931–	studied under Jack Lenor Larsen, University of Michigan	RAA	fibre artist
Petry, Nancy (Mrs. Wargin)	1931–	studied under John Lyman and Gordon Webber, McGill University; under Henri Goetz, Académie de la Grande Chaumière, Paris		painter
Piddington, Helen Vivian	1931–	studied under F.W. McWilliam, Slade School of Art, London; under Gertrude Hermes, Central School of Arts and Crafts, London		painter
Robbie, Enid	1931–2002	Slade School of Art, London		painter
Roy, Elayne (née Mailhot)	1931–	studied under Jean Paul Lemieux, École des beaux-arts, Quebec City		painter
Swartzman, Roslyn (née Scheinfeld)	1931–	Montreal Artists School; studied under Arthur Lismer, MMFA; under Albert Dumouchel, École des beaux-arts, Montreal	ARCA, PDCC, SCPE	etcher, printmaker
Vanterpool, Joanna	1931–	University of Saskatchewan; Banff School of Fine Arts; studied in Wisconsin		painter
Wales, Shirley	1931–			printmaker, sculptor
Wieland, Joyce	1931–1998	studied under Carl Shaefer and Doris McCarthy, Central Technical School, Toronto; married the artist Michael Snow		painter
Barry, Anne Meredith (née Smyth)	1932–2003	OCA; studied under Nicholas Hornyansky	HC, PDCC, SCA	painter
Bury, Brenda	1932–	studied under Anthony Betts, London		painter
Devlin, Joyce (née Noble)	1932–	studied under Jessie Topham Brown, Vernon, B.C.; Vancouver School of Art; West England College of Architecture, London	BCSA, LGP	painter
Hanes, Ursula Ann	1932–	Cambridge School of Art, England; studied under William Zorach and John Hovannes, Art Students League, New York	ARCA, NESA, OSA, SSC	sculptor
Mackey, Eleanor Dorothy (née Johnston)	1932–	studied under Dennis Osborne, John Martin, Tony Urquhart, and Gerald Trottier		painter

NAME	DATES	BACKGROUND AND TRAINING	MEMBERSHIPS	TYPE OF ARTIST
Maki, Sheila Anne	1932–	North Bay Teachers College; University of British Columbia	OSA, PDCC, SCA, SCPE	printmaker, painter
Markham, Peggy	1932–	self-taught	ECOAS, MAA, NSSA	painter
Renals, Dorothy Ann	1932–	married Norman Renals	OSA	painter
Sisler, Rebecca	1932–	studied under Jacobine Jones, OCA; Royal Danish Academy of Fine Arts, Copenhagen	OSA, SSC	sculptor
Coulter, Marilyn	1933–	Central Technical School and Northern Secondary School, Toronto; Instituto de Allende, San Miguel de Allende, Mexico	HVAC	painter
Cutting, Lorna (née Russell)	1933–	studied fine arts, University of Saskatchewan; Banff School of Fine Arts; founding member, Shoestring Art Gallery		painter
Drouin, Michèle	1933–	studied under Jean Paul Lemieux and Benoît East, École des beaux-arts, Quebec City		painter
Gervais, Lise	1933–1998	studied under Stanley Cosgrove, Jacques de Tonnancour, Jean Simard, and Louis Archambault, École des beaux-arts, Montreal	CAPQ, CSEA	painter, sculptor
Hanson, Gertrude Jean	1933–	OCA	CSPWC, OSA	painter
Kantaroff, Maryon	1933–	University of Toronto; Berkshire College of Art; Sir John Cass College of Art and Chelsea College of Art, London		sculptor
Malach, Lorraine	1933–2003	studied in Regina; Pennsylvania Academy of Fine Arts, Barnes Foundation		painter
Maltais, Marcelle	1933–	studied under Jean Dallaire, Jean Paul Lemieux, and Jean Soucy, École des beaux-arts, Quebec City	AANFM	painter
Bain, Freda	1934–	Rhode Island School of Design; Sir George Williams University; Saidye Bronfman Centre, Montreal	AGQ, CGQ	painter, etcher, printmaker
Boone, Sue	1934–	École des beaux-arts, Geneva; H.B. Beal Technical School, London (Ontario); Instituto de Allende, San Miguel de Allende, Mexico		painter
Cosgrove, Terry	1934–	studied under Jock Macdonald, OCA		painter
Kipling, Barbara Ann Epp	1934–	Vancouver School of Art; Instituto Allende, San Miguel de Allende, Mexico	ARCA, BCSA	printmaker, painter
Lubojanska, Janina	1934–	National College of Fine Arts, Poland	WAL	painter, sculptor
Phillipson, Gillian (Gill) Saward	1934–1983	H.B. Beal Technical School, London (Ontario); Instituto Allende, San Miguel de Allende, Mexico	OSA	painter
Rawlyk, Mary E.	1934–	Mount Allison University; Rochester Memorial Gallery, New York; Nova Scotia College of Art; Brighton Polytechnic, England	OSA	printmaker
Steen, Lois	1934–	studied under Jock Macdonald, Banff School of Fine Arts		painter

NAME	DATES	BACKGROUND AND TRAINING	MEMBERSHIPS	TYPE OF ARTIST
Syme, Ruth Ellen (née Charman)	1934–	Alberta College of Art, Calgary	ASA, OSA	painter
Wilson, Dorothy R.	1934–	Central Technical School, Toronto	OSA, SCA, SSC	sculptor, etcher
Woolnough, Hilda	1934–2007	Chelsea School of Art, London; Instituto Allende, San Miguel de Allende, Mexico; Central School of Art & Design, London; Nova Scotia College of Art and Design, Halifax		printmaker
Filion, Pierrette	1935–			painter
Foss, Patricia Ann	1935–	Dundas Valley School of Art, Ontario	SSC	sculptor
Fulford, Patricia Parsons (Mrs. Raymond Spiers)	1935–	studied under Thomas Bowie and Jacobine Jones, OCA; under Eric Schilsky, Edinburgh College of Art; married the sculptor Raymond Spiers	ARCA	sculptor
Levine, Marilyn Ann	1935–2005	University of Alberta; member of Canadian Group of Painters	CCA, CGP, WPO	ceramic artist
Pratt, Mary Frances (née West)	1935–	studied under Alex Colville and Lawren P. Harris, Mount Allison University; married the painter Christopher Pratt	ARCA	painter
Rattray, Dawn Amelia McCracken	1935–			painter
Sanders, Benita	1935–	Chelsea School of Art, London; National Academy of Art, Florence; Atelier 17, Paris		painter
Steel, Stephanie Quainton	1935–	studied under Stephen Lowe and Brian Travers-Smith, Victoria	CSPWC, FCA	painter
Thomas, Lotti	1935–	OCA; University of Toronto		printmaker
Cohen, Sorel	1936–	Concordia University		photographer
Corne, Sharron Zenith	1936–	studied Fine Arts, University of Manitoba	WAG	painter
Dickson, Jennifer	1936–	Goldsmiths College, University of London; studied under Stanley Hayter, Paris	ARCA, CSGA, PDCC, RA, RSPE, SCPE	painter, printmaker
Pflug, Christiane Sybille (née Shütt)	1936–1972	self-taught		painter
Versailles-Choquet, Marie	1936–	studied under John Stuart and Claude Théberge, Concordia University; École des beaux-arts, Montreal	APPL	painter
Calvé, Louise Clermont	1937–	studied under Stanley Cosgrove, Jacques de Tonnancour, Albert Dumouchel, and Jean-Paul Mousseau, École des beaux-arts, Montreal		painter
Caruso, Barbara	1937–	Doon School of Fine Art, Ontario; OCA; Instituto Allende, San Miguel de Allende, Mexico		painter, printmaker
Cornet, Lucienne	1937–	École des beaux-arts, Toulon		painter, printmaker
Dyck, Aganetha	1937–	self-taught; teaches in the Manitoba Arts Council's artists in the schools program	RCA	sculptor, installation artist

NAME	DATES	BACKGROUND AND TRAINING	MEMBERSHIPS	TYPE OF ARTIST
Froment, Yvette	1937–	Université de Montréal	CPQ, RAAV	painter
Haller, Norma	1937–	studied under Arthur Lismer and Anne Savage, MMFA; Saidye Bronfman Centre, Montreal	CAR, SAPQ	painter, sculptor
Matsubara, Naoko	1937–	Kyoto Academy of Fine Arts; Royal College of Art, London		painter, printmaker
Ohe, Dorothy Katie von der	1937–	Alberta College of Art, Calgary; studied under Arthur Lismer, MMFA	ARCA, ASA	sculptor, printmaker
Raphael, Shirley	1937–	Concordia University; Boston University; University of Calgary		painter
Suzuki, Aiko	1937–2005	studied under Mashel Teitelbaum and Richard Gorman, Toronto		painter, fibre artist
Tanobe, Miyuki	1937–	studied under Itaru Tanabe; studied Nihonga under grand master Maeda Seison; École supérieure des beaux-arts, Paris		painter, etcher
Butler, Sheila	1938–	Carnegie Mellon University, Pittsburgh	WAG	painter
Desjardins-Faucher, Huguette	1938–	studied under Albert Dumouchel, École des beaux-arts, Montreal		printmaker
Foreman, Nicole	1938–	Université du Québec	CSPWC	painter
Foster, Velma Alvada	1938–	studied under Illingworth Kerr, Ron Spickett, and Stan Perrott, Alberta College of Art, Calgary	ASA	etcher
Frenkel, Vera	1938–	studied under Arthur Lismer, John Lyman, and Albert Dumouchel	SCPE	sculptor, printmaker, installation artist
Godwin, Phyllis	1938–	Provincial Institute of Technology and Art, Calgary		painter
Handera, June	1938–	studied under Jock Macdonald, OCA		painter
Kitsco, Margaret Rose	1938–	studied under H.G. Glyde, University of Alberta; Slade School of Art, London		painter
Allain, Marie-Hélène	1939–	Collège Notre-Dame d'Acadie, Moncton		sculptor
Grauer, Gay Sherrard (Sherry)	1939–	École du Louvre and Atelier Ziegler, Paris; California School of Fine Arts, San Francisco	ARCA	painter, sculptor
Jacobs, Katja	1939–	Akademie der bildenden Künste, Freiberg; École des beaux-arts, Brussels		painter
Mackay, Francine	1939–	studied under Arthur Lismer, École des beaux-arts, Montreal; under Eric Goldberg; under Helmut Gerth		painter
Wildman, Sally	1939–	OCA; Goldsmiths College, University of London	OSA	painter
Zegray, Lucienne Boucher	1939–	Concordia University; Saidye Bronfman Centre, Montreal	PSA, PSC	painter

LIST OF ILLUSTRATIONS

69 Emily Carr, *Pine Near the Hillside* (c. 1940), oil on canvas, 22¾ × 29¾ inches (57.8 × 75.6 cm), Private Collection, Ontario, Photo: Michael Cullen

71 Helen McNicoll, *The Chintz Sofa* (1912), oil on canvas, 32 × 39 inches (81.3 × 99 cm), Private Collection, Ontario, Photo: Thomas Moore

73 Helen McNicoll, *On the Beach* (1912), oil on canvas, 25 × 30 inches (63.5 × 76.2 cm), Private Collection, Ontario, Photo: Thomas Moore

75 Helen McNicoll, *In the Market, Montreuil* (c. 1912), oil on canvas, 16 × 18 inches (40.6 × 45.7 cm), Private Collection, Alberta, Photo: John Dean

77 Helen McNicoll, *Sunny September* (1913), oil on canvas, 36 × 40 inches (91.4 × 101.6 cm), Private Collection, Colorado, Photo: Jeffrey Wells

79 Helen McNicoll, *In the Tent* (1914), oil on canvas, 32 × 25 inches (81.3 × 63.5 cm), Private Collection, Ontario, Photo: Thomas Moore

81 Henrietta Shore, *Little Girls* (c. 1915), oil on canvas, 38½ × 28½ inches (97.8 × 72.4 cm), Private Collection, California

83 Henrietta Shore, *Nannies* (c. 1918), oil on canvas, 19½ × 23½ inches (49.5 × 59.7 cm), Private Collection, Ontario, Photo: Thomas Moore

85 Henrietta Shore, *Irises,* or *Gloxinia by the Sea* (c. 1930–1935), oil on canvas, 26 × 26 inches (66 × 66 cm), Private Collection, California, Photo: "Q" Siebenthal

87 Mabel May, *The Regatta* (c. 1913–1914), oil on canvas, 18 × 22 inches (45.7 × 55.9 cm), National Gallery of Canada, Ottawa

89 Mabel May, *Violet and Rose* (c. 1918), oil on canvas, 28 × 24 inches (71.1 × 61 cm), Private Collection, Ontario, Photo: Thomas Moore

91 Emily Coonan, *Visiting a Sick Child* (c. 1911), oil on board, 12¼ × 8¼ inches (31.1 × 21 cm), Private Collection, Ontario, Photo: Thomas Moore

93 Emily Coonan, *En Promenade* (c. 1915), oil on board, 12 × 10½ inches (30.5 × 26.7 cm), Private Collection, Ontario, Photo: Thomas Moore

95 Emily Coonan, *Still Life* (c. 1940), oil on canvas, 24 × 21 inches (61 × 53.3 cm), Private Collection, Quebec, Photo: Thomas Moore

97 Prudence Heward, *Tonina* (1928), oil on canvas, 27 × 27 inches (68.6 × 68.6 cm), Private Collection, Ontario, Photo: Thomas Moore

99 Prudence Heward, *Italian Woman* (c. 1930), oil on canvas, 24 × 20 inches (61 × 50.8 cm), Private Collection, Alberta, Photo: John Dean

101 Prudence Heward, *Girl Under a Tree* (1931), oil on canvas, 48¼ × 76¼ inches (122.5 × 193.7 cm), Art Gallery of Hamilton, Gift of the Artist's Family, 1961, Photo: Cheryl O'Brien

103 Prudence Heward, *Portrait of the Artist's Nephew* (1936), oil on canvas, 18¼ × 18¼ inches (46.4 × 46.4 cm), Private Collection, New York, Photo: Hendrik Lossmann

105 Simone Hudon-Beaulac, *Québec vu du port* (c. 1930), etching on paper, 14 × 11 inches (35.5 × 27.9 cm), Private Collection, Ontario, Photo: Thomas Moore

107 Christiane Pflug, *At Night* (1962), graphite on paper, 12½ × 9½ inches (31.8 × 24.1 cm), Private Collection, Ontario, Photo: Thomas Moore

109 Christiane Pflug, *Roses and Dead Bird* (1963), oil on canvas, 15¾ × 18½ inches (40 × 47 cm), Private Collection, Ontario, Photo: Thomas Moore

111 Christiane Pflug, *Untitled (Kitchen Door with Ursula)* (1966), oil on canvas, 65 × 76 inches (164.8 × 193.2 cm), Collection of The Winnipeg Art Gallery, acquired with the assistance of the Women's Committee and The Winnipeg Foundation, accession # G-66-89, Photo: Ernest Mayer, The Winnipeg Art Gallery

113 Christiane Pflug, *Cottingham School After the Rain* (1969), oil on canvas, 49¾ × 39 inches (126 × 99 cm), Pflug Family Collection, Photo: Thomas Moore

MASTERS OF THEIR CRAFT

114 Ethel Seath, *Nuns, St. Sulpician Garden,* cropped. See page 135.

117 Frances Jones, *In the Conservatory* (1883), oil on canvas, 18¼ × 31¾ inches (46.5 × 80.6 cm), Nova Scotia Archives and Records Management, Halifax (147.329), Gift of Colonel A.N. Jones, Halifax, 1979, Photo: Steve Farmer

119 Margaret Campbell Macpherson, *Lake Como* (c. 1905), oil on canvas, 32 × 26 inches (81.3 × 66 cm), Private Collection, Newfoundland, Photo: Fraser Ross

121 Mary Bell Eastlake, *Market Scene, Bruges* (c. 1891), oil on panel, 5¾ × 8¾ inches (14.6 × 22.2 cm), Private Collection, Ontario, Photo: Thomas Moore

123 Mary Bell Eastlake, *Girl with Butterfly* (c. 1910), oil on board, 13¼ × 9½ inches (33.7 × 24.1 cm), Private Collection, Ontario, Photo: Thomas Moore

125 Mary Bell Eastlake, *Mobilization Day 1914: French Fisherwomen Watching the Departure of the Fleet* (c. 1917), oil on canvas, 34 × 43 inches (86.3 × 109.5 cm), National Gallery of Canada, Ottawa

127 Florence McGillivray, *Canal, Venice* (1917), oil on panel, 13 × 16 inches (33 × 40.6 cm), Private Collection, Ontario, Photo: Thomas Moore

129 Sophie Pemberton, *Un livre ouvert* (1901), oil on canvas, 65½ × 42½ inches (166.5 × 108 cm), Art Gallery of Greater Victoria, 1959.012.001 Gift of the Artist, Photo: Bob Matheson

131 Sophie Pemberton, *Woman by the Fire* (c. 1902), oil on canvas, 38 × 20 inches (96.5 × 50.8 cm), Private Collection, British Columbia, Photo: Ted Clarke

133 Mary Riter Hamilton, *Market Scene, Giverny* (1907), oil on canvas, 15 × 18 inches (38.1 × 45.7 cm), Private Collection, Paris, Photo: L'Image

135 Ethel Seath, *Nuns, St. Sulpician Garden* (1930), oil on panel, 16 × 12 inches (40.6 × 30.5 cm), Private Collection, Ontario, Photo: Thomas Moore

137 Ethel Seath, *Still-Life with Apples,* or *Flower Study* (1934), oil on canvas, 22 × 20 inches (55.9 × 50.8 cm), Private Collection, Alberta, Photo: John Dean

139 Ethel Seath, *Quebec Village* (1948), oil on panel, 16 × 12 inches (40.6 × 30.5 cm), Private Collection, Alberta, Photo: John Dean

141 Florence Wyle, *Study of a Girl* (c. 1931), painted plaster, 22 [h] × 7 [w] × 7 [d] inches (55.9 [h] × 17.8 [w] × 17.8 [d] cm), Private Collection, Ontario, © 2008 Art Gallery of Ontario, Photo: Thomas Moore

143 Marion Long, *Bay Street, Looking South* (c. 1930), oil on canvas, 10 × 12 inches (25.4 × 30.5 cm), Private Collection, Ontario, Photo: Thomas Moore

145 Mabel Lockerby, *On the Canal* (1926), oil on panel, 9 × 12 inches (22.9 × 30.5 cm), Private Collection, Ontario, Photo: Thomas Moore

147 Mabel Lockerby, *The Haunted Pool* (c. 1947), oil on board, 12 × 15 inches (30.5 × 38.1 cm), Private Collection, Alberta, Photo: John Dean

149 Sarah Robertson, *The Red Sleigh* (c. 1924), oil on board, 15 × 18 inches (38.1 × 45.7 cm), Private Collection, Ontario, Photo: Thomas Moore

151 Sarah Robertson, *Mother House, Nuns of the Congregation* (c. 1932), oil on panel, 10 × 12 inches (25.4 × 30.5 cm), Private Collection, Ontario, Photo: Thomas Moore

153 Rody Kenny Courtice, *The Game* (c. 1949), oil on canvas, 18½ × 20 inches (47 × 50.8 cm), The Robert McLaughlin Gallery, Oshawa, Gift of Isabel McLaughlin, 1989, Photo: Thomas Moore

155 Kathleen Moir Morris, *Sunday Service, Berthierville* (1924), oil on canvas, 14 × 18 inches (35.5 × 45.7 cm), Private Collection, Colorado, Photo: Jeffrey Wells

157 Kathleen Moir Morris, *McGill Cab Stand* (c. 1927), oil on canvas, 18 × 24 inches (45.7 × 61 cm), Private Collection, Alberta, Photo: John Dean

159 Anne Savage, *Paradise Lost* (1927), oil on panel, 9 × 12 inches (22.9 × 30.5 cm), Private Collection, Ontario, Photo: Thomas Moore

161 Anne Savage, *Owl Totem, Kispiax* (1927), oil on canvas, 23¼ × 28¼ inches (59.1 × 71.8 cm), Private Collection, British Columbia, Photo: Ted Clarke

163 Anne Savage, *Quebec Farm* (1935), oil on canvas, 25 × 30 inches (63.5 × 76.2 cm), Private Collection, Quebec, Photo: Anne-Marie Hamel

165 Lilias Torrance Newton, *Self-Portrait* (c. 1929), oil on canvas, 24¼ × 30 inches (61.5 × 76.6 cm), National Gallery of Canada, Ottawa, Photo: C. Hupe

167 Lilias Torrance Newton, *Nude in the Studio* (undated), oil on canvas, 80 × 36 inches (203.2 × 91.5 cm), Art Gallery of Ontario, Toronto, The Thomson Collection, Photo: Thomas Moore

169 Regina Seiden, *Children with Nuns* (c. 1920), oil on canvas, 21¼ × 29½ inches (54 × 75 cm), Private Collection, Alberta, Photo: John Dean

171 Paraskeva Clark, *Myself* (1933), oil on canvas, 40 × 30 inches (101.6 × 76.2 cm), National Gallery of Canada, Ottawa

173 Kathleen Daly, *Indian Playmates* (c. 1938), oil on canvas, 30 × 25 inches (76.2 × 63.5 cm), Private Collection, Alberta, Photo: John Dean

175 Yvonne McKague Housser, *Sisters* (c. 1934), oil on canvas, 30 × 24 inches (76.2 × 61 cm), Private Collection, Alberta, Photo: John Dean

177 Yvonne McKague Housser, *Spring Pattern* (1955), oil on masonite, 30 × 40 inches (76.2 × 101.6 cm), The Robert McLaughlin Gallery, Oshawa, Gift of Isabel McLaughlin, 1995, Photo: Thomas Moore

179 Elizabeth Wyn Wood, *Northern Island* (1927), bronze mounted on black Belgian marble base, 8 [h] × 15 [w] × 8¼ [d] inches (20.5 [h] × 37.7 [w] × 20.8 [d] cm) without base, Private Collection, New Brunswick, Photo: David Corkum

The general resources listed below are divided into primary sources, such as artists' files in archives and interviews with the artists, and secondary sources: books, exhibition catalogues, conference proceedings, doctoral dissertations, master's theses, journal articles, newspaper and magazine articles, films, and websites. These general resources are followed by listings for each of the thirty-six artists featured in the book.

PRIMARY SOURCES

Artists' files. Robert McLaughlin Gallery Archives, Oshawa, ON.

———. Edward P. Taylor Research Collection and Archives. Art Gallery of Ontario, Toronto.

———. Library and Archives. National Gallery of Canada, Ottawa.

———. Archives, Montreal Museum of Fine Arts.

Blakely, Phyllis R. "Three Nova Scotia Women Artists: Maria Morris Miller, Frances Jones Bannerman, and Annie Louisa Pratt." Art Gallery of Nova Scotia Archives, Halifax, n.d.

Carlyle, Florence. Correspondence, 1914–1923. Woodstock Art Gallery, ON.

———. Letter. Isabel Mackay fonds (MS-2367). British Columbia Archives, Victoria.

———. Letters. Museum London, ON. Gift of Alice Graves, 1981.

———. Letters. Woodstock Art Gallery, ON. Bequest of Florence Johnston.

Deeks, F. Historical Sketch of the Women's Art Association of Canada: 25th Anniversary. Published in Women's Art Association of Canada Annual Report 1911–1912. Archives of the Women's Art Association of Canada, Toronto.

École des beaux-arts fonds. Bibliothèque des arts, Université du Québec à Montréal.

Edward Weston Archive. Center for Creative Photography, University of Arizona.

Exhibition catalogue files. Canadian National Exhibition Archives, Toronto.

Exhibition catalogue files. Regional History Room, D.B. Weldon Library, University of Western Ontario, London, ON.

Hill, Charles. Interview with Paraskeva Clark, October 18, 1973. Library and Archives, National Gallery of Canada, Ottawa.

———. Interview with Paraskeva Clark, January 30, 1974. Library and Archives, National Gallery of Canada, Ottawa.

———. Interview with Paraskeva Clark (transcription), March 1980. National Film Board of Canada.

———. Interview with Lilias Torrance Newton, September 11, 1973. Library and Archives, National Gallery of Canada, Ottawa.

———. Interview with Jori Smith, June 16, 1974. Library and Archives, National Gallery of Canada, Ottawa.

Hopkins-McCord letters. McCord Family Papers 5031. McCord Museum of Canadian History, Montreal.

Hudson's Bay Company Archives. Montreal correspondence 1863–1865, 1866, 1869–1870. Manitoba Archives, Winnipeg.

Johnston, Florence. "Florence Carlyle 1864–1923." 1971. Vertical files, Reference Room, Woodstock Public Library, ON.

Jones, Hugh G., and E. Dyonnet. "History of the Royal Canadian Academy of Arts." 1934. Edward P. Taylor Research Library and Archives, Art Gallery of Ontario, Toronto.

Mills Archives, Special Collections, McMaster University, Hamilton, ON.

Murray, Joan. Interview with Paraskeva Clark (transcription), May 29, 1979. Robert McLaughlin Gallery Archives.

Nute, G.L., Papers. [Frances Anne Hopkins] University of Minnesota Library, Duluth Campus.

Singer, Gail. Interview with Paraskeva Clark (transcription), March 1980. National Film Board of Canada.

Vertical files for Carlyle, F., Wilde, O. Woodstock Public Library, ON.

Women's Art Association, Album 1895–1897. London Room Collection. London Public Library (Main Branch), ON.

Women's Art Association of Canada Archives, Toronto.

SECONDARY SOURCES

Adamson, Jeremy. The Hart House Collection of Canadian Paintings. Toronto: University of Toronto Press: 1969.

Adley, Allyson Sarah. "Re-Presenting Diasporic Difference: Images of Immigrant Women by Canadian Women Artists, 1913–1932." Master's thesis, Concordia University, 1999.

Allaire, Sylvain. "Les Canadiens au salon officiel de Paris entre 1870 et 1910, sections peinture et dessin." Journal of Canadian Art History 4, no. 2 (1977/1978): pp. 141–154.

Antaki, Karen. Montreal Women Artists of the 1950s. Montreal: Concordia Art Gallery, 1988.

Aylen, Marielle Barbara Desiree. "Interfaces of the Portrait: Liminality and Dialogism in Canadian Women's Portraiture Between the Wars." Master's thesis, Carleton University, 1996.

Barbeau, Marius. Kingdom of the Saguenay. Toronto: Macmillan Canada, 1936.

Barlow, Margaret. Women Artists. Westport, CT: Hugh Lauter Levin Associates, 1999.

Bayer, Fern. The Ontario Collection. Toronto: Fitzhenry and Whiteside, 1984.

Beavis, Lori. "An Educational Journey: Women's Art Training in Canada and Abroad 1880–1929." Master's thesis, Concordia University, 2006.

Beckett, Jane, and Deborah Cherry, eds. *The Edwardian Era*. London: Barbican Art Gallery and Phaidon, 1987.

Bertrand, Magdeleine. "Les femmes artistes du Québec de 1875 à 1925." Master's thesis, Université de Montréal, 1990.

Boime, Albert. *The Academy & French Painting in the Nineteenth Century*. London: Phaidon, 1971.

Boyanoski, Christine. *Sympathetic Realism: George A. Reid and the Academic Tradition*. Toronto: Art Gallery of Ontario, 1986.

Bradfield, Helen. *Art Gallery of Ontario: The Canadian Collection*. Toronto: McGraw-Hill Canada, 1970.

Braide, Janet. *William Brymner*. Kingston: Agnes Etherington Art Centre, 1979.

Brown, F. Maud. *Breaking Barriers: Eric Brown and the National Gallery*. Toronto: Society for Art Publications, 1964.

Buchanan, D.W. *The Growth of Canadian Painting*. Toronto: Collins, 1950.

——. "The Gentle and the Austere – A Comparison in Landscape Painting." *University of Toronto Quarterly* 2 (October 1941): pp. 72–77.

Burns, Sarah. *Inventing the Modern Artist*. New Haven: Yale University Press, 1996.

Cameron, Janice, et al. *Eclectic Eve*. Toronto: Canadian Women's Educational Press, 1972.

Canadian Women Artists History Initiative, Concordia University. http://cwahi.concordia.ca

Chadwick, Whitney. *Women, Art, and Society*. London: Thames and Hudson, 1990.

Charlesworth, Hector. "Ontario Society of Artists Annual Exhibition." *Saturday Night*, March 23, 1914.

Cherry, Deborah. *Painting Women: Victorian Women Artists*. London: Routledge, 1993.

Cherry, Deborah, and Janice Helland, eds. *Local/Global: Women Artists in the Nineteenth Century*. Burlington, VT: Ashgate, 2006.

Colgate, William. *Canadian Art: Its Origin and Development*. 2nd ed. Toronto: Ryerson Press, 1967.

Creative Canada: A Biographical Dictionary of Twentieth-Century Creative and Performing Artists. Victoria: University of Toronto Press and McPherson Library, University of Victoria, 1971.

The Development of Painting in Canada 1665–1945. Toronto: Art Gallery of Toronto, National Gallery of Canada, Musée de la province de Québec, Art Association of Montreal, 1945.

Dignam, Mary Ella. "Canadian Women in the Development of Art." *Women of Canada, Their Life and Work*, pp. 209–215. Produced by the National Council of Women of Canada for distribution at the Paris International Exhibition 1900; rpt. N.p.: NCWC, 1975.

Duval, Paul. *Canadian Impressionism*. Toronto: McClelland & Stewart, 1990.

——. *Four Decades: The Canadian Group of Painters and Their Contemporaries, 1930–70*. Toronto: Clarke, Irwin, 1972.

——. *Canadian Drawings and Prints*. Toronto: Burns & MacEachern, 1952.

——. *Canadian Watercolour Painting*. Toronto: Burns & MacEachern, 1954.

Dyonnet, Edmond. *Memoirs of a Canadian Artist*. Montreal, 1951.

Farr, Dorothy, and Natalie Luckyj. *From Women's Eyes: Women Painters in Canada*. Kingston, ON: Agnes Etherington Art Centre, 1975.

Ferrari, Pepita, and Erna Buffie. *By Woman's Hand*. National Film Board of Canada, 1994. Film.

Ferrari, Pepita. *The Petticoat Expeditions* [Part 2]. National Film Board of Canada, 1997. Film.

Fleming, Roy Franklin. "Royal Academy of Canadian Art." *The Year Book of Canadian Art 1913*. London and Toronto: J.M. Dent & Sons, 1913.

Ford, Harriet. "The Royal Canadian Academy of Arts." *Canadian Magazine* 3 (May 1894): pp. 45–50.

Gallati, Barbara Dayer. *Children of the Gilded Era*. New York: Merrell, 2004.

Gerdts, William. *American Impressionism*. Seattle: The Henry Art Gallery, University of Washington, 1980.

——. *American Impressionism*. New York: Abbeville, 1984.

——. "Impressionism in the United States." In *World Impressionism: The International Movement, 1860–1920*, edited by Norma Broude. New York: Abrams, 1990.

Greer, Germaine. "The Repression of Women Artists." *Atlantic Monthly*, September 1979, pp. 66–77.

Gualtieri, Julia. "The Woman as Artist and as Subject in Canadian Painting (1890–1930): Florence Carlyle, Laura Muntz Lyall, Helen McNicoll." Master's thesis, Queen's University, 1989.

Hammond, Harmony. *Lesbian Art in America*. New York: Rizzoli, 2000.

Harper, J. Russell. *Canadian Paintings in Hart House*. Toronto: Art Committee of Hart House, University of Toronto, 1955.

——. *Early Painters and Engravers in Canada*. Toronto: University of Toronto Press, 1970.

——. *Painting in Canada: A History*. 2nd ed. Toronto: University of Toronto Press, 1977.

Helland, Janice. Review of *By a Lady: Celebrating Three Centuries of Art by Canadian Women* by Maria Tippett. *Journal of Canadian Art History* 15, no. 1 (1994): pp. 125–133.

Heller, Jules, and Nancy G. Heller, eds. *North American Women Artists of the Twentieth Century: A Biographical Dictionary*. New York & London: Garland, 1995.

Heller, Nancy G. *Women Artists: An Illustrated History*. London: Virago, 1987.

Hill, Charles C. *Canadian Painting in the Thirties*. Ottawa: National Gallery of Canada, 1975.

Hubbard, R.H. *National Gallery of Canada, Catalogue of Paintings and Sculpture, Vol. III: Canadian School*. Toronto: University of Toronto Press, 1960.

——. *The Development of Canadian Art*. Ottawa: Queen's Printer, 1963.

Hudson, Anna Victoria. "Art and Social Progress: The Toronto Community of Painters, 1933–1950." Ph.D. diss., University of Toronto, 1997.

Johnson, J., and A. Gruetzner. *Dictionary of British Artists 1880–1940*. Suffolk: Baron Publishing, 1976.

Jordan, Katharine A. *Fifty Years: The Canadian Society of Painters in Water Colour 1925–1975*. Toronto: Art Gallery of Ontario, 1976.

The Julian Academy, Paris 1868–1939. New York: Shepherd Gallery, 1989.

Kyle, Fergus. "The Ontario Society of Artists." *The Year Book of Canadian Art 1913*. London and Toronto: J.M. Dent & Sons, 1913.

Landry, Pierre. "L'Apport de l'art nouveau aux arts graphiques du Québec, de 1898 à 1910." Master's thesis, Université Laval, 1983.

Library and Archives Canada/Bibliothèque et Archives Canada. "Celebrating Women's Achievements: Women Artists in Canada." 2002. http://collectionscanada.ca/women/002026-500-e.html

Lippard, Lucy R. *From the Center: Feminist Essays on Women's Art*. New York: Dutton, 1976.

———. *The Pink Glass Swan: Selected Essays on Feminist Art*. New York: New Press, 1995.

Lord, Barry. *The History of Painting in Canada: Towards a People's Art*. Toronto: NC Press, 1974.

Lorimer, James. *The Ex: A Picture History of the Canadian National Exhibition*. Toronto: James Lewis and Samuel, 1973.

Luckyj, Natalie. *Visions and Victories: 10 Canadian Women Artists, 1914–1945*. London, ON: London Regional Art Gallery, 1983.

MacCuaig, Stuart. *Women's Art Association of Hamilton: The First 100 Years*. Hamilton, ON: Art Gallery of Hamilton, 1996.

MacDonald, Colin S. *A Dictionary of Canadian Artists*. Ottawa: Canadian Paperbacks, 1971.

MacTavish, Newton. *The Fine Arts in Canada*. Toronto: Macmillan Canada, 1925.

———. *Ars Longa*. Toronto: Ontario Publishing Company, 1938.

Mainprize, Garry. "The National Gallery of Canada: A Hundred Years of Exhibitions." *RACAR* 11, pp. 1–2, 3–78.

Martin, Elizabeth, and Vivian Meyer. *Female Gazes: Seventy-Five Women Artists*. Toronto: Second Story Press, 1997.

Mastin, Catharine. *Canadian Artists in Paris and the French Influence*. Calgary: Glenbow Museum, 1999.

McInnes, Graham Campbell. *Canadian Art*. Toronto: Macmillan Canada, 1950.

McKendry, Blake. *The New A to Z of Canadian Art*. Kingston, ON: B. McKendry, 2001.

McLeish, John A.B. *September Gale: A Life of Arthur Lismer*. 2nd ed. Toronto: J.M. Dent & Sons, 1973.

McMann, Evelyn de R. *Montreal Museum of Fine Arts, Formerly Art Association of Montreal, Spring Exhibitions, 1880–1970*. Toronto: University of Toronto Press, 1988.

———. *Royal Canadian Academy of Arts/Académie Royale des Arts du Canada: Exhibitions and Members, 1880–1979*. Toronto: University of Toronto Press, 1981.

McTavish, David. *Canadian Artists in Venice 1830–1930*. Kingston: Agnes Etherington Art Centre, 1984.

Milner, John. *The Studios of Paris: The Capital of Art in the Late Nineteenth Century*. New Haven: Yale University Press, 1988.

Morgan, Henry J. *The Canadian Men and Women of the Time: A Handbook of Canadian Biography*. 1st ed. Toronto: William Briggs, 1898.

———. *The Canadian Men and Women of the Time: A Handbook of Canadian Biography of Living Characters*. 2nd ed. Toronto: William Briggs, 1912.

Morris, Jerrold. *The Nude in Canadian Painting*. Toronto: New Press, 1972.

———. *100 Years of Canadian Drawings*. Toronto: Methuen, 1980.

Murray, Joan. *The Birth of the Modern: Post-Impressionism in Canadian Art, c. 1900–1920*. Oshawa, ON: Robert McLaughlin Gallery, 2001.

———. *Canadian Art in the Twentieth Century*. Toronto: Dundurn, 1999.

———. *Confessions of a Curator: Adventures in Canadian Art*. Toronto and Oxford: Dundurn, 1996.

———. *Home Truths: A Celebration of Family Life by Canada's Best-Loved Painters*. Toronto: Key Porter, 1997.

———. *Impressionism in Canada 1895–1935*. Toronto: Art Gallery of Ontario, 1973.

———. *Ontario Society of Artists: 100 Years 1872–1972*. Toronto: Art Gallery of Ontario, 1972.

———. *Pilgrims in the Wilderness: The Struggle of the Canadian Group of Painters (1933–1969)*. Oshawa, ON: Robert McLaughlin Gallery, 1993.

Newlands, Anne. *Canadian Art: From Its Beginnings to 2000*. Toronto: Firefly, 2000.

———. *Canadian Paintings, Prints and Drawings*. Toronto: Firefly, 2007.

Nochlin, Linda. "Why Have There Been No Great Women Artists." *Art News* 69, no. 9 (1971): p. 39.

Nunn, Pamela Gerrish. *Victorian Women Artists*. London: Women's Press, 1987.

Ontario Society of Artists, Toronto. Catalogues of Annual Exhibitions, 1890–1972.

Ostiguy, Jean-René. *Modernism in Quebec Art, 1916–46*. Ottawa: National Gallery of Canada, 1982.

Page, Anne Mandely. "Canada's First Professional Women Painters, 1890–1914: Their Reception in Canadian Writing on the Visual Arts." Master's thesis, Concordia University, 1991.

Pantazzi, Sybille. "Foreign Art at the Canadian National Exhibition 1905–1938." *National Gallery of Canada Bulletin* 22 (1973): pp. 21–42.

Petteys, Chris, et al. *Dictionary of Women Artists: An International Dictionary of Women Artists Born Before 1900*. Boston: G.K. Hall, 1985.

Pilot, Robert W. "Recollections as an Art Student." *Sun Life Review,* April 1958, p. 5.

Pollock, Griselda. *Vision & Difference: Femininity, Feminism and the Histories of Art*. London and New York: Routledge, 1988.

Prakash, A.K. *Canadian Art: Selected Masters from Private Collections*. Ottawa: Vincent Fortier Publishing, 2003.

Reid, Dennis. *A Concise History of Canadian Painting*. 2nd ed. Toronto: Oxford University Press, 1988.

———. "Impressionism in Canada." In *World Impressionism: The International Movement 1860–1920*, edited by Norma Broude. New York: Abrams, 1990.

———. "Tom Thomson and the Arts and Crafts Movement in Toronto." *Tom Thomson*. Toronto: Art Gallery of Ontario, 2002.

———. *Toronto Painting: 1953–1965.* Ottawa: National Gallery of Canada, 1972.

Robertson, Heather. *A Terrible Beauty: The Art of Canada at War.* Toronto: James Lorimer & Company; Robert McLaughlin Gallery, Oshawa; National Museum of Man, and National Museums of Canada, Ottawa; 1977.

Royal Academy Exhibitors 1905–1970. Wakefield, Yorkshire: East Ardsley, EP Publishing, 1973.

Royal Canadian Academy of Arts. Catalogues of Annual Exhibitions, 1890–1930.

Sisler, Rebecca. *Passionate Spirits: A History of the Royal Canadian Academy of Arts, 1880–1980.* Toronto: Clarke, Irwin, 1980.

"Six Montreal Women Artists at Montreal Museum of Fine Arts." *Montreal Daily Star,* May 6, 1950.

Smart, Patricia. *Les femmes du Refus global.* Montréal: Boréal, 1998.

Smith, Frances K. *André Biéler: An Artist's Life and Times.* Toronto: Firefly, 2006.

Stacey, Robert. *The Hand Holding the Brush: Self-portraits by Canadian Artists.* London, ON: London Regional Art Gallery, 1983.

St. Jean, France. "La réception critique dans la presse montréalaise francophone des décennies 1930 et 1940 de l'oeuvre de cinq femmes artistes: Prudence Heward, Lilias Torrance Newton, Anne Savage, Marian Scott et Jori Smith." Master's thesis, Université du Québec à Montréal (UQAM), 1999.

Thompson, Allison. "A Worthy Place in the Art of Our Country: The Women's Art Association of Canada 1887–1987." Master's thesis, Carleton University, 1989.

Three Hundred Years of Canadian Art. Ottawa: National Gallery of Canada, 1967.

Tippett, Maria. *By a Lady: Celebrating Three Centuries of Art by Canadian Women.* Toronto: Viking, 1992.

Trépanier, Esther. *Montreal Women Painters on the Threshold of Modernity.* Montreal: Montreal Museum of Fine Arts, 1997.

Van Hook, Bailey. *Angels of Art: Women and Art in American Society, 1876–1914.* Pennsylvania State University Press, 1996.

Wein, Jo Ann. "The Parisian Training of American Women Artists." *Woman's Art Journal* 2 (Spring-Summer 1981): pp. 41–44.

Weinberg, H. Barbara. *The Lure of Paris: Nineteenth-Century American Painters and Their French Teachers.* New York: Abbeville, 1991.

Weinberg, H. Barbara, et al. *American Impressionism and Realism.* New York: Abrams, 1994.

Weisberg, Gabriel P., and Jane R. Becker, eds. *Overcoming All Obstacles: The Women of the Académie Julian.* New York: The Dahesh Museum; Piscataway, NJ: Rutgers University Press, 1999.

Whybrow, Marion. *St. Ives, 1893–1993: Portrait of an Art Colony.* London: Antique Collectors' Club, 1994.

Williamson, Moncrieff. *Through Canadian Eyes: Trends and Influences in Canadian Art: 1815–1965.* Calgary: Glenbow-Alberta Institute, 1976.

Wilmerding, John. *American Art.* Harmondsworth: Penguin, 1976.

Wistow, David. *Canadians in Paris 1867–1914.* Toronto: Art Gallery of Ontario, 1979.

Withrow, Oswald C.J. *The Romance of the Canadian National Exhibition.* Toronto: Reginald Saunders, 1936.

Year Book of Canadian Art 1913. Compiled by the Arts and Letters Club of Toronto. London and Toronto: J.M. Dent & Sons, 1913.

Yeldham, Charlotte. *Women Artists in Nineteenth-Century France and England.* 2 vols. New York and London: Garland Publishing, 1984.

Beaver Hall Group

Avon, Susan. "The Beaver Hall Group and Its Place in the Montreal Art Milieu and the Nationalist Network." Master's thesis, Concordia University, 1994.

The Beaver Hall Group/Le groupe de Beaver Hall. Ottawa: National Gallery of Canada, 1966.

Forster, Merna. *100 Canadian Heroines: Famous and Forgotten Faces.* Toronto: Dundurn, 2004.

Hill, Charles C. *The Group of Seven: Art for a Nation.* Ottawa: National Gallery of Canada, 1995.

Kalbfleisch, John. "Beaver Hall painters sought to define Canada." *Gazette* (Montreal), January 16, 2005.

Kennedy, Janice. "The Other Group of Seven." *CanWest News* (Don Mills), January 24, 2001.

———. "Women set tone of Canadian art." *Star-Phoenix* (Saskatoon), February 11, 2006.

Kozinska, Dorota. "In their own image: The Beaver Hall Group of 10 woman painters – dismissed by some critics of the day as 'paintresses' – shared a passion for art, independence and the bold lines of feminism." *Gazette* (Montreal), September 20, 1999.

McCullough, Norah. *The Beaver Hall Group.* Ottawa: National Gallery of Canada, 1966.

Meadowcroft, Barbara. *Painting Friends: The Beaver Hall Women Painters.* Montreal: Véhicule, 1999.

Millar, Joyce. "The Beaver Hall Group: Painting in Montreal, 1920–1940." *Woman's Art Journal* 13 (Spring/Summer 1992): pp. 3–9.

Walters, Evelyn. *The Women of Beaver Hall: Canadian Modernist Painters.* Toronto: Dundurn, 2005.

Women Painters of the Beaver Hall Group. Montreal: Concordia Art Gallery, 1982.

Florence Carlyle

Anonymous. "Miss Florence Carlyle." *The Gentlewoman,* August 10, 1895.

Apostol, Jane. *Painting with Light: A Centennial History of the Judson Studios.* Los Angeles: Historical Society of Southern California, 1997.

Baker, Victoria. *Paul Peel: A Retrospective 1860–1892.* London, ON: London Regional Art Gallery, 1986.

Bell, Margaret. "Women and Art in Canada." *Everywoman's World,* June 1914, pp. 7, 15–16.

Blunt, R. *The Carlyle's Chelsea Home.* London: George Bell & Sons, 1895.

Butlin, Susan. *Florence Carlyle.* Woodstock, ON: Woodstock Public Art Gallery, 1993.

——. "Making a Living: Florence Carlyle and the Negotiation of a Professional Artistic Identity." Master's thesis, Carleton University, 1995.

Carlyle, Florence. "A Week of Student Life in Paris." *Sentinel-Review* (Woodstock), February 10, 1936. Reproduced in W.G. Trestain, "Art Study in Paris Hard Work, Wrote Florence Carlyle," *London Free Press,* November 18, 1938.

——. In "Dreams of Genius" by Stambury R. Tarr. *Canadian Magazine* 9 (May 1897), pp. 14–21, illustrations.

——. "Mary's Child." *Time and Tide.* London, England, 4 (November 23, 1923): pp. 1177–1179.

Carlyle, Thomas. "Project of a National Exhibition of Scottish Portraits (1854)." *Critical and Miscellaneous Essays: Collected and Republished.* Volume 7. London: Chapman & Hall, 1872.

Carlyle's House. London, The National Trust, 1975 (updated 1992).

Carlyle's House Catalogue. London: The Carlyle's House Memorial Trust, 1995 (facsimile of 1885).

Charlesworth, Hector. "Pictures by Florence Carlyle: Memorial Exhibition of Works by a Famous Canadian Painter." *Saturday Night* 40 (June 6, 1925): p. 3.

"Collected Pictures of Florence Carlyle." *Mail and Empire,* May 28, 1925.

Deacon, Florence E. "Representative Women: Miss Florence Carlyle." *Globe* (Toronto), June 8, 1912.

Dignam, M.E. "The Loan Portrait Exhibition." *Globe* (Toronto), April 8, 1899.

Doyle, Lynn C. "The Academy Exhibition." *Globe* (Toronto), March 5, 1898.

Effigy (pseud.). "Art and Artists." *Saturday Night* 6 (March 18, 1893): p. 15.

Eisenman, Stephen, Thomas Crow, et al. *Nineteenth Century Art: A Critical History.* London: Thames and Hudson, 1994.

Eitner, Lorenz. "The Open Window and the Storm-Tossed Boat: An Essay in the Iconography of Romanticism." *Art Bulletin* 37 (December 1955): pp. 281–290.

Florence Carlyle: Oxford County Art Association Centennial Exhibition. Woodstock, ON: Centennial Art Gallery, 1967.

Four Hundred Years of Fashion. London: Victoria and Albert Museum and William Collins, 1984.

Fraser, Marie, and Lesley Johnstone, eds. *Instabili: La question du sujet.* Montréal: La Centrale (Galerie Powerhouse) and Artextes, 1990.

Gualtieri, Julia. "The Woman as Artist and as Subject in Canadian Painting (1890–1930): Florence Carlyle, Laura Muntz Lyall, Helen McNicoll." Master's thesis, Queen's University, 1989.

Hale, Katherine. "Canada Lost Great Colourist in Florence Carlyle." *Toronto Star Weekly,* June 16, 1923.

Henderson, J. "Permanent collection of gallery on display." *Sentinel-Review* (Woodstock), August 16, 1976.

Hilderley, Laurene. "Carlyle painting finds a new home." *Sentinel-Review* (Woodstock), March 2, 1992.

Hume, Blanche B. "Florence Carlyle A.R.C.A." *The New Outlook,* July 10, 1925.

Judson, David. "William Lees Judson Timeline." djudson@judsonstudios.com

Kerr, Estelle M. "The Artist." *Saturday Night* 26 (June 7, 1913): p. 29.

Kritzwiser, Kay. "At home with Florence Carlyle." *Globe and Mail,* December 29, 1982.

Lambourne, Lionel. *The Aesthetic Movement.* London: Phaidon, 1996.

——. *Victorian Painting.* London: Phaidon, 1999.

Lawson, Shelley. "Who was Florence Carlyle?" *London Free Press,* December 28, 1990.

MacBeth, Madge. "Canadian Women in the Arts." *Maclean's* 27 (October 1914): pp 23–25.

Mancoff, Debra N., ed. *John Everett Millais: Beyond the Pre-Raphaelite Brotherhood. Studies in British Art 7.* New Haven and London: Yale University Press, 2001.

Marrs, Edwin W., Jr., ed. *The Letters of Thomas Carlyle to His Brother Alexander.* Cambridge, MA: Belknap Press of Harvard University Press, 1968.

McKellar, Elisabeth Leiss. "Out of Order: Florence Carlyle and the Challenge of Identity, 1864–1923." Master's thesis, University of Western Ontario, 1995.

A Memorial Exhibition of the Paintings of the Late Florence Carlyle, A.R.C.A. Toronto: Jenkins Art Gallery, 1925.

Murray, Joan. *Florence Carlyle: Against All Odds.* London, ON: Museum London, 2004.

Nead, Lynda. *Myths of Sexuality: Representations of Women in Victorian Britain.* Oxford: Basil Blackwell, 1988.

Nochlin, Linda. *Women, Art, and Power and Other Essays.* New York: Harper & Row, 1988.

N., H.A. "Impressions of the Canadian Academy." *Montreal Daily Herald,* November 26, 1913.

O'Brien, Kevin. *Oscar Wilde in Canada: An Apostle for the Arts.* Toronto: Personal Library, 1982.

Page, Anne Mandely. "Canada's First Professional Women Painters, 1890–1914: Their Reception in Canadian Writing on the Visual Arts." Master's thesis, Concordia University, 1991.

Patterson, Norman. "The Exhibition Habit." *Canadian Magazine* 27, no. 4 (August 1906): pp. 291–298.

Poole, Nancy Geddes. *The Art of London, 1830–1980.* London, ON: Blackpool, 1984.

Raghubir, Pauline C. "Florence Carlyle 1864–1923: The Evolution of Life Experience into Art." Master's thesis, York University, 1998.

Rechnitzer, Olaf P. "Nations Acclaim London Artists." *London Advertiser,* January 17, 1925, Magazine Section, p. 1.

Smith-Rosenberg, Carroll. *Disorderly Conduct: Visions of Gender in Victorian America.* New York: Knopf, 1985.

Tickner, Lisa. *Modern Life and Modern Subjects: British Art in the Early Twentieth Century.* New Haven: Yale University Press, 2000.

"Towards a Lesbian Aesthetic: Florence Carlyle, 1850–1923." Naomi Savage interview with Elisabeth Leiss McKellar. *Gargoyle* (University of Toronto), October 17, 1996.

Treuherz, Julian. *Victorian Painting.* London: Thames & Hudson, 2001.

Van (pseud.). "Art and Artists." *Saturday Night* 3 (January 25, 1890): p. 6.

Wissman, Fronia E. *Bouguereau.* San Francisco: Pomegranate Artbooks, 1996.

Emily Carr

Blanchard, Paula. *Life of Emily Carr.* Seattle: University of Washington Press, 1987.

Carr, Emily. *Book of Small.* Toronto: Clarke, Irwin, 1942.

——. *Complete Writings of Emily Carr.* Introduction by Doris Shadbolt. Vancouver: Douglas & McIntyre, 1997.

——. *Fresh Seeing: Two Addresses by Emily Carr.* Toronto: Clarke Irwin, 1966.

——. *Growing Pains: The Autobiography of Emily Carr.* Toronto: Clarke, Irwin, 1946.

——. *House of All Sorts.* Toronto: Clarke, Irwin, 1944.

——. *Hundreds and Thousands: The Journals of Emily Carr.* Toronto: Clarke, Irwin, 1966.

——. *Klee Wyck.* Toronto: Clarke, Irwin, 1941.

Crean, Susan. *The Laughing One: A Journey to Emily Carr.* Toronto: HarperCollins Canada, 2001.

Crean, Susan, ed. *Opposite Contraries: The Unknown Journals of Emily Carr and Other Writings.* Vancouver: Douglas & McIntyre, 2003.

Dilworth, Ira. "Emily Carr – Canadian Painter and Poet in Prose." *Saturday Night* 57 (November 8, 1941).

——. "Emily Carr." *Canadian Art* 2, no. 3 (February–March 1945): p. 118.

Dilworth, Ira, and Lawren Harris. *Emily Carr: Her Paintings and Sketches.* Ottawa: National Gallery of Canada; Toronto: Oxford University Press, 1945.

Harris, Lawren. "Emily Carr and Her Work." *Canadian Forum* 21, no. 251 (December 1941): pp. 277–278.

Hembroff-Schleicher, Edythe. *Emily Carr, the Untold Story.* Seattle: Hancock House, 1978.

——. *Portrayal of Emily Carr.* Toronto: Clarke, Irwin, 1969.

Laurence, Robin. *Beloved Land: The World of Emily Carr.* Vancouver: Douglas & McIntyre, 1996.

Mallory, Catherine. *Victorian and Canadian Worlds of Emily Carr: Study of a Divided Imagination.* Halifax: Dalhousie University, 1979.

Mason-Dodd, Kerry. *Sunlight in the Shadows: The Landscape of Emily Carr.* Oxford: Oxford University Press, 1984.

Moray, Gerta. "Emily Carr and the Traffic in Native Images." In *Antimodernism and Artistic Experience,* edited by Lynda Jessup. Toronto: University of Toronto Press, 2001.

——. *Northwest Coast Native Culture and the Early Indian Paintings of Emily Carr, 1899–1913.* Toronto: University of Toronto Press, 1993.

——. "'T'Other Emily:' Emily Carr, the Modern Woman Artist and Dilemmas of Gender." *RACAR* 26, nos. 1–2 (1999): pp. 73–90.

——. *Unsettling Encounters: First Nations Imagery in the Art of Emily Carr.* Vancouver: University of British Columbia, 2006.

Morra, Linda, ed. *Corresponding Influence: Selected Letters of Emily Carr and Ira Dilworth.* Toronto: University of Toronto Press, 2006.

Newlands, Anne. *Emily Carr: An Introduction to Her Life and Art.* Toronto: Firefly, 1996.

Shadbolt, Doris. *Art of Emily Carr.* Toronto: Clarke, Irwin; Vancouver: Douglas & McIntyre, 1979.

——. *Emily Carr.* Vancouver: Douglas & McIntyre, 1990.

——. *Emily Carr: A Centennial Exhibition Celebrating the One Hundredth Anniversary of Her Birth.* Vancouver: J.J. Douglas, 1975.

——. "Emily Carr: Legend and Reality." *Arts Canada* 28 (June 1971): pp. 17–21.

——. *Seven Journeys: The Sketchbooks of Emily Carr.* Vancouver: Douglas & McIntyre, 2002.

Stacton, David D. "The Art of Emily Carr." *Queen's Quarterly* 57 (Winter 1950–1951): pp. 499–509.

Stewart, Jay, et al. *To the Totem Forests: Emily Carr and Contemporaries Interpret Coastal Villages.* Victoria: Art Gallery of Greater Victoria, 1999.

Thom, Ian M. *Emily Carr in France.* Vancouver: Vancouver Art Gallery, 1991.

Thom, Ian M., et al. *Emily Carr: New Perspectives on a Canadian Icon.* Vancouver: Douglas & McIntyre, 2006.

Tippett, Maria. *Emily Carr: A Biography.* Toronto: Stoddart, 1994. First published by Oxford University Press, Oxford, 1979.

——. "A Paste Solitaire in a Steel Claw Setting: Emily Carr and Her Public." *BC Studies* 20 (Winter 1973–1974): pp. 3–13.

Turpin, Marguerite. *The Life and Work of Emily Carr (1871–1945): A Selected Bibliography.* Vancouver: University of British Columbia, 1965.

Udall, Sharyn. *Carr, O'Keeffe, Kahlo: Places of Their Own.* New Haven: Yale University Press, 2000.

Walker, Doreen, ed. *Dear Nan: Letters of Emily Carr, Nan Cheney and Humphrey Toms.* Vancouver: University of British Columbia, 1990.

Walker, Stephanie Kirkwood. *This Woman in Particular: Contexts for the Biographical Image of Emily Carr.* Waterloo, ON: Wilfrid Laurier University Press, 1996.

Paraskeva Clark

Abell, Walter. "Some Canadian Moderns." *Magazine of Art* 30, no. 7 (July 1937): pp. 422–427.

——. "Art and Democracy." In *The Kingston Conference: Conference of Canadian Artists,* edited by André Biéler and Elizabeth Harrison. Kingston, 1941.

——. "Canadian Aspirations in Painting." *Culture* 3 (1942): pp. 172–182.

Adaskin, Harry. *A Fiddler's World.* Vancouver: November House, 1977.

Alford, John. "Trends in Canadian Art." *University of Toronto Quarterly* 14, no. 2 (January 1945): pp. 168–180.

The Arts in Canada. Canadian Citizenship Series Pamphlet, no. 6. Ottawa: Department of Citizenship and Immigration, 1958.

Ayre, Robert. "The Canadian Group of Painters." *Canadian Art* 6, no. 3 (Spring 1949): pp. 98–102.

——. "The Last Show of the Old Year and the First of the New." *Montreal Star,* December 31, 1954.

Barwick, Frances Duncan. *Pictures from the Douglas M. Duncan Collection.* Toronto and Buffalo: University of Toronto Press, 1975.

Bell, Andrew. "The Art of Paraskeva Clark." *Canadian Art* 7, no. 2 (1949): pp. 42–46.

——. "Toronto as an Art Centre." *Canadian Art* 6, no. 2 (Christmas 1948): pp. 74–75.

——. "Canadian Painting and the Cosmopolitan Trend." *The Studio* 150, no. 751 (October 1955): pp. 97–105.

Brace, Brock. "Russian-Born Painter and Patriot Holding Exhibit for Charity Fund." *The Varsity* (University of Toronto), December 11, 1942.

Broadfoot, Barry. *Ten Lost Years.* Don Mills, Ontario: Paperjacks, 1975.

Brooks, Leonard. *Oil Painting: Traditional and New.* New York: Reinhold Publishing, 1963.

Brown, Eric. "Canada's National Painters." *The Studio* 103 (June 1932): pp. 311–323.

Buchanan, Donald W. "Variations in Canadian Landscape Painting." *University of Toronto Quarterly* 10, no. 1 (October 1940): pp. 39–45.

——. "Contemporary Painting in Canada." *The Studio* 129, no. 625 (April 1945): pp. 99–111.

——. "Paraskeva Clark (1898–) An Honest Sophistication." *The Growth of Canadian Painting.* London, Toronto: William Collins & Son, 1950.

Clark, Paraskeva. "The Artist Speaks: A Statement by Paraskeva Clark." *Canadian Review of Music and Art* 3, nos. 9–10 (1944): pp. 18–19.

——. "Canadian Artists: Thoughts on Canadian Painting." *World Affairs* 8, no. 6 (February 1943): pp. 17–18.

——. "Come Out from Behind the Pre-Cambrian Shield." *New Frontier* 1, no. 12 (April 1937): pp. 16–17.

——. "Travelling Exhibitions – Is the Public's Gain the Artist's Loss?" *Canadian Art* 7, no. 1 (Autumn 1949): pp. 21–24.

Comfort, Charles. "Where I Stand on Spain." *New Frontier* 1, no. 8 (December 1936): pp. 13–16.

"Contemporary Soviet Painting." *Globe and Mail,* April 13, 1945.

Dacre, Douglas. "The Butcher with a Poet's Soul." *Maclean's* 64 (October 1, 1951): pp. 18–19, 61–63, 65–66.

Donegan, Rosemary. *Reflections of Our Labour.* Ottawa: CLC Labour Education Studies Centre, 1980.

Fairley, Barker. "Canadian Art: Man vs. Landscape." *Canadian Forum* 19, no. 227 (December 1939): pp. 284–288.

Freedman, Adele. "In the Shadow of the 30s: The Winter of Paraskeva Clark." *Toronto Life,* February 1979, pp. 127–129.

Greenwood, Michael. *Art Deco Tendencies in Canadian Painting.* Toronto: Art Gallery of York University, 1977.

Hambleton, Josephine. "A Painter of Sylvan Canada." *Ottawa Citizen,* January 17, 1948.

——. "Canadian Artists: XVIII Paraskeva Clark." *Kingston Whig Standard,* February 2, 1948.

Hobart, Cathy. "Art Transformed." *Branching Out* 7, no. 1 (Spring 1980): pp. 12–13.

Hume, Christopher. "'Painting is not a woman's job': But Paraskeva Clark has made it in a man's world." *Toronto Star,* January 29, 1983.

Jarvis, Alan, ed. *Douglas Duncan: A Memorial Portrait.* Toronto: University of Toronto Press, 1974.

The J.S. McLean Collection of Paintings. Toronto: Art Gallery of Ontario, 1968.

MacLachlin, Mary E. *Paraskeva Clark: Paintings and Drawings.* Halifax: Dalhousie Art Gallery, 1982.

MacLeod, Wendell, Libbie Park, and Stanley Ryerson. *Bethune: The Montreal Years, an Informal Portrait.* Toronto: James Lorimer and Company, 1978.

McInnes, Graham. "Contemporary Canadian Artists Series No. 7: Paraskeva Clark." *Canadian Forum* 17, no. 199 (August 1937): p. 166.

McLean, J.S. "On the Pleasures of Collecting Paintings." *Canadian Art* 10, no. 1 (Autumn 1952): pp. 2–7.

Mulligan, H.A. "Show of the Month." *Canadian Comment,* May 1937.

Nicol, Pegi. "The Passionate Snows of Yesteryear." *Canadian Forum* 16, no. 183 (April 1936): p. 21.

O'Rourke, Kathryn. "Labours and Love: Issues of Domesticity and Marginalization in the Works of Paraskeva Clark." Master's thesis, Concordia University, 1995.

Paintings and Drawings from the Collection of J.S. McLean. Ottawa: National Gallery of Canada, 1952.

Paintings of a Province. Toronto: Art Institute of Ontario, 1967.

Paraskeva Clark and Carl Schaefer. Toronto: Art Gallery of Toronto, 1954.

Paraskeva Clark, Carl Schaefer, Caven Atkins, David Milne. Toronto: Art Gallery of Toronto, 1939.

Pavlichenko, Luidmila, and Jessica Smith. "Lieutenant Luidmila Pavlichenko and the American People." *Soviet Russia Today,* October 1942, pp. 8–10, 33–34.

Purdie, James. "Visual power part of Bush's critical legacy." *Globe and Mail* (Toronto), January 29, 1977.

Redgrave, F. "The Divine Grumpiness of Paraskeva Clark." *Art Magazine* 63, no. 4 (June–August 1983): pp. 58–59.

Sabbath, Lawrence. "Paraskeva Clark." *Canadian Art* 17, no. 5 (September 1960): pp. 291–293.

Shkapskaya, Maria. "Soviet Women on all Fronts: The Women of Leningrad." *Soviet Russia Today,* October 1942, pp. 17, 20, 21, 34.

Singer, Gail, Kathleen Shannon, and Margaret Pettigrew. *Portrait of the Artist as an Old Lady.* National Film Board of Canada, 1982. Film.

Stewart, Roderick. *Bethune.* Toronto: New Press, 1973.

——. *The Mind of Norman Bethune.* Wesport, CT: Lawrence Hill, 1977.

"Strength and Sensitivity Blend in Fine Painting." *Toronto Evening Telegram,* February 15, 1947.

Underhill, Frank. "The Season's New Books: *Yearbook of the Arts in Canada.*" *Canadian Forum* 16, no. 191 (December 1936): pp. 27–28.

Emily Coonan

See Beaver Hall Group listings (above).

Antaki, Karen. *Emily Coonan (1885–1971)*. Montreal: Concordia University, 1987.

Gagnon, François-Marc. "Painting in Québec in the Thirties." *Journal of Canadian Art History* 3, nos. 1–2 (Fall 1976): p. 10.

Rody Kenny Courtice

Boutilier, Alicia. *Four Women Who Painted in the 1930s and 1940s: Rody Kenny Courtice, Bobs Cogill Haworth, Yvonne McKague Housser and Isabel McLaughlin*. Ottawa: Carleton University Art Gallery, 1998.

"Fine Work Marks R.C.A. Exhibition." *Gazette* (Montreal), November 20, 1925.

Jackson, A.Y. *A Painter's Country*. Toronto: Clarke, Irwin, 1972.

Jansma, Linda. *Rody Kenny Courtice: The Pattern of Her Times*. Oshawa, ON: Robert McLaughlin Gallery, 2006.

LeCoq, Thelma. "Four Women Who Paint." *Chatelaine* 21, no. 9 (September 1948): p. 9.

Rody Kenny Courtice, B. Cogill Haworth, Yvonne McKague Housser, Isabel McLaughlin, November 15–December 15, 1940. Toronto: Art Gallery of Ontario, 1940.

Kathleen Daly

Alexander Bercovitch, Kathleen Daly, George Pepper, William A. Winter. Toronto: Art Gallery of Toronto, 1942.

Daly, Kathleen F. "People of the North: An Album of Distinguished Paintings." *North*, March–April 1962, p. 1.

Dutka, Joanna. *Kathleen Daly, George D. Pepper*. Kleinburg, ON: McMichael Canadian Art Collection, 1999.

Gagnon, François-Marc, and Suzanne Presse. *Kathleen Daly, George D. Pepper: Retrospective*. Baie-St-Paul, Québec: Centre d'Exposition de Baie-St-Paul, 1996.

Kathleen Daly: Canmore Workings. Banff: Whyte Museum of the Canadian Rockies, 1987.

Pepper, Kathleen Daly. "An Infidel from Canada Paints Inside Morocco." *Globe Magazine*, June 1957.

Mary Bell Eastlake

A Catalogue of Oil Paintings, Water Colours and Pastels by Mrs. C.H. Eastlake (M.A. Bell), On View in the Front Room of the Galleries, 24th March to 12th April, 1923. Montreal: Art Association of Montreal, 1923.

Des Rochers, Jacques. "Bel exemple de preraphaelisme au Canada." *Collage*, Winter 2003/2004, p. 12.

An Exhibition of Oils, Water Colours and Pastels by Mrs. C.H. Eastlake (M.A. Bell). Toronto: Art Gallery of Toronto, 1927.

Ford, H. *Catalogue of Pictures, Pastels and Enamels by Charles H. Eastlake, R.B.A. and M.A. Bell (Mrs. Eastlake)*. Montreal: The Art Gallery, Phillips Square, 1902.

Prakash, A.K. *Mary Bell Eastlake (1864–1951)*. Calgary: Masters Gallery, 2006.

Quigley, Jane. "Volendam as a Sketching Ground." *Studio* 38 (1906): pp. 118–125.

"Varied Works by Mrs. C.H. Eastlake." *Gazette* (Montreal), March 26, 1923.

Marcelle Ferron

Ayre, Robert. "Marcelle Ferron's powerful drive." *Montreal Star*, October 16, 1965.

——. "Suzanne Bergeron and Marcelle Ferron at the Galerie Agnes Lefort, Montreal." *Canadian Art* 21 (January 1964): p. 8.

Boudreau, Pierre de Ligny. "Marcelle Ferron: A Young Painter." *Canadian Art* 12, no. 4 (Summer 1955): pp. 148–149.

Daigneault, Gilles. "Marcelle Ferron: le rythme de la sagesse." *Vie des arts* 22, no. 89 (Winter 1977–1978): pp. 30–32.

Delloye, Charles. "Marcelle Ferron." *Aujourd'hui* 6 (April 1962): pp. 20–21.

Gaston, Robert. *Autour de Marcelle Ferron*. Québec: Loup de Gouttière, 1995.

Jasmin, C. "Marcelle Ferron à la galerie Agnes Lefort, Montreal." *Canadian Art* 19 (March 1962): pp. 101–102.

Lussier, Réal. *Marcelle Ferron*. Montréal: Musée d'art contemporain, 2000.

Marcelle Ferron de 1945 à 1970. Montréal: Musée d'art contemporain, 1970.

Millet, Robert. "Une verrière de Marcelle Ferron." *Maclean's* 8, no. 6 (June 1968): pp. 12–13.

Montbizon, Réa. "Encounter: La Ferron." *Gazette* (Montreal), October 16, 1965.

Nasgaard, Roald. *Abstract Painting in Canada*. Vancouver: Douglas & McIntyre, 2007.

Sarrazin, Jean. "Marcelle Ferron ou la quête joyeuse de la lumière/Marcelle Ferron or the Joyous Search for Light." *Vie des arts* 61 (Winter 1970–1971): pp. 30–33, 81–82.

Smart, Patricia. "Automatisme: un lieu d'égalité pour les femmes?" *Vie des arts* 42, no. 170 (Spring 1998): pp. 42–46.

Viau, G. "Marcelle Ferron." *Aujourd'hui* 5 (December 1960): p. 59.

Villeneuve, Paquerette. "Marcelle Ferron: telle qu'en elle-meme." *Vie des Arts* 44, no. 179 (Summer 2000): pp. 47–50.

Wescher, Herta. "Les secrets de Marcelle Ferron." *Vie des arts* 43 (Summer 1966): pp. 68–69.

Woods, Kay. "Gallery Moos, Ltd., Toronto; exhibit." *Artscanada* 37 (December/January 1980–81): p. 43.

Mary Riter Hamilton

Baele, Nancy. "Lest we forget: Grief for Vicitims of First World War shows through in restrained style of Mary Riter Hamilton." *Ottawa Citizen*, April 12, 1993.

Berry, Virginia. *Vistas of Promise: Manitoba 1874–1919*. Winnipeg: Winnipeg Art Gallery, 1987.

Bruce, J.E.M. "Mary Riter Hamilton." *Gold Stripe* no. 2 (May 1919): pp. 22–23.

Davis, Angela. "An Artist in No-Man's Land." *Beaver*, October/November 1989, pp. 6–16.

——. "Mary Riter Hamilton: Manitoba Artist 1873–1954." *Manitoba History*, Spring 1986, pp. 22–27.

Davis, Angela, and Sarah McKinnon. *No Man's Land: The Battlefield Paintings of Mary Riter Hamilton*. Ottawa: War Amps of Canada and National Archives of Canada, 1989.

Deacon, Florence E. "The Art of Mary Riter Hamilton." *Canadian Magazine*, October 1912, p. 557.

Exhibition of paintings, water-colors, pastels and drawings by Mary Riter Hamilton, on view from May 4th until May 18th, 1912. Winnipeg: Winnipeg Industrial Bureau, 1912.

Gessell, Paul. "What did Mary Hamilton really see?" *Ottawa Citizen*, November 11, 1998.

Iavarone, Mike. "The Battlefield Art of Mary Riter Hamilton." World War I: Trenches on the Web. www.worldwar1.com/sfmrh.htm

"Mary Riter Hamilton: An Artist Impressionist on the Battlefields of France." *Gold Stripe* no. 1 (1919): pp. 11, 12.

Mary Riter Hamilton 1873–1954. Victoria: Art Gallery of Greater Victoria, 1978.

Taylor, E.A. "The American Colony of Artists in Paris." *International Studio*, August 1911.

Williamson, Moncrieff. *Through Canadian Eyes: Trends and Influences in Canadian Art: 1815–1965*. Calgary: Glenbow-Alberta Institute, 1976.

Prudence Heward

See Beaver Hall Group listings (above).

Anne Savage, Prudence Heward, Sarah Robertson, Ethel Seath: Exhibition, February 1940. Toronto: Art Gallery of Toronto, 1940.

Braide, Janet, and Nancy Parke-Taylor. *Prudence Heward (1896–1947): An Introduction to Her Life and Work*. Montreal: Walter Klinkhoff Gallery, 1980.

Duval, Paul. "Art and Artists: Prudence Heward Show." *Saturday Night* 58 (April 24, 1948): p. 19.

Emeny, Shirley Kathleen. "Plurality and Agency: Portraits of Women by Prudence Heward." Master's thesis, University of Alberta, 1999.

Grafftey, Heward. *Portraits from a Life*. Montreal: Véhicule, 1996.

Holgate, Edwin. "Prudence Heward." *Canadian Art* 4, no. 4 (Summer 1947): pp. 160–161.

Lismer, Arthur. "Works by Three Canadian Women." *Montreal Star*, May 9, 1934.

Luckyj, Natalie. *Expressions of Will: The Art of Prudence Heward*. Kingston, ON: Agnes Etherington Art Centre, 1986.

Pearce, Lynne. "The Viewer as Producer: British and Canadian Feminists Reading Prudence Heward's 'Women.'" *RACAR* 25, nos. 1–2 (1998): pp. 94–103.

Prakash, A.K. "Prudence Heward: Master of Representational Expressionism" in *Canadian Art: Selected Masters from Private Collections*. Ottawa: Vincent Fortier Publishing, 2003.

Savage, Anne. *Memorial Exhibition, Prudence Heward 1896–1947*. Ottawa: National Gallery of Canada, 1948.

St. Jean, France. "La réception critique dans la presse montréalaise francophone des décennies 1930 et 1940 de l'oeuvre de cinq femmes artistes: Prudence Heward, Lilias Torrance Newton, Anne Savage, Marian Scott et Jori Smith." Master's thesis, Université du Québec à Montréal (UQAM), 1999.

Frances Anne Hopkins

Adamson, Jeremy. *From Ocean to Ocean: Nineteenth-Century Watercolour Painting in Canada*. Toronto: Art Gallery of Ontario, 1978.

Allodi, Mary. *Canadian Watercolours and Drawings in the Royal Ontario Museum*. Toronto: Royal Ontario Museum, 1974.

Arthur, Elizabeth, ed. *Thunder Bay District 1821–1892: A Collection of Documents*. Toronto: Champlain Society and University of Toronto Press, 1973.

Burant, Jim. "Evidence points to D.A. Gillies as central figure in canoe project." *Ottawa Citizen*, November 28, 1997.

Chalmers, John W. "Frances Anne Hopkins: The Lady Who Painted Canoes." *Canadian Geographical Journal* 83, no. 1 (1971): pp. 18–27.

Clark, Janet E., and Robert Stacey. *Frances Anne Hopkins, 1838–1919: Canadian Scenery*. Thunder Bay, ON: Thunder Bay Art Gallery, 1990.

Clayton, Ellen C. *English Female Artists*. 2 vols. London, 1876.

Feltes, N. "Voy(ag)euse: Gender and Gaze in the Canoe Paintings of Frances Anne Hopkins." *Ariel, a Review of International English Literature* 24, no. 4 (October 1993): pp. 7–24.

Graves, Algernon. *Principal London Exhibitions: 1760–1893*. London: Henry Graves, 1895.

——. *The Royal Academy of Arts: A Complete Dictionary of Contributors and Their Work, From Its Foundation in 1769 to 1904*. Vol. 2. London: Henry Graves, 1905.

Guillet, Edwin C. "Her Paintings Show Voyageur's Life." *Toronto Daily Star*, December 12, 1958.

Harper, J. Russell. *A Century of Colonial Painting*. Ottawa: National Gallery of Canada, 1964.

Holme, Charles, ed. *The Old Watercolour Society 1804–1904*. London: The Studio, 1905.

Hopkins, Elisabeth Margaret. "Grandmama." *Beaver* 307, no. 3 (Winter 1976): pp. 25–29.

Huneault, Kristina. "Placing Frances Anne Hopkins: A British-Born Artist in Colonial Canada." In *Local/Global: Women Artists in the Nineteenth Century*, edited by Deborah Cherry and Janice Helland. Burlington, VT: Ashgate, 2006, pp. 179–200.

Huyshe, G.L. *The Red River Expedition*. London: Macmillan, 1871.

Johnson, Alice M. "Edward and Frances Hopkins of Montreal." *Beaver* 302, no. 2 (Autumn 1971): pp. 4–17.

——. "The Hopkins Book of Canoe Songs." *Beaver* 302 (Autumn 1971): pp. 54–58.

Johnson, Jane, ed. *Works Exhibited at the Royal Society of British Artists, 1824–1893 and the New English Art Club 1888–1917*. Suffolk, England: Antique Collectors Club, 1975.

Laviolette, Mary-Beth. "Frances Anne Hopkins: Interview with Janet E. Clark." *Artichoke* 2, no. 1 (1991): pp. 8, 9.

Merritt, Susan E. "Frances Anne Hopkins (1838–1919)." In *Her Story II: Women from Canada's Past.* St. Catharines, ON: Vanwell Publishing, 1995.

Miller, Audrey. "Frances Anne Hopkins, 1838–1919." In *Lives and Works of the Canadian Artists,* edited by Robert H. Stacey. Toronto: Dundurn, 1977.

Morse, Eric. *Fur Trade Routes of Canada, Then and Now.* Ottawa: Queen's Printer, 1968.

Nunn, Pamela Gerrish. "Ruskin's Patronage of Women Artists." *Woman's Art Journal,* Fall/Winter 1981/82, pp. 8–13.

Nute, Grace Lee. "Voyageurs' Artist." *Beaver* 218 (June 1947): pp. 32–37.

The Painted Past: Selected Paintings from the Picture Division of the Public Archives of Canada. Ottawa: National Archives of Canada, 1987.

Pomeroy, Jordana, ed. "'We Got Upon Our Elephant & Went Out After Subjects': Capturing the World in Watercolor." In *Intrepid Women: Victorian Artists Travel.* Burlington, VT: Ashgate, 2005.

Rand, Margaret. "Rediscovering Voyageur Artist Frances Hopkins." *Canadian Geographic* 102, no. 3 (1982): pp. 22–29.

Reid, Dennis. *Collector's Canada.* Toronto: Art Gallery of Ontario, 1988.

——. *Our Own Country Canada: Being an Account of the National Aspirations of the Principal Landscape Artists in Montreal and Toronto 1860–1890.* Ottawa: National Gallery of Canada, 1979.

Ruskin, John. *Modern Painters.* New York: Knopf, 1987.

Sinclair, Catherine. "Let's Have an Old-Time Canadian Christmas." *Chatelaine,* December 1961.

Thomas, Ann. *Fact and Fiction: Canadian Painting and Photography 1860–1900.* Montreal: McCord Museum of Canadian History, 1979.

Thomson, D., ed. *Fifty Years of Art: Being Articles and Illustrations Selected from "The Art Journal."* London: Virtue, 1900.

Weiler, Robert. *Canoe Woman: The Story of Frances Anne Hopkins.* Washington, D.C.: Robert Weiler, 1994.

Williamson, Moncrieff. *Through Canadian Eyes: Trends and Influences in Canadian Art: 1815–1965.* Calgary: Glenbow-Alberta Institute, 1976.

Wilson, Clifford. "Voyageurs: An Oil Painting by Frances Anne Hopkins." *Naturalist* 10 (Winter 1959).

Yvonne McKague Housser

Anderson, Janice. "Creating Room: Canadian Women Mural Painters and Rereadings of the Public and the Private." Ph.D. diss., Concordia University, 2002.

Boutilier, Alicia. *4 Women Who Painted in the 1930s and 1940s: Rody Kenny Courtice, Bobs Cogill Haworth, Yvonne McKague Housser and Isabel McLaughlin.* Ottawa: Carleton University Art Gallery, 1998.

Boyanoski, Christine. "Charles Comfort's Lake Superior Village and the Great Lakes Exhibition." *Journal of Canadian Art History* 12, no. 2 (1989): pp. 174–198.

Frye, Helen Kemp. "Yvonne McKague Housser." *Canadian Forum* 18 (September 1938): pp. 176–177.

Housser, Yvonne McKague. "Paris: The Magnet." *Quality Street,* April 1926, pp. 9–10, 24, 29.

Murray, Joan. *The Art of Yvonne McKague Housser.* Oshawa, ON: Robert McLaughlin Gallery, 1995.

Nelson, Charmaine. *Through An-Other's Eyes: White Canadian Artists – Black Female Subjects.* Oshawa, ON: Robert McLaughlin Gallery, 1998.

Simone Hudon-Beaulac

Martin, Denis. *L'Estampe au Québec, 1900–1950.* Musée du Québec, 1988.

Frances Jones

Davies, Gwendolyn. "Art, Fiction and Adventure: The Jones Sisters of Halifax." *Journal for the Royal Nova Scotia Historical Society* 5 (2002): pp. 1–22.

Kelly, Gemey. *Backgrounds: Ten Nova Scotia Women Artists.* Halifax: Dalhousie Art Gallery, 1984.

O'Neill, Mora Dianne, and Caroline Stone. *Two Artists Time Forgot: Frances Jones (Bannerman) and Margaret Campbell Macpherson.* Halifax: Art Gallery of Nova Scotia, 2006.

O'Neill, Mora Dianne. *Choosing Their Own Path: Canadian Women Impressionists.* Halifax: Art Gallery of Nova Scotia, 2001.

Piers, Harry. "Artists in Nova Scotia." *Collections, Nova Scotia Historical Society* 18 (1914): p. 156.

Shutlak, Garry D. "The Honourable A.G. Jones and family called roomy Bloomingdale on the Northwest Arm home." *The Griffin, Heritage Trust of Nova Scotia* (December 2002): pp. 6–9.

Stacey, Robert, and Liz Wylie. "Eighty: 1887–1967." In *Eighty/Twenty: 100 Years of the Nova Scotia College of Art and Design.* Halifax: Art Gallery of Nova Scotia, 1988.

Maud Lewis

Hamilton, Laurie. *The Painted House of Maud Lewis.* Fredericton: Goose Lane, 2001.

Woolaver, Lance, and Bob Brooks. *The Illuminated Life of Maud Lewis.* Halifax: Nimbus and Art Gallery of Nova Scotia, 1996.

Mabel Lockerby

See Beaver Hall Group listings (above).

Ayre, Robert. "Art in Montreal." *Canadian Art* 8, no.1, Autumn 1950.

Mabel Lockerby, Pegi Nicol MacLeod, Kathleen Morris, Marian Scott. Toronto: Art Gallery of Toronto, 1941.

Meadowcroft, Barbara. *Mabel Lockerby (1882–1976): Retrospective Exhibition.* Montreal: Walter Klinkhoff Gallery, 1989.

"Old World Port Still Hums." *Beaver,* December 7, 1967.

Marion Long

Haviland, Richard. "Marion Long R.C.A., O.S.A., 'An Artist to her Fingertips.'" *Montreal Standard,* October 29, 1938.

"An Interview with Miss Marion Long." *The Magnet* 6, no. 1 (March 1924): pp. 54, 55.

"First Woman in 50 Years to Get Full Membership R.C.A." *Ottawa Citizen,* November 18, 1933.

Long, Marion. "Developing a National Art." *Canadian Home Journal,* January 1921.

Miller, Muriel. *Famous Canadian Artists.* Peterborough: Woodland Publishing, 1983.

Pringle, Gertrude. "Miss Marion Long." *Saturday Night,* April 24, 1926.

Robson, A.H. *Canadian Landscape Painters.* Toronto: Ryerson Press, 1932.

"Toronto Woman Artist Thinks Bay St. Beautiful." *Toronto Star,* November 20, 1933.

Toronto Star, August 19, 1970.

Laura Muntz Lyall

Fallis, Margaret. "Laura Muntz Lyall A.R.C.A. 1860–1930." Paper for Canadian Studies, Carleton University, 1985.

Gualtieri, Julia. "The Woman as Artist and as Subject in Canadian Painting (1890–1930): Florence Carlyle, Laura Muntz Lyall, Helen McNicoll." Master's thesis, Queen's University, 1989.

MacTavish, Newton. "Laura Muntz and Her Art." *Canadian Magazine* 37, no. 5 (September 1911): pp. 419–426.

Mulley, Elizabeth. "Madonna/Mother/Death and Child: Laura Muntz and the Representation of Maternity." RACAR 25, nos. 1–2 (1998): pp. 84–93.

———. "Women and Children in Context: Laura Muntz and the Representation of Maternity." Ph.D. diss., McGill University, 2000.

Murray, Joan. *Laura Muntz Lyall: A Passion to Paint.* Forthcoming.

Page, Anne Mandely. "Canada's First Professional Women Painters, 1890–1914: Their Reception in Canadian Writing on the Visual Arts." Master's thesis, Concordia University, 1991.

Pegi Nicol MacLeod

Brandon, Laura. "Exploring 'the Undertheme': The Self-Portraits of Pegi Nicol MacLeod (1904–1949)." Master's thesis, Queen's University, 1992.

———. *Pegi by Herself: The Life of Pegi Nicol MacLeod, Canadian Artist.* Montreal and Kingston: McGill-Queen's University Press, 2005.

Harper, J. Russell. "Pegi Nicol MacLeod: A Maritime Artist." *Dalhousie Review* 43, no. 1 (Spring 1963): pp. 40–50.

Karlinsky, Amy. "Pegi Nicol MacLeod." *Border Crossings* 24, no. 3 (August 2005): p. 93.

Mabel Lockerby, Pegi Nicol MacLeod, Kathleen Morris, Marian Scott. Toronto: Art Gallery of Toronto, 1941.

McInnes, Graham. "Contemporary Canadian Artists Series No. 8: Pegi Nicol MacLeod." *Canadian Forum* 17, no. 200 (September 1937): pp. 202–203.

MacLeod, Pegi Nicol. "Canadian Women Painters." *Toronto Daily Star,* September 3, 1947.

McTavish, Lianne. "Pegi Nicol MacLeod: Paragraphs in Paint." *Arts Atlantic* 65, no. 1 (Winter, 2000).

Memorial Exhibition, Pegi Nicol MacLeod, 1904–1949. Ottawa: National Gallery of Canada, 1949.

Murray, Joan. *Daffodils in Winter: The Life and Letters of Pegi Nicol MacLeod, 1904–1949.* Moonbeam, ON: Penumbra, 1984.

Ostroff, Michael. *Pegi Nicol: Something Dancing About Her.* National Film Board, 2005. Film.

Smith, Stuart Allen. *Pegi Nicol MacLeod.* Fredericton, NB: Gallery 78, 1981.

Margaret Campbell Macpherson

Bell, Peter. "Painters of Newfoundland." *Canadian Antiques Collector* 10, no. 6 (January 14, 1975): pp. 1–7.

Campbell, Julian. *Peintres britanniques en Bretagne.* Pont-Aven: Musée de Pont-Aven, 2004.

Fink, Lois Marie. *American Art at the Nineteenth-Century Paris Salons.* Cambridge: Cambridge University Press, 1990.

Macpherson, Alan. "Margaret Campbell Macpherson: Newfoundland Artist." *Creag Dhubh* no. 55 (Spring 2003): pp. 28–29.

Madison, O. "Artist Margaret Campbell Macpherson b. St. John's NF." GenForum. http://www.jenforum.org/macpherson/messages/350.html

O'Neill, Mora Dianne. *Choosing Their Own Path: Canadian Women Impressionists.* Halifax: Art Gallery of Nova Scotia, 2001.

O'Neill, Mora Dianne, and Caroline Stone. *Two Artists Time Forgot: Frances Jones (Bannerman) and Margaret Campbell Macpherson.* Halifax: Art Gallery of Nova Scotia, 2006.

Mabel May

See Beaver Hall Group listings (above).

"Art: Canadian Impressionists." *Saturday Night,* April 17, 1951.

"Art: Over 100 Paintings Shown by Mabel May: Work of Montreal Artist at Dominion Gallery Reveals Varying Phases." *Gazette* (Montreal), February 11, 1950.

"Les Arts: Mabel May, A.R.C.A., à la Dominion Gallery." *Le Canada* (Montreal), February 10, 1950.

Doyon, Charles. "La Peinture: Retrospective H. Mabel May." *Haut Parleur* (Ste-Hyacinthe), February 26, 1950.

Huot, Maurice. "Les Expositions: Quarante ans de peinture par Mabel May." *La Patrie* (Montreal), February 10, 1950.

"Mabel May expose à la Dominion Gallery." *Le Canada* (Montreal), February 11, 1950.

"Peinture impressioniste." *La Presse* (Montreal), February 14, 1950.

Robitaille, Adrien. "Les Expositions – Science, vigueur et gout sont les marques de ce grand talent canadien." *Le Devoir* (Montreal), February 11, 1950.

Saturday Night, April 17, 1951.

Florence Helena McGillivray

Catalogue of an Exhibition of Paintings of At Home and Abroad by F.H. McGillivray, A.R.C.A., O.S.A. Montreal: Art Association of Montreal, 1928.

Murray, Joan. *Tom Thomson: Design for a Canadian Hero*. Toronto: Dundurn, 1998.

Robson, A.H. *Canadian Landscape Painters*. Toronto: Ryerson Press, 1932.

Schell, H.R., et al. *Florence McGillivray Retrospective Exhibition at "The Station."* Whitby, ON: Whitby Arts, 1970.

Topp, Elizabeth Cadiz. *Endless Summer: Canadian Artists in the Caribbean*. Kleinburg, ON: McMichael Canadian Art Collection, 1988.

Helen McNicoll

The Art Association of Montreal Memorial Exhibition of Paintings by the late Helen G. McNicoll, R.B.A., A.R.C.A. Montreal: Art Association of Montreal, 1925.

Betterton, Rosemary. "Women Artists, Modernity and Suffrage Cultures in Britain and Germany 1890–1920." In *Women Artists and Modernism,* edited by Katy Deepwell. Manchester: Manchester University Press, 1998.

Betterton, Rosemary, ed. *Looking On*. London: Pandora, 1987.

Brooke, Janet M. *Discerning Tastes: Montreal Collectors 1880–1920*. Montreal: Montreal Museum of Fine Arts, 1989.

Broude, Norma. "A World of Light: France and the International Impressionist Movement 1860–1920." In *World Impressionism: The International Movement, 1860–1920,* edited by Norma Broude. New York: Abrams, 1990.

Carbin, Clifton F. *Deaf Heritage in Canada*. Montreal: McGill Ryerson, 1996.

Forster, Merna. *100 Canadian Heroines: Famous and Forgotten Faces*. Toronto: Dundurn, 2004.

Gualtieri, Julia. "The Woman as Artist and as Subject in Canadian Painting (1860–1930): Florence Carlyle, Laura Muntz Lyall, Helen McNicoll." Master's thesis, Queen's University, 1989.

Harrison, Charles. *English Art and Modernism 1900–1939*. 2nd ed. New Haven: Yale University Press, 1994.

Heilbrun, Carolyn G. *Writing a Woman's Life*. New York: Ballantine, 1988.

Higonnet, Anne. *Pictures of Innocence: The History and Crisis of Ideal Childhood*. London: Thames and Hudson, 1998.

Huneault, Kristina. "Impressions of Difference: The Painted Canvases of Helen McNicoll." *Art History* 27, no. 2 (April 2004): pp. 349–350.

Hurdalek, Marta H. *The Hague School: Collecting in Canada at the Turn of the Century*. Toronto: Art Gallery of Ontario, 1983.

Lacombe Robinson, Lynne. "Tranquil Transgressions: The Formation of a Feminine Social Identity in Helen McNicoll's Representations of Women." Master's thesis, University of Alberta, 2003.

Lowrey, Carol. *Visions of Light and Air: Canadian Impressionism, 1885–1920*. New York: Americas Society Art Gallery, 1995.

Luckyj, Natalie. *Helen McNicoll: A Canadian Impressionist*. Toronto: Art Gallery of Ontario, 1999.

Marchese, Frank. "The Return of Sunlight." *Art Impressions* 13, no. 3 (February/March 1998): pp. 19–22.

Murray, Joan. *Helen McNicoll, 1879–1915: Oil Paintings from the Estate*. Toronto: Morris Gallery, 1974.

O'Neill, Mora Dianne. *Choosing Their Own Path: Canadian Women Impressionists*. Halifax: Art Gallery of Nova Scotia, 2001.

Page, Anne Mandely. "Canada's First Professional Women Painters, 1890–1914: Their Reception in Canadian Writing on the Visual Arts." Master's thesis, Concordia University, 1991.

Parker, Rozsika. *The Subversive Stitch*. London: Women's Press, 1984.

Pollock, Griselda. *Mary Cassatt, Painter of Modern Women*. London: Thames and Hudson, 1998.

Robins, Anna Gruetzner. "British Impressionism: The Magic and Poetry of Life Around Them." In *World Impressionism: The International Movement 1860–1920,* edited by Norma Broude. New York: Abrams, 1990.

Taylor, Hilary. "If a young painter be not fierce and arrogant, God … help him: some women art students at the Slade." *Art History* 9, no. 2 (June 1986): pp. 232–244.

Tickner, Lisa. *The Spectacle of Women: Imagery of the Suffrage Campaign 1907–14*. Chicago: University of Chicago Press, 1988.

Weeks, Charlotte J. "Women at Work: The Slade Girls." *Magazine of Art* (1883): pp. 324–329.

Wortley, Laura. *British Impressionism: A Garden of Bright Images*. Studio Fine Art Publications, 1988.

Kathleen Moir Morris

See Beaver Hall Group listings (above).

"Exhibition of Arts Club." *Gazette* (Montreal), November 17, 1956.

Haviland, Richard H. "Canadian Art and Artists – Kathleen Moir Morris, A.R.C.A., Landscape Painter, Noted for Winter Scenes." *Montreal Standard*, June 10, 1939.

Kozinska, Dorota. *Retrospective Exhibition: Kathleen Morris (1893–1986)*. Montreal: Walter Klinkhoff Gallery, 2003.

Mabel Lockerby, Pegi Nicol MacLeod, Kathleen Morris, Marian Scott. Toronto: Art Gallery of Toronto, 1941.

Prakash, A. "Kathleen Moir Morris, 1893–1986: peindre la joie de vivre avec brio." *Magazin'art* 11, no. 3 (Spring 1999): pp. 78–82.

Smith, Frances K. *Kathleen Moir Morris*. Kingston, ON: Agnes Etherington Art Centre, 1983.

Lilias Torrance Newton

See Beaver Hall Group listings (above).

Armstrong, Julian. "Montreal Artist Ready to Paint Queen, Nervous at 'thought' of Entering Palace." *Gazette* (Montreal), February 16, 1957.

Ayre, Robert. "Lilias Torrance Newton, Painter of the Queen." *The Montrealer,* February 1957.

Burgoyne, St. George. "Portraits by Lilias T. Newton R.C.A. Form Interesting Exhibition." *Gazette* (Montreal), October 28, 1939.

"Canadian Woman in the Public Eye." *Saturday Night* 42, no. 52 (November 12, 1927).

Edwin Holgate, A.Y. Jackson, Arthur Lismer, Lilias Torrance Newton. Toronto: Art Gallery of Toronto, 1940.

Farr, Dorothy. *Lilias Torrance Newton, 1896–1980*. Kingston, ON: Agnes Etherington Art Centre, 1981.

"Foremost Canadian Woman Artist Visits City on First Trip West." *Lethbridge Herald,* August 30, 1946.

Furst, Herbert. *Portrait Painting, Its Nature and Function*. New York: Frank-Maurice Inc., 1928.

Haviland, Richard H. "Canadian Art and Artists – Lilias Torrance Newton, R.C.A. – Well Known Montreal Portrait Painter and Teacher." *Montreal Standard*, December 17, 1938.

The Kingston Conference Proceedings. Reprint, Kingston: Agnes Etherington Art Centre, Queen's University, 1991.

Meadowcroft, Barbara. *Lilias Torrance Newton (1896–1980): Retrospective exhibition*. Montreal: Walter Klinkhoff Gallery, 1995.

St. Jean, France. "La réception critique dans la presse montréalaise francophone des décennies 1930 et 1940 de l'oeuvre de cinq femmes artistes: Prudence Heward, Lilias Torrance Newton, Anne Savage, Marian Scott et Jori Smith." Master's thesis, Université du Québec à Montréal (UQAM), 1999.

Sophie Pemberton

Gilmore, Bernice C. *Artists Overland: A Visual Record of British Columbia 1793–1886*. Burnaby, BC: Burnaby Art Gallery, 1980.

Graham, Colin. "Art in Review: Un livre ouvert." *Times* (Victoria), February 27, 1954.

——. *Sophie Deane-Drummond*. Victoria, BC: Art Gallery of Greater Victoria, 1967.

House, Maria Newberry. *Plantae Occidentalis: 200 Years of Botanical Art in British Columbia*. Vancouver: Botanical Garden, University of British Columbia, 1979.

Macdonald, J.F. *Paris of the Parisians*. London: Grant Richards, 1900.

Page, Anne Mandely. "Canada's First Professional Women Painters, 1890–1914: Their Reception in Canadian Writing on the Visual Arts." Master's thesis, Concordia University, 1991.

Sophie Pemberton Retrospective Exhibition. Vancouver: Vancouver Art Gallery, 1954.

Thom, Ian. *Art BC: Masterworks from British Columbia*. Vancouver: Douglas & McIntyre, 2000. See esp. "Sophie Pemberton."

Tuele, N.C. "B.C.'s first woman painter misses fame." *The Ubyssey*, December 1, 1978.

Tuele, Nicholas. "Sophia Theresa Pemberton: Her Life and Art." Master's thesis, University of British Columbia, 1980.

——. *Sophie Theresa Pemberton, 1869–1959*. Victoria, BC: Art Gallery of Greater Victoria, 1978.

Williamson, Moncrieff. "Art In Review: Long, Distinguished Life Links Artist With History." *Times* (Victoria), October 25, 1958.

Christiane Pflug

Allodi, Mary. "Christiane Pflug." *Arts Canada* 29, no. 5 (December 1972–January 1973): pp. 42–47.

Christiane Pflug website. http://www.christianepflug.com

Christiane Pflug. Introduction by F. Eckhardt. Winnipeg: Winnipeg Art Gallery, 1966.

Christiane Pflug 1936–1972. Introduction by Ann Davis. Winnipeg: Winnipeg Art Gallery, 1972.

Davis, Ann. *The Drawings of Christiane Pflug*. Winnipeg: Winnipeg Art Gallery, 1979.

——. *Somewhere Waiting: The Life and Art of Christiane Pflug*. Toronto: Oxford University Press, 1991.

Duval, Paul. *High Realism in Canada*. Toronto: Clarke, Irwin, 1974.

Lavut, Karen. *Simple Things: The Story of a Friendship*. Toronto: Mercury Press, 1999.

Sarah Robertson

See Beaver Hall Group listings (above).

Anne Savage, Prudence Heward, Sarah Robertson, Ethel Seath: Exhibition, February 1940. Toronto: Art Gallery of Toronto, 1940.

Ayre, Robert. "Sarah Robertson." *Montreal Star*, February 23, 1952.

Meadowcroft, Barbara. *Sarah Robertson (1891–1948): Retrospective Exhibition*. Montreal: Walter Klinkhoff Gallery, 1991.

Sarah Robertson, 1891–1948: Memorial Exhibition. Ottawa: National Gallery of Canada, 1951.

Anne Savage

See Beaver Hall Group listings (above).

Andrus, Donald F.P. *Annie D. Savage: Drawings and Watercolours*. Montreal: Sir George Williams Art Gallery, Concordia University, 1974.

Anne Savage, Prudence Heward, Sarah Robertson, Ethel Seath: Exhibition, February 1940. Toronto: Art Gallery of Toronto, 1940.

Ayre, Robert. *The Laurentian Painters: Painters in a Landscape*. Toronto: Art Gallery of Ontario, 1977.

——. "Renewal and Discovery – the art of Anne Savage." *Montreal Star*, April 12, 1969.

Beavis, Lynn. *Anne Savage*. Montreal: Leonard & Bina Ellen Art Gallery, Concordia University, 2002.

Braide, Janet. *Anne Savage: Her Expression of Beauty*. Montreal: Montreal Museum of Fine Arts, 1980.

Braide, Janet, and A. Hirsch. *Anne Savage*. Montreal: Montreal Museum of Fine Arts, 1980.

Calvin, H.A. "Anne Savage, Teacher." Master's thesis, Sir George Williams University, 1967.

Constantinidi, Mela, and Helen Duffy. *The Laurentians: Painters in a Landscape*. Toronto: Art Gallery of Ontario, 1977.

Cook, Sharon Anne, et al., eds. *Framing Our Past: Canadian Women's History in the Twentieth Century*. Montreal and Kingston: McGill-Queen's University Press, 2001.

Ferrari, Pepita and Erna Buffie. *By Woman's Hand*. National Film Board of
　　Canada, 1994. Film.

LeTellier, Lisanne. "Anne Savage, 1896–1971, Trailblazer in Every Sense of the
　　Word." *Magazin'art* 17, no. 1 (Fall 2004): pp. 106–110, 156.

MacGowan, S.J., R.C. Amaron, and E. Eaton. *Avançons*. Illustrated by Anne
　　D. Savage. Toronto: Macmillan Canada, 1942.

McDougall, Anne. *Anne Savage: The Story of a Canadian Painter*. 2nd ed.
　　Ottawa: Borealis, 2000.

——. "Anne Savage." *Vie des arts* 21, no. 86 (Spring 1977): pp. 50–53.

Meadowcroft, Barbara. *Anne Savage (1896–1971): Retrospective Exhibition*.
　　Montreal: Walter Klinkhoff Gallery, 1992.

Montgomery-Whicher, Rose, Julia L. Olivier, and Leah B. Sherman. *Anne
　　Savage Archives, 1896–1971*. Montreal: Leonard and Bina Ellen Art
　　Gallery, 1989.

Savage, Anne. *Canadian Group of Painters: Exhibition '60*. Montreal:
　　Montreal Museum of Fine Arts, 1961.

Sherman, Leah. "Anne Savage: A Study of Her Development as an Artist/
　　Teacher in the Canadian Art World, 1925–1950." In *Histories of Art and
　　Design Education*, edited by David Thistlewood. *Canadian Review of Art
　　Education, Research and Issues* 29, no. 2 (2002): p. 45.

——. *Anne Savage: A Retrospective*. Montreal: The Art Gallery, Sir George
　　Williams University, 1969.

——. *Anne Savage*. Montreal: Leonard and Bina Ellen Art Gallery, 2002.

Sherman, Leah B., and Angela Nairne Grigor. *A Comparison of the Influences
　　of Anne Savage and Arthur Lismer: Oral History Project*. Montreal:
　　Concordia University, Oral History Montreal Studies, 1985.

St. Jean, France. "La réception critique dans la presse montréalaise franco-
　　phone des décennies 1930 et 1940 de l'oeuvre de cinq femmes artistes:
　　Prudence Heward, Lilias Torrance Newton, Anne Savage, Marian
　　Scott et Jori Smith." Master's thesis, Université du Québec à Montréal
　　(UQAM), 1999.

Charlotte Schreiber

Baring-Gould, Rev. S. *Now the Day Is Over*. Designs by Charlotte Schreiber;
　　engraved by Mr. Bridgen. Toronto: Hart & Rawlinson, 1881.

Browning, Elizabeth Barrett. *The Rhyme of the Duchess May*. Illustrated by
　　C.M.B. Morrell. London: Sampson Low, Marston, Low, and Searle, 1873.

Canadian Illustrated News (Montreal), April 24, 1880.

Charlotte Schreiber, R.C.A. (A Retrospective). Toronto: Erindale Campus,
　　University of Toronto, 1985.

Fallis, Margaret. "Charlotte Schreiber R.C.A., 1834–1922." Master's thesis,
　　Carleton University, 1985.

Farr, Dorothy. "Schreiber, Charlotte Mount Brock." *Canadian Encyclopedia*.
　　Toronto: McClelland & Stewart, 2000.

Kritzwiser, Kay. "A Tale of Two Women with Power to Communicate." *Globe
　　and Mail*, April 22, 1967.

Sartin, Stephen. *A Dictionary of British Narrative Painters*. Leigh-on-Sea:
　　F. Lewis, 1978.

Saturday Globe (Toronto), March 2, 1895.

Spenser, Edmund. *The Legend of the Knight of the Red Crosse* or *Of Holinesse*.
　　Illustrated by Charlotte M.B. Morrell. London: Sampson Low, Son &
　　Marston, 1871.

Weaver, Emily P. "Pioneer Canadian Women." *Canadian Magazine*, May 1917,
　　pp. 32–36.

Ethel Seath

See Beaver Hall Group listings (above).

*Anne Savage, Prudence Heward, Sarah Robertson, Ethel Seath: Exhibition,
　　February 1940*. Toronto: Art Gallery of Toronto, 1940.

Cook, Sharon Anne, et al., eds. *Framing Our Past: Canadian Women's History
　　in the Twentieth Century*. Montreal and Kingston: McGill-Queen's
　　University Press, 2001.

Little, Roger. *Ethel Seath: A Retrospective Exhibition*. Montreal: Walter
　　Klinkhoff Gallery, 1987.

Students of Ethel Seath Exhibition. Montreal: Maison Alcan, 1987.

Regina Seiden

See Beaver Hall Group listings (above).

Henrietta Shore

Aikin, Roger, and Richard Lorenz. *Henrietta Shore: A Retrospective Exhibition:
　　1900–1963*. Monterey: The Monterey Peninsula Museum of Art, 1986.

Aikin, Roger. "Henrietta Shore and Edward Weston." *American Art* 6, no. 1
　　(Winter 1992): pp. 43–61.

Armitage, Merle. *Henrietta Shore*. New York: E. Weyhe, 1933.

Brown, Carolyn. "The Life and Art of Henrietta Shore." Senior thesis,
　　University of California, Santa Cruz, 1977.

Henniker-Heaton, Raymond. *Paintings by Henrietta Shore*. New York: Ehrich
　　Galleries, 1923.

Henri, Robert. *The Art Spirit: Notes, Articles, Fragments of Letters and
　　Talks to Students, Bearing on the Concept and Technique of Picture Making,
　　the Study of Art Generally, and on Appreciation*. Boulder: Westview, 1984.

Key, Archibald. "Parallels – and an Expatriate." *Canadian Forum*, July 1932,
　　p. 384.

Kovinick, Phil, and Marian Yoshiki-Kovinick. *An Encyclopedia of Women
　　Artists of the American West*. Austin: University of Texas Press, 1998.

Roznoy, Cynthia. "Henrietta Shore: American Modernist." Ph.D. diss., City
　　University of New York, 2003.

Wardle, Marian, ed. *American Women Modernists: The Legacy of Robert Henri:
　　1910–1945*. Piscataway, NJ: Rutgers University Press, 2005.

Jori Smith

Antaki, Karen. *Jori Smith: A Celebration*. Montreal: Leonard & Bina Ellen Art
　　Gallery, Concordia University, 1977.

Baker, Victoria, et al. *Scenes of Charlevoix 1784–1950*. Montreal: Montreal
　　Museum of Fine Arts, 1982.

Le Marchand, L. "Une double personnalité semble se partager le talent de Jori Smith." *Photo-Journal,* December 1947.

McInnes, Graham. "Contemporary Canadian Artists Series No. 6: Jori Smith and Jean Palardy." *Canadian Forum* 17, no. 198 (July 1937): pp. 130–131.

Smith, Jori. *Charlevoix County, 1930.* Manotick, ON: Penumbra, 1998.

St. Jean, France. "La réception critique dans la presse montréalaise francophone des décennies 1930 et 1940 de l'oeuvre de cinq femmes artistes: Prudence Heward, Lilias Torrance Newton, Anne Savage, Marian Scott et Jori Smith." Master's thesis, Université du Québec à Montréal (UQAM), 1999.

Varley, Christopher. *The Contemporary Arts Society, Montreal, 1939–1948.* Edmonton: Edmonton Art Gallery, 1980.

Elizabeth Wyn Wood

Baker, Victoria. *Emanuel Hahn and Elizabeth Wyn Wood: Tradition and Innovation in Canadian Sculpture.* Ottawa: National Gallery of Canada, 1997.

Brooker, Bertram. "Sculpture's New Mood." *Yearbook of the Arts in Canada, 1928–1929.* Toronto: Macmillan Canada, 1929.

Hambleton, Josephine. "Canadian Women Sculptors." *Dalhousie Review* 29, no. 3 (October 1949): pp. 327–337.

Le Bourdais, D.M. "Hahn and Wife Sculptors." *Maclean's* 58, no. 21 (November 1, 1945): pp.19–20.

Voaden, Herman. "Elizabeth Wyn Wood." *Maritime Art* 2, no. 5 (June–July 1942): pp. 145–149.

Wood, Elizabeth Wyn. "Art and the Pre-Cambrian Shield." *Canadian Forum* 16, no. 193 (February 1937): pp. 13–15.

——. "Canadian Handicrafts." *Canadian Art* 2, no. 5 (Summer 1945): pp. 86–194, 207, 225.

——. "Foreword." *Canadian Women Artists.* New York: Riverside Museum, 1947.

Florence Wyle

Bedard, Michael, and Les Tait. *The Clay Ladies.* Toronto: Tundra, 1999.

Boyanoski, Christine. *Loring and Wyle: Sculptors' Legacy.* Toronto: Art Gallery of Ontario, 1987.

Butlin, Susan. "Women Making Shells: Marking Women's Presence in Munitions Work 1914–1918: The Art of Frances Loring, Florence Wyle, Mabel May and Dorothy Stevens." *Canadian Military History* 5, no. 1 (1996): pp. 41–48.

Cameron, Elspeth. *And Beauty Answers: The Life of Frances Loring and Florence Wyle.* Toronto: Cormorant, 2007.

Catalogue of an Exhibition of Canadian War Memorials. Toronto: Art Gallery of Toronto, 1926.

Chapman, Christopher. *Loring and Wyle.* Canadian Broadcasting Corporation, 1965. Film.

Coutu, Joan Michele. "Design and Patronage: The Architecture of the Niagara Parks, 1935–1941." Master's thesis, Queen's University, 1989.

Dunington-Grubb, L.A. "Sculpture as a Garden Decoration." *Canadian Homes and Gardens,* March 1927.

Gilpin, William. "The idolater: At home with the Sculptor of Hercules, Cerberus and Pan at the Canadian National Exhibition." *Toronto Life* 31, no. 13 (September 1997): p. 106.

Hambleton, Josephine. "Canadian Women Sculptors." *Dalhousie Review* 29, no. 3 (October 1949): p. 327–337.

Huneault, Kristina. "Heroes of a Different Sort: Gender and Patriotism in the War Workers of Frances Loring and Florence Wyle." *Journal of Canadian art history* 15, no. 6 (1993): pp. 26–49.

Jacobine Jones, Frances Loring, Dora Wechsler, Florence Wyle: March, 1942. Toronto: Art Gallery of Toronto, 1942.

Jarvis, Alan. *Frances Loring, Florence Wyle.* Toronto: Pollock Gallery, 1969.

Jones, Donald. "Loring-Wyle Memorial Park honors odd-couple sculptors." *Toronto Star,* June 18, 1983.

Leslie, Cassandra. "Canadian Sculpture: Coming of Age." Library and Archives Canada. http://collections.concordia.ca/cgi-bin/cgiwrap/sldb/edbnet.pl

Morrison, Anne K. "Nationalism, Cultural Appropriation and an Exhibition." *Collapse* no. 5 (July 2000): pp. 94–121.

Rooney, F. "Frances Loring and Florence Wyle, Sculptors." *Resources for Feminist Research (Canada)* 13, no. 4 (1984): pp. 21–23.

Sisler, Rebecca. *Florence Wyle, 1881–1968.* Toronto: Dundurn, 1978.

——. *The Girls: A Biography of Frances Loring and Florence Wyle.* Toronto: Clarke, Irwin, 1972.

Stacey, Robert H. *Lives and Works of the Canadian Artists.* Toronto: Dundurn, 1977.

Wylie, Liz. "Loring, Frances – Florence Wyle, Art Gallery of Ontario, Toronto: Review." *Vanguard* 16, no. 5 (November 1987): p. 38.

This book is set in Arno Pro, a Renaissance typeface designed by Robert Slimbach. Arno, named after the river that flows through Florence, is based on the venerable Venetian typefaces of the fifteenth century that hold the memories of handwriting with a broad-nib pen. Measured, stately and luminous, Arno has a full set of optical sizes allowing the proportions and weights to vary with size for maximum legibility. Arno was honoured in 2007 by both the Type Directors Club and the journal *Typographica.*

Printed on 100 pound Garda Silk, an archival sustainable paper certified by the Forest Stewardship Council
Separations by Moveable Inc., Toronto
Printed and bound in Canada by Friesens, Altona